STARTING WITH THE UNIVERSE

BUCKMINSTER
FULLER

WHITNEY MUSEUM OF AMERICAN ART, NEW YORK in association with YALE UNIVERSITY PRESS, NEW HAVEN AND LONDON

STARTING WITH THE UNIVERSE

EDITED BY

K. MICHAEL HAYS

DANA MILLER

WITH ESSAYS BY

ANTOINE PICON

ELIZABETH A. T. SMITH

CALVIN TOMKINS

BUCKMINSTER

FULLER

This catalogue was published on the occasion of the exhibition *Buckminster Fuller: Starting with the Universe*, organized by the Whitney Museum of American Art, New York, in association with the Department of Special Collections of the Stanford University Libraries. The exhibition was curated by K. Michael Hays, adjunct curator of architecture, and Dana Miller, associate curator, with the assistance of Jennie Goldstein, curatorial assistant, Whitney Museum of American Art.

Whitney Museum of American Art, New York
June 26–September 21, 2008
Museum of Contemporary Art, Chicago
Summer 2009

Major support for the exhibition is provided by the Henry Luce Foundation, The Horace W. Goldsmith Foundation, and The Solow Art and Architecture Foundation.

Significant support for the catalogue is provided by the Dedalus Foundation.

This publication was produced by the Publications Department at the Whitney Museum of American Art, New York: Rachel de W. Wixom, head of publications; Beth A. Huseman, editor; Beth Turk, assistant editor; Anna Knoell, designer; Vickie Leung, production manager; Anita Duquette, manager, rights and reproductions; Berit Potter, rights and reproductions assistant; and Jessa Farkas, rights and reproductions assistant; in association with Yale University Press: Patricia Fidler, publisher, art and architecture; Mary Mayer, production manager; John Long, photo editor; and Kate Zanzucchi, senior production editor.

Copyeditor: Miranda Ottewell
Proofreader: Martin Fox
Indexer: Carol Roberts

Designed by Wilcox Design
Set in Charter by Amy Storm
Printed on 150 gsm Lumisilk
Printed and bound by CS Graphics, Singapore

Library of Congress Cataloging-in-Publication Data
Fuller, R. Buckminster (Richard Buckminster), 1895–1983.
Buckminster Fuller : starting with the universe / edited by K. Michael Hays and Dana Miller ; with essays by Antoine Picon, Elizabeth A. T. Smith, and Calvin Tomkins.
p. cm.
Catalog of an exhibition at the Whitney Museum of American Art, NY, June 26–Sept. 21, 2008.
Includes bibliographical references and index.
ISBN 978-0-300-12620-4 (pbk. : alk. paper)
1. Fuller, R. Buckminster (Richard Buckminster), 1895–1983—Exhibitions. 2. Visionary architecture—Exhibitions. 3. Architecture and technology—Exhibitions. I. Hays, K. Michael. II. Miller, Dana. III. Whitney Museum of American Art. IV. Title. V. Title: Starting with the universe.
NA737.F8A4 2008
720.92—dc22
2007046865

10 9 8 7 6 5 4 3 2 1

CONTENTS

Foreword

AN EXHIBITION IS A VERB

I well remember a particular visit to my local bookstore when I was in high school. It was during the Vietnam era—a time of social unrest, political distrust, and general disillusionment with all things that smacked of authority, even for a middle-class teenager in the suburbs of New York. It was also a moment of great hope and idealism characterized by communes, vegetarianism, nomadism, drug experimentation, political activism, and interest in Eastern religions. For me, like any seventeen-year-old, access to the counterculture was above all through records—the music, the lyrics, and the album covers. I also loved books, but visionary and counterculture books did not usually seem to make it to the shelves of the Brentanos and Doubleday bookstores I frequented.

There were several books that caught my attention on this particular visit. Two were by the leaders of the Yippies—Abbie Hoffman and Jerry Rubin. Hoffman's *Steal This Book* was a survival manual for self-proclaimed radicals with a title that exhorted potential readers to immediate action. Rubin's no less inflammatory *Do It! Scenarios of the Revolution* had an introduction by Black Panther Eldridge Cleaver. There was also an unmissable little volume with a riveting silver and black cover, R. Buckminster Fuller's *I Seem to Be a Verb*. I recall first skimming its pages like a flip book, then devouring it line by line and image by image. I literally couldn't make heads or tails of it; half of the text was upside down. There were cartoons, news clippings, diagrams, film stills, photographs, statistics, reproductions of art works, scientific photographs, and the most amazing, incongruous graphic treatment I had ever seen. Fuller, as Antoine Picon points out in his essay in this volume, was an emergent figure of our information society. There were outlandish pairings of images and words such as a photograph of a young boy surrounded by a crowd and news reporters with the caption: "Several youngsters, including a boy of age five who signed his application with a cross, have been granted patents by the U.S. Patent Office in recent years." There were seemingly idiosyncratic quotes from literature, philosophy, the press, and sources as diverse as Amy Vanderbilt and an Indian sitar-maker. Hoffman was quoted ("Today is the first day of the rest of your life") as were my music heroes from John Lennon and Frank Zappa to Janis Joplin and Donovan. It was clear to me from this artist's book (a term unknown to me at the time) that it was not only what Fuller communicated but how he communicated. Furthermore, his connection to countercultural, utopian thinking was part of his larger political and ethical world view. (It was sometime later that I realized that the designer of this treasured book, Quentin Fiore, studied at the New Bauhaus in Chicago, and also designed *Do It!* as well as another miniscule volume I loved, Marshall McLuhan's *The Medium Is the Massage*.)

I loved this small paperback from the moment I cracked its spine and read on the opening page: "I live on Earth at present, and I don't know what I am. I know that I am not a category. I am not a thing—a noun. I seem to be a verb, an evolutionary process—an integral function of the Universe." This $1.65 Bantam book (classified as sociology) was proof to a teenage boy that a little book could be a powerful tool. (*I Seem to Be a Verb* accompanied me to college and has continued to be a companion ever since.) As my passion for art also increased at this time I loved the quote on the title page: "'There's a smell of paint here' —Overheard at the Museum of Modern Art." I was intrigued that art was integral to Fuller's thinking, noting that he referenced artists ranging from René Magritte to Marcel Duchamp and Willem de Kooning, who was quoted in the volume as saying, "I make a picture and someone comes in and calls it art." In time, I was to learn of Fuller's close friendships with artists of all stripes, including Josef Albers, Isamu Noguchi, John Cage, and Merce Cunningham, and his significant connection to the legendary Black Mountain College in North Carolina, where he was an instrumental thinker, influential teacher, and Prime Mover in the cause of revolutionary, experimental ideas, a topic eloquently discussed in Dana Miller's essay. For me, Fuller was a figure who seemed to connect many fields of knowledge—art, science, technology, mathematics, poetry, urbanism, and architecture. This sort of synthetic, interdisciplinary view with its pervasive aesthetic, poetic, and ethical attitude has once again come to the fore in our culture and has been tremendously influential, knowingly and unknowingly, on the current generation of artists as pointed out in Elizabeth A. T. Smith's engaging text.

At the Whitney Museum of American Art, we believe our time—artistically, not to mention philosophically and environmentally—demands a Buckminster Fuller exhibition. Given the verblike nature of his work, Fuller always has been hard to pin down. His vision is difficult to approximate and present, much less encompass in an exhibition. This is the first major exhibition in the United States devoted to his work in nearly two decades. Given his manifold connections to art and artists, Fuller has long shown his drawings, models, constructions, and manufactured works in museums and art contexts, from the first exhibition of his Dymaxion House organized by Lincoln Kirstein at the Harvard Society of Contemporary Art in 1929 to his installation of a geodesic dome in the sculpture garden of the Museum of Modern Art in 1959. The Whitney attempted to host a major Fuller exhibition from Chicago's Museum of Science and Industry in 1973, but it determined that the installation created "insuperable" problems. As director Jack Baur regretfully wrote in a letter to the director of the Chicago museum, "neither the car nor the dome could be placed on our third floor galleries." (It is obvious

from this assessment that Fuller himself was not asked to weigh in on the installation; the word insuperable would not have been in his vocabulary.)

Fuller was a quintessential showman. I imagine he must have loved organizing museum exhibitions of his work almost as much as he loved giving his celebrated hours-long lectures. As he quoted Bob Dylan in *I Seem to Be a Verb*, "Inside the museum infinity goes up on trial." A museum exhibition, especially one by the same museum that could not present his large-scale projects in 1973, can provide only a glimpse of the breadth of Fuller's ideas, accomplishments, and vision. It is our hope, however, that in the details (the artifacts) one can apprehend the big picture—"the extraordinary generalized principle and their complex interactions that are apparently employed in the governance of universal evolution"—and appreciate the beauty that was Buckminster Fuller's mind.

We are grateful for the generous support that allowed the Whitney to realize a Fuller exhibition and made the catalogue possible. Namely our thanks go to the Henry Luce Foundation, Tom Slaughter and the Horace W. Goldsmith Foundation, Jack Flam and the Dedalus Foundation, and the Solow Art and Architecture Foundation.

It has been a pleasure to collaborate with the Museum of Contemporary Art in Chicago on the tour of the exhibition. Special thanks are due to Chicago's Madeleine Grynsztejn, Pritzker Director, and Elizabeth A. T. Smith, James W. Alsdorf Chief Curator and deputy director for programs, for exposing an even wider audience to Fuller's ideas. I also am grateful to Calvin Tomkins for kindly allowing us to reprint *In the Outlaw Area.* The Whitney owes its greatest debt to the exhibition's co-curators, K. Michael Hays, adjunct curator of architecture, and Dana Miller, associate curator, for their vision and dedication. They recognized the importance of organizing a Fuller retrospective not only for the historical record but for what it would mean to artists of today.

ADAM D. WEINBERG
Alice Pratt Brown Director

Exhibitions and catalogues of this scope require the generosity and assistance of numerous people. There are several individuals without whom this exhibition would have been nearly impossible. First and foremost among them are the members of Buckminster Fuller's family. Our heartfelt thanks go to Allegra Fuller Snyder, Jaime Snyder, and Alexandra May for the support, time, and energy they lent to us from the very beginning of this project and the sage advice they offered at crucial moments. John Ferry, at the Estate of R. Buckminster Fuller, also deserves special thanks. We also are greatly indebted to the staff at the Special Collections Library at Stanford University who worked in association with the Whitney Museum of American Art to organize this exhibition. We would like to thank Michael Keller, Ida M. Green University Librarian, director of academic information resources; Assunta Pisani, associate university librarian for collections and services; and Catherine M. Tierney, associate university librarian for technical services, for their support and encouragement of this project. Roberto G. Trujillo, head, department of special collections, Frances and Charles Field Curator of Special Collections, and Hsiao-Yun Chu, assistant professor product design and development, San Francisco State University, and former assistant curator and projects coordinator, R. Buckminster Fuller Collection at Stanford, worked with us to develop the initial concept of the project and remained supportive and helpful throughout. Glynn Edwards, head of manuscripts processing, department of special collections; Mattie Taormina, head of public services and manuscripts processing librarian, department of special collections; Polly Armstrong, public services manager; and the rest of the staff at the Special Collections Library graciously facilitated access to more than 1,400 linear feet of Fuller's archive. Our special thanks go to Maria Grandinette, Mary R. and Elizabeth K. Raymond Conservator, and acting head, preservation department, head, conservation treatment, Stanford University Libraries; Debra Fox, paper conservator; Rowan Geiger, objects conservator; Carolee Wheeler; and Sarah Newton. Their generosity, collegiality, and hours of tireless work made it possible for us to safely bring a substantial body of new material from the Fuller archive to light in both the catalogue and exhibition.

One of our primary goals in organizing this exhibition was to track down Fuller material held outside of Palo Alto and to show this material together with Stanford's holdings. We are, therefore, extremely grateful to the other lenders to this exhibition. Among those who loaned works from their private collections are Chuck and Elizabeth Byrne, Alexandra and Samuel May, Shoji Sadao, and Kenneth Snelson. Our thanks go to the public institutions that opened their collections to us as well. Among those who helped facilitate loans from their institutions are Gerald Beasley and Janet Parks at Avery Architectural and Fine Arts Library, Columbia University; Barry Bergdoll, Christian Larsen, Pamela Popeson, and Linda Roby at the

Museum of Modern Art; Jenny Dixon and Larry Giacoletti at the Noguchi Museum; Alfred Pacquement, Olivier Cinqualbre, and Jean-Claude Boulet at the Musée National d'Art Moderne, Centre Georges Pompidou; Marc Pachter, James Barber, and Kristin Smith at the National Portrait Gallery, Smithsonian Institution; Pamela Hackbart-Dean, Randy Bixby, and Leah Broaddus at the Special Collections Research Center, Morris Library, Southern Illinois University Carbondale; Jim Cuno and Joseph Rosa at the Art Institute of Chicago; Betty Sue Flowers, Renée Gravois, and Michael MacDonald at the Lyndon Baines Johnson Library and Museum; H. Fisk Johnson, chairman and CEO and chairman of the board, Kelly Semrau, Greg Anderegg, and Terri Boesel at S.C. Johnson & Son, Inc.

Fuller touched many people during his life and many of those friends, colleagues, and students have, in turn, shared valuable stories, advice, and information in meetings and in informal conversations. Among those, we would like to offer our special thanks to Shoji Sadao and Thomas Zung, partners with Fuller in his architecture firm. Shoji and Thomas met with us several times over the course of this project and offered invaluable advice on many aspects of the show. Also included in this group are Ruth Asawa, Albert Lanier, Carl Solway, Jack Masey, Jay Baldwin, Roger Stoller, Jonathan Marvel, Mary and Harold Cohen, Ken Snelson, Sue Cook, and Raz Ingrasci.

We would also like to thank the staff at the R. Buckminster Fuller Institute, in particular Elizabeth Thompson, executive director. Elizabeth was unfailingly gracious and generous throughout the project. The several scholars who worked on Fuller's massive archive before us deserve mention—Joachim Krausse, Claude Lichtenstein, Michael John Gorman, and Eva Diaz. They, without exception, willingly shared their thoughts and advice. Our colleague Christiane Paul, adjunct curator of new media arts at the Whitney, was extremely helpful to us in exploring some of the possibilities this show presented. Among the additional scholars, arts professionals, artists, and others who spoke with us about this project were Callie Angell, Irit Batsry, Chuck Byrne, Ila Cox, Jenny Dixon, Ronald Feldman, Howard Goldfarb, Marc Greuther, Fritz Haeg, Linda Henderson, Jasper Johns, Peggy Kaplan, Vincent Katz, Dodie Kazanjian, Michael Lobel, Josiah McElheny, Shamim Momin, Toshiko Mori, Felicity Scott, Frank Smiegel, Sarah Taggart, Nato Thompson, Fred Turner, Anthony Vidler, Nick Weber, and Molly Wheeler.

We are thankful to Antoine Picon, Elizabeth A. T. Smith, and Calvin Tomkins for their substantial contributions to the catalogue and the scholarship on Fuller. At Yale University Press, the co-publisher of this catalogue, we are grateful to Patricia Fidler, Kate Zanzucchi, Mary Mayer, and John Long. Jean Wilcox is to be commended for a thoughtful design that captures the spirit of Fuller without dispatching him to the shelves of history. Within the Museum our thanks for the catalogue go to the publications department, led by Rachel de W. Wixom, head of publications. A special thank you to Beth Huseman, editor, for her help at a crucial stage.

At the Whitney, we have had the pleasure and privilege to work with a fantastic team of colleagues on this exhibition. We are most appreciative for the support and enthusiasm that Adam D. Weinberg, Alice Pratt Brown Director, and Donna De Salvo, chief curator and associate director for programs, have shown for this somewhat atypical project since its inception. There is no question that this project would not have come together without the exceptional quality and quantity of work produced by Jennie Goldstein. Every curatorial team should be lucky enough to have such a bright, talented, and warm-hearted curatorial assistant working with them. In addition to all of the curatorial support she offered, she compiled a smart, thoughtful contextual chronology and the most comprehensive bibliography on Fuller to date. Meg Calvert-Cason joined the team in the fall of 2007 and her exhibition experience and attention to detail were also essential to the realization of this project. Over the last two years, we have been assisted by several interns on various aspects of this project and they include Kim Conaty, Amara Craighill, Kristen France, Diana Kamin, as well as researcher Matico Josephson.

In other departments at the Whitney, we would also like to thank Christy Putnam, associate director for exhibitions and collections management; Lynn Schatz, exhibitions coordinator, and Seth Fogelman, senior registrar. Christy helped in many ways to bring this complex exhibition to fruition. Lynn's help with coordination of the exhibition and tour was invaluable, and Seth managed the enormously complicated logistics of the exhibition with great skill. Among the other staff at the museum who provided essential assistance in organizing, funding, and coordinating this catalogue, exhibition, and its accompanying programs are David Little, Margie Weinstein, and Kathryn Potts in education; Alexandra Wheeler, Hillary Strong, Ann Holcomb, Amy Roth, and Mary Anne Talotta in development; Beverly Parsons, Seth Fogelman, Kelley Loftus, Joshua Rosenblatt, and the art handlers; Mark Steigelman, Ray Vega, Jeffrey Bergstrom, and the audio visual team in exhibitions and collections management; Carol Mancusi-Ungaro and Matthew Skopek in conservation; Jeffrey Levine, Stephen Soba, and Rich Flood in marketing and communications; Bridget Elias, Anita Duquette, Nick Holmes, Emily Krell, and Limor Tomer.

At Harvard we would like to thank the following graduate students for their help: Michelle Chang, Emily Farnham, Patrick Hobgood, Iannis Kandyliaris, Ilias Papageorgiou, and, in particular, Brigid Boyle. Michael Meredith, associate professor of architecture, generously devoted his time and talents to the exhibition.

We remain indebted to each of these individuals and institutions for their contributions to this catalogue, the exhibition, and its programming.

K. MICHAEL HAYS AND
DANA MILLER

Introduction

K. MICHAEL HAYS
AND DANA MILLER

History has a way of generating figures to help us move our collective narrative forward. We needed a Buckminster Fuller during the last century to help us see the perils and possibilities of that era and to point the way toward the twenty-first century. Fuller taught us to think in totalities just when the world seemed to be breaking apart into specialized disciplines and practices, dividing itself into unrelated objects, forces, and events. He insisted on the significant interconnectedness of things otherwise thought disparate, detached, or irrelevant. Our world and everything in it are built from the same basic structures and systems, even those things that seem too minute to be significant—like the only possible arrangement of four equidistant points—or too vast and complex for synthesis—like the universe. As Fuller commented:

> I did not set out to design a house that hung from a pole, or to manufacture a new type of automobile, invent a new system of map projection, develop geodesic domes, or Energetic-Synergetic geometry. I started with the Universe as an organization of energy systems of which all our experiences and possible experiences are only local instances. I could have ended up with a pair of flying slippers.[1]

Starting with the universe, Fuller sought the most basic of nature's forms and forces, or in his words, "how nature builds." Universe (he used the word usually without the definite article and always capitalized) is everything humanity has ever been or can ever become conscious of—or as Fuller put it, "Universe is all that isn't me *and* me." Though ultimately unrepresentable and unknowable to any single person, Universe was envisioned by him as nevertheless manifest in dynamic, regenerative, geometrical patterns of energy and information. For every idea or innovation he put forth a physical representation—many primary examples are presented in this catalogue—that captured those patterns, presenting the visible traces of universal operations, and even putting those operations to practical use. In particular, Fuller believed that all physical and metaphysical experience could be described in terms of arrays of tetrahedra, the primary particles of the cosmos. His most famous inventions, the structures he called geodesic and tensegrity (a portmanteau of tensional integrity), all constructed on the principle of the tetrahedron, present us with nothing less than the shapes of Universe itself.

Starting with the universe, Fuller sought to produce anticipatory comprehensive design solutions that would benefit the largest segment of humanity while consuming the fewest resources. Ultimately, Fuller addressed fields ranging from mathematics, engineering, and environmental science to literature, philosophy, architecture, and visual art in his theories and innovations. Indeed, he refused to distinguish these spheres as discrete areas of investigation. He was among the first truly transdisciplinary thinkers, propagating a worldview of globally integrated systems,

which he explained with neologisms like synergetics (the exploration of nature's coordinate systems) and ephemeralization (or "doing more with less"). Fuller gamely put forth anticipatory solutions to humanity's mounting problems without any sense of irony and was often met with skepticism or disregard. But in his worldview, failure was a necessary step on the path to success and he pressed on, relentlessly expounding his philosophies until his death at the age of eighty-seven.

Starting as he did from the universe and ending up with visual-spatial models with which to ponder universal philosophical problems in the here and now, it is not surprising that Fuller has had a tremendous impact on the visual arts and architecture. His sensibilities and modes of working were deeply aesthetic and many of his closest friends and supporters were artists. Today, his lessons take on an even greater relevance. Fuller's concepts are ripe for reexamination by artists, architects, designers, scientists, and poets; they are touchstones for discussions of environmental conservation and the efficient use of resources, the manufacture and distribution of housing, and the global organization of information. This catalogue and the associated exhibition bring together materials—some not seen in decades, some never seen at all except by his closest collaborators—as an inspiration and a resource for those who will remember Fuller and can now reframe his accomplishments and think upon them anew. The exhibition and catalogue also are intended for an entire generation who know little or nothing about Fuller but share his curiosity about nature's structures or his sense of urgency about economies, ecologies, and their interactions.

This catalogue is not a comprehensive introduction to the work or thought of Fuller; others have provided that.[2] Instead, it offers several of the many possible prisms through which we can now view the multifaceted career of Fuller. We are grateful to Antoine Picon and Elizabeth Smith for offering two astute essays on Fuller's impact, the former placing him within the history of utopian thought and the emergence of a society of information and communication and the latter illuminating several of the important ways in which Fuller's impact is manifest in contemporary art. We also are pleased to reprint Calvin Tomkins's seminal 1966 *New Yorker* article, which perhaps more than any other profile from Fuller's lifetime captures the international figure at the height of his creative powers while also drawing an intimate portrait of the individual. The catalogue is rounded out by a contextual chronology by Jennie Goldstein, which reminds us that although Fuller was a singular individual, he was always part of the historical fabric of his time.

Together, these essays, the chronology, and the illustrations provide documentary insistence on Fuller's continuing relevance as an aid to history—for we need a generosity of mind and a devotion to the earth and all its inhabitants, indeed to the universe, now as never before.

Notes

1. Buckminster Fuller, *Synergetics Dictionary: The Mind of Buckminster Fuller,* ed. E. J. Applewhite (New York: Garland, 1986), 4:16.

2. Just a few examples include the classic account by Robert Marks, as well as those by Hugh Kenner, Lloyd Steven Seiden, and the recent expansions by Michael John Gorman and Joachim Krausse and Claude Lichtenstein, all listed in the bibliography of this volume.

FULLER'S GEOLOGICAL ENGAGEMENTS

WITH ARCHITECTURE

K. MICHAEL HAYS

In a 1996 film interview, Philip Johnson denied that Buckminster Fuller should ever have been described as an architect. "Bucky Fuller was no architect and he kept pretending he was," insisted Johnson. "It was very annoying."[1] Johnson makes a fundamental distinction in this interview that, like many of his prescient sarcasms, has turned out to be right. On the one hand is Fuller, a "technical genius," a "wordsmith"; "he was an inventor and a guru and a poet" and "a lovely man personally, in addition." On the other hand is the architect, designer of tombs and monuments, who produces meaningful forms, who has cultural obligations, who has to have style, which Fuller did not. Today we might use different words—architecture is a "signifying practice," perhaps, or a "cultural mediation," "symbolic realization" or "representation." But our point would be the same as Johnson's: architecture deals with the codes through which culture is produced and reproduced, the formal arrangements handed down through history that confer meaning to viewers who can read the codes. "Mr. Fuller was not interested in architecture," said Johnson. That is, Fuller was not interested in codes. We must develop Johnson's insight by placing Fuller in the various contexts in which his work engages architecture.

The 1920s were years of explosive productivity for the architectural avant-garde, and Fuller's inaugural contributions should be seen as woven into the warp of the avant-garde context, albeit at its edges. Like many of the progressive tendencies in Europe, Fuller's fundamental concern was the use of advanced technologies for the efficient production and distribution of housing—or as he preferred to call it, "shelter," which denotes not only local ecological control for an individual or a family but also the entire system of elements and forces, distances and movements, that must converge and connect in order to construct that particular local event of being housed.

In Fuller's first programmatic drawings, which appeared in early 1928, the scale of idea is already global, the direction of thinking is "from inside out" (that is, from the local event to the system in which it is embedded), and the prevailing architectural feature is the central vertical support. The diagram that organizes these three components of Fuller's program will not change, though it will be endlessly modulated and reinterpreted throughout his career. In its first version, a sketch of Lightful Houses (plate 4), concentric circles delineate bands emanating from the earth in which a strange array of objects is arranged: the World Tree grows from the earth diametrically opposite a mooring mast with dirigible airship; a pair of high-voltage towers emerges opposite a pagoda; in between rise a lighthouse, a skyscraper, an obelisk, and a ship with a tall transmission tower. Floating between these vertical objects are an airplane, sailboat, collapsible stool, bird, tennis racket, umbrella, automobile, and steamer trunk—all objects associated with either structural tension or mobility. Outside the bands are a baby, a church, a heart, and the sun. And finally the texts at the edges: "time, metal, mechanics/time exquisite light, time slow matter/time,

fellowship, production." The array appears like so many imaginary objects of desire, free-floating without a system of connections yet to bring them into a coherent structure—except, of course, the earth itself. By thinking a multiplicity of elements held in one world of four dimensions, Fuller is beginning to conceptualize that system in terms of movements, distances, patterns, and intensities, in an abstract diagram I will call geological. By *geological* I don't mean just soil and gemstones, of course, but rather a logic or system that is centered on the earth as an environment and a planet in a cosmos. At first, Fuller titled the system 4D, though many other names would follow; Fuller's naming, as we know, was profligate. Perhaps overnaming is a necessary byproduct of geological thinking, which is holistic, even totalizing; empiricist but also transcendentalist; technocratic and metaphysical—such contradictions issue neologisms as stabilizers. And as Fuller develops *Lightful* into 4D, 4D into Dymaxion, and Dymaxion into geodesics and synergetics (the geometry of thought itself), his geological diagram engages architecture in ways that are fruitful for rethinking both the architectural history of the present and Fuller's own trajectory.

In Air Ocean World Town Plan (for a similar idea, see plates 2 and 5), a drawing that summarizes his 4D program, the diagram takes on a concrete, almost narrative quality that will drive the entirety of his early work. We see 4D Houses with ten decks suspended from a central mast. Discrete controlled environments, self-sustaining and dust-free, these dwelling machines are placed around the earth, including in unlikely places like the Arctic Circle, Siberia, the Sahara Desert, and the Amazon forest. The towers are surrounded by the air ocean through which airships and planes move along the great circle routes, connecting the local towers to each other and to the world's existing population centers. Globalization, transportation, information, and energy exchange: Fuller's design program is already in place.

In the 4D work the common concerns and differences between Fuller and the interwar architectural vanguard can be glimpsed (plate 6). For Fuller, materials and methods were valued according to their performance. Aluminum alloys, high-strength steel cables, structurally stable transparent plastics, and pneumatic floors and doors made a lightweight and dynamic apparatus that could be air-transported and erected anywhere in the world by shelter utility companies modeled on automobile manufacturers and other service industries. Wrapping the unit with an aerodynamic shield reduced heat loss and produced an "energy valve" in a continuum of energy transfers. Suspending floors and walls from a central mast made it feasible that all the equipment housed in the mast—including elevators, air conditioning, bathroom units, waste disposal, laundry, and cooking—be manufactured under a single contract rather than by many specialized firms, and that the entire structure could be easily relocated and recycled.

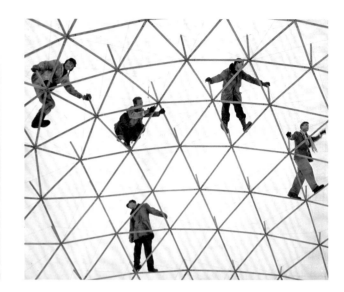

The subsidiary system's dwelling devices, resultant to comprehensive processing, are equivalent to electronic tubes which may be plugged into the greater regenerative circuits of the electronic communication systems. "House," in comprehensive designing, would be as incidental to the world-around network dwelling service as is the telephone transceiver instrument to the energy processing in communication systems, which are in turn within the larger systems of industry . . . itself within the universal systems of macrocosmically and microcosmically pertinent evolution.[2]

While so-called functionalist architects certainly shared an interest in fabrication and performance, they treated the weight of the building and its relation to the ground as primarily an issue of ideological signs and codes. The conjunction of skyscraper and airship appears as a utopian emblem in the Soviet projects of the 1920s. The leftist ABC group published photographs of heavy, old buildings crossed out next to approved, ideologically correct lightweight industrial structures. László Moholy-Nagy published photographs of dirigibles, lightweight metal stairways, and workers constructing the spherical dome at the Zeiss planetarium in Jena (figs. 1 and 2); Moholy provides the caption, "A new phase of our victory over space: men poised in a swaying open network, like airplanes flying in formation."[3] Lightweight constructions countered the moribund monumentality of traditional architecture, while open floors raised above the ground produced the concept and code (if not the fact) of a socially free and open space to emerge out of the dark and decrepit culture of the old city. Projects like Le Corbusier's Maison Citrohan, 1922 (the name itself is a code for automobile design), El Lissitzky's Wolkenbügel (Cloudhanger) for Moscow, 1925 (fig. 3), and Hannes Meyer and Hans Wittwer's Peterschule for Basel, 1927 (which

seems ready to take flight; fig. 4), are emblematic of an entire ethos of architecture made of habitable units standardized and mass-produced like a car, and elevated above the ground by a metal structure. The buildings are functional, no doubt. But more important, the various suspended platforms, cables, walkways, stairs, and balconies are treated for maximum visual and psychological effect. They are encoded as criticisms of tradition and proposals for a future way of life in a way that Meyer rightly labeled propagandistic.

Not that Fuller was unacquainted with the idea of getting the word out. He admired Le Corbusier's promotion of his own *machine à habiter*:

> My own reading of Corbusier's *Towards a New Architecture*, at the time when I was writing my own, nearly stunned me by the almost identical phraseology of his telegraphic style of notation with the notations of my own set down completely from my own intuitive searching and reasoning unaware even to the existence of such a man as Corbusier.[4]

He continuously experimented with a graphic logo with which to brand his 4D and Dymaxion propositions (plates 20 and 47). And in the May and November 1932 issues of *Shelter* magazine he made ideological use of photographs of ships, planes, bridges, and high-tension towers with precisely the same intention as László Moholy-Nagy in *The New Vision* and Hannes Meyer in "Die neue Welt," that is, to advertise the technological apparatus adequate to contemporary life.

But the defining characteristic of the avant-garde is neither just progressive ideology nor an interest in the quiddity of new materials and the raw aesthetic impact of new shapes and organizations. Rather it is the operation of reflexivity, in which the nature of materials (flatness, brightness, tension) and the organizing

EL LISSITZKY
(1890–1941)
Wolkenbügel (Cloudhanger),
3 Moscow, 1925

4 **HANNES MEYER**
(1889–1954) and
HANS WITTWER
(1894–1952)
Peterschule, Basel, 1927

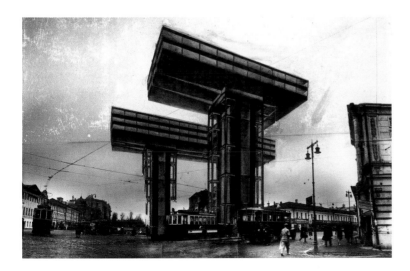

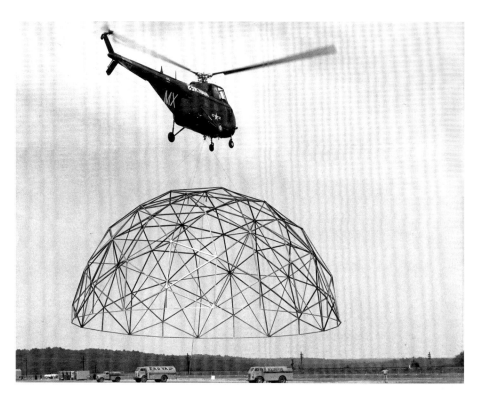

structures of perception itself (diagonals, layers, rotation) are folded back on them-
selves to become the object of aesthetic expression and experience. Form thereby
becomes content, producing an opacity of the architectural sign and a shift of focus
to the very operations and apparatuses of sign production. Reflexive aesthetic prac-
tice foregrounds materials, techniques, and operations of construction, thus reduc-
ing the transparency of style. Whereas Fuller's 4D project strives for total trans-
parency; it is nothing but its performance, an "invisible energy valve"—function and
matter organized in time.

Fuller's work differs from contemporaneous architecture, first, then, in its
lack of a code of reflexivity. "Lack" is not quite the right way to put it, since it is pre-
cisely the absence of reflexivity—the freeing up of matter and function from any
specific kind of content—that enabled Fuller's push toward an unencoded function-
ality of multiple, heterogeneous elements connected across different sites and
domains of effectivity, all subsumed by an even higher unity. Fuller insisted that the
fundamental 4D machine can be found at work at the level of the individual, the
family, society, and the planet, and that it is operative in technology, climate, popu-
lation, and economics. Such a machine cannot be coded; it is made of nothing more
than its connections. It is a geological diagram that organizes functions and guides
the multiple interactions of different matters.[5]

Fuller's work quickly became known to small and scattered groups of archi-
tects mainly through lectures, including a presentation of the Dymaxion House to the

Architectural League of New York in 1929. The project was exhibited at the Marshall Field's department store and published in the Chicago journal *Architecture* in June of the same year. *Architectural Record* published it as a "weekend house" in 1930. The larger architectural audience, however, was created later, in the mid-1950s. Fuller's geodesic domes were exhibited for the first time at the Tenth Triennale in Milan, 1954 (the same year he received the U.S. patent for the dome), drawing the attention of the international design community. These first domes were constructed of paperboard and staples, but for the 1957 Triennale, the U.S. government commissioned an aluminum version covered in fabric. In 1956, John McHale—a founding member of the Independent Group of Great Britain who had coined the term Pop Art in 1954 —published an article on Fuller in the widely read British journal *Architectural Review*.[6] Meanwhile Fuller was mesmerizing students across the United States. The Yale student journal *Perspecta* reported on a studio Fuller taught in 1951–52.[7] North Carolina State College's *Student Publications of the School of Design* published Fuller's "No More Second Hand God."[8] In 1954 *Architectural Forum* mentions Fuller's visits to North Carolina State College and to Princeton University, and it published a short article, "Marines Test a Flying Bucky Fuller Barracks," with what would become the famous photograph of a helicopter transporting Fuller's dome (fig. 5).[9] In 1960, Arthur Drexler at the Museum of Modern Art launched the exhibition *Three Structures by Buckminster Fuller*. The Fuller phenomenon was in place.

But it was the historian Reyner Banham who was the single most important advocate for Fuller in the architecture world. In the conclusion to his polemical revisionist history of modernism, *Theory and Design in the First Machine Age* (1960), Banham presents Fuller as the contemporary analogue of his Futurist architect-hero Sant'Elia and avatar of the Second Machine Age:

> There is something strikingly, but coincidentally, Futurist about the Dymaxion House. It was to be light, expendable, made of those substitutes for wood, stone and brick of which Sant'Elia had spoken, just as Fuller also shared his aim of harmonizing environment and man, and of exploiting every benefit of science and technology. Furthermore, in the idea of a central core distributing services through surrounding space there is a concept that strikingly echoes Boccioni's field-theory of space, with objects distributing lines of force through their surroundings.[10]

The final point is remarkably suggestive, but the lines-of-force idea was not developed. Instead, Banham stressed Fuller's advocacy of the constant renewal of the environment, using Fuller's own words (quoted from a letter sent by Fuller to John McHale in 1955) to criticize the "outside-in" thinking of mainstream architecture—"they only looked at problems of modifications of the surface of end-products, which end-

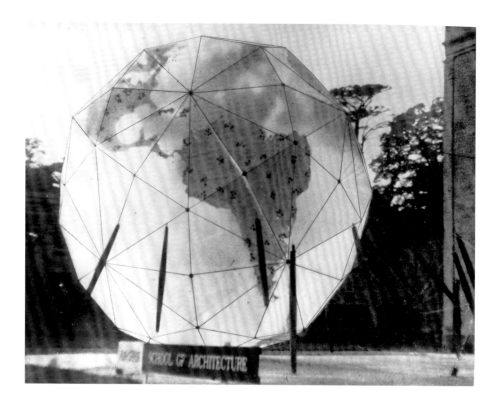

Geoscope, School of Architecture, Nottingham, England, ca. 1962

products were inherently sub-functions of a technically obsolete world"—and to recommend what Fuller termed "the science-initiated transcendental transformations of the industrializing world's unhaltable trend to constantly accelerate change" in a quest for ever-better environmental performance.[11]

In his review of Banham's book, Alan Colquhoun dramatized the stakes of the full embrace of the Fullerian machine: "In introducing him as *deus ex machina* of his argument, Dr. Banham is raising the fundamental question of the validity of architecture itself in any sense that we understand that term." Colquhoun understood that the absence of reflexivity and self-conscious codes in Fuller's work could yield only "the image of a technique which has reached an optimum of undifferentiation." Highly critical of Fuller, he nevertheless caught the motivation behind the antirepresentational, pure matter-energy assemblage that is the geodesic dome: "In Fuller's domes the forms are identified by their lines of force, resembling those High Gothic structures where a framework alone defines the volumes which it encloses, and seeming to exemplify Fuller's philosophy of the forms of art being absorbed back into the technical process."[12]

What Colquhoun could not recognize was that by dealing with purely functional elements, forces, and the multiplicity of their relations in different domains, Fuller's thought comes close to what Gilles Deleuze termed a "transcendental empiricism," which is antirepresentational, vitalistic, and open to the multiple and diver-

gent experiences and manifestations of life, or as Fuller put it, to "the everywhere and everywhen nonsimultaneously intertransforming, differently enduring, differently energized, independently episodic and overlapping, eternally regenerative, scenario Universe's laws."[13] For Fuller everything that exists is a modulation of something else, an articulation of one substance—Nature, God, or Universe; "I am quite confident, because I have been exploring it for a long time, that nature has just one coordinate system."[14] But this does not mean Fuller's geological diagram is just an abstraction that transcends all possible experience. Rather it is an empirical system of differential relations that creates and organizes actual times, movements, trajectories, and ultimately sensations.

Perhaps the best demonstration of such cognitive and perceptual possibilities is the Geoscope (fig. 6). Beginning in 1952, working with John McHale and architecture students at Cornell University, University of Minnesota, and Princeton University, Fuller designed a globe, 200 feet in diameter, made up of triangular panels analogous to the Dymaxion Air-Ocean World Map (1943) and furnished with 10 million tiny computer-controlled pixels of light—a spherical computer display monitor for viewing Earth in the universe from inside out, like an enfolded Google Earth except with more cosmic ambitions. Fuller had speculated on such a prospect as early as 1928:

> The point of view, through introspection, unlimited to the segmental area of our temporal eyes, is our abstract central position in the center of the universe, looking or building from inside out, as from the center of a great glass globe of the earth. Through this globe may be viewed the progression of relative positions to the starry universe, looking along the time lines in all directions. The separate paragraph thoughts are only connected by their common truths, which are the material crystalline spheres of sensible and reasonable fact, through which the radial time lines of individualism must inevitably pass in their outward progression towards the temporal infinity.[15]

His subsequent cartographic and geodesic research enabled Fuller to actualize this early idea.

Using cybernetic data gathering and feedback all organized by computer, the Geoscope would graphically display the inventory and patterns of the world's resources and needs, in real time, slowed down, or speeded up, simultaneously or separately, for study and comparison—from energy consumption to stock trading, voting trends to weather patterns, tourist routes to military movements. It was an inverted planetarium for playing out the World Game, a "macro-micro-Universe-information" machine, geo-info-video-dome for the comparative display of flows, patterns, and intensities of population, climate, geology, sociology, finance, and their distributions

and interactions. "It was to satisfy the same need of humanity—to comprehend the total planetary, all-evolutionary historical significance of each day's development—that the 200-foot, or sixty-meter, -diameter Geoscope was developed."[16] Fuller proposed that it be displayed at the United Nations building in New York as well as the U.S. Pavilion at the Montreal Expo 67, among other places (plate 154). The Expo dome had its beginnings, in fact, in the Geoscope; the initial project included a rectangular space-frame hovering over an unfolded Geoscope equipped with consoles on a balcony for players of the World Game.[17] The Geoscope was the concrete embodiment of Fuller's geological diagram.

Fuller's dome made him famous in architecture circles. And yet, of the modern architecture heroes who were practicing during the 1950s—including Marcel Breuer, Walter Gropius, Le Corbusier, Ludwig Mies van der Rohe, Eero Saarinen, and Frank Lloyd Wright—only Louis Kahn seemed to have been directly influenced by Fuller. In an extraordinary unpublished article of 1982, Fuller recounts the time when, liv-

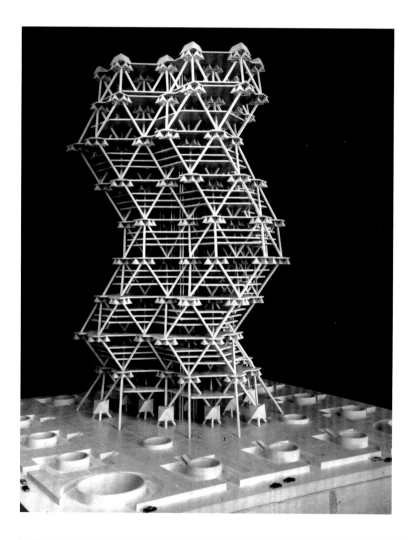

LOUIS KAHN (1901–1974)
and **ANNE TYNG** (b. 1920)
Model for City Tower, Philadelphia,
1956–57
Louis I. Kahn Collection, University of
Pennsylvania and the Pennsylvania
Historical and Museum Commission,
Philadelphia

ing in New York and teaching at Yale University (having been summoned there by the chair of the Architecture Department, George Howe), he regularly boarded the Philadelphia–New Haven train in New York and traveled to Yale with Kahn. During these trips, according to Fuller's account, Kahn converted to geodesic thinking, the results of which were the octet (octahedron-tetrahedron) truss used by Kahn in the Yale Art Gallery (1951–53), and the City Tower project for Philadelphia (fig. 7), which is basically a geodesic skyscraper, done in collaboration with Anne Tyng beginning in 1952.[18] Kahn and Tyng understood Fuller's energetic-synergetic geometry as both architectural tool and social mobilization, generator of practical shapes with cosmic implications. Tyng later published a theoretical article, "Geometric Extensions of Consciousness," that explores the geometrical foundations of human consciousness itself—what she calls "mind-matter."[19] The tetrahedral and hexagonal geometries propounded by Fuller were empirical structures flowing "from microcosm to macrocosm," the dynamic basis of biological organisms as well as social formations and cultural practices, making interconnections across all of humanity and nature and promising fundamental transformation in social and mental life. In the early work of Kahn and Tyng, the geological diagram was the sponsor of an architecture that promised to engender a new society.[20]

From the mid-1930s through the 1960s Buckminster Fuller was recognized as the architectural conscience for social technology. An important related aspect of his work remained latent for the most part, however—the aspect glimpsed in different ways by Tyng, Kahn, Banham, and Colquhoun. This is the second way Fuller's work differed from contemporaneous architecture: whereas architecture would seem to be fundamentally a search for stability, Fuller sought a model of reality based on movable elements and flows of very different sorts—physical, psychological, environmental, social—elements that interconnect and enter into structures, where structure is defined as a "locally regenerative pattern integrity."[21] "Both man and universe are indeed complex aggregates of motion," Fuller insisted.[22] The resolution of reality into renewable patterns of movement is the most radical of Fuller's ideas for architecture, for it challenges not only stability but space itself as architecture's fundamental principal. "'Space' is meaningless," Fuller insisted. "We have relationships —but not space."[23]

Though it became famous as the most stable structural system available, Fuller's geodesics must be understood first as a system based on distances and movements. Consider the cuboctahedron as the basic geodesic sphere. The cuboctahedron comprises fourteen surfaces—six squares and eight triangles—twenty-four identical edges, and twelve identical vertices with two triangles and two squares meeting at each. In the cubic close packing of twelve spheres around one sphere, to connect the centers of the twelve outer spheres gives a cuboctahedron; the center of each outer sphere connects to the center sphere with an interval of the same length or "frequency."

YONA FRIEDMAN (b. 1923)
Ville Spatiale (Spatial City), project,
Perspective, 1958—59
Felt-tipped pen on tracing paper
13 ½ x 19 ½ in. (34.3 x 49.5 cm)
The Museum of Modern Art, New York,
Gift of the Howard Gilman Foundation
8 1192.2000

9 **PETER COOK**
(b. 1936)
Plug-in City, Max. Pressure Area, 1964

We therefore understand the vertices as vectors moving outward from these centers in waves or lines of force—Fuller's "twelve degrees of freedom." The geometry of the cuboctahedron is the structure that these flows temporarily enter into—Fuller called it "vector equilibrium." It is his principal model for an omnidirectional process of growth and change. It can also be a dome, but the dome is understood not as simply a stable cover, but as a cosmic machine, plugged into and traversed by the forces of the universe.

We are reminded of Banham's perception of the lines of force radiating through time and distance. Banham correctly recognized Fuller's geological engagements with architecture as "other":

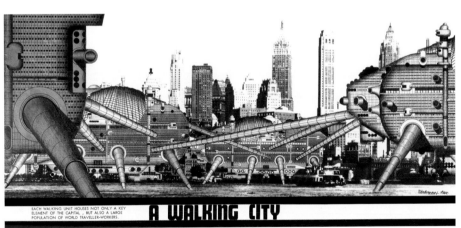

EACH WALKING UNIT HOUSES NOT ONLY A KEY
ELEMENT OF THE CAPITAL , BUT ALSO A LARGE
POPULATION OF WORLD TRAVELLER-WORKERS.

A WALKING CITY

STANLEY TIGERMAN
(b. 1930)
10 Model for Urban Matrix, 1967

11 **RON HERRON**
(1930–1994)
A Walking City, New York, 1964

But more fundamentally "other" is the approach of a designer like Buckminster Fuller, especially as the architectural profession started by mistaking him for a man preoccupied with creating structures to envelop spaces [like the space-frames of Robert le Ricolais or Konrad Wachsmann]. The fact is that, though his domes may enclose some very seductive-seeming spaces, the structure is simply a means towards, the space merely a by-product of, the creation of an environment, and that given other technical means, Fuller might have satisfied his quest for ever-higher environmental performance in some more "other" way. [24]

After Kahn and Tyng, architects did not return to this sort of architectural alterity until the late 1990s, when, armed with different theoretical tools, a new generation of scholars and designers approached Fuller's work again with open-mindedness. Sanford Kwinter's is a particularly forceful voice:

> Fuller was the first designer in history to understand structure as a pattern comprised entirely of energy and information. . . . He conceived of the universe itself as an energetico-informational continuum, something dynamic, and always transforming. . . . He was the first designer to have comprehensively understood the social and natural environment as a fluid, shapable, and active medium. . . . Fuller's simple point is that a large part of a society's fixed capital and public goods comprises infrastructural possibilities— techniques—that remain woefully unexplored. Here, and nowhere else, lies the true problem of design for the 21st century: the marriage of fixed and intellectual capital. But to get there, we must pass through Fuller.[25]

The 1960s and '70s were years of intense search and struggle for architecture to conceptualize new forms of collective habitation, and Fuller's were not the only radical propositions. Constantinos Doxiadis used global statistics and theorized the growth of cities in terms of time rather than space. Kenzo Tange's influential 1960 Plan for Tokyo would extend the growth of that city over the bay using artificial islands connected by bridges. Around the same time, Yona Friedman's Ville Spatiale (fig. 8) and Constant Nieuwenhuis's New Babylon superimposed an entirely new architecture above old European capitals using suspended freedom-granting space-frames and movable dwelling modules. In 1964 the Archigram group advertised Peter Cook's Plug-in City (fig. 9), which stretched out from London across the Channel and utilized standardized building units plugged into a flexible support structure. Soon after that, Stanley Tigerman in Chicago produced a series of giant floating tetrahedral city projects (fig. 10). Meanwhile Ron Herron's Walking City simply sidled up and squatted near whatever neighbor its traveler-workers thought attractive (fig. 11).[26] These and other such projects continue the progressive experiments of the interwar avant-garde, now in the different context of a rapidly emerging consumer-information society, even as they assuage old anxieties about the historical city (which was usually left in place in these proposals), often with appeals to Pop and Sci-fi subcultures, transgeneric practices, and psychedelic environmental pleasures. The heterogeneity of architectural expression in these works project the desire for a heterogeneity of sensual and psychic experience, and the new technologies of building, organization, and communication are all in the service of experiential effect.

Fuller's engagement with the problem of collective living was developed at the same time but came directly from his earlier concept of the individual domicile

as an energy valve in a vast system of energy exchange, except now the energy valve was shifted to the urban scale. Taking the city of New York as an example, Fuller noted that the existing individual buildings placed in the Manhattan grid, with their outside-in-designed decorative fins and other spongelike ornaments, maximize surface area and together give off heat like an enormous air-cooled engine. An inside-out-designed dome over Manhattan would function in precisely the opposite way—as an environmental control valve that would minimize energy use even while connecting its inhabitants with the cosmos (plate 145).

> From the inside there will be uninterrupted contact with the exterior world. The sun and moon will shine in the landscape, and the sky will be completely visible, but the unpleasant effects of climate, heat, dust, bugs, glare, etc. will be modulated by the skin to provide Garden of Eden interior.[27]

Doming over Manhattan was only a corrective, of course. Fuller would rather leave the city behind altogether and occupy those parts of the globe previously uninhabitable, like the ocean and the polar icecaps. A series of schemes designed with Shoji Sadao in the late 1960s further develop the energy-valve schema. Tetra City is a paradigm of a new class of floating omni-surfaced ecologies (plate 146). Measuring two miles at each of its edges, it gives its one million "passengers" maximum access to outside living in tiered, terraced garden homes, while community services, shops, and recreational facilities are housed inside the structure and efficiently serviced from the "common, omni-nearest possible center of all polyhedra." This is, of course exactly the same diagram as the 4D House, with its central mast housing all equipment and services. Tetra City is even more mobile than 4D. It may be anchored near a coast or floated out to sea and used as a way station for globe-circling ships and planes. The tetrahedral structure itself may be expanded symmetrically using recycled materials from obsolete land buildings. Cloud Nine, extraordinary as it is, is fundamentally the same project, now spherical rather than tetrahedral, and engineered for the air-ocean world rather than water (plate 144).

The photomontages of these giant floating megastructures are among Fuller's most intriguing images. The scale, geometrical purity, and abstract surfaces, in contrast with the landscapes that are their temporary hosts, suggest further comparison with the *architettura radicale* of Italy around 1970 and especially with Superstudio's 1969 Continuous Monument (fig. 12)—a single blank monolith that stretches across the entire earth, unrelenting, crossing deserts and forests, valleys and lakes, as well as old cities whose inhabitants would have no choice but to take refuge in this new and singular form of "total urbanization":

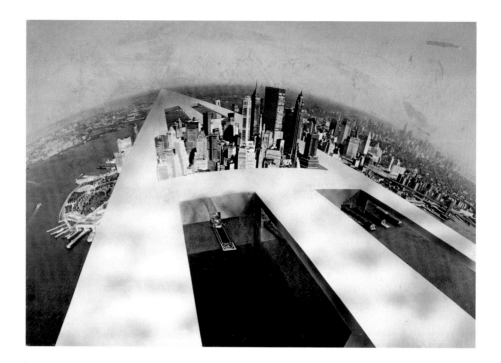

12

New York for example. A superstructure passes over the Hudson and the point of the peninsula joining Brooklyn and New Jersey. And a second perpendicular structure for expansion. All the rest is Central Park. This is sufficient to hold the entire built-up volume of Manhattan. . . . And from the Bay, we see New New York arranged by the Continuous Monument into a great plane of ice, clouds or sky.[28]

In the architectural magazine *Casabella* (1971), the genesis of this project is narrated: A single square, the basis of all architecture, dissolves over the earth and its particles float through the air, settling randomly across the globe, where they grow into their final form. One is reminded, of course, of the status of the triangle and its infinitely generative capabilities in Fuller's system.

But if the empiricist leanings of Banham and the Archigram architects, who explored the potentials of social technologies to totally reshape the environment, permit a partial match of Archigram's work with Fuller's, the comparison with the radical architecture of Superstudio forces to the foreground what are, in fact, the very real differences between Fuller's megastructures and all the rest. The projects of Superstudio, Archigram, Constant, and Friedman alike are first and foremost ideological criticisms of the cultural codes and conventions of an emerging consumer society—anti-utopias whose proper functions are antagonism and disruption, using the New as a radical and systematic break with the present. Technology and social program are preoccupations, but architectural form—or even style, to return to Johnson's dis-

tinction—is still a primary concern. As Banham attested, "*Archigram* can't tell you for certain whether Plug-in City can be made to work, but it can tell you what it might look like."[29] And though some of these architects' work certainly contains serious propositions, it trades much more freely in irony, paradox, and aesthetic negativity. Superstudio's Continuous Monument, in particular, is a pure practice of negation, a revolt of the object—the laying to waste of tradition through relentless repetition and counterpoint.

In contrast, Tetra City and Cloud Nine are not cultural critiques, and they do not really propose an aesthetics of a new technological environment (though certainly they have been taken to do so). They are rather visual models of a complex of elements and connections, many invisible, that enable dwelling—organizations of immaterial as well as material processes that include climate, transportation, and communication, forces that enter into a pattern or structure, then grow into archipelagos of omnidirectional ecologies, giant biospheres suspended in the world net. This is the third difference between Fuller's geological diagram and architecture (which may also be thought of as a product of the prior two): with Fuller we must think beyond the view that technology, architecture, and human individuals are discreet things and systems that may act upon one another, but are still self-defined and external to one another. We must envision a differentiated totality where these distinctions no longer hold: we must recognize a continuum that includes the flows of air that buoy the enclosure and supply oxygen for its passengers, the sun and snow, the movements of bodies, nutrients, and fuels in and out of the enclosures, the movement of capital, the movement of the enclosures themselves through time and distance in postterrestrial becoming. Fuller: "I am convinced of the utter integrity of the *total experience*, and of the indicated extensibleness of the comprehensive integrity-apparent universe."[30] The universe is a vast Bit Torrent communications protocol distributing data to ever-multiplying recipients. Such a complex can include signs and codes among its many elements and functions, of course, perhaps even necessarily. But it is not reducible to an aesthetic or a style. Tetra City and Cloud Nine are transfer stations in this complex; they are not what they look like but what they do; they are not nouns but verbs. They are what Fuller called "articulations," in the same sense that he uses the term in "No More Secondhand God":

> Here is God's purpose—
> for God to me, it seems,
> is a verb
> not a noun,
> proper or improper;
> is the articulation
> not the art, objective or subjective;

is loving,

not the abstraction "love" commanded or entreated;

is knowledge dynamic,

not legislative code,

not proclamation law,

not academic dogma, nor ecclesiastic canon.[31]

Architecture as articulation, not art; dynamic knowledge, not code. Articulations are made, sustained, transformed, and destroyed in a continuum of concrete practices, one of which is architecture.

Fuller was awarded the Royal Gold Medal of Architecture by the Royal Institute of British Architects in 1968 and the Gold Medal from the American Institute of Architects in 1970. But Fuller was not an architect. His collaborative friendships with architects like Norman Foster, with whom he designed the Autonomous House in 1982, and Nicholas Grimshaw & Partners, whose Eden Project of 1996 is a showcase for biodiversity and global sustainability housed in eight geodesic domes, stand among Fuller's professional architectural legacies. But Fuller was never an architect. A new generation of architects who rediscover Fuller will be inspired not by self-conscious reflexivity, spatial invention, or radical cultural critique, but by his modeling of a globalized system of contingency and structure, organization and change, temporary stability and constant renewal. This was his prediction:

> The great *aesthetic* which will inaugurate the twenty-first century will be the utterly invisible quality of intellectual *integrity*—the integrity of the individual in dealing with his scientific discoveries—the integrity of the individual in dealing with conceptual realization of comprehensive inter-relatedness of all events; the integrity of the individual in dealing with the only experimentally arrived at information regarding invisible phenomena; and finally the integrity of all those who formulate invisibly within their respective minds and invisible with the, only mathematically dimensionable, advanced production technologies, on the behalf of their fellow men.[32]

Such are Fuller's geological engagements with architecture.

Notes

1. "Buckminster Fuller: Thinking Out Loud," documentary in the *American Masters* series, Thirteen/WNET, April 10, 1996, http://www.thirteen.org/bucky/johnson.html.

2. Buckminster Fuller, "Influences on My Work," in *The Buckminster Fuller Reader*, ed. James Meller (London: Penguin, 1972), 61.

3. László Moholy-Nagy, *The New Vision* (1928; repr., New York: Wittenborn, Schultz, 1947), 189.

4. Buckminster Fuller, "On Paul Nelson," letter to

Margaret Fuller, 1928, in *Your Private Sky: R. Buckminster Fuller: Discourse*, ed. Joachim Krausse and Claude Lichtenstein (Zurich: Lars Müller, 2001), 80.

5. I have taken recourse here to the concept of an abstract machine as "the aspect or moment at which there is no longer anything but functions and matters," from Gilles Deleuze and Felix Guattari, *A Thousand Plateaus: Capitalism and Schizophrenia* (Minneapolis: University of Minnesota Press, 1987), 141.

6. John McHale, "Buckminster Fuller," *Architectural Review* 120 (July 1956): 13–20.

7. R. Buckminster Fuller, "The Cardboard House," *Perspecta* 2 (1953): 28–35.

8. R. Buckminster Fuller, "No More Second Hand God," *Student Publications of the School of Design* (Raleigh: North Carolina State College) 4, no. 1 (Fall 1953): 16–24.

9. *Architectural Forum* 100 (March 1954): 37.

10. Reyner Banham, *Theory and Design in the First Machine Age* (New York: Praeger, 1960), 327.

11. Ibid., 326, 327. Fuller's letter was published in *Architectural Design* 31, no. 7 (July 1961).

12. Alan Colquhoun, "The Modern Movement in Architecture," *British Journal of Aesthetics* 2, no. 1 (January 1962): 63.

13. R. Buckminster Fuller, *Critical Path* (New York: St. Martin's Press, 1981), 163.

14. Buckminster Fuller, "The Music of the New Life," *Music Educators Journal* 52, no. 6 (June–July 1966): 67.

15. Buckminster Fuller, *4D Time Lock* (1928; repr., Albuquerque, N. Mex.: Biotechnic Press, Lama Foundation, 1972), 31.

16. Fuller, *Critical Path*, 171–72.

17. For a discussion, see Jonathan Massey, "Buckminster Fuller's Cybernetic Pastoral: the United States Pavilion at Expo 67," *Journal of Architecture* 11, no. 4 (September 2006): 463–83. Also see Mark Wigley, "Planetary Homeboy," *ANY* 17 (1997).

18. Fuller reports, "I was talking in terms of the future of humanity and the enormous responsibility of the young world to take on the new technology, for, as I saw it, it was only that new technology that made possible the option to make all humanity a success. Lou found almost unbridled enthusiasm in each of my new university audiences. We talked about this a great deal. I think this was very much of a turning point in his life. He said so to me. He set about doing his own 'thinking out loud' exploration. Lou next designed the Yale Art Gallery (1951–53). He used my octet (octahedron-tetrahedron) truss for his reinforced concrete, clear-span ceiling structure. Then he began designing projects with the octet truss used as the infrastructure of the entire building (Philadelphia City Hall project, 1952–53; a city tower study, 1953–57). He said, 'Bucky, you never thought of living inside your geometry.'" Buckminster Fuller, "Kahn Essay," typescript, ser. 8, box 201, folder 5, R. Buckminster Fuller Papers, Department of Special Collections, Stanford University Libraries.

The structure of the Yale Art Gallery is not, in fact, an octet truss, but rather long concrete beams with diagonal webbing filled in between.

19. Anne Griswold Tyng, "Geometric Extensions of Consciousness," *Zodiac* 19 (1969): 130–73.

20. For a discussion see Sarah Williams Ksiazek, "Critiques of Liberal Individualism: Louis Kahn's Civic Projects, 1947–57," *Assemblage* 31 (December 1996): 56–79. The "from microcosm to macrocosm" comment is from Tyng, "Anatomy of Form/Atom to Urban," unpublished ms., 1962, cited in Williams Ksiazek.

21. Buckminster Fuller, *Synergetics: Explorations in the Geometry of Thinking*, in collaboration with E. J. Applewhite (New York: Macmillan, 1979), 315.

22. R. Buckminster Fuller, *Utopia or Oblivion: The Prospects for Humanity* (New York: Bantam, 1969), 348.

23. Ibid., 18.

24. Reyner Banham, *The New Brutalism: Ethic or Aesthetic?* (New York: Reinhold, 1966), 69.

25. Sanford Kwinter, "Fuller Themselves," *ANY* 17 (1997): 62.

26. Walking City didn't actually walk but rather retracted its legs and glided along on a cushion of air.

27. Buckminster Fuller, quoted in John Allwood, *The Great Exhibitions* (London: Studio Vista, 1977), 169.

28. Superstudio, "Il monumento continuo," *Casabella* 358 (1971): 22.

29. Reyner Banham, "A Clip-on Architecture," *Architectural Design* 35 (November 1965): 535.

30. Fuller, "Influences on My Work," 67–68.

31. R. Buckminster Fuller, *No More Secondhand God and Other Writings* (Carbondale: Southern Illinois University Press, 1963), 28.

32. R. Buckminster Fuller, "Planetary Planning," in *Jawaharlal Nehru Memorial Lectures, 1967–1972* (Bombay: Bharatiya Vidya Bhavan, 1973), 112–13.

THOUGHT PATTERNS:

BUCKMINSTER FULLER
THE SCIENTIST-ARTIST

DANA MILLER

Intuition and aesthetics automatedly trigger us into consciousness of the existence of opportunities to consider and selectively initiate alternative acts or position-taking regarding oncoming events, potential realizations or unprecedented breakthroughs in art, technology and other human productivity.

BUCKMINSTER FULLER, foreword to *Projections: Anti-Materialism*, 1970

While architects and engineers frequently greeted Buckminster Fuller with skepticism or suspicion, he deftly navigated artistic circles throughout his life. Fuller believed artists were uniquely positioned to conceptualize solutions to humanity's mounting problems because of their capacity to recognize nature's inherent patterns and extrapolate comprehensive design applications from them. He consciously cultivated friendships with artists with whom he felt a kinship and from whom he was able to draw inspiration. And although Fuller claimed that he never considered the visual impact of his structures while devising them, much of his work can be viewed as aesthetic exploration. If something wasn't beautiful when he finished it, Fuller knew it wasn't correct. This essay will illuminate some of the more important episodes in a career that intersected with those of sculptors, painters, and film and video artists again and again. Fuller's significant presence in the art world of the 1960s and early '70s will be a key focus, as it goes largely unnoted in the literature on Fuller and in the art historical accounts of that period.

Fuller's ardent belief in experientially gained information was crucial to understanding his philosophy. Testing hypotheses through trial and error and accepting failure as part of the process was essential to the "experientially founded mathematics" at the root of his comprehensive design program. As was the case with many of Fuller's deeply held convictions, he could trace the origins of this approach back to childhood. As a severely cross-eyed toddler, Fuller could see only large patterns and colors, and his earliest understanding of the world was based upon his imagination and physical intuition. When he was in kindergarten, his teacher gave his class toothpicks and peas and asked them to build houses. "All the other children, none of whom had eye trouble, put together rectilinear box houses," he recalled. "Not having visualized the rectilinearity about me, I used only my tactile sense. My finger muscles found that only the triangle had a natural shape-holding capability. I therefore felt my way into producing an octahedron-tetrahedron truss assembly. . . . It was this experience which undoubtedly started me off at fifteen to look for nature's own structural coordinate system."[1] Employing "nature's own structural coordinate system" teleologically

to benefit all of humanity became the foundation of Fuller's lifework as a comprehensive anticipatory design scientist.[2] The corollary to Fuller's belief in nature's coordinate systems is that man-made edifices built upon those principles will be structurally sound and aesthetically resolved. They will *look* and *feel* right.

Fuller's belief in intuition and experientially gained information meant that his design science revolution needed artists as much as scientists and designers. Artists could recognize local patterns and envision ways to translate them into three-dimensional models and universal applications. They often did so in advance of legitimizing scientific discoveries. According to Fuller, this was because artists had resisted specialization and maintained their inherent ability to think independently, intuitively, and comprehensively, while rigorous education had forced scientists into institutionalized methodology and specialization.[3] "Artists are now extraordinarily important to human society. By keeping their innate endowment of capabilities intact, artists have kept the integrity of childhood alive until we reached the bridge between the arts and sciences. Their greatest faculty is the ability of the imagination to formulate conceptually. Suddenly, we realize how important this conceptual ability is."[4] For Fuller, thinking conceptually meant using the mind, not the brain. "Many creatures have brains. Man alone has mind. Parrots cannot do algebra; only mind can abstract. Brains are physical devices for storing and retrieving special case experience

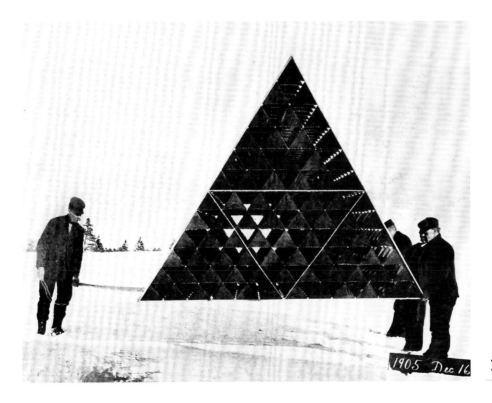

1 Alexander Graham Bell's (1847–1922) Frost King kite held by three workers, 1905

data. Mind alone can discover and employ the generalized scientific principles found holding true in every special case experience."[5] Fuller believed that "only minds can conduct science and produce art,"[6] and the highest compliment he could confer upon someone was to call him or her a "scientist-artist." Artists also frequently worked in an anticipatory fashion rather than waiting to be presented with specific commissions or challenges. Unlike scientists, architects, or engineers who were reliant upon patrons or external mandates, artists were not members of what Fuller called the "slave professions."

By locating the source of his innovations and patents in nature, Fuller could sidestep the inevitable challenges to the originality of his work. Alexander Graham Bell's experiments with tetrahedral kites and space-frame towers (fig. 1) were a key precedent to Fuller, though one he insisted was brought to his attention long after he reached his independent conclusions.[7] The fact that he had unknowingly pursued investigations similar to Bell's was added proof that a universal coordinated system existed. "It's the way nature behaves, so we both discovered nature. It isn't something you invent. You discover it."[8] One progenitor Fuller did acknowledge was D'Arcy Wentworth Thompson. Thompson's seminal 1917 book *On Growth and Form* demonstrated the morphological similarities of a wide variety of organic substances and the mathematical basis underlying their structure and growth.[9] Thompson's arguments were punctuated with illustrations by Ernst Haeckel and photos by Arthur Worthington, among others, and in later versions with photos by Harold Edgerton as well (fig. 2).

Spread from D'Arcy Wentworth Thompson (1860–1948), *On Growth and Form* (2nd ed. Cambridge: Cambridge University Press; New York: MacMillan, 1943; 1st ed. 1917), with illustrations by Ernst Haeckel (1834–1919)

Romany Marie's tavern, the eponymous gathering spot run by the Romanian émigré Romany Marie Marchand, was the setting for a seminal period in Fuller's development. As New York's version of Paris's café society, Romany Marie's was filled with artists and intellectuals, and Fuller became a regular in the late 1920s. "There I would stay, a table-sitter, all evening, until very late into the night," he recalled. "It was the Greenwich Village of the late '20s and early '30s that generated great new thinking—and I gained many friends for my concepts, and lost none."[10] It was there that Fuller, a polymath and autodidact whose formal education amounted to being kicked out of Harvard twice, began crafting his persona as a maverick outsider unrestrained by academic or commercial fiefdoms. Fuller also sharpened his oratory skills in this milieu, holding forth on his Dymaxion House, which he described as a dwelling machine suspended on a mast that could turn to meet the sun. One room in the house was set aside for books, maps, drawing boards, globes, and radio sets. Called the "Go-Ahead-With-Life room," it was an early example of Fuller's commitment to the accumulation and visual display of information and set the blueprint for later endeavors such as the Geoscope and World Game.

Among the artists Fuller met at Romany Marie's was the young Isamu Noguchi. When Noguchi moved to a new, window-wrapped studio, Fuller planned the interior environment. "Under Bucky's sway I painted the whole place silver—so that one was almost blinded by the lack of shadows," Noguchi remembered. "There I made his portrait head in chrome-plate bronze—also form without shadows" (plate 41).[11] More than three decades before Warhol's silver-paint- and foil-covered Factory, Fuller conceived of an entirely reflective silver studio for Noguchi. Noguchi's highly reflective bust of Fuller was among the first works of art to use chrome plating, a process then reserved primarily for automobiles. The choice of media was only appropriate for the man who advocated the harnessing of technology to meet humanity's needs. At that time Noguchi was supporting himself as an artist, and Fuller, who was regularly broke, often slept on the floor of his studio. They became lifelong friends, and their mutual influence can be detected throughout both careers, including in works such as Noguchi's *Miss Expanding Universe* (see plate 40) and the streamlined models of the Dymaxion car on which they collaborated (plate 46).[12]

When Marie moved her eatery to Minetta Street in 1929, Fuller offered his design services. He devised chairs based on contemporary airplane and steamship furnishings and painted the walls and pipes silver (plate 22). He lit the space brightly using horn-shaped aluminum fixtures, explaining, as Marie recalled, that "pseudos wouldn't come and hide in my place, they prefer to go hide in dark rooms, dark dining rooms where you can't see them well—can't see through them. To this room, Bucky said, only real and upright people would come, because you would immediately see all the way through them and they wouldn't mind the test."[13] In practice, the design was less than successful. The chairs collapsed the evening the tavern opened. "It was the most

ridiculous spectacle you ever saw in your life," Marie recalled. "It wasn't enough that there was a deviation with all the luminosity—when they sit down, they fall down."[14] The next morning she hired a carpenter to make benches to her specifications.

The following year Fuller designed "A Collector's Room" for the architect Ely Jacques Kahn, which went unrealized. The room, which resembled the streamlined form of the Dymaxion car, was to have niches for displaying sculpture (plates 42 and 43). It was "an outwardly tensed, ovaloid shaped, hyperbolic parabola, faceted, tension (tent) fabric room for installation in the Grand Central Palace at a proposed Architectural Show for a sculptors' exhibit room—lighting for the room and its sculptural exhibits to diffuse inwardly through the comprehensive translucent, tensed, white fabric 'walling,' from lights exterior to the structure."[15] Noguchi's studio, Romany Marie's, and the Collector's Room all demonstrate Fuller's early affinity for total environments, employing illumination, reflectivity, translucency, color, tension, and shape to maximum sensorial effect.

Fuller continued to promote his Dymaxion House in the early 1930s, often making contacts at Romany Marie's. He accepted lecture invitations from the Harvard Society for Contemporary Art (recently founded by Lincoln Kirstein, Edward

HAZEL LARSEN ARCHER
(1921–2001)
Buckminster Fuller as the Baron
Medusa in *The Ruse of Medusa* at
Black Mountain College, summer 1948

Warburg, and John Walker) and his friend Katherine Drier, under the auspices of the Société Anonyme. But by 1932 his work on *Shelter* and his burgeoning Dymaxion car business occupied most of his time and took him away from New York's artistic community.

Much has already been written on the two summers that Fuller taught at Black Mountain College, 1948 and 1949, including his encounters with Josef and Anni Albers, Ruth Asawa, John Cage, Merce Cunningham, Willem and Elaine de Kooning, Richard Lippold, and Kenneth Snelson. Yet it was a crucial experience for Fuller and must be discussed, if only briefly.[16] Josef Albers hired Fuller for the 1948 summer session at the suggestion of the architect Bertrand Goldberg, whom he thanked, writing, "The whole affair of which I was somewhat doubtful, turned out very well. He has accepted and has arrived just the other day. And last night he gave a talk for about three hours and he proves to be a great man."[17] Despite his professed disdain for Bauhaus philosophy, Fuller thrived in the cross-disciplinary, makeshift atmosphere of BMC, and he would become lifelong friends with Albers and his wife Anni.[18]

By all accounts Fuller cast a spell on many who were there in 1948, commencing with the lecture he gave that first evening. Cunningham was in attendance and recalled, "I remember thinking it's Bucky Fuller and his magic show. It was immediate, I think, with all of us who were there . . . this immediate absolute adoration and love of this man because of his . . . ideas, the width of the ideas. The grandeur with which he saw things and the way in which he spoke about them and demonstrated them."[19] That performative magic was further unleashed when Fuller played the lead in *The Ruse of Medusa*, part of Cage's summer-long concentration on Erik Satie (the play was directed by Arthur Penn, also featured Cunningham and Elaine de Kooning, and employed props and sets by Ruth Asawa and Willem and Elaine de Kooning; fig. 3).

During that summer Cage and Cunningham grew close to Fuller, who appreciated the fields of music, dance, theater, and athletics not the least for their ability to heighten and utilize man's "intuitive dynamic sense." The three of them breakfasted together every morning and dreamed up an imaginary "finishing school" they would run. It was a "schematic new school. . . . We would finish anything. In other words, we would really break down all of the conventional ways of approaching school. And the 'finishing school' was going to be a caravan, and we would travel from city to city."[20] Both men credited Fuller with expanding their thinking into a multitude of other directions and encouraging them to think holistically and universally.[21] Cage in particular remained in close contact with Fuller, and years later he struggled to reconcile his belief in indeterminacy with Fuller's vision of a structured universe, eventually noting with relief, "There's a beautiful statement in Fuller's *Education Automation* [1963] [*sic*] in which he says that the whole idea of things being fixed is a notion that we no longer need."[22]

4

Much of Fuller's first summer at BMC was occupied with constructing a large-scale great-circle dome. Despite the immense level of anticipation, the dome, composed of strips of aluminum Venetian blinds, refused to rise. Immediately dubbed the "Supine Dome," it was a lesson, Fuller rationalized, in failure as a necessary step on the path to success. Kenneth Snelson, a young artist who had intended to pursue painting at BMC, was chosen by Albers to assist Fuller in his classes that summer because of his demonstrated abilities with three-dimensional structures and worked on the Supine Dome. The following winter, when Snelson was back in Oregon, he created several sculptures, including *Early X-Piece* (1948–49), an example of a discontinuous compression structure made of wood and nylon (plate 86). Snelson sent photographs of the work to Fuller and then brought the sculptures with him to BMC the following summer. Fuller, immediately recognizing the structural possibilities that Snelson's sculpture presented, having apparently been searching for such solutions himself, asked to have *Early X-Piece*. In the early 1950s, photos of similar works began to appear in articles about Fuller, without attribution to Snelson. Soon after, Fuller

coined the word *tensegrity* to describe tensional integrity with discontinuous compression. Snelson remembers Fuller asking him what he thought of "calling *our* structure 'tensegrity,'" thereby signaling his intention to take at least partial credit for the innovation Snelson had developed that winter.[23] This series of events resulted in a lasting rift between student and teacher.[24]

For much of the 1950s Fuller was absorbed with inventorying and tracking the earth's resources, culminating with the Geoscope or Minni-Earth projects, discussed at length in K. Michael Hays's essay in this volume. More than the artifacts that preceded it, the Geoscope was meant to be a *symbolic* visual display of information, an attention-getting dramatization. As Mark Wigley has asserted, Fuller conceived of the Geoscope "as a mechanism for blurring the distinction between science and art."[25] This distinction was further blurred in projects that Fuller worked on with John McHale and Shoji Sadao starting in the late 1950s, such as Dome Over Manhattan and Cloud Nine. The latter was presented as a photomontage in which spherical cloud cities float above a sublime landscape of deep canyons (plate 144). These monumental, airborne living spaces were the seemingly inevitable conclusion of Fuller's early experimentations with total environments and his emphasis on buoyancy and lightfulness. One also can't help but be reminded of Bell's tetrahedral kite experiments.

Beginning in the mid-1950s Fuller was increasingly included in gallery and museum exhibitions, as well as art periodicals. A full-scale exhibition of Fuller's work at the Walker Art Center was discussed. H. Harvard Arnason, then director of the Walker, was a principal supporter, and Gyorgy Kepes, professor of visual design at the Massachusetts Institute of Technology, was slated to design the exhibition. Fuller fantasized that the viewer would become a "comprehensive apprehender and possibly a neophyte comprehensive designer" subsequent to seeing the show.[26] That exhibition never came to pass, but in 1959 Arthur Drexler, curator of architecture at the Museum of Modern Art, organized an exhibition of Fuller's work in the museum's sculpture garden. *Three Structures by Buckminster Fuller* ran from September 1959 to winter of 1960 and included a geodesic radome, an octet truss, and a tensegrity mast. A smaller accompanying show with models and didactics was held indoors and overlapped for some of that time. In a wall text Drexler wrote, "Central to Fuller's genius, is the insight his ideas give us into universal order. That is an achievement which ranks him with other great poets, scientists, and artists."[27] The exhibition was widely reported on in the popular press and in art journals. An interesting side note is that Jean Tinguely's infamous *Homage to New York* (1960) was literally hatched inside Fuller's dome (fig. 4). Billy Klüver and engineers from Bell Labs built the self-destroying machine inside Fuller's radome in MoMA's garden over a period of several weeks. This would initiate Klüver's decades-long mediation between artists and engineers.

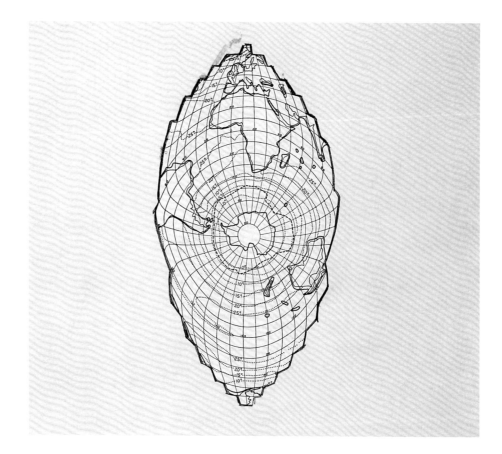

5

The growing recognition that Fuller enjoyed in the 1950s reached a crescendo in the mid-1960s.[28] Fuller wrote several books in short succession and was the subject of extensive press coverage, including a 1964 *Time* cover story and Calvin Tomkins's *New Yorker* profile two years later, reprinted in this volume.[29] Fuller was no longer described exclusively in terms of engineer, architect, or inventor. Peter Blake called him "one of the great creators of beautiful sculpture of this century."[30] His writings became increasingly relevant to artists as a dialogue about the relationship between the arts and the sciences grew in import, led by figures such as C. P. Snow and Kepes. In 1965 Fuller contributed "Conceptuality of Fundamental Structures" to *Structure in Art and in Science*, one of the Vision + Value series edited by Kepes. He wrote, "The brush and chisel artists who, despite the literary man's frustrations, tried to *follow* the scientists into 'nonconceptuality' with their 'non-representational' quasi-abstractions are now proven to have been intuitively sound in their conviction that they could really follow or even lead science in the game of intuitive probing."[31]

In John Chandler and Lucy Lippard's review of the Vision + Value series, entitled "Visual Art and the Invisible World," they wrote, "What scientists seem to want from art is the method or process of the artist, his powers of visualization—an

important part of the method of Galileo and early science, but neglected in the last century." Not surprisingly, Fuller figured prominently in their review, including his assertion that he had finally provided a physical model that artists and scientists alike might use to represent the imperceptible forces around us: "Buckminster Fuller suggests that the major reason for the failure of the public to keep informed about the 'evoluting realities' of science was the literary man's inability to follow into realms where there were no conceptual models or analogies. Visual artists were not only able to enter these realms, but also occasionally lead the way 'in the game of intuitive probing.' However, the result was that neither artist nor scientist was understood by the word-stuck public at large. Fuller claims that his own discovery of the 'natural four axis, 60 degree, tetrahedronal coordinate system' has returned 'conceptuality of dynamic structural principles to scientific validity.'"[32]

Chandler and Lippard's account of the discussion echoed the "new sensibility" that Susan Sontag had described in her 1965 essay "One Culture and the New Sensibility." Sontag spoke of a new cultural establishment that unashamedly drew upon scientific developments and was oriented toward the plastic rather than the literary arts. "This new establishment includes certain painters, sculptors, architects, social planners, film-makers, TV technicians, neurologists, musicians, electronics engineers, dancers, philosophers, and sociologists. . . . Some of the basic texts for this new cultural alignment are to be found in the writings of . . . Buckminster Fuller, Marshall McLuhan, John Cage, Andre Breton, Roland Barthes . . . [and] Gyorgy Kepes."[33]

Fuller's growing impact was also manifest in the art of the 1960s, one such example being the milestone 1966 exhibition *Primary Structures*. The show announced the ascendancy of large-scale, geometrically based sculpture in contemporary art. Curator Kynaston McShine used Fuller's neologism *tensegrity* to describe Forrest Myers's contribution and wrote in the catalogue, "Central to many of the principles upon which many of the artists like Forrest Myers work are the structures of Buckminster Fuller. Fuller's theories, now widely accepted and implemented, have been insights into the dynamic structure of nature, and into the interrelationship of physics, mathematics and philosophy."[34] McShine also drew a connection between Sol LeWitt's structures and Fuller, describing their white cubic framework as possessing "a logic and structure that seems to be what Fuller described as 'comprehensive design.' The modular pattern, which is so fundamental and universal in nature, in this piece assumes extraordinary beauty."[35] Even *Time* noted in its review that the artists "wax hot for the Geodesic Architect Buckminster Fuller."[36]

Several of the artists in *Primary Structures* showed at the Park Place Gallery, namely Peter Forakis, Robert Grosvenor, and Myers. In his 1966 essay "Entropy and the New Monuments," Robert Smithson noted that the Park Place Group had "permuted the 'models' of R. Buckminster Fuller's 'vectoral' geometry in the most astounding manner." He continued:

Fuller was told by certain scientists that the fourth dimension was "ha-ha," in other words, that it is laughter. . . . Laughter is in a sense of kind of entropic "verbalization." How could artists translate this verbal entropy, that is "ha-ha" into "solid models"? Some of the Park Place artists seem to be researching this "curious" condition. The order and disorder of the fourth dimension could be set between laughter and crystal-structural, as a device for unlimited speculation.[37]

And yet the art historical accounts of *Primary Structures* rarely mention Fuller.[38] Perhaps this is partly because the Park Place artists are not the ones who, over time, have come to exemplify the Minimalist movement that that exhibition ostensibly baptized.

"Entropy and the New Monuments" was not the only instance in which Smithson cited Fuller.[39] Smithson was drawn to Fuller and to Alexander Graham Bell for their attempts to isolate within the disorder of the natural world key organizing principles that could be translated into monumentally scaled artifacts. They saw no conflict between organic structures and modern technology. Fuller's forays into cartography also provided a precedent for Smithson's investigations into alternative mapping systems (fig. 5). In his 1968 "A Museum of Language in the Vicinity of Art" Smithson wrote: "R. Buckminster Fuller has developed a type of writing and original cartography, that not only is pragmatic and practical but also astonishing and teratological. His *Dymaxion Projection* and *World Energy Map* is a *Cosmographia* that proves Ptolemy's remark, that, 'no one presents it rightly unless he is an artist'" (fig. 6).[40]

In the spring of 1967, Fuller's work was included in a show entitled *Projects for Macrostructures* at the Richard Feigen Gallery in New York. His contribution included the Project for Floating Cloud Structure (the Cloud Nine project), Tetra City, a large-scale floating tetrahedron that could house up to a million people, and Harlem Redesign, a "slum clearing project" that had appeared in a 1965 issue of *Esquire* (plate 148).[41] Ronald Bladen, Christo, Hans Hollein, Claes Oldenburg, and Tony Smith were among the others included in the exhibition. Tetra City was featured on the cover of the March 1967 *Arts Magazine* with the contentious title "A Minimal Future?" (fig. 7). Dan Graham's article "Models and Monuments: The Plague of Architecture" considered the Feigen show, as well as two others, prominently

7 Cover of *Arts Magazine* 41, no. 5 (March 1967)

TONY SMITH (1912–1980)
Page from sketchbook #52, ca. 1951
Ink on paper
10 3/8 x 7 7/8 in. (26.3 x 20 cm)
8 Tony Smith Estate, New York

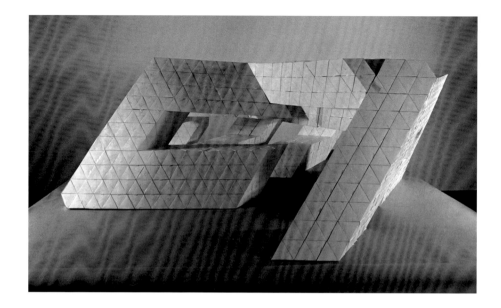

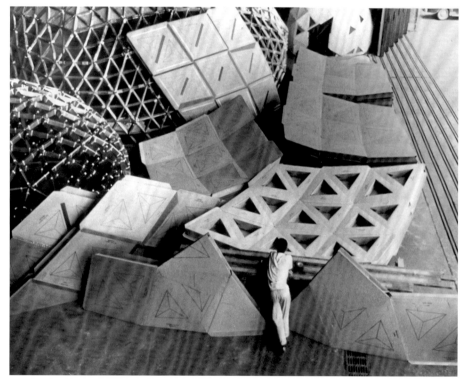

illustrating Fuller's megastructure projects.[42] And yet despite Fuller's high level of visibility in these art contexts, his significant engagement with the art world of the 1960s goes unnoted in most recent art historical accounts of this period. This significant exchange also remains absent in the literature on Fuller. The one consistent exception is the writing on Kenneth Snelson. One could argue the reverse in his case—too much of the writing on Snelson revolves around Fuller.

One intriguing area of future investigation might be Tony Smith's relationship to Fuller. Considering that Smith was well versed in architectural history and cited D'Arcy Thompson and Alexander Graham Bell as influences, the literature on Smith somewhat conspicuously elides Fuller.[43] Smith had to have had at least a passing familiarity with Fuller through his friendships with Barnett Newman and Gerome Kamrowski. The hexagons of Smith's 1950–51 East Hampton church project were admittedly indebted to Thompson and Frank Lloyd Wright but perhaps owed something to Fuller's Dymaxion House as well—and we know that Smith did own copies of plans for Fuller's house (see fig. 8).[44] *Bat Cave*, Smith's contribution to the 1970 Expo in Osaka, was made in collaboration with the Container Corporation of America. It was composed of thousands of die-cut cardboard tetrahedra and octahedra, a reiterative patterning that was reworked for the *Art and Technology* exhibition at the Los Angeles County Museum in 1971 (fig. 9). *Bat Cave* came less than two decades after Fuller collaborated with the Container Corporation of America on die-cut cardboard unit geodesic domes for the 1954 Milan Triennale (fig. 10).[45] Another ripe area for investigation would be to look at Joseph Beuys through the prism of Fuller's work. The two met in 1974 at the Black and White Oil Conference in Edinburgh, and Beuys made photographic multiples in 1980 to commemorate the event. But even before 1974 Beuys's work showed an affinity with Fuller's ideas, not least in his notion of "social sculpture"—using aesthetics to help forge a sustainable future.

Fuller was never more visible than in summer of 1967, when the three-quarter skybreak sphere he created for the U.S. Pavilion, the most dramatic structure he ever realized, was unveiled at the Montreal Expo.[46] The pavilion's theme was "Creative America," and Alan Solomon was hired to curate a contemporary art exhibition entitled *American Painting Now*. Solomon selected a show of large-scale paintings, the exception being a soft sculpture by Claes Oldenburg that hung from the roof (fig. 11). Jasper Johns proposed a painting based upon Fuller's Dymaxion Air-Ocean World Map, thinking "it seemed logical . . . to make a work which repeated the motif of the structure."[47] Employing Cage as his emissary, Johns obtained Fuller's permission to use the map in this manner. Johns wrote and thanked him, explaining, "I'm delighted. I intend to hinge the six-foot triangles so that it will be possible to change the form of the picture should it ever have to be shown in different environments."[48] He made the enormous work, his first and only painting of a world map, in his studio in twenty-two separate panels (fig. 12). "The stretcher bars used were angled so that the work could bend to form an icosahedron globe, but the clumsiness and weight of the work made this idea an impossibility."[49] As envisioned, the multipart painting represented a map of possibilities with no single, fixed viewpoint, exemplifying Fuller's notion of a "fluid geography." When Johns first saw the painting assembled in Montreal, he was disappointed, feeling it conformed too closely to Fuller's concept (fig. 13). Over the course of the next four years he reworked it, abandoning the

CLAES OLDENBURG
(b. 1929)
Giant Soft Fan, 1966–67, as installed in *American Painting Now* at the U.S. Pavilion of the Montreal Expo 67
Construction of vinyl filled with foam rubber, wood, metal, and plastic tubing
Fan: 10 ft. x 4 ft. 10 7/8 in. x 5 ft. 1 7/8 in. (3 x 1.4 x 1.5 m), variable; plus cord and plug: 24 ft. 3 1/4 in. (7.3 m) long
The Museum of Modern Art, New York, The Sidney and Harriet Janis Collection

11

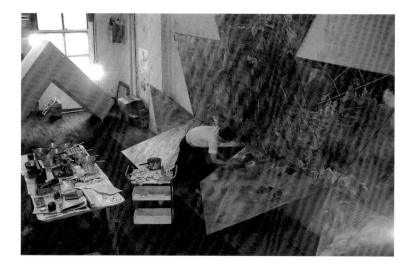

temperature index of Fuller's map and removing the hinges, among other alterations. Johns described the final result as "a complicated visual experience. It's both a map *and* a painting."[50] On December 3, 1971, Cunningham performed *Loops* at MoMA in front of Johns's painting, where it had been installed in the Founder's Room. Slides by Charles Atlas were projected onto the wall, and he was accompanied by music by Gordon Mumma.[51]

As the 1960s came to a close, the preponderance of unseen forces and vectors that constitute our environment, particularly the electromagnetic spectrum, gained primacy in Fuller's vast speaking program. His Montreal dome was the epitome of light-

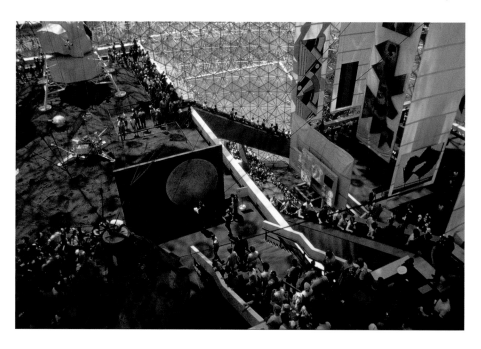

fulness, transparency, and material dilution. This dematerialization of architecture was the logical result of his philosophy of ephemeralization and paralleled the dematerialization of the art object at that time. In his foreword to the exhibition catalogue for *Projections: Anti-Materialism*, a 1970 show at the La Jolla Museum of Art, Fuller wrote, "When successful, tomorrow's architecture will be approximately invisible, not just figuratively speaking, but literally as well. What will count with world man is how well the architecture serves all humanity while sublimating itself spontaneously. Architecture may be accomplished tomorrow with electrical field and other utterly invisible environment controls."[52]

Artists, specifically those engaged with developing media, closely followed Fuller's emphasis on nonvisible forces, the "ha-ha" that he spoke of and Smithson commented on. Inspired by Fuller, Stan Vanderbeek began to construct his Movie-Drome in 1963. He showed his multiscreen films inside the domed circular building, which was his attempt at a theater of infinite space, "with no 'edge' to the screen . . . a total Envelope-Environment—allowing an almost endless amount of image material to flow over you and around the Drome."[53] The collective Raindance published the alternative television movement journal *Radical Software*, which included a pirated interview with Fuller in its first issue in 1970 (fig. 14). Ant Farm and USCO were two of the several other antiestablishment collectives influenced by Fuller's work. The members of Ant Farm considered him a hero and "the lone voice in the wilderness among architects and engineers."[54] In 1969 they "kidnapped" Fuller on

14 Cover of first issue of *Radical Software* 1, no. 1 (1970)

DOUG MICHAELS
(1943–2003; cofounder of Ant Farm)
The Reunion, 1970/96
15 Photocollage

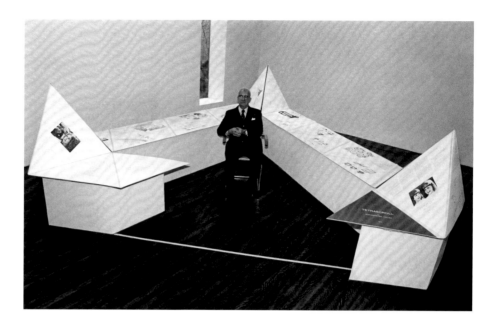

Installation view of *Tetrascroll*, 1977, at the Ronald Feldman Gallery, New York (January 29–February 26, 1977)

his way to a lecture at the University of Houston's engineering school. Instead of delivering him to the school, they took him to see his Dymaxion car in the exhibition *The Machine at the End of the Mechanical Age*, which was on tour in Houston at the time (fig. 15). Their 1970 *Inflatocookbook* illustrated Energy Credit, an invented paper currency that incorporated Fuller's visage and a geodesic dome in its design. Fuller penned the introduction to Gene Youngblood's seminal *Expanded Cinema*, the first book to treat video as an art medium. He wrote: "Humans still think in terms of an entirely superficial game of static things—solids, surfaces, or straight lines—despite that no things—no continuums—only discontinuous, energy quanta-separate event packages—operate as remotely from one another as the stars of the Milky Way. Science has found no 'things'; only events. Universe has no nouns; only verbs."[55]

In February 1975 Fuller's friend Edwin Schlossberg took him to the print workshop Universal Limited Artist Editions as an eightieth-birthday present. There Tatyana Grosman, the proprietor, introduced Fuller to lithography, which he took to immediately. He began crafting a version of the story "Goldilocks and the Three Bears," retold to explain the mysteries of the universe and the possibilities for mankind's future. "I know that we have the option to make it. That's different than being optimistic. It's touch and go. Goldy is very concerned. That's what this is all about. I'm interested in making artifacts that give us options."[56]

Characteristically, Fuller rejected the traditional rectangular structure of a book and created the *Tetrascroll* from twenty-six triangular pages (plates 164–71). Written in all caps with minimal punctuation, the text included an "epilever" rather than an "epilogue" by Schlossberg. The color was to match a seagull feather, and the

book was bound using Dacron, a material frequently used in sailing. Each hinged page of the book can be folded in multiple directions, creating numerous possible configurations of the *Tetrascroll*, much like his Dymaxion maps and Johns's vision for his painting. In January of 1977, as part of their Projects series MoMA installed the *Tetrascroll* along two perpendicular walls in proximity to an installation of Cage's work.[57] A second print was exhibited almost simultaneously on tables arranged in a V shape at Ronald Feldman Fine Arts, and a third was shown at the Fendrick Gallery in a tetrahedronal frame structure (figs. 16 and 17). Fuller called the *Tetrascroll* "everything I think and feel in mathematics and philosophy and everything else." Grossman described it as "a very beautiful achievement by an artist, a pure vision expressed in lithography."[58]

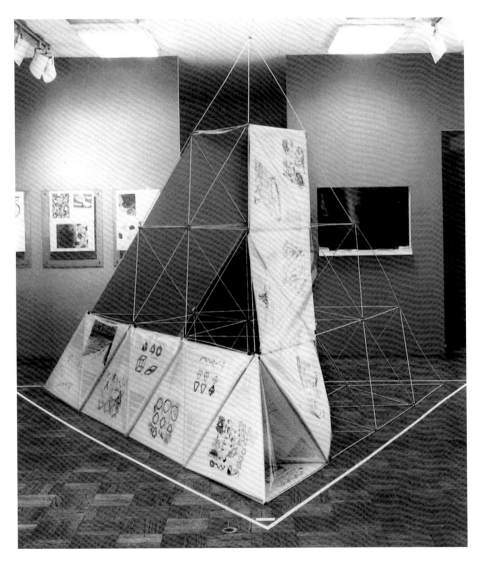

17 Installation view of *Tetrascroll*, 1977, at the Fendrick Gallery, Washington, D.C. (February 14– March 12, 1977)

After Grossman's death in 1982, Calvin Tomkins wrote an homage listing some of the artists she had worked with through the years. Johns was among those, but Fuller was not. Slighted, Fuller wrote Tomkins a somewhat bitter but telling missive:

> It seems unreasonable for Jasper Johns to be rated as an artist because he employs the beauty and whole unique lay-out, shape, and color of my Dymaxion Sky-Ocean World Map to make his 50 foot hanging for the Expo dome in Montreal in 1967 as an art form, and that Jasper Johns would later receive a $150,000 price for a somewhat modified form of a picture of my map, and not even think of offering any of it to me.[59]

Fuller's intersection with the artistic avant-garde spanned an astonishing period of the twentieth century, from Romany Marie's to the explosion of video and new media art in the 1970s. Throughout this time Fuller remained focused on locating, representing, and utilizing patterns in nature, and toward the end of his life he chose to represent his investigations in several formal artistic modes. Yet he stated that it was his "life long working assumption that the name 'artist,' 'poet' or 'musician' can only be bestowed on individuals by contemporary of later society, that these titles cannot be professed."[60] While he was alive, there were those who considered him an artist, including Marshall McLuhan, who called him the Leonardo da Vinci of the twentieth century. Since his death the number of those who refer to him as an artist has dramatically increased.[61] Certainly one can argue that Fuller's adult life was a single performative experiment; indeed, he called himself Guinea Pig B for that very reason. He believed artists were essential to society because they could broaden our range of perception and fuel our imagination. He saw patterns and built structures that represented as yet unverified forces in nature, including what would later be known as the C_{60} carbon molecule. Fuller expanded our options for the future; thus, by his own definition, he was unquestionably a scientist-artist of the highest order.

Notes

Epigraph. Buckminster Fuller, foreword to *Projections: Anti-Materialism* (La Jolla, Calif.: La Jolla Museum of Art, 1970), n.p.

1. From Dorothy Harley Eber, "Prologue: An Interview with Buckminster Fuller," in *Genius at Work: Images of Alexander Graham Bell* (New York: Viking Press, 1982), 11. Fuller delved into other "important-design-influence experiences" in a fourteen-page letter to John McHale dated January 7, 1955, M1090, ser. 4, box 2, folder 1, R. Buckminster Fuller Papers, Department of Special Collections, Stanford University Libraries.

2. Even after he received his glasses at age four,

Fuller claimed that he was preternaturally attuned to the patterns around him. "Good luck for me I was born cross-eyed." As quoted in Deborah Shapely, "Declaration of War Was Commencement for Class of 1917," *Harvard Crimson*, June 13, 1967.

3. Fuller noted that resistance to specialization is often interpreted by the school system as delinquency or a learning disability, with the result that many such youths drop out of school and become "minor outlaws or artists using sounds or visual compositions in which they can safely use their own language to say anything they want about the going order of life." As quoted in Howard Taubman, "Environment as Key to

Achievement Is Theme of R. Buckminster Fuller," *New York Times*, November 28, 1967.

4. Fuller, "Emergent Humanity: Its Environment and Education," from *R. Buckminster Fuller on Education*, reprinted in *Buckminster Fuller: Anthology for a New Millennium*, ed. Thomas Zung (New York: St. Martin's Griffin, 2001), 114.

5. Fuller, introduction to Gene Youngblood, *Expanded Cinema* (New York: E. P. Dutton, 1970), 20–21.

6. From a talk Buckminster Fuller presented at a dinner of the American Academy and Institute of Arts and Letters in New York on January 18, 1978, published as "Josef Albers (1888–1976)" in *Leonardo* 11, no. 4 (Autumn 1978): 311.

7. Beginning in 1898 Bell worked in his laboratory in Baddeck, Nova Scotia, on a series of tetrahedral structures—kites and towers in particular. He also worked on a hydrofoil craft he called the HD, and in 1919 the fourth version, HD-4, set a world marine speed record.

8. From Eber, "Interview with Buckminster Fuller," 9.

9. The book was the first entry listed in "Live Book Squad (The mobile 'shelf' [footlocker] of B. Fuller as of September, 1949)," M1090, subser. 25, box 8, folder 4, Fuller Papers.

10. Fuller, *An Autobiographical Monologue/Scenario*, ed. Robert Snyder (New York: St. Martin's Press, 1980), 61.

11. Ibid., 62.

12. The fascinating relationship between Fuller and Noguchi has been explored in depth in the recent exhibition *Best of Friends: Buckminster Fuller and Isamu Noguchi* at the Noguchi Museum (May 19–October 15, 2006), and will be expanded in a forthcoming book by its curator, Shoji Sadao.

13. Robert Schulman, *Romany Marie: The Queen of Greenwich Village* (Louisville, Ky.: Butler Books, 2006), 105–6.

14. Ibid., 106.

15. Letter from John Dixon, Fuller's assistant, to Donald Robertson, dated December 6, 1954, M1090, ser. 4, box 2, folder 4, Fuller Papers.

16. For a thorough account of the summer of 1948 see Mary Emma Harris, *The Arts at Black Mountain College* (Cambridge, Mass.: MIT Press, 1987). Other good sources on Fuller and BMC include Eva Diaz, "Experiment, Expression, and the Paradox of Black Mountain College," in *Starting at Zero: Black Mountain College, 1933–57* (Bristol, England: Arnolfini; Cambridge, Kettle's Yard, 2006); Martin Duberman,

Black Mountain: An Exploration in Community (New York: W. W. Norton, 1993); and Vincent Katz, ed., *Black Mountain College: Experiment in Art* (Madrid: Museo Nacional Centro de Reina Sofía, 2002).

17. Josef Albers, letter to Bertrand Goldberg, July 14, 1948, general files 2, box 12, folder Fuller, Bucky, 1948–1949, Black Mountain College Records, 1933–1956, courtesy North Carolina Office of Archives and History, Raleigh. Quoted with permission of the Josef and Anni Albers Foundation. Goldberg had met Albers at the Bauhaus when he studied there in 1932. They became reacquainted when Albers and his wife fled Europe and settled in the United States. Goldberg may have suggested Fuller after turning down Albers's invitation for that summer himself. Fuller had been so slow to respond to Albers's invitation that he invited another architect, Charles Burchard, a professor at Harvard. In the end both Burchard and Fuller taught at the college that summer.

18. In 1939 Fuller wrote to Frederick Kielser about the Bauhaus and its offshoots in the United States: "Nothing seems more fatuous than esthetically emotional exclamations of 'appreciation' of the physical properties of the myriad new materials by so called 'industrial designers,' which exclamation on one hand indicate that the speaker anticipates public acclaim for his perspicacity in making the 'discovery' and, on the other hand, infers that the anonymous industrial individuals who have spent years in developing the materials should have been so blind as to expend that effort unwitting the dynamics and potentials of their endeavor." Letter to F. J. Kiesler, April 14, 1939, Research Library, The Getty Research Institute, Los Angeles, California (850940). Although Albers's *Homage to the Square* series is commonly described as originating in 1949, Fuller recounted being present at this seminal moment. "One Sunday morning in August, 1948, when I was fortunate enough to be present, Albers developed his system of simple arrangements of squares within squares as explicit articulations of his color harmonies." From Fuller, "Josef Albers (1888–1976)," *Leonardo* 11, no. 4 (Autumn 1978): 311. Fuller described the *Homage to the Square* series as a set of generalized principles discovered by Albers.

19. Interview with Merce Cunningham, from PBS American Masters, *Buckminster Fuller: Thinking Out Loud*, http://www.thirteen.org/bucky/merce.html (accessed August 23, 2007).

20. Mary Emma Harris, interview with Buckminster

Fuller, October 3, 1971, box 30, folder Fuller, Buckminster, transcript p. 34, Black Mountain College Research Project (1933–73), North Carolina State Archives, Raleigh.

21. Ruth Asawa and Albert Lanier remembered that Fuller's sense of the world as a united entity was fairly novel and somewhat controversial. Immediately following World War II, this notion was perceived by some to be anti-American. Interview with the author, February 21, 2007.

22. Richard Kostelantz, ed., "Conversation with John Cage," in *John Cage* (New York: Praeger, 1970), 10. For a discussion of Cage and Fuller, see Branden Joseph, "Hitchhiker in an Omni-Directional Transport: The Spatial Politics of John Cage and Buckminster Fuller," *ANY* 17 (1997): 40.

23. Kenneth Snelson, interview with the author, May 21, 2007.

24. For further discussion of the complicated relationship between Fuller and Snelson, see transcript for Mary Emma Harris, interview with Kenneth Snelson, May 25, 1972, box 37, folder Snelson, Kenneth, Black Mountain College Research Project (1933–73), North Carolina State Archives, Raleigh; Katz, *Black Mountain College*; Duberman, *Black Mountain*; and http://www.grunch.net/snelson/.

25. Mark Wigley, "Planetary Homeboy," *ANY* 17 (1997): 20.

26. Letter from Fuller to Gyorgy Kepes, dictated to his assistant, John Dixon, and dated December 20, 1954, M1090, ser. 4, box 2, folder 1, Fuller Papers.

27. Arthur Drexler, text of wall label for "Structures by Buckminster Fuller," Buckminster Fuller artist file, library of the Museum of Modern Art, New York.

28. See K. Michael Hays in this volume for an account of Fuller's growing reputation in the 1950s.

29. *Nine Chains to the Moon*, published in 1938, was Fuller's only book available in any significant quantity in the United States before 1962. Fuller published several major books in the 1960s: *Untitled Epic Poem on the History of Industrialization* and *Education Automation* in 1962, *Ideas and Integrities*, *No More Secondhand God and Other Writings*, and a reprint of *Nine Chains to the Moon* in 1963, and *Operating Manual for Spaceship Earth*, *50 Years of Design Science Revolution and the World Game*, and *Utopia or Oblivion* in 1969.

30. Peter Blake, "Five Shapers of Today's Skyline," *New York Times*, October 21, 1962.

31. Fuller, "Conceptuality of Fundamental Structures," in *Structure in Art and in Science*, ed. Gyorgy Kepes (New York: George Braziller, 1965), 80–81.

32. John Chandler and Lucy R. Lippard, "Visual Art and the Invisible World," *Art International* 11, no. 5 (May 1967): 27.

33. Susan Sontag, "One Culture and the New Sensibility," in *Against Interpretation and Other Essays* (New York: Noonday Press, 1966), 298.

34. Kynaston McShine, introduction to *Primary Structures: Younger American and British Sculptors* (New York: Jewish Museum, 1966), n.p.

35. Ibid.

36. "Engineer's Esthetic," *Time*, June 3, 1966.

37. Robert Smithson, "Entropy and the New Monuments," *Artforum* 4 (June 1966): 31.

38. Linda Dalrymple Henderson is one of the few to discuss Fuller's influence on the Park Place Group. See "Dean Fleming, Ed Ruda, and the Park Place Gallery" in *Blanton Museum of Art: American Art since 1900* (Austin, Tex.: Blanton Museum of Art, 2006), 379–87.

39. Among the other essays in which Smithson cites Fuller are "The Artist as Site-Seer; Or, a Dintorphic Essay" (1966–67) in *Robert Smithson: The Collected Writings*, ed. Jack Flam (Berkeley: University of California Press, 1996), 342; and "Towards the Development of an Air Terminal Site," *Artforum* 5 (Summer 1967): 37. Both of these essays also mention Alexander Graham Bell. Smithson also discusses Fuller and entropy in an interview with Alison Sky published as "Entropy Made Visible," *On Site* 4 (1973).

40. From "A Museum of Language in the Vicinity of Art," *Art International* 12, no. 3 (March 1968): 27. By 1971 Smithson had characterized Fuller as a utopian and distanced himself from Fuller's program: "Unlike Buckminster Fuller, I'm interested in collaborating with entropy. . . . After all, wreckage is often more interesting than structure. At least, not as depressing as Dymaxion domes. Utopian saviors we can do without." From an interview with Gregoire Muller, published as "The Earth . . . Is a Cruel Master," *Arts Magazine* 46, no. 2 (November 1971): 40.

41. June Meyer, "Instant Slum Clearance," in *Esquire* 63, no. 4 (April 1965): 108–11.

42. The other two exhibitions were *Scale Models and Drawings* at the Dwan Gallery and *Architectural Sculpture, Sculpture Architecture*, at the Visual Arts Gallery. For more discussion on 1960s megastructures, see Hays's essay in this volume.

43. Chandler and Lippard briefly group Fuller and Smith together: "The organic structure of Tony Smith's sculptures and Buckminster Fuller's geodesic domes may be difficult to discern, yet both find the source of their tetrahedral structure in nature." John Chandler and Lucy R. Lippard, "Visual Art and the Invisible World," *Art International* 11, no. 5 (May 1967): 29. Later that year Lippard took pains to distinguish between the two in an essay on Smith, writing in a footnote: "There are areas in which Smith's ideas, particularly as regards tetrahedral construction and continuity, seem to have affinities with those of Buckminster Fuller. In fact the two have very little in common, and Fuller's incontestable influence on art has been in an intellectual rather than an esthetic sphere." Lucy R. Lippard, "Tony Smith: 'The Ineluctable Modality of the Visible,'" *Art International* 11, no. 6 (Summer 1967): 27.

44. Joan Pachner explains, "While he later denied any interest in Fuller, Smith did own a set of blueprints for Fuller's Dymaxion House; it is uncertain when he obtained them." See Pachner, *Tony Smith: Architect, Painter, Sculptor* (Ph.D. diss., New York University, 1993), 85.

45. W. Paepcke, president of CCA, was a supporter of Fuller's. Paepcke was also a patron of Herbert Bayer and László Moholy-Nagy, whom he helped start the American Bauhaus in Chicago. In 1950 Paepcke founded the Aspen Institute, where Fuller became a regular visitor.

46. Among the other architects considered for the U.S. Pavilion were John Johansen, Philip Johnson, Ludwig Mies van der Rohe, and Paul Rudolph. Marcel Breuer sent an unsolicited submission. According to Jack Masey, it was Peter Chermayeff of Cambridge Seven Associates who suggested that Fuller build a three-quarter sphere rather than a hemispherical dome. Later Fuller showed Masey sketches from several decades before in which he had depicted a three-quarter dome. Masey had first met Fuller when he, under the auspices of the United States Information Agency (USIA), asked Fuller to contribute a geodesic dome to the Jeshyn trade fair in Kabul, Afghanistan, in 1956. They worked together again in 1959 on the Moscow fair dome. Jack Masey, interview with the author, May 8, 2007. For a detailed discussion of the U.S. Pavilion, see Jonathan Massey, "Buckminster Fuller's Cybernetic Pastoral: The United States Pavilion at Expo 67," *Journal of Architecture* 11, no. 4 (September 2006): 463–83.

47. Jasper Johns in a letter to the author, September 12, 2007.

48. Jasper Johns in a letter to Fuller, January 23, 1967, M1090, ser. 2, box 154, folder 2, Fuller Papers. Solomon was initially under the impression that Johns would not be able to contribute a new work and was prepared to borrow Johns's large painting *Studio II* from private collectors. Letter from Alan Solomon to Victor Ganz, December 7, 1966, Alan R. Solomon Papers, Archives of American Art.

49. Johns to author, September 12, 2007.

50. "Treasure Map," *Newsweek*, February 15, 1971, 90.

51. In February 1971 newspapers reported on the rumor that the German collector Peter Ludwig had bought *Map*, which prompted MoMA to install the work before it left the country. Their Founder's Room was the only space large enough to accommodate the work. See chronology in Kirk Varnedoe, *Jasper Johns: A Retrospective* (New York: Museum of Modern Art, 1997), 239.

52. Fuller, foreword to *Projections: Anti-Materialism* (La Jolla, Calif.: La Jolla Museum of Art, 1970), n.p.

53. Stan Vanderbeek, quoted in Douglas Davis, *Art and the Future* (New York: Praeger, 1973), 49.

54. Doug Michels, from "Interview with Ant Farm," in Connie M. Lewallen and Steve Seid, *Ant Farm, 1968–1978* (Berkeley and Los Angeles: University of California Press, 2004), 44.

55. Buckminster Fuller, introduction to Gene Youngblood, *Expanded Cinema* (New York: E. P. Dutton, 1970), 24.

56. As quoted in Amei Wallach, "Bucky and Tatyana," *Newsday*, February 6, 1977.

57. Cage had two works on display, *Apartment House 1776* and *Renga*, a system of graphic notation using tracings of drawings from Henry David Thoreau's journals.

58. Amei Wallach, introduction to *Tetrascroll, Goldilocks and the Three Bears: A Cosmic Fairy Tale*, by R. Buckminster Fuller (New York: St. Martin's Press, 1975), x.

59. Letter from Fuller to Calvin Tomkins, dated October 6, 1982, M1090, ser. 7, box 6, folder 3, Fuller Papers.

60. Ibid.

61. Victoria Vesna, "Bucky Beat," *Artbyte* 1, no. 3 (August–September 1998): 22–29; Linda Weintraub, "I Seem to Be a Verb: R. Buckminster Fuller as Pioneering Eco-Artist," *Art Journal* 65, no. 1 (Spring 2006): 65–66; Wigley, "Planetary Homeboy."

FULLƐR'S AVATARS:

A VIEW FROM THE PRESENT

ANTOINE PICON

There are many Buckminster Fullers. A rapid survey reveals the existence of a series of contrasting figures: the marginal inventor of the 1920s and the world-famous prophet of the 1960s and '70s, the protégé of the U.S. military and the inspiration for alternative communities like Drop City,[1] the advocate of technological progress and rationalization and the defender of the environment. Paradoxically, this confusion has been created by Fuller's endless attempts to explain himself through books, articles, and lectures, not to mention the systematic recording of his life in his Dymaxion Chronofile. His wish to be transparent, like a rigorously defined experiment—to use one of his favorite characterizations of his attitude toward life[2]—has produced the opposite effect: an impression of opacity generated by an overabundance of details.

A closer study of Fuller's trajectory reveals, however, the persistence of themes and preoccupations, like his transcendentalist emphasis on the creative power of the individual, or his desire to promote a "revolution in design."[3] These themes and preoccupations are not distributed randomly. They organize themselves along axes that make it possible to reconstruct another series of avatars of Buckminster Fuller. Are those avatars closer to what the man was in reality than those I mentioned earlier? The answer is difficult to give. At least, because they are the direct product of our power of investigation, they correspond to the reasons we have to be interested still in Fuller's work today.

In this essay, I would like to explore two possible interpretations of Buckminster Fuller. The first relates him to the emergence of the society of information and communication. Due to projects like his World Game, Fuller is often presented as a forerunner of digital culture. What can be said about his relation to information, communication, network, computing, and simulation? It is striking to observe how this kind of question has replaced former inquiries regarding Fuller's contribution to structural design.

The utopian constitutes the other avatar of Buckminster Fuller that I will deal with. Contrary to the information-age Fuller, Fuller the utopian has always been a widely discussed subject. In the 1960s and '70s, critics were generally fascinated by the brave new world he promised in his books and lectures. Later, his optimistic take on the capacity of man to steer "Spaceship Earth" was seen as typical of the demiurgic and technocratic tendencies of the postwar period.[4] In connection with the emergence of a digital Fuller, the utopian dimension is probably acquiring a new meaning today.

After a long purgatory, utopia is indeed reappraised, not necessarily in terms of a global, well-crafted project, another ideal city after all those that have been produced from the Renaissance on, but as the promise that, with a proper course of action, something different can take place in the near future. In the digital realm, we are no longer fascinated by the discourses on the Global Village that accompanied

the creation and early developments of the Internet. The Global Village perspective was, after all, nothing but the ideal city reinvented. In recent years, we have become more sensitive to the notion that utopia is less a definitive state of affairs than an open-ended process, a process that should furthermore empower the individual instead of giving precedence to impersonal collectives. And this is perhaps where Fuller might fit in, despite the colossal dreams of Cloud Nine or Tetra City, as a passionate advocate of utopia as a process giving a key role to the individual. The ultimate expression of his utopian vision, the World Game, was after all a process. This may account for the fascination the endeavor exerts on so many of us today. Just like "digital Fuller," Fuller the utopian definitely belongs to our present.

"Digital Fuller"

From the very beginning of his career, Fuller displayed interests that were clearly related to information and communication. He was, for instance, obsessed with figures and statistics that he collected from all kinds of sources, from daily newspapers to the proceedings of the American Statistical Association. Above all, he was fascinated by the phone and the radio, and their potential to transform everyday life. The proposals and perspectives he elaborated in the 1920s and '30s under the generic title of 4D or Dymaxion already spoke to the society of information and digital culture, with its trends toward universal mobility, delocalization, and mass customization (see plates 5 and 15).

Fuller's society of the future was characterized by a fluidity of communication that allowed individuals to live pretty much everywhere on the surface of the earth, including the two poles. Why should one have a New York Stock Exchange when one could imagine a "mechanical stock exchange" functioning at the scale of the entire planet?[5] Why have localized schools and universities when one could teach children, young men, and women at home, using radio broadcasting?[6] Material production itself could be decentralized along the main transportation infrastructures, roads and railways, according to the pattern imagined by Fuller for the production and temporary storage of his Dymaxion Houses.[7] Never was Fuller as prescient as when he announced the possibility that mass media could satisfy individual preferences, foreshadowing the principle of generalized customization Nicholas Negroponte proclaimed in his influential best seller *Being Digital*.[8]

This fluidity found its implicit counterpart in the creation of global organizations, like the ones that would replace the existing stock exchange and the various schools and universities. The Dymaxion universe was actually far more ambiguous in that respect than its creator officially acknowledged, an ambiguity that was to form the germ of the enduring tension between individualistic and technocratic leanings typical of Fuller's later proposals. In that respect too, the author of *4D Time Lock* and *Nine Chains to the Moon* announced the fundamental ambivalence of our

society of information and communication, with its constant oscillation between the desire for individual freedom and the simultaneous need for coordination and control.

Fuller was not the only one to set out on this path. Where he was perhaps especially farsighted was in his understanding of the fundamentally strategic ability required to cope with massive flows of information. While one could survive as a tactician in the traditional industrial society, a new world of highly strategic choices was gradually unfolding, in step with the proliferation of data and the explosive growth of telecommunication. This world was in dire need of visualization techniques to make choices easier. From his Dymaxion Air-Ocean World Map to his postwar Geoscope and World Game, a number of Fuller's inventions are related to our need, in an information-based society, to distinguish patterns and trends where we previously saw only forms and backgrounds.

As a technical adviser to the magazine *Fortune* from 1938 to 1940, Fuller could already present himself as having a special talent for seeing patterns and trends. Indeed, some of the charts he produced for the magazine, like Dynamics of Progress, Comparison of U.S. Economy with the Rest of the World, or Profile of the Industrial Revolution were quite remarkable (figs. 1 and 2). The experience of World War II reinforced this talent through episodes like his working, alongside filmmakers,

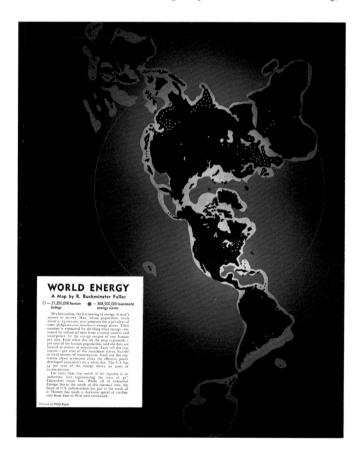

World Energy Map, as published in *Fortune*, February 1940

Profile of the Industrial Revolution as Exposed by the Chronological Rate of Acquisition of Basic Inventory of Cosmic Absolutes—the 92 Elements, 1946

2

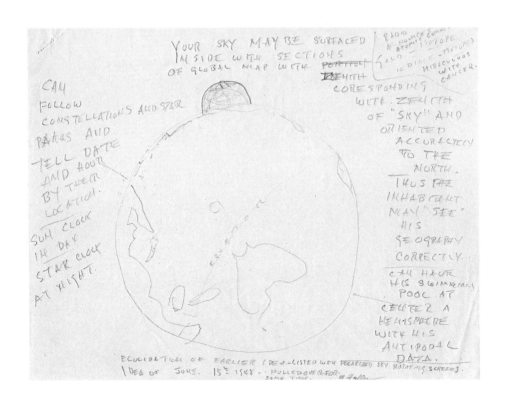

Sketch illustrating an early conception of the Geoscope, 1948

3

designers, and architects like John Ford, Raymond Loewy, and Louis Kahn, for the Office of Strategic Services, offering synthetic visual presentation of key data for the president of the United States and his advisers.[9] The Geoscope, as an attempt to present a global image of the planet using a geodesic sphere, was a direct inheritor of this project (fig. 3).

Postwar, Buckminster Fuller was even more clearly in tune with the development of a new society giving precedence to information, communication, and networks. His discourse was influenced by the rhetoric of cybernetics, with its emphasis on trajectory steering. Operations research and game theory also left their marks, though their influence was limited by Fuller's fundamental interest in geometry rather than calculus (fig. 4). The ideal of mechanization that had characterized the Dymaxion period was now complemented by the perspective of computerization. For Fuller, the computer represented the ability to pass seamlessly from the collection of data to their dynamic visualization. Initiated as a series of seminars using paper and pencil, like the 1969 session at the New York Studio School, the World Game was meant to transform itself eventually into a giant computer simulation.[10] In direct relation to this perspective, the notion of scenario became crucial in the thinking of its inventor. The World Game revolved around the construction of scenarios about the future of the planet—that is to say, trajectories linking series of possible events. There again, Fuller was in profound accordance with the rising importance given to events in the culture of information and communication. With their bits of data that

Sketch for Dymaxion Kinetic Vector Structure, 1947, demonstrating Fuller's geometric explorations

4

are nothing more than elementary occurrences, information and electronic communication are fundamentally commensurable with events, in other words with "what happens" or what may happen, to paraphrase Paul Virilio.[11]

Fuller's optimistic scenarios were all based on the alliance between his enduring fascination with military-style planning and a new concern for the environment. Although probably the most emblematic representative of this collusion between these seemingly discordant preoccupations, Fuller was by no means the only one to navigate between them; he was joined by a whole range of figures of the time. Based on the hypothesis of "closed worlds" the behavior of which could be predicted, the new tools of the period, like cybernetics, system theory, linear programming, and computer modeling, emphasized the finitude of resources and the need for their careful allocation—whether they were Cold War weaponry or natural resources. It is no coincidence that an engineer like Jay Forrester could translate the computer techniques he had elaborated for the U.S. Air Defense, for the Semi-Automatic Ground Environment (SAGE) system in particular, into the simulated world dynamics used by the Club of Rome to explore the limits of economic growth in the 1970s. Fuller's "Spaceship Earth" was a particular instance of the "closed world" perspective that triumphed both at the Pentagon and in environmentally conscious circles.[12]

This perspective was of course inseparable from the development of communication networks. Building on some of his prewar intuitions, Fuller now announced the transformation of education into an industry using "an educational machine technology that will provide tools such as the individually selected and articulated two-way TV and an intercontinentally net-worked, documentaries call-up system."[13] Interactivity, with the "two-way TV," and individual customization would be the fundamental characteristics of the global networked society of the future.

One should not, however, hold up Buckminster Fuller as an advocate of the new culture of information and communication who was totally aware of all its implications. The idea of hybridization between man and technology, for instance—in other words, the question of the cyborg that was emerging at the time, from cybernetic reflections on the analogy between mind and computer to practical attempts by the military at a more efficient coupling between man and machine[14]—remained foreign to him.

More generally, Fuller remained at heart a traditional humanist. Just like his friend Constantinos Doxiadis, an architect and planner who was another postwar prophet of communication and networks, his aim was not to immerse man completely in the sphere of accelerated physical transfer, information processing, and instant messaging, much less to equip him with steel and silicon organs, but rather to re-create the conditions for a new equilibrium, for a regained serenity in a frenzied world.[15] Nothing is more telling, in that respect, than the photographs showing Fuller in the geodesic home he lived in from 1960 to 1971 in Carbondale, Illinois.

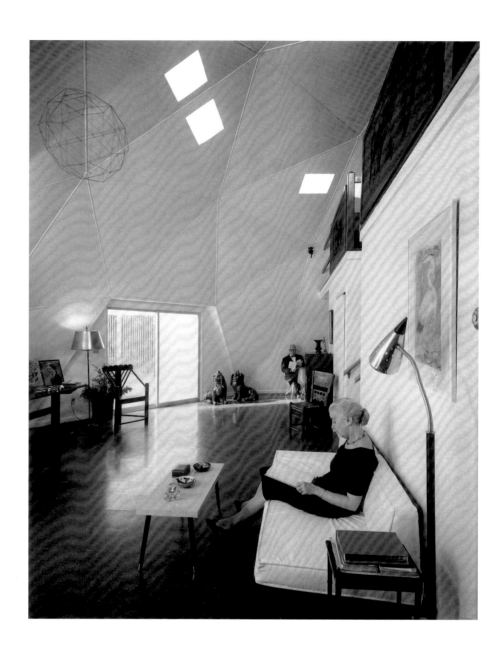

Buckminster and Anne Fuller inside
their dome house, Carbondale,
Illinois, ca. mid-1960s

Despite its futuristic geometry, the home is quiet, meditative in ambience, almost like
a seventeenth-century Dutch interior (fig. 5).

If Fuller was clearly a major representative of the fundamental shift occur-
ring in these years from the design of objects to the conception of artificial ambi-
ences and environments, an evolution he epitomized with his famous project of a
giant dome covering a large part of Manhattan to provide a semitropical climate
inside (plate 145), he was certainly not extreme to the point of imagining, like some
younger representatives of radical architecture, that man could be fundamentally
altered in his essence through changes in his surroundings.[16] The type of relation he

envisioned between man and the environment was much closer to the Enlightenment quest for perfectibility: mankind's defects were the result of unhealthy conditions of life. As he had put it optimistically in *4D Time Lock*, "Education and the proper upbringing of the young in modern, truthful, healthful environment will quickly efface crime and both mental and physical deformities."[17]

Prophets are not always as farsighted as their admirers would like them to be. Some of Buckminster Fuller's ideas are actually more conservative than the popular picture of the relentless advocate of rationalization and progress seems to imply. After all, through his great-aunt Margaret Fuller, he remained indebted all his life to the nineteenth-century transcendentalist legacy. But it is not only ideas that make prophets. In the case of Fuller, a series of very concrete patterns of behavior reinforce his emblematic status. It is as much by these patterns as by his ideas that he announces the rise of information and communication.

I have already mentioned Fuller's passion for data gathering, a passion he expressed through his systematic paper clipping. The Chronofile, especially in its first decades, is replete with clippings from all kinds of newspapers and journals (pages 212–13). This clipping was definitely linked to a new attitude to data, to the ability to extract, package, and process it, a perspective announcing its transformation into what we today call information.[18]

Even more telling were the various strategies Fuller used to disseminate his ideas. Some of these strategies were of a technical nature, like his use of the mimeograph, a cheap mode of reproduction, to put his early writings in circulation. Others were of a more social nature, like the experimental seminar organized in July 1929 to elaborate *4D Time Lock*. Traditional writing was to be replaced by recording and editing a series of exchanges between Fuller and a group of expert architects and engineers.[19]

More generally, throughout his career, Buckminster Fuller relied heavily on processes involving state-of-the-art reproduction and communication technologies as well as a heavy dose of social networking. It is no accident that he was immediately seduced by Doxiadis's Ekistics initiative, with its intricate blend of information gathering, publications, and social events like the Delos meetings organized from 1963 on (fig. 6).[20] Like Doxiadis, postwar Fuller acquired and maintained his worldwide celebrity through his skilled use of media and social network.

A Paradoxical Utopian

The cunning manipulation of media and people might seem at first fundamentally at odds with the alleged disinterestedness of utopia. But the opposition does not stand up to closer investigation, for utopia in the industrial age is not only about the evocation of a brave new world painted with the vivid colors of a dream. No longer a mere literary genre as it had been from the Renaissance to the eighteenth century, after the model of Thomas More's seminal fiction, it aims to transform concretely the

6 Cover of *Ekistics* 30, no. 177 (August 1970), a journal edited by Constantinos Doxiadis dedicated to the theorization of human settlements based on hexagonal infrastructures

world.[21] Because of that ambition, utopia is closely allied with the communication techniques that can make the dream persuasive enough to generate political and social effects.[22] In other words, modern and contemporary utopia is intimately linked to media manipulation and social networking. Early-nineteenth-century utopians like the French Saint-Simonians were already experts at these practices.[23] A similar degree of expertise was to characterize many subsequent enterprises. Fuller the utopian is actually inseparable from Fuller the master of communication and public relations.

Now, the exact nature of Fuller's utopian vision is not easy to pin down. It seems to present contradictory features indeed. First and foremost, the emphasis is on a more and more immaterial society. Fuller's key principle of ephemeralization, which he defined as the trend toward doing more with less, describes the progression "from material to abstract," toward "intangibility, non-sensoriality."[24] Throughout, Fuller's writings tend to undermine the importance of materiality in favor of intellectual intuition and reasoning, the principles central to his later work *Synergetics*. Nothing is more revealing in that respect than one of his prospectuses for his 4D Houses, in which we find the following statement: "At the high points of each era of the great progression, has it been realized that materials in themselves signify nothing and can be nothing without the will and the creative urge, and that character, happiness, love, harmony, and all the eternal qualities of truth are abstract and of the soul, and have but the freer play for the lack of any material impediment."[25] Beside materials, objects themselves have only a relative value and should not be fetishized. Ephemeralization implies a certain distance from objects, a distance often based on the privilege given to services rather than to the physical possession of things. As Fuller once noted, to own a telephone handset has no real importance; what counts is to subscribe to a phone plan. By the same token, housing was to be considered as a service rather than a product industry appealing to the instinct of home ownership.[26] Here again, one is tempted to relate Fuller's stress on immateriality and service to his understanding of the implications of the rise of information and communication. His advocacy of immateriality is not without analogy to the kind of discourse we have heard since from theorists of digital culture like Nicholas Negroponte or William Mitchell.

But at the same time, the legacy of Fuller is essentially composed of a series of fascinating objects, like the Dymaxion house, car, and bathroom, the Wichita House, or his various geodesic domes. Despite his appeal to what he characterized in turn as the abstract or the metaphysical, he insisted on the practical, engineering-like nature of his proposals: "I must always 'reduce' my inventions to physically working models and must never talk about the inventions until physically proven — or disproven."[27]

Many other contradictions can be pointed out in Fuller's vision of the future. As I have already noted, this future is marked by contradictory trends toward decen-

Sketch by Fuller on postcard showing
the cathedral of Seville fitting inside
7 his Montreal Expo 67 geodesic dome

tralization and centralization, freedom and control. "We are convinced that, with the progress of life, the living abodes of humans will become more and more decentralized, and industry more and more centralized and mechanicalized," he wrote in one of his early prospectuses.[28] The radical nature of the decentralization of life he had in mind prevents us from interpreting this statement as a simple endorsement of the American suburban model.

Another striking discrepancy lies in the spectacular contrast between Fuller's quest for structural lightness and the gigantism of many of his postwar proposals. This gigantism was to reach its climax with tensegrity megastructures like Cloud Nine and Tetra City (plates 144 and 147), which would have dwarfed Manhattan skyscrapers. Some of his realizations were already of respectable size. As Fuller showed using a postcard from Seville, the cathedral of the Spanish city, by no means a small building, could fit entirely inside his geodesic dome at the Montreal Expo 67 (fig. 7).

All these apparent contradictions are actually related to a fundamental tension that runs throughout Fuller's life and work, between the immaterial, light, and mobile on the one hand, the physical, heavy-duty, and large-scale on the other. Now I described these contradictions as apparent, for Fuller's ultimate utopia revolves precisely around the way to solve the antinomy between these two series of terms.

His flirting with the megastructural movement may actually provide some insight into what he really aimed at, for his gigantic structures were supposed to be light to the point of being able to float in the air because of their use of the tensegrity principle. In that respect, Fuller was not far from the structural intuitions of someone like Le Ricolais, who believed that less could sometimes be attained through

YOU HAVE TO WRITE USING A SPECIAL KEYBOARD

THE KEYS ARE REPRESENTING ROOM-SHAPES

WHOSE POSITIONS CAN BE ROTATED WITH A SPECIAL KEY

A "WORD" TYPED WITH THESE KEYS SHOWS A STRING OF ROOMS

A "TEXT" IS A SUITE OF "WORDS": YOUR FLOOR PLAN AND THAT OF YOUR NEIGHBOURS

THE "WORDS" ARE TYPED ONTO A "GRID"

THIS "GRID" REPRESENTS THE "INFRASTRUCTURE" INTO WHICH THE FLATS ARE FITTED

OBVIOUSLY YOUR FLAT HAS TO BE DETAILED: DOORS WINDOWS EQUIPMENTS (BATH, KITCHEN, WC ETC)

AND YOU HAVE TO DECIDE FINAL ORIENTATION ROTATING THE PLAN

THE "TEXT" CAN BE OF SEVERAL "PAGES": EACH "PAGE" IS THE PLAN OF A DIFFERENT FLOOR

A "TEXT" TYPED BY MANY PEOPLE PRODUCES THE PLAN OF A NEIGHBOURHOOD

A CITY IS A COLLECTIVE "TEXT"

"TYPED" BY THOSE WHO WANT TO LIVE THERE

THE "TEXT" TYPED ON THE FLATWRITER

IS NOT THE COMPLETE CITY PLAN BUT RATHER A "WISHING LIST":

THE FIRST STEP TOWARDS HAVING YOUR TOWN BE AS YOU LIKE

Yona Friedman, a page from the program of "Flatwriter," *Pro Domo* (Barcelona: Actar, 2006)

more, through a massive mobilization of means.[29] Ephemeralization, that is, more *with* less, could paradoxically lead to less *through* more.

Despite its technocratic connotations, the postwar megastructural movement was linked to the project of using technology to free humanity from the mechanical enslavement of the industrial era. In the megastructures to come, men would wander freely, enjoying their rediscovery of natural sensations such as those provided by light and wind. In that respect, megastructures were comparable to giant liners, enabling their passengers to take full advantage of a direct contact with the elements.

The analogy with the liner was not lost on Fuller, who had been a sailor in his youth and was convinced of the maritime origins of modernity though the emblematic figure of the "pirate."[30] Before ephemeralization, streamlining had been one of his key concepts, a concept definitely owing something to ship design. Megastructures, just like ships, proposed redemption from the misuse of technology through advanced technology. This redemption went hand in hand with a curious primitivism. What megastructures were ultimately about was the direct experience of a long-forgotten contact with nature.

Fuller the utopian is of course not reducible to Fuller the designer of megastructural projects, but the latter is once again revealing. In the past decade, the meaning of megastructures has been revisited in the light provided by their contemporaneousness with the rise of information and communication. Among other things, it has become more and more evident that in the eyes of their most lucid advocates, megastructures were not really objects, but principles of connection and growth.[31] Put another way, they had more to do with software than hardware, a property that was to lead to proposals like Yona Friedman's "Flatwriter," a computerized system of spatial allocation within the urban megastructures of the future (fig. 8).[32] Another alternative explored by the Italian radical group Superstudio was the ultimate replacement of megastructures by equipped surfaces, giant grids on which a nomadic humanity could roam while enjoying all the benefits of advanced technology.[33]

Fuller is certainly not foreign to this kind of perspective. More generally, megastructures are emblematic of the real status of objects in the "revolution in design" he had in mind, namely the concretization of an attitude toward life, the trace of steps taken in the right direction. Neither the Cloud Nine and Triton City structures nor his tetrahedral city project nor his Old Man River town concept in Saint Louis are to be confused with the ideal cities of the past. They are not meant to prescribe a univocal social organization and style of life; they represent, rather, moments in the development of an endless game with the possibilities of the future. In other words, they mark a trajectory.

We are in the midst of a renewed interest in trajectory steering and scenario-oriented management techniques. Along with the desire to understand our immediate past, this might account for the fascination that the cybernetic era exerts on so many

young theorists and historians today.[34] The reinterpretation of Fuller the utopian is inseparable from that context. Its interest lies also in its resonance with one of the most nagging questions of our time: How can we reconcile the emphasis put on the individual dimension and the possibility of a common principle of hope? After all, Fuller himself liked to present his trajectory as the incarnation of such reconciliation.

Of course, we no longer believe that the universe obeys at a fundamental level the laws of synergetic geometry. We no longer take at face value Fuller's claims to possess the true solution to all the problems plaguing the earth. But there is a definite appeal in his proposal that we consider the future of the world as a game that can be won against all odds. More than the prophet, even more than the digital or the utopian proper, the player might ultimately be the most attractive avatar of Buckminster Fuller today.

Notes

1. Cf. Felicity D. Scott, *Architecture or Techno-Utopia: Politics after Modernism* (Cambridge, Mass.: MIT Press, 2007), 157–67.

2. See, for instance, R. Buckminster Fuller and Kiyoshi Kuromiya, *Critical Path* (New York: St. Martin's Press, 1981), 124.

3. This expression is already present in Fuller's first book, *4D Time Lock* (Chicago: privately printed, 1928; Albuquerque, N.Mex.: Lama Foundation, 1972), 13.

4. R. Buckminster Fuller, *Operating Manual for Spaceship Earth* (Carbondale: Southern Illinois University Press, 1969).

5. R. Buckminster Fuller, *Nine Chains to the Moon* (Philadelphia: J. B. Lippincott, 1938; Garden City, N.Y.: Anchor, 1971), 230.

6. Fuller, *4D Time Lock*, 5.

7. See Fuller's notes for *4D Time Lock*, M1090, ser. 8, box 2, R. Buckminster Fuller Papers, Department of Special Collections, Stanford University Libraries.

8. Nicholas Negroponte, *Being Digital* (New York, 1995; reprint, New York: Vintage, 1996), 163–71.

9. See Barry Katz, "The Arts of War: 'Visual Presentation' and National Intelligence," *Design Issues* 12, no. 2 (Summer 1996): 3–21; and above all Mark Wigley, "Planetary Homeboy," *ANY* 17 (1997): 16–23.

10. Cf. the various documents on the World Game kept in M1090, ser. 18, Projects Files, boxes 24–25, Fuller Papers.

11. On the relation between information and event, see Pierre Levy, *La Machine univers: Création, cognition et culture informatique* (Paris: La Découverte, 1987), 124 in particular. Paul Virilio, *Ce qui arrive* [What happens] (Paris: Fondation Cartier pour l'Art Contemporain, Actes Sud, 2002).

12. Cf. Paul Edwards, *The Closed World: Computers and the Politics of Discourse in Cold War America* (Cambridge, Mass.: MIT Press, 1996); Agatha C. Hughes and Thomas P. Hughes, eds., *Systems, Experts, and Computers: The Systems Approach in Management and Engineering, World War II and After* (Cambridge, Mass.: MIT Press, 2000).

13. R. Buckminster Fuller, *Education Automation: Freeing the Scholar to Return to His Studies* (Carbondale: Southern Illinois University Press, 1962), 48.

14. Cf. Les Levidow and Kevin Robins, eds., *Cyborg Worlds: The Military Information Society* (London: Free Association, 1989).

15. On that point, our interpretation of Doxiadis is slightly different from the perspective adopted by Mark Wigley in "Network Fever," in *Grey Room*, no. 4 (Summer 2001): 82–122. On Doxiadis see also Alexandros-Andreas Kyrtsis, ed., *Constantinos A. Doxiadis: Texts, Design Drawings, Settlements* (Athens: Ikaros, 2006).

16. Cf. Dominique Rouillard, *Superarchitecture: Le Futur de l'architecture, 1950–1970* (Paris: Editions de La Villette, 2004).

17. Fuller, *4D Time Lock*, 6.

18. See on that theme the articles gathered under the title "Cut and Paste um 1900," in *Kaleidoskopien*, no. 4 (2002).

19. "Meeting Tuesday, July 9, 1929 Architectural

League, New York. Verbatim report by: National Stenotype," Dymaxion Chronofile, vol. 36, 1929, M1090, ser. 2, box 21, Fuller Papers.

20. For a detailed account of the Delos meetings, see the journal *Ekistics*. From 1975 to 1977, Fuller was president of the World Society for Ekistics. On Ekistics as a discipline, defined by Doxiadis as the science of human settlements, see Panayiota Pyla, "Ekistics, Architecture and Environmental Politics, 1945–1976: A Prehistory of Sustainable Development" (Ph.D. diss., MIT, 2002).

21. Michèle Riot-Sarcey, Thomas Bouchet, and Antoine Picon, eds., *Dictionnaire des Utopies* (Paris: Larousse, 2002).

22. On the relations between utopia and communication, see Armand Mattelart, *The Invention of Communication* (Paris: La Découverte, 1994; English ed., Minneapolis: University of Minnesota Press, 1996).

23. Cf. Antoine Picon, *Les Saint-Simoniens: Raison, imaginaire et utopie* (Paris: Belin, 2002).

24. Fuller, *Nine Chains to the Moon*, 256. One of the best analyses of the concept of ephemeralization can be found in Martin Pawley, *Buckminster Fuller* (London: Trefoil, 1990).

25. "4D Housing & The Time Dimension," Dymaxion Chronofile, vol. 36, 1929, M1090, ser. 2, box 21, Fuller Papers.

26. Pawley, *Buckminster Fuller*, 24.

27. Fuller and Kuromiya, *Critical Path*, 125.

28. "Cosmopolitan Home Corporation Lightful products," manuscript, M1090, ser. 8, box 2, Fuller Papers.

29. On Le Ricolais's paradoxical statement that less can be achieved through more, see Peter McCleary, *Robert Le Ricolais: Visions and Paradoxes* (Madrid: COAM, 1997).

30. The figure appears in almost all his accounts of world history. See, for instance, his *Operating Manual for Spaceship Earth*.

31. This dimension of the megastructure was already present in Alison and Peter Smithson's projects like their celebrated Golden Lane. Cf. Rouillard, *Superarchitecture*.

32. Sabine Lebesque, *Yona Friedman: Structures Serving the Unpredictable* (Rotterdam: NAI, 1999), 50–51.

33. Peter Lang, *Superstudio: Life without Objects* (Milan: Skira, 2003).

34. To mention only a few: Branden Hookway, *Pandemonium: The Rise of Predatory Locales in the Postwar World* (New York: Princeton Architectural Press, 1999); Reinhold Martin, *The Organizational Complex: Architecture, Media, and Corporate Space* (Cambridge, Mass.: MIT Press, 2003); Michael Kubo, "Constructing the Cold War Environment: The Architecture of the Rand Corporation, 1950–2005" (master's thesis, Harvard University, 2006).

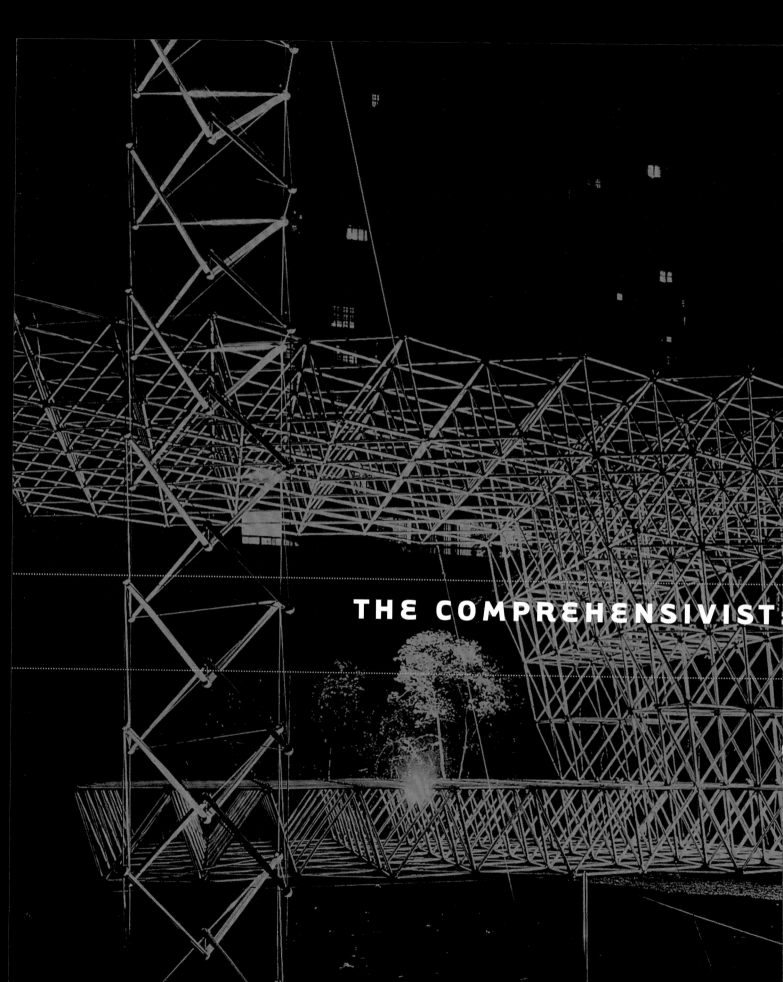

THE COMPREHENSIVIST

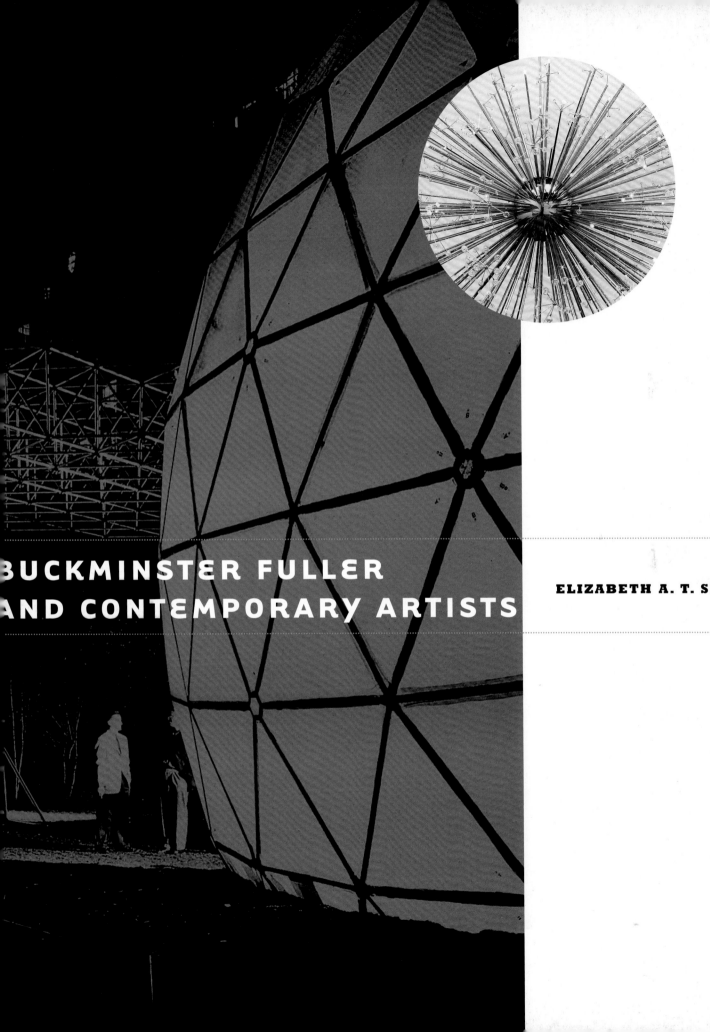

BUCKMINSTER FULLER
AND CONTEMPORARY ARTISTS

ELIZABETH A. T. SMITH

The wide range of ideas and achievements associated with Buckminster Fuller—utopian, visionary thinking about systems and their interconnectedness, the structural and aesthetic manifestations of integrity, the relationship between pragmatism and abstract concepts, and the potential of human beings as driving forces of change—resonates in current and recent contemporary art practice. Examples abound of artists who cite Fuller directly as a touchstone for their own thinking; for others, the relationship to his work and ideas resembles a set of shared intuitions or loose affinities. Still others find Fuller relevant as fodder for ideas about shifting interpretations of and uncharted terrains within modernism, including the idea of utopia and its failures. The range of responses to Fuller among today's artists parallels the expansive and sometimes contradictory way in which his example—not only his work and ideas, but also his persona—has been continuously reevaluated and reinterpreted, beginning in the 1950s and escalating, with ebbs and flows, into the present in ways that manifest "synergy" with the thinking and exigencies of each decade.

The position of Fuller, who called himself a "comprehensive anticipatory design scientist,"[1] as an avatar for today's artists might best be appreciated as stemming from a ceaseless kind of restlessness, where everything is constantly in a state of discovery or of "becoming"—always in flux, never static. Beyond the rationality and tectonics associated with many of Fuller's achievements, the role of intuition in his work and ideas, as well as the philosophical richness and sense of spirituality that increasingly manifested itself later in his career, have profound resonance today, increasingly setting him apart from his contemporaries and from other modernists. This sphere of influence, centering on the intuitive or psychic/spiritual, contrasts intriguingly with the way in which Fuller is often credited as a forerunner of digital culture—a system based on logic and rationality—as is compellingly analyzed elsewhere in this publication.

This essay will consider several examples of shared intuitions or affinities between Fuller and various artists active during the past decade. These artists are part of a generation whose work strongly reveals the legacy of conceptualism as well as the impact of minimalism, perceptual modes, feminism, and the performative practices that, though they have percolated within art since the 1960s, have widely proliferated only in the last decade. Extending the boundaries of traditional approaches to media and inviting new practices, disciplines, and models of meaning into the art world, conceptualism ushered in a reconsideration of art that transformed it "beyond recognition," in the words of noted art theorist Craig Owens.[2] With an amorphous yet pervasive legacy, Fuller demonstrates a clear kinship to artists concerned with cross-disciplinary investigation, particularly those navigating uncharted terrain in terms of using or rethinking systems as the basis for individual works or bodies of work. Often, like Fuller, these artists choose to work collaboratively with others to

gain the perspective of specialized applications of knowledge, yet their achievements are highly individualistic and, like Fuller's, sometimes difficult to categorize or to relate to those of their contemporaries.

Perhaps the best-known artist of his generation to acknowledge the inspiration of Fuller, not only in his methods of working but also in his ideas and approaches, is Olafur Eliasson. Profoundly interested in experience and interaction, the effects of time and space, the physical and visual properties of physics, and the relationships between the part or the fragment and the whole—all concepts that also stimulated Fuller—Eliasson also resembles Fuller in the way he communicates his ideas, involving extensive scientific reference and prolific textual elaboration.[3]

Many of Eliasson's works in a series of projects involving mathematical patterns and symmetries draw directly from Fuller's experiments with geometric form. His *Model Room* installation of 2003 presents an enclosed space filled with specially designed shelves and tables on which are positioned a profusion of small geometric objects resembling scientific models—geodesic domes, kaleidoscopes, and lattice-shaped constructions—signaling a restless and energetic mode of experimentation derived from the act of making as the basis of artistic discovery (fig. 1). *Model Room* was created in collaboration with Einar Thorsteinn, an architect who had extensive contact and involvement with Fuller and who has been a crucial transmitter of his

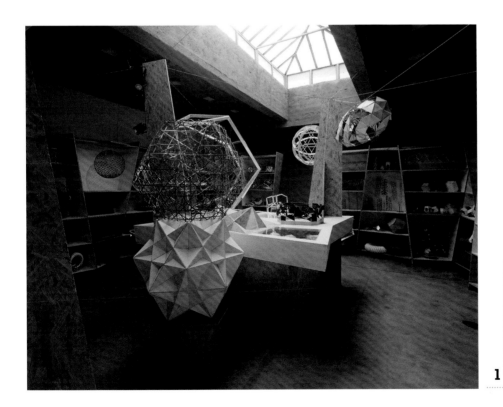

OLAFUR ELIASSON
(b. 1967)
Model Room, 2003
Chipboard display cabinets,
mixed media models, maquettes,
and prototypes
Dimensions variable
Courtesy the artist and Tanya Bonakdar
1 Gallery, New York

ideas about the aesthetics and utility of geometry and mathematical forms to Eliasson, with whom he has worked directly since 1996.[4] The same year, Eliasson realized the Blind Pavilion for the Venice Biennale—his most extensive application of ideas about geometry, non-Euclidian space, and perception to date (fig. 2). In this large-scale installation of various spatial and perceptual sequences achieved through the use of a kind of "energetic geometry," utilizing both interior and exterior spaces of the existing pavilion structure, the objects presented in *Model Room* seemed to have expanded to an architectural scale, offering a compellingly participatory experience for the viewer.

Describing his concept of the relationship between subjectivity, time, space, and responsibility as "the most attractive model for understanding and communicating the idea of temporality in relation to individual objects and the world at large," Eliasson has coined the term YES ("Your Engagement Sequence"):

> By including YES as a central element of perception, the governing dogma of timelessness and static objecthood may be renegotiated, thus making your responsibility for an active engagement in the concrete situation apparent. . . . In other words, engagement has consequences and these entail some feeling of responsibility. . . . "YES," or the fifth dimension, creates a perspective that is personal; it functions to individualize the other

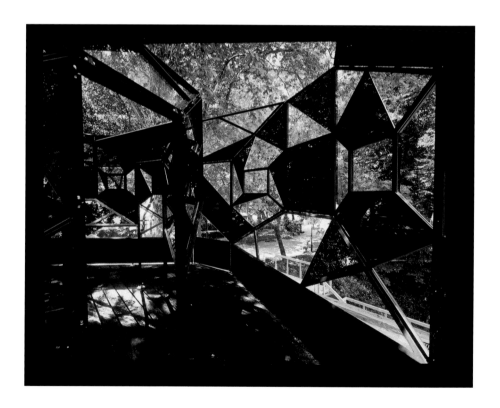

OLAFUR ELIASSON
Blind Pavilion, 2003
Steel construction, black and
transparent glass
8 ft. 2 1/2 in. x 24 ft. 7 1/4 in.
(2.5 x 7.5 m)
Installation: Danish Pavilion,
2003 Venice Biennale
Private collection

dimensions of space. I am interested in the potential inherent in giving the individual subject this dimensionality as a sort of tool that relativizes the other existent, presumed static dimensions upon which our conception of space is based.[5]

Commingling art, science, engineering, and architecture, Eliasson's approach to systemic components and emphasis on revealing rather than masking their mechanisms of display appears to link him as closely to Fuller as to such artists as Robert Irwin and James Turrell, with whom he is often connected in a shared interest in phenomenological and perceptual effects.[6] Furthermore, the ethical dimension of agency implied in Eliasson's statements about YES offers intriguing parallels with related concepts of Fuller's, as does his commitment, in various projects since the late 1990s, to utilizing or manipulating natural phenomena, not just to explore perception but also to reflect on man's place in the chain of life on Earth.

Eliasson has commented that he is drawn to utopian architects and thinkers such as Fuller because "they've got that ability to think about their own vision from the outside. . . . Artistic practice has rediscovered its ability to constantly redefine its own programme, and architectural discourse has opened up to other fields in the same way. This is why the fact of integrating architects—and engineers and experts as well—is crucial for me in opening up to other ways of working."[7]

The fluidity of intellectual parameters and disparate interests characteristic of Fuller is also apparent in other artists who have cited him directly as a source or a subject matter in their own work. In her installation *Fuller's Flow* (2003), artist Irit Batsry has reconsidered and taken as a source of inspiration Fuller's vision for the Biosphere, created as the U.S. Pavilion for Montreal Expo 67 (fig. 3). Her project, a video and mixed media installation situated within the Biosphere itself, references Fuller's creation of the dome and its aesthetic possibilities while advancing theories about perception. Batsry's project, commenting on the shifting nature of architectural innovation from the time of the Biosphere's creation in 1967, when it was considered a technological marvel, to its condition as an almost forgotten relic today, seeks to reinvigorate the meaning of technological interactivity. Paying homage to Fuller's precedent, she probes his ideas about space as stated in 1929: "A room should not be fixed, should not create a static mood, but should lend itself to change so that its occupants may play upon it as they would upon a piano,"[8] using myriad media including sound, moving imagery, and three-dimensional alterations to the space to offer a kinesthetic, sensorial reinterpretation.

Batsry's interest in Fuller is of long standing. She encountered Fuller's book *Utopia or Oblivion* in 1988 while researching her trilogy Passage to Utopia, finding in Fuller's writing "an essential connection between the personal and the collective" that she had missed in the writings of other utopian thinkers.[9] In 1991, her video *A*

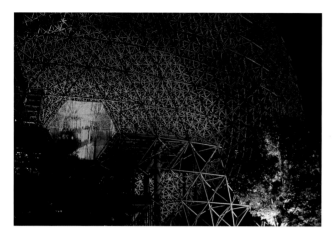

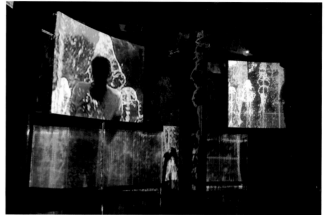

IRIT BATSRY (b. 1957)
The Biosphere (Buckminster Fuller's 67 Expo Geodesic Dome), Montreal, 2002; outdoor architectural projection (left) and indoor architectural video installation, 3 moving and 3 stationary projections in a circular space (right). Dimensions variable

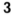
3

Simple Case of Vision and an installation titled *. . . of persistence of absence . . .* took as their subject matter a childhood vision disorder that caused Fuller to have almost constant blurred vision. In her work, Batsry sought to give form to the way defective vision alters perception; in Fuller's case, he credited this experience as having indelibly shaped how he gained information and learned to make sense of the world around him.

> I was born cross-eyed. . . . My vision was thereafter fully corrected with lenses. Until four I could see only large patterns, houses, trees, outlines of people with blurred coloring. While I saw two dark areas on human faces, I did not see a human eye or a teardrop or a human hair until I was four. Despite my new ability to apprehend details, my childhood's spontaneous dependence only upon big pattern clues has persisted.[10]

For Batsry, this physiological fact was of immense significance to Fuller's future contributions to the world of ideas and also offers a potent metaphor for the primacy of perception and intuition as a catalyst to invention in human experience. Seeking to use Fuller's actual text as material in combination with other sensorial effects, Batsry discusses her approach as follows:

> Part of my practice at that time was processing many images and texts without predetermining how and when they will be used. . . . In the beginning of one of these residencies I typed Fuller's text [cited above] into the character generator, played it back hundreds of times and transformed it in many different ways using colorizers, superimposing and mixing it with live camera images and the "wobullator" (a Nam June Paik device that allows for transforming the image through voltage control). I ended up using all five

days of the residency treating this one paragraph and ended up with a few hours of recorded material.[11]

Various artists have considered Fuller's complex role within and relationship to modernism from a more theoretical standpoint. Artist Josiah McElheny has undertaken one of the most sustained considerations of Fuller from this standpoint in a body of work and writings exemplified by a 2005 project titled *An End to Modernity* (fig. 4). This monumental sculpture, approximating both a chandelier and a model of the universe as explained by the Big Bang theory, presents a scientifically accurate rendition of the isotropic nature of the universe. Created in collaboration with an astronomer and incorporating references to 1960s-era scientific and culturally derived concepts and objects, the piece was accompanied by a documentary film also produced by the artist. The hundreds of component parts within the sculpture present a vast network that appears to coalesce into a unified whole, yet can never be fully comprehended or apprehended by the viewer.[12]

An End to Modernity culminates a series of objects and investigations McElheny has made over the past few years that reference Fuller directly: specifically a conversation between Fuller and sculptor Isamu Noguchi in 1929 that led to their proposal for creation of a "Total Reflective Abstraction"—a world of form without shadow, completely reflective form in a totally reflective environment.[13] Intrigued by Fuller and Noguchi's arrival at the idea of an aesthetic utopia of "endless everywhere," McElheny in his interpretation of it encompasses both a meditation on modernism and its failures and a fascination with "the intersection of specific concepts and abstract ones."[14] What emerges is a problematic, ambivalent relationship to the concept of "Total Reflective Abstraction" in McElheny's work. While it has served as a powerful stimulus for McElheny in various of his own sculptural objects and environments, as, for example, in *Buckminster Fuller's Proposal to Isamu Noguchi for the New Abstraction of Total Reflection* (2003), his approach to this concept is both an embrace and a critique. In *An End to Modernity*, McElheny signals the impossibility of rendering the totality of the universe as imagined by modernism, calling into question the idea of any kind of totalizing vision as imagined by Fuller or other modernists, yet creating an object so encompassing and seductive that it renders concrete the power of that vision.

McElheny states that he is intrigued by the exploration of concepts that "didn't fit within the context of the moment they were invented, or have always been there but are constantly being returned to because they are needed in a different way."[15] A related strand of thinking about Fuller and modernism has been articulated by writer Francesco Manacorda, who acknowledges Fuller's centrality to a revisionist modernism that has exerted a profound influence on a generation of young artists drawn to the more obscure, lateral impulses within modernism. These were fueled

66
67

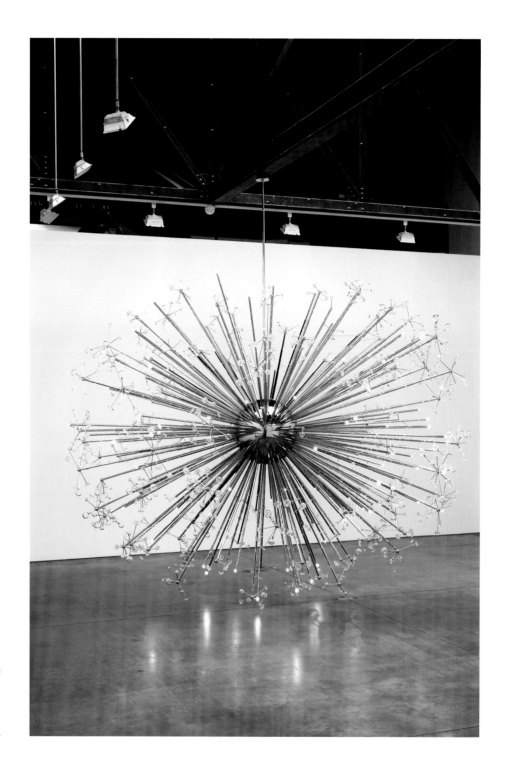

JOSIAH MCELHENY (b. 1966)
An End to Modernity, 2005
Chrome-plated aluminum, electric
lighting, hand-blown glass, steel cable
and rigging
Diameter 16 ft. (4.8 m)
Courtesy Andrea Rosen Gallery,
New York

4

by intuition and organic rather than rational models, constituting what he describes as "a gothic side of the modern movement."[16] For Manacorda, Fuller stands among the "heretical" figures of modernism, whose fantastic visions such as the Cloud Nine project reveal a hallucinatory blurring of reality and fiction, as distinct from the ideal of harnessing or marshaling Earth's systems toward a common good.[17]

In a different way, artist Pedro Reyes reveals an equally strong ongoing fascination with modernism—primarily with the notion of resuscitating ideas that have fallen into disuse or disfavor but demonstrate new potential. Contrasting with artists who see evidence in Fuller's utopianism of the failure of modernism, Reyes's position is more generous. He comments, "The 'modern' does not have a fixed value; it becomes more or less interesting to us. . . . For me, modernism is a toolbox, but it is primarily part of an historical compost."[18] Paralleling Fuller in the voracious mix of ideas and disciplines from which he draws inspiration, Reyes's work interweaves the social, scientific, mathematical, philosophical, and aesthetic—consistently going beyond issues of form or making them integral to symbolic and philosophical concerns.

Described by writer Tatiana Cuevas as "an idealist: he lives and works thinking of ways to improve the world," Reyes embraces Fuller as a precursor and potent source of inspiration for many of his projects, including Parque Vertical (2000), Floating Pyramid (2004), Dream Digester (2005), and Velotaxi (2008).[19] His interest in taking structures or ideas associated with modernism and rehabilitating them in some way, toward often surprising ends, corresponds to Fuller's regenerative thinking. For instance, in Parque Vertical (2000), Reyes re-visioned a 1962 example of modernist architecture by Mario Pani as a vertical park/urban form by means of a relatively

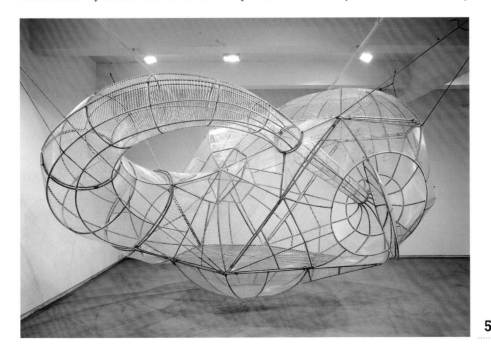

PEDRO REYES (b. 1972)
Capula Klein's Bottle, 2007
Stainless steel frame woven on vinyl
6 ft. 6³/₄ in. x 6 ft. 6³/₄ in. x 11 ft. 5³/₄ in.
(2 x 2 x 3.5 m)
5 Courtesy the artist

modest alteration of the infrastructure; naming this unrealized project the "World Environmental Center" has generated attention to and interest in its possibilities as a model of sustainability and ecological aspirations.

The suspended sculptures in Reyes's Capulas series, ongoing since 2001, approximate Fuller's work in the way they resemble scientific models based on mathematics and geometry—interactive spaces with an exploratory, experimental character rather than static objects (fig. 5). Expressing his shared interest in the physical and conceptual properties of the microscopic sea creatures called radiolaria with Fuller, Reyes's Capulas also function much like many of Eliasson's projects in that they are defined by sensate experience and physical/perceptual engagement. The wordplay of their name—from *cupola, capillary, capsule*—resonates with Fuller's term *Dymaxion* (from *dynamic, maximum, ion*) and his coinage of other neologisms to emphasize distinctive experiences, concepts, or forms.

Fuller's visionary experiments with methods of dematerializing structure to make it more efficient and lightweight have fueled Reyes's ideas for various specific projects. His design for the Velotaxi, a human-powered passenger vehicle planned to debut in 2008, is indebted to the example of Fuller's Dymaxion car as well as the performative, anti-institutional character of Chris Burden's 1976 B-car (fig. 6). Applying his artistic/engineering acumen to the problem of creating an alternative to the ubiquitous automobile, Reyes turned the spaces of the Museum of Mexico City into a factory for eight months—an assembly line for the production of prototype vehicles, to be immediately put into circulation in Mexico City's downtown upon completion. The artist comments:

> Instead of bringing an exhibition into the museum, the museum produces these objects, and the exhibition will take place outside. The project has several goals. One is to replace cars with nonemission vehicles; another is to enable a migration of the unemployed from informal to more formal economies. . . . Henry Ford and Frederick Taylor created the foundations of the economy that we live in. I wanted to do something more than criticize how they opened the path for sweatshops, planned obsolescence, consumerism, and drive-thru societies. I thought, if these mechanisms, which approved to be so effective, have led us to ravish the planet, it is because techne has prevailed over ethos. It's very easy to be enticed by technology and to be indifferent to its moral consequences. But it is useless to resist these driving forces. What we have to do is create new driving forces in the opposite direction, toward healing, not destruction.[20]

While Reyes's work clearly manifests a sensibility of relational aesthetics with its emphatic commitment to creating new models of social interaction through art, he

acknowledges and embraces Fuller as a catalytic example for achieving a similar goal. He points to concepts he feels are most relevant and inspirational from Fuller, including: "Guinea Pig B. How an unemployed middle-aged person, married with kids, can turn his life into an experiment to test the maximum good he can do for the planet. . . . Dome for Kabul 1956. Turn a B-52 into a carrier for a dome. Same as placing a flower in the barrel of a gun. Self assembly in 24 hours without special training. . . . No more secondhand god. Talk with the sources of knowledge, not the intermediaries."[21]

The work of artist Andrea Zittel also invites comparison to that of Fuller, in his self-appointment as "Guinea Pig B" and commitment to using himself and his life as raw material for explorations about improving the quality of everyday living. Drawing upon ideas that are both scientific and intuitive, and focusing attention on details of how to achieve more efficient, compact design, Zittel has sought primarily to redefine the role of the artist in relationship to the larger culture.

In the early 1990s, Zittel began to design objects resembling furniture, with the goal of creating one piece that could satisfy all human needs. Reminiscent of Fuller's Standard of Living Package (1948–49), Zittel's Living Units were tested by the artist herself for a period of one year each. The Living Units exemplify Zittel's Fulleresque focus on systems of maximum efficiency and how they can be customized for the individual; she also "uses her body to test the authenticity of her art to the world" in a way that stems from earlier precedents in performative and feminist art.[22]

In the 1999 project A-Z Time Trials, Zittel probed the emotional and physiological effects of the absence of conventional measures of time by casting herself as "guinea pig Z" in a quasi-scientific experiment in which she analyzed her own responses to this absence, seeking to better understand human needs and agency (fig. 7). Various additional projects of Zittel's resonate intriguingly with Fuller—for instance, the documentary impulse of her *A-Z Personal Profiles Newsletter* with his ongoing Chronofile of his life in relationship to society—yet references to Fuller in Zittel's highly original and idiosyncratic body of work blend with psychology, social commentary, and humor as well as a distinct emphasis on the quotidian rather than the utopian. Asserting that she has always been interested in "the hybrid position he created for his practice," Zittel comments on the specific appeal of Fuller's designs for the Dymaxion bathroom and the Wichita House, a built version of the Dymaxion Dwelling Machine that was inhabited by a family for years before falling into disuse, as having triggered her thinking about authorship and authenticity as a young artist.[23] Aspects of her current and recent work, however, including projects developed as part of "A-Z Advanced Technologies," reveal the continuing legacy of Fuller's restless experimentation with materials and their applications to improving daily living.

Similarly involved with creating objects and designs that are both utilitarian in purpose and infused with social critique is the Danish collective N55. Since 1993 this group has been at work on a series of projects ranging from hygiene systems to space-

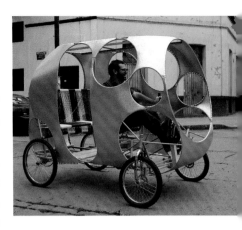

PEDRO REYES
Velotaxi, 2007
Aluminum, vinyl, and mechanical parts
51 1/4 x 78 3/4 x 63 in. (1.3 x 2 x 1.6 m)
6 Courtesy the artist

ANDREA ZITTEL (b. 1965)
*Free Running Rhythms and Patterns:
Version II*, 2000
¼ in. walnut veneer panels, latex and
oil-based paint, vinyl lettering, black-
and-white photos
27 panels, each 79 x 31 ⅝ x 2 in.
(200.7 x 80.3 x 5.1 cm)
Courtesy Andrea Rosen Gallery, New York

7

frames to fish farms—all stemming from the concept of providing socially useful artifacts that will in some way improve human life and circumstances. Disseminated in the form of "manuals" published on their Web site, with clear descriptions of their purpose, physical components, and construction techniques—and thereby demo-cratically available to all—N55's designs range from modest objects conceived for individual usage to more ambitious concepts on a larger, civic scale.[24] These works can be seen as gestures encompassing social and political commentary about issues ranging from ecological degradation to immigration to community-building and deployment of leisure time, yet in their dedication to inhabitable structures and sys-tems, they are indebted to Fuller's visionary mass-produced, easily deployed systems of housing and transportation—his array of "designs for mobility."

In 1976, author Stephen Mark Dobbs prognosticated a Fuller-inflected future for art:

> The Buckminster Fuller Future. Politics will be obsolete, and the rational use of Earth's resources will liberate most people to pursue self-development and avocational interests. The arts and humanities will prosper. Artists will be admired as models of efficient use of resources and energy, achieving maximum impact in a given form. But some artists, taking advantage of the liberal climate, will reject sophisticated technologies at their disposal and will take sheets of paper, brushes, and paint and inscribe images as they used to do in the twentieth century. For a time there will be a trend toward pre-scientific attitudes, exalting the mystical and emotional against the rational and scientific, but that wave of nostalgia will spend itself on a brief

flurry of enthusiasm for four-color psychedelic posters and videotapes of "Let's Make a Deal."[25]

More than thirty years later, it is evident that this scenario—one of several posited by the writer as a future vision for art and its societal impact—has not played out entirely as imagined, yet Fuller's impact on the future of creative practice has perhaps been more wide-ranging than previously thought. Fuller's continuing influence on architecture, digital culture, environmental awareness and urges toward sustainability, and overall global vision has been substantial, while his currency with artists has been simultaneously pervasive and diffuse, palpable yet difficult to pinpoint or define with certainty. Yet numerous artists have pointed to the persistence of Fuller's legacy or revealed affinities with his thinking, from Robert Smithson's engagement with Fuller's ideas in the mid-1960s to those discussed in this essay whose work approximates Fuller's "comprehensivist" position, confounding conventional definitions of categorization. Artist Mel Chin, known for a significant body of environmentally committed, often socially and politically activist work since the early 1990s, has noted, "I'm not so interested in working with scientists, but the world of ideas is full of scientific relationships."[26] In this respect he articulates the thinking of many artists, architects, designers, and others in creative fields whose interests have taken them beyond the narrow categories of disciplinary boundaries and closer to a sphere of activity characterized more by its approach to problem-solving, whether for pragmatic or symbolic ends. Fuller can be appreciated as a spiritual godfather to this strain of thinking and action.

Alternatively, an artist such as Sarah Sze, who has always developed her sculpture and installation work without the intervention or collaboration of others, points to Fuller's contribution in the creation of scientific models that reveal both structure and relationships between physical objects (fig. 8). "It's the investigation of structures that can perform all of these functions: act as models for something to be realized full scale, represent laws and behavior, and question the practical application of objects and structures in the real world, that I find intriguing," she comments.[27] The idea of revealing the way something works as a stimulus for form resonates within Sze's work; a sense of flux, disequilibrium, dynamism, and the interconnectedness of microcosmic to macrocosmic components are defining features of her sculpture. The connections between her work and Fuller's are perhaps more tenuous than those between Fuller and any of the artists I have discussed above. Nevertheless, in its constellation of always interdependent parts that suggest a magnitude of organic, technological, scientific, and philosophical relationships, Sze's work most satisfactorily embodies the spirit of Fuller's commitment to explorations of omnidirectional processes of growth and change, and most eloquently references the terrain of comprehensivism he advocated.

8

In her characterization of Fuller as an "illusive mutant artist, impossible to categorize," writer Victoria Vesna states that he "foreshadows the complex persona of a contemporary media artist."[28] She offers a compelling analysis of his significance for this emerging strain of practice, noting that "very early on he recognized the computer as a human extension, never losing the organic quality in his interpretation of the human/machine relationship." Going on to describe him as a "performance artist who constructed practical prototypes of some of his visions," she points to the persistence of an "invisible aesthetic of integrity" underlying and unifying all of his work.[29] The notion of the invisible quality of integrity as an aesthetic and ethic, articulated directly by Fuller in 1973 and quoted elsewhere in this publication, stands as a compelling, comprehensive vision that permeates his work's significance for a younger generation of artists.

Notes

1. Michael John Gorman, *Buckminster Fuller: Designing for Mobility* (Milan: Skira, 2005), 16.

2. Craig Owens, "Detachment: From the Parergon," in *Beyond Recognition: Representation, Power, and Culture*, ed. Scott Bryson, Barbara Kruger, Lynne Tillman, and Jane Weinstock (Berkeley and Los Angeles: University of California Press, 1992), 38.

3. In a 2006 essay titled "Vibrations," Eliasson begins with a quote from Fuller about the properties of physics that underpins his own ideas about time, energy, subjectivity, criticality, and other alternatives to modernist concepts of space. Olafur Eliasson, "Vibrations," in *Your Engagement Has Consequences: On the Relativity of Your Reality* (St. Louis: St. Louis Art Museum, 2006), 59.

4. Thorsteinn, founder of the Reykjavik-based

research institute "Constructions Lab" in 1973, had a close personal and professional relationship with Fuller. His contributions are referenced extensively in the literature on Eliasson. For his role in Eliasson's *Model Room*, see Karen Rosenberg, "Room with a View: Eliasson's Elegant Universe," *Village Voice*, May 2003, http://www.villagevoice.com/art/0320,Rosenberg,43999,13.html (accessed June 27, 2007). See also Madeleine Grynsztejn, "(Y)our Entanglements: Olafur Eliasson, the Museum, and Consumer Culture," in *Take Your Time: Olafur Eliasson*, ed. Madeleine Grynsztejn (San Francisco: Museum of Modern Art, 2007), 25–26 and 31 n. 48.

5. Eliasson, "Vibrations," 62–63.

6. An extensive analysis of Eliasson's relationship to the so-called Light and Space artists is found in Pamela M. Lee, "Your Light and Space," in Grynsztejn, *Take Your Time*. See also Susan May, "Meteorologica," in *Olafur Eliasson: The Weather Project* (London: Tate Modern, 2004), http://weboelisson.dyndns.info:8080/PDF/Meteorologica.pdf (accessed June 27, 2007).

7. "Conversation between Olafur Eliasson and Hans Ulrich Obrist," http://weboeliasson.dyndns.info:8080/PDF/Conversation_HUO_OE.pdf (accessed August 20, 2007). Collaboration with others from related fields and in various roles has become a primary working method for Eliasson, who maintains a studio of approximately thirty individuals ranging from mathematicians to carpenters, as well as the aforementioned Einar Thorsteinn.

8. Buckminster Fuller, Dymaxion Chronofile, vol. 36, 1929, M1090, ser. 2, box 21, R. Buckminster Fuller Papers, Department of Special Collections, Stanford University Libraries.

9. E-mail from Irit Batsry to the author, October 24, 2007.

10. Buckminster Fuller, from *Utopia or Oblivion: The Prospects for Humanity* (New York: Bantam, 1969), quoted in an e-mail from Batsry to the author, October 24, 2007.

11. Ibid.

12. See "Josiah McElheny," in *Part Object Part Sculpture*, ed. Helen Molesworth (Columbus: Wexner Center for the Arts, Ohio State University, 2005–6), 253.

13. Barbara Pollack, "Beyond the Looking Glass," *Art News* 102, no. 11 (December 2003): 109. See also Dana Miller's essay in this volume, "Thought Patterns: Buckminster Fuller the Scientist-Artist,"

for the "entirely reflective silver studio" Fuller conceived for Noguchi.

14. "Josiah McElheny Talks about *An End to Modernity* and *Conceptual Drawings for a Chandelier, 1965*, both 2005," *Artforum* 44, no. 3 (November 2005): 237.

15. Art: 21 film on Josiah McElheny, PBS, http://www.pbs.org/art21/artists/mcelheny/clip2.html (accessed September 14, 2007).

16. Francesco Manacorda, "The Dark Side of Modernism: Architecture, Science Fiction, and the Organic," *Flash Art* 37 (March–April 2004): 91.

17. Manacorda points to artists Tobias Putrih, Ian Kiaer, Jeff Ono, and Bjorn Dahlem as responsive to figures such as Fuller and Frederick Kiesler as stimuli for work that seeks to find "a path from the artificial to the primordial" using science fiction, architectural references, and scale models as tools to investigate modernism's hidden gothicisms. Ibid., 91–92. Another artist of the same generation engaged with the idea of failure within modernism, specifically Fuller and utopianism, is Christine Tarkowski, whose project Searching for the Failed Utopia takes the form of a series of recent sculptures and installations.

18. Tatiana Cuevas, "Pedro Reyes," *Bomb*, no. 94 (Winter 2005/2006): 21.

19. Ibid.

20. E-mail from Pedro Reyes to the author, October 17, 2007. See also Anuj Desai, "Building a Better Pedicab," *ArtNews* 106, no. 8 (September 2007): 141–42.

21. E-mail from Pedro Reyes to the author, September 24, 2007.

22. Lynn Zelevansky, *Sense and Sensibility: Women Artists and Minimalism in the Nineties* (New York: Museum of Modern Art, 1994), 32–33.

23. E-mail from Andrea Zittel to the author, October 27, 2007.

24. See Web site www.n55.dk.

25. Stephen Mark Dobbs, "From Buck Rogers to Buckminster Fuller: On the Future of Art," *Art Education* 29, no. 3 (March 1976): 11.

26. "A Composite Interview with Mel Chin," in *Inescapable Histories: Mel Chin* (Kansas City, Mo.: ExhibitsUSA, Mid-America Arts Alliance, 1996), 36.

27. E-mail from Sarah Sze to the author, September 14, 2007.

28. Victoria Vesna, "Bucky Beat," *Artbyte* 1, no. 3 (August–September 1998): 25.

29. Ibid., 28.

PLATES

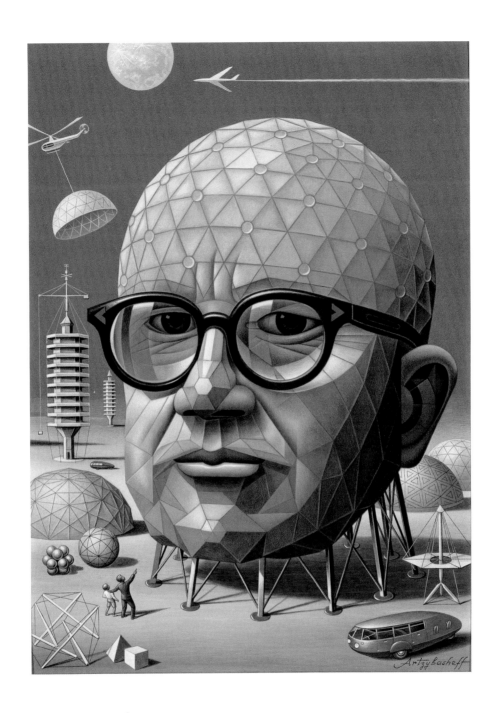

BORIS ARTZYBASHEFF (1899–1965)
R. Buckminster Fuller, 1963
Tempera on board
21 1/2 x 17 in. (54.6 x 43.2 cm)

pl. 1

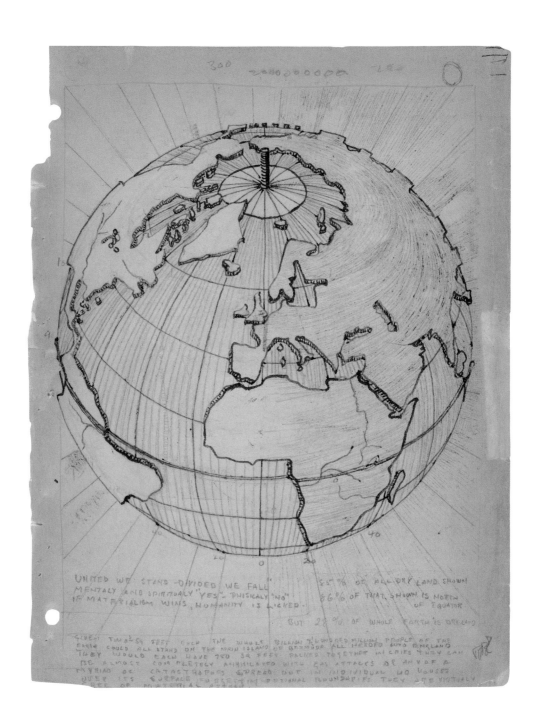

One Ocean World Town, ca. 1927
Ink and graphite on paper
10 7/8 x 8 7/16 in. (27.6 x 21.4 cm)

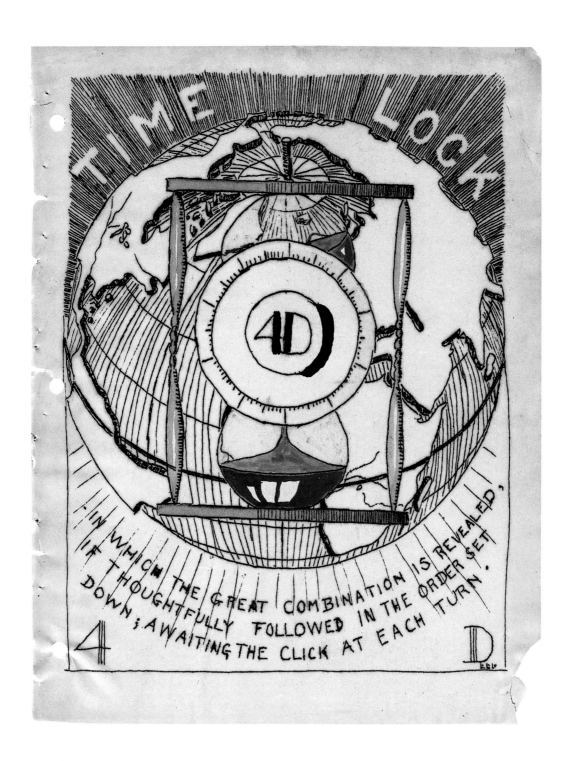

Cover design for *4D Time Lock*, 1928
Ink and gouache on paper mounted
on paper
pl.3 11 1/16 x 8 9/16 in. (28.1 x 21.8 cm)

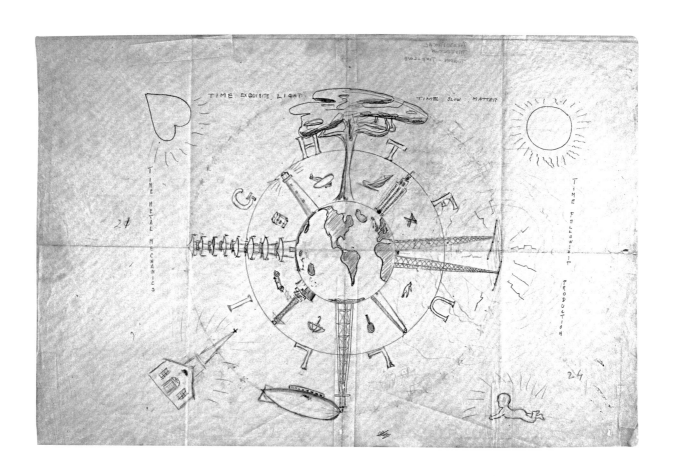

Sketch of Lightful Houses "Time
Exquisite Light," ca. 1928
Graphite on tracing paper
pl.4 18 7/8 x 29 7/8 in. (47.9 x 75.9 cm)

4D Lightful Towers and 4D Transport,
ca. 1928
Graphite and ink on paper
pl. 5 11 x 8 1/2 in. (27.9 x 21.6 cm)

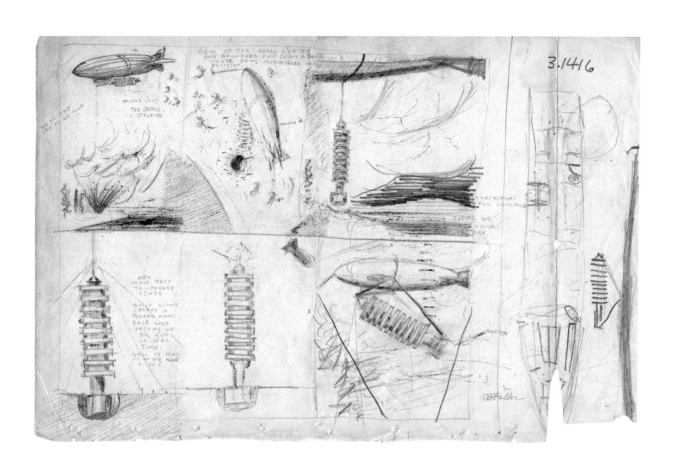

Sketch of Zeppelins dropping bombs and delivering
4D Towers to be planted in craters, ca. 1928
Graphite and ink on paper
8 1/2 x 13 in. (21.6 x 33 cm) (irregular)

pl. 6

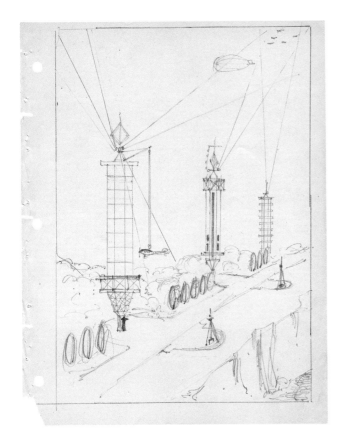

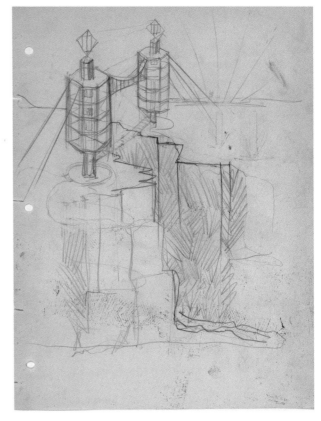

Sketch of 4D Towers, ca. 1928
Graphite on paper
pl. **7** 11 x 8 ½ in. (27.9 x 21.6 cm)

pl. **8** 4D Tower Suspension Bridge, ca. 1928
Graphite on paper
11 x 8 ½ in. (27.9 x 21.6 cm)

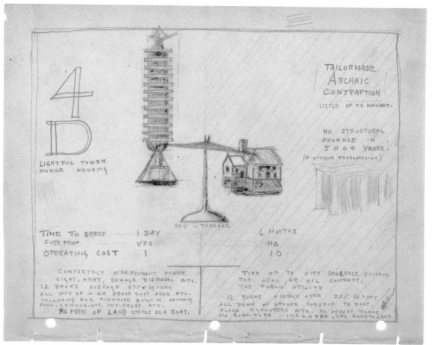

Comparison of Lightful Tower and
Traditional Home, 1927
Ink on paper "mimeo-sketch"
pl. 9 8 x 10 5/8 in. (20.3 x 27 cm)

4D Lightful Tower, Mobile Housing,
ca. 1928
Graphite and ink on paper
pl. 10 8 1/2 x 10 7/8 in. (21.6 x 27.6 cm)

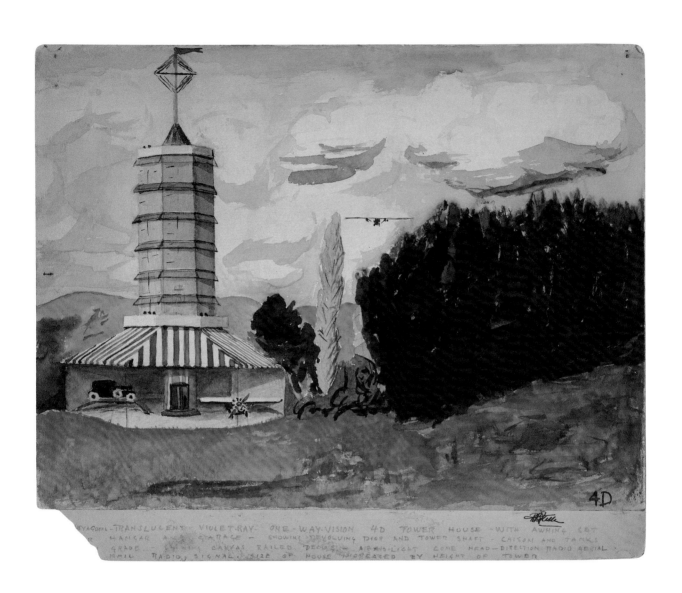

ANNE HEWLETT FULLER

(1896–1983)

4D Tower: perspective, ca. 1928

Gouache on paper mounted on board

pl. 11 10 x 12 in. (25.4 x 30.5 cm)

12

1 SKY PROMENADE
2 POWER
3 SALON AND GRILL
4 PRIVATE
5 "
6 "
7 "
8 SERVANTS + NURSERY
9 LIBRARY
10 GYMNASIUM
11 SWIMMING POOL

14

4D

TYPICAL 4D EXTERIOR
SOLUTION SKETCH.
AS ABOARD SHIP THE
CIRCULATION QUESTIONS
ARE SO SIMPLE
TO PROVIDE ENTRANCE
DETAIL CONSTRUCTION
SOCIAL AND OTHER
DEFECTS IN NO WISE
INDICATED HERE.

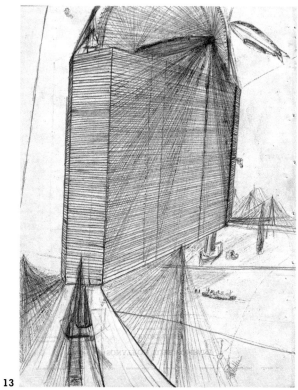

13

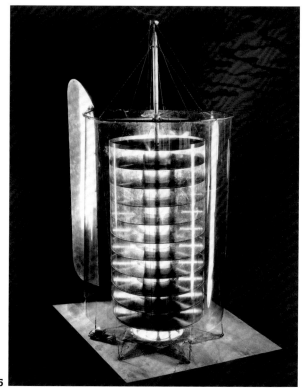

15

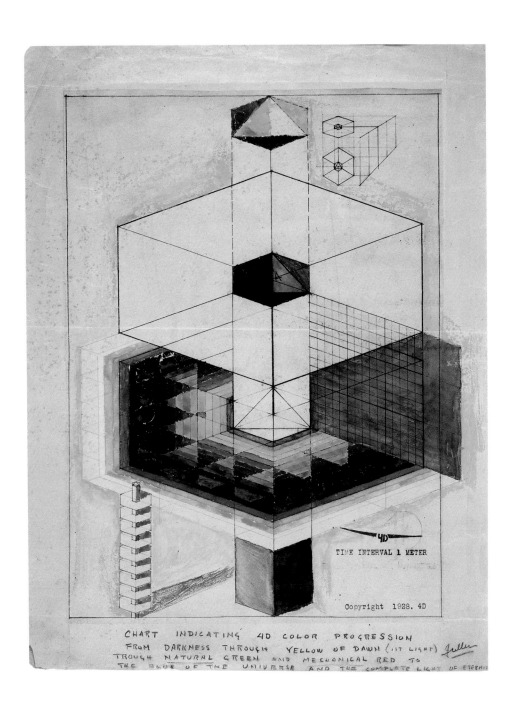

CHART INDICATING 4D COLOR PROGRESSION
FROM DARKNESS THROUGH YELLOW OF DAWN (1ST LIGHT) *Fuller*
TROUGH NATURAL GREEN AND MECHANICAL RED TO
THE FLOOR OF THE UNIVERSE AND THE COMPLETE LIGHT OF ETERNITY

TIME INTERVAL **1** METER

Copyright 1928. 4D

Opposite:

10 Deck 4D Tower, 1928
Graphite on paper
pl. 12 10 7/8 x 8 1/2 in. (27.6 x 21.6 cm)

pl. 13 Attempt to synthesize the Brooklyn
Bridge and the Ferris Wheel, ca. 1928
Ink and graphite on paper
11 x 8 1/2 in. (27.9 x 21.6 cm)

Typical 4D Interior Solution Sketch,
ca. 1928
Graphite and ink on paper
pl. 14 10 7/8 x 8 1/2 in. (27.6 x 21.6 cm)

pl. 15 Model of Dymaxion Shelter with
Streamlining Shield, ca. 1932

4D Tower: Time Interval 1 Meter, 1928
Gouache and graphite over positive
Photostat on paper
pl. 16 14 x 10 7/8 in. (35.6 x 27.6 cm)

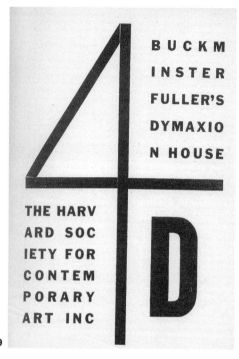

17

18

19

20

Buckminster Fuller's Dymaxion House
The Harvard Society for Contemporary Art,
Inc., exhibition brochure cover, 1930
Ink on paper
pl. 19 11 x 8 in. (27.9 x 20.3 cm) (folded folio)

4D logo stencil, ca. 1928
Graphite on excised paper with gold
overpaint mounted on paper
pl. 17 11 x 8 ½ in. (27.9 x 21.6 cm)

pl. 18 Study for 4D logo, ca. 1928
Watercolor, ink, and graphite on paper
8 ½ x 11 in. (21.6 x 27.9 cm)

pl. 20 4D logo, combining compass needle, teardrop,
and crescent moon, 1928
Ink, graphite, and white highlights on paper
11 x 8 ⅜ in. (27.9 x 21.3 cm)

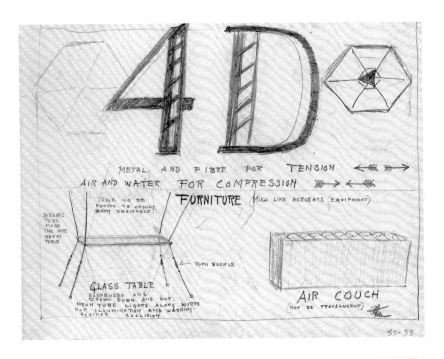

Sketches of 4D furniture, ca. 1928
Graphite on paper
pl.21 8 5/16 x 10 15/16 in. (21.1 x 27.8 cm)

Proposed Design for Interior of
Romany Marie Tavern, ca. 1929
Graphite on paper
pl.22 8 1/2 x 10 7/8 in. (21.6 x 27.6 cm)

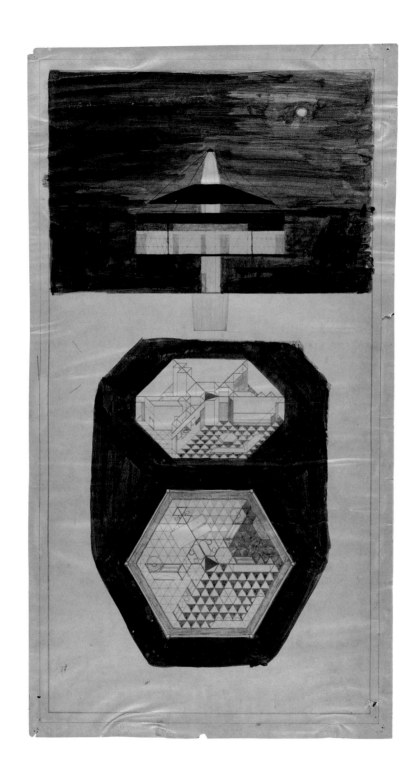

A Dymaxion Home, Project
Elevation, axonometric, and plan,
ca. 1930
Graphite and watercolor on Photostat
pl. 23 22 1/2 x 12 1/4 in. (57.2 x 31.1 cm)

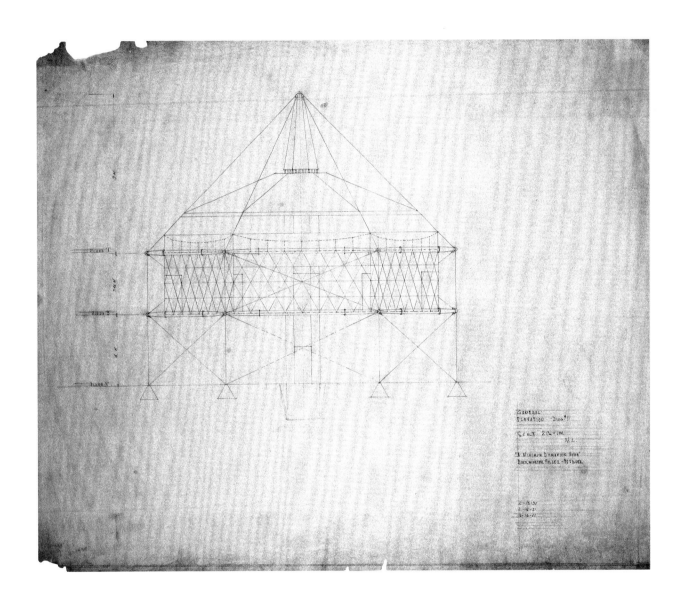

pl.**24** A Minimum Dymaxion Home, 1931
Graphite on tracing paper
24 1/8 x 28 5/16 in. (61.3 x 72 cm)

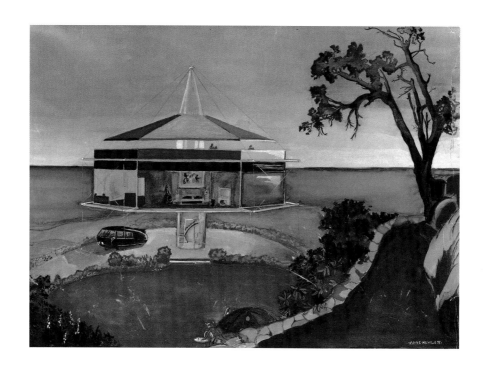

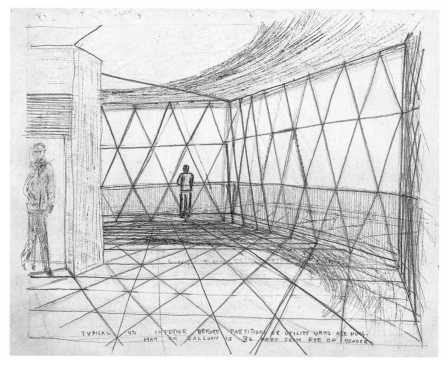

ANNE HEWLETT FULLER

Dymaxion House with Dymaxion Car, ca. 1934
Watercolor, ink, and graphite on
illustration board
pl.25 13 1/8 x 17 1/8 in. (33.3 x 43.5 cm)

Typical 4D Interior Before Partitioning
or Utility Units are Hung, ca. 1928
Graphite and ink on paper
pl.26 8 1/2 x 10 7/8 in. (21.6 x 27.6 cm)

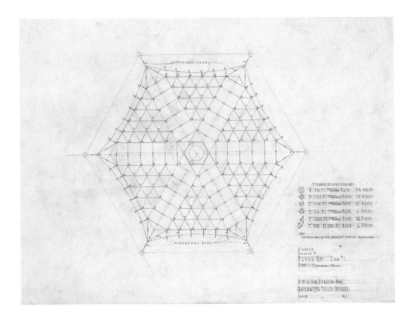

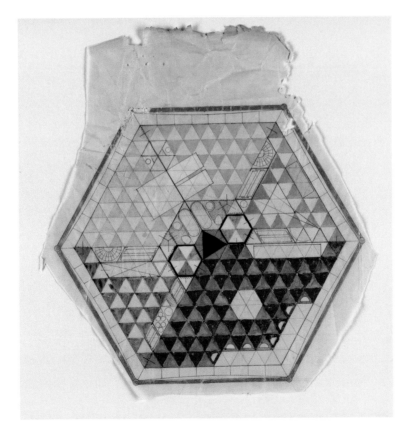

A Minimum Dymaxion Home, Floor Net
DWG #1, 1931
Graphite on tracing paper
pl.27 19 ³/₁₆ x 24 ¹³/₁₆ in. (48.7 x 63 cm)

Dymaxion House, Project Plan, ca. 1927
Graphite, watercolor, and metallic ink on
tracing paper
pl.28 10 ³/₄ x 10 in. (27.3 x 25.4 cm) (irregular)

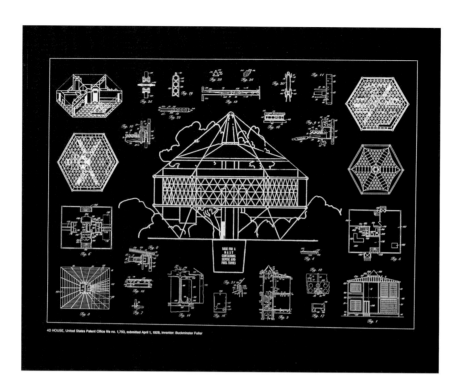

4D House. United States Patent Office file
no. 1,793, submitted April 1, 1928, inventor:
Buckminster Fuller
From the portfolio *Inventions: Twelve Around One*, 1981
Screenprint in white ink on clear polyester film
overlaid on a Curtis plain blue backing sheet
pl.29 30 x 40 in. (76.2 x 101.6 cm)

4D House. United States Patent Office file
no. 1,793, submitted April 1, 1928, inventor:
Buckminster Fuller
From the portfolio *Inventions: Twelve Around One*, 1981
Screenprint on Lenox paper
pl.30 30 x 40 in. (76.2 x 101.6 cm)

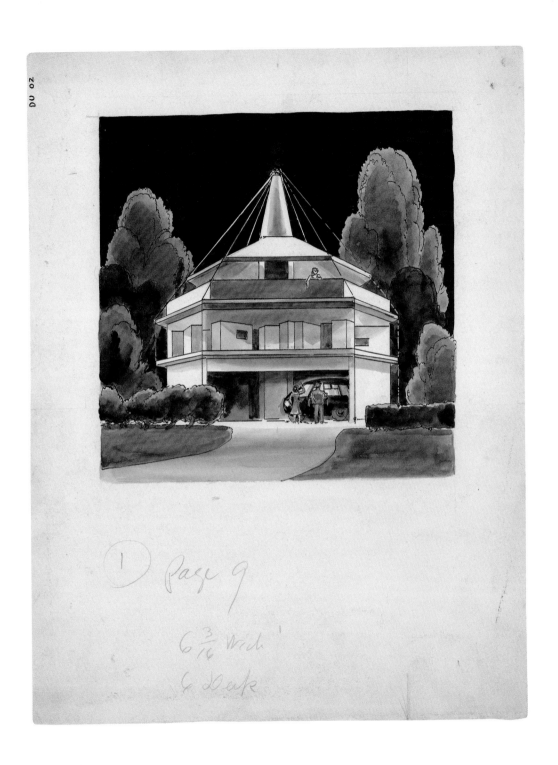

Unknown artist, likely
ANNE HEWLETT FULLER
Dymaxion House, ca. 1929
Ink and wash on paper
pl.31 11 9/16 x 8 11/16 in. (29.4 x 22.1 cm)

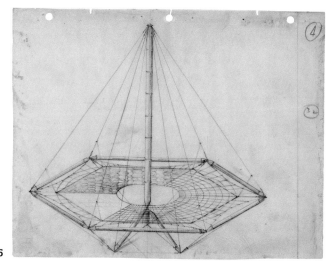

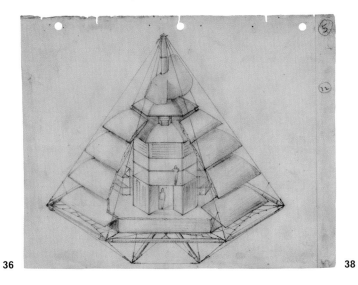

36

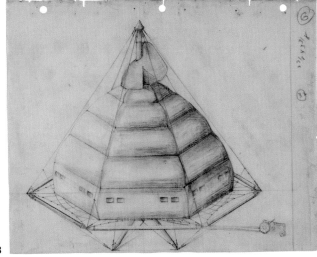

38

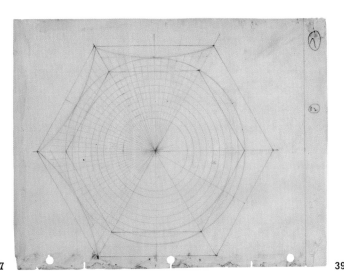

37

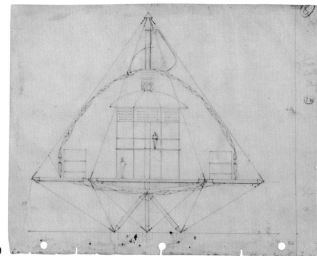

39

pl.**36** Structural Studies Associates sketch
for Dymaxion 20-Worker-Shelter for
Russian Cooperative Mobile Farming,
ca. 1932
Graphite on tracing paper mounted
on paper
8 9/16 x 10 7/8 in. (21.8 x 27.6 cm)

pl.**37** Structural Studies Associates sketch
for Dymaxion 20-Worker-Shelter for
Russian Cooperative Mobile Farming,
ca. 1932
Graphite on tracing paper mounted
on paper
8 7/16 x 11 in. (21.4 x 27.9 cm)

pl.**38** Structural Studies Associates sketch
for Dymaxion 20-Worker-Shelter for
Russian Cooperative Mobile Farming,
ca. 1932
Graphite on tracing paper mounted
on paper
8 9/16 x 10 7/8 in. (21.8 x 27.6 cm)

pl.**39** Structural Studies Associates sketch
for Dymaxion 20-Worker-Shelter for
Russian Cooperative Mobile Farming,
ca. 1932
Graphite on tracing paper mounted
on paper
8 1/2 x 10 7/8 in. (21.6 x 27.6 cm)

Shelter 2, no. 5 (1932)
Cover features a reproduction of
Isamu Noguchi's hanging sculpture
pl.**40** *Miss Expanding Universe*, 1931

ISAMU NOGUCHI (1904–1988)
R. Buckminster Fuller, 1929
Chrome-plated bronze
pl.**41** 13 x 8 x 10 in. (33 x 20.3 x 25.4 cm)

Plan of "A Collector's Room," 1931
Graphite on tracing paper
14 3/8 x 11 5/8 in.
pl.42 (36.5 x 29.5 cm) (irregular)

Isometric Drawing for "A Collector's
Room," 1931
Graphite on tracing paper
pl.43 15 x 14 1/4 in. (38.1 x 36.2 cm)

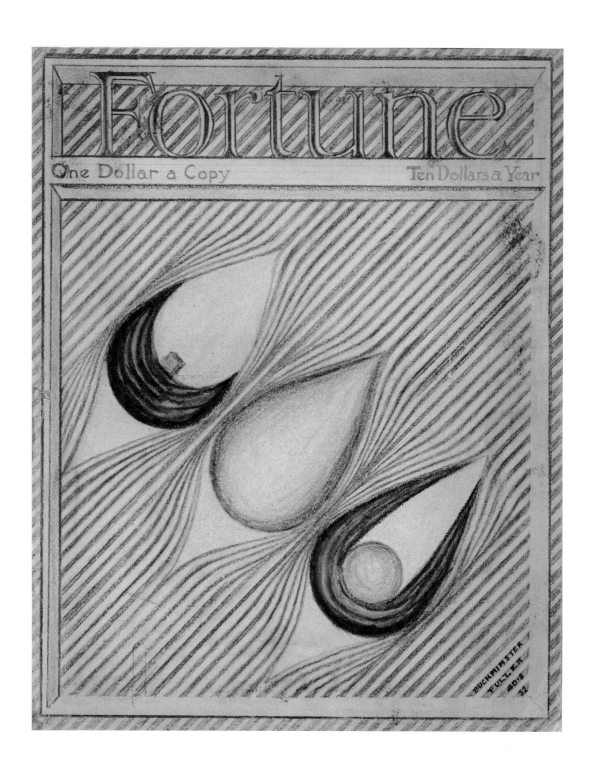

Mock-up of *Fortune* cover demonstrating
three typical streamline equivalents, 1932
Colored pencil and graphite on paper
mounted on magazine page
pl. 44 14 x 11 ¼ in. (35.6 x 28.6 cm)

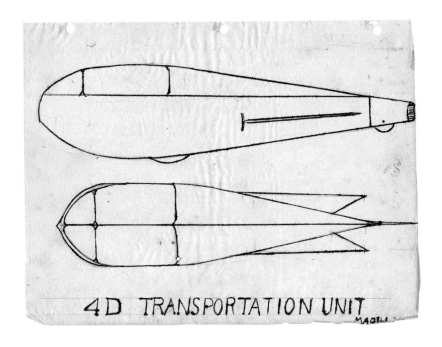

Sketch for 4D Transportation Unit,
ca. 1928
Graphite and ink on tracing paper
pl.45 8½ x 11 in. (21.6 x 27.9 cm)

ISAMU NOGUCHI
in collaboration with
BUCKMINSTER FULLER
pl.46 Gypsum models of 4D Transport, ca. 1932

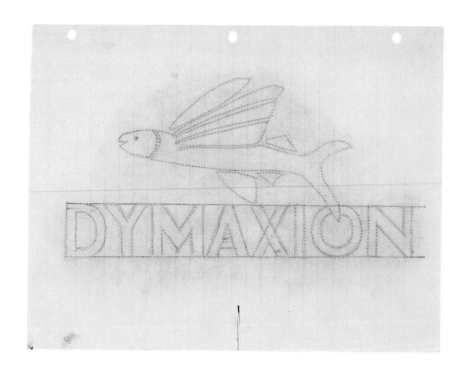

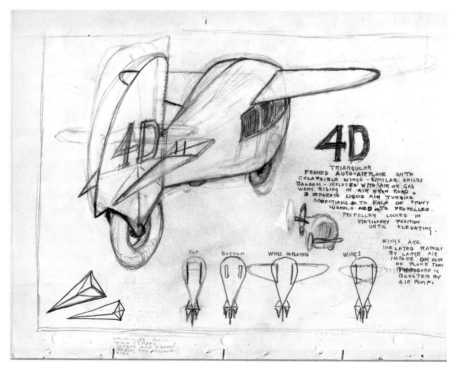

Study for Dymaxion Trademark,
ca. 1933
Graphite on perforated paper
pl.47 8 ⁵/₁₆ x 10 ⁷/₈ in. (21.1 x 27.6 cm)

Sketch for 4D Transportation Unit,
ca. 1929
Ink and graphite on paper
pl.48 8 ¹/₂ x 11 in. (21.6 x 27.9 cm)

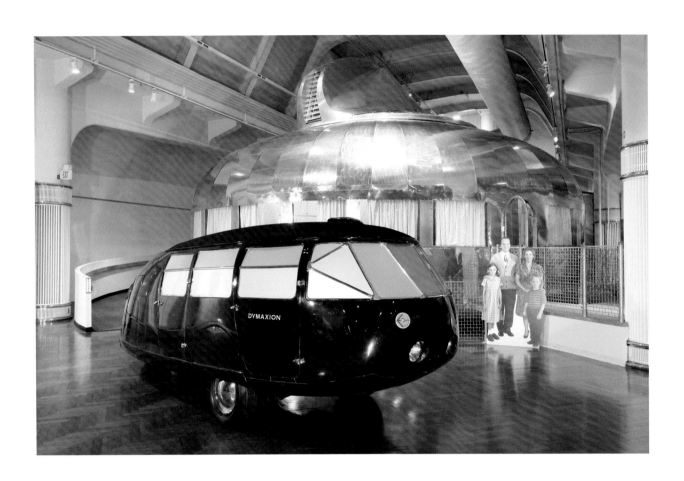

pl.**49** Dymaxion "2" 4D Transport, 1934, in front of Dymaxion House in the Henry Ford

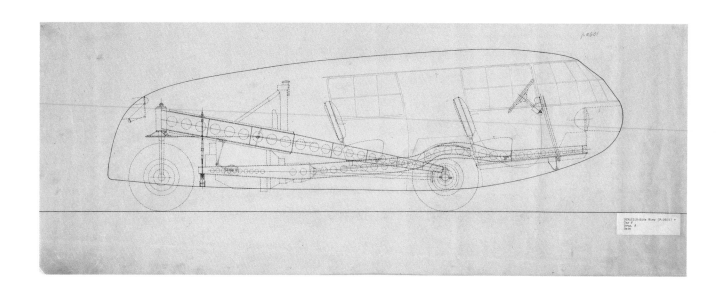

Dymaxion Car, ca. 1933
Ink on tracing paper
13 1/2 x 35 13/16 in. (34.2 x 91 cm)

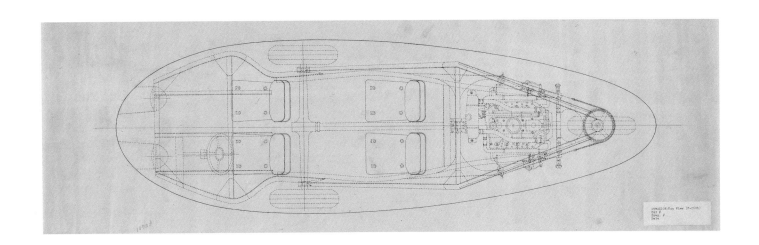

Dymaxion Car, Plan or Top View,
ca. 1933
Ink on tracing paper
11 x 35 1/2 in. (27.9 x 90.2 cm)

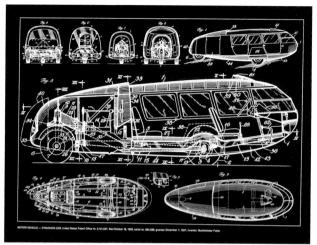

52

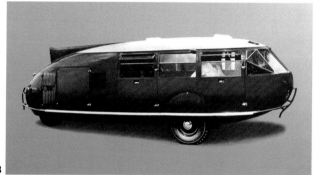

53

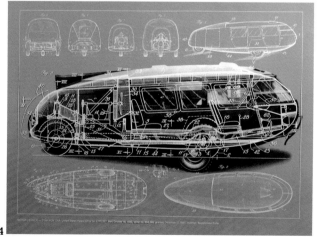

54

Motor Vehicle—Dymaxion Car, United
States Patent Office no. 2,101,057,
filed October 18, 1933, serial no.
694,068, granted December 7, 1937,
inventor: Buckminster Fuller
From the portfolio *Inventions:
Twelve Around One*, 1981
Screenprint in white ink on clear
polyester film overlaid on a Curtis
plain blue backing sheet
pl.52 30 x 40 in. (76.2 x 101.6 cm)

Detail of Motor Vehicle—Dymaxion
Car, United States Patent Office no.
2,101,057, filed October 18, 1933,
serial no. 694,068, granted December
7, 1937, inventor: Buckminster Fuller
From the portfolio *Inventions:
Twelve Around One*, 1981
Screenprint on Lenox paper
pl.53 30 x 40 in. (76.2 x 101.6 cm)

Motor Vehicle—Dymaxion Car, United
States Patent Office no. 2,101,057,
filed October 18, 1933, serial no.
694,068, granted December 7, 1937,
inventor: Buckminster Fuller
From the portfolio *Inventions:
Twelve Around One*, 1981
Screenprint in white ink on clear
polyester film overlaid on screenprint
on Lenox paper
pl.54 30 x 40 in. (76.2 x 101.6 cm)

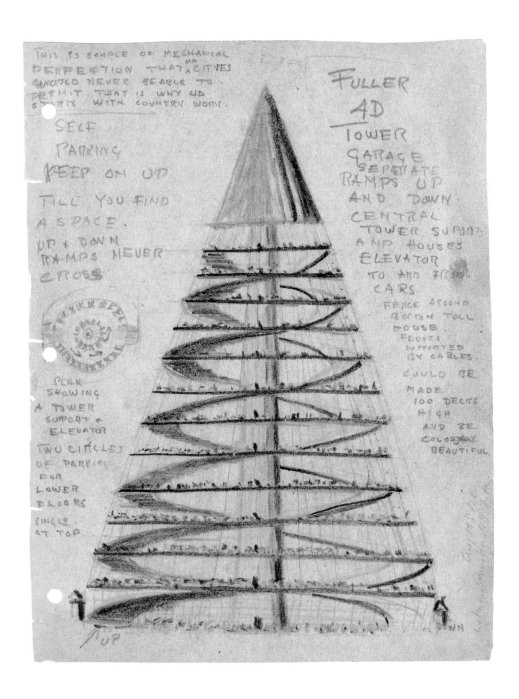

THIS IS SAMPLE OF MECHANICAL
PERFECTION THAT OLD CITIES
SHOULD NEVER BE ABLE TO.
PERMIT. THAT IS WHY 4D
STARTS WITH COUNTRY WORK.

SELF

PARKING

KEEP ON UP

TILL YOU FIND

A SPACE.

UP + DOWN
RAMPS NEVER

CROSS

PLAN
SHOWING
A TOWER
SUPPORT +
ELEVATOR

TWO CIRCLES
OF PARKING
FOR
LOWER
FLOORS

SINGLE
AT TOP.

FULLER
4D
TOWER

GARAGE
SEPARATE
RAMPS UP
AND DOWN
CENTRAL
TOWER SUPORT
AND HOUSES
ELEVATOR
TO AND FROM
CARS

FENCE AROUND
BOTTOM TOLL
HOUSE.
FLOORS
SUPPORTED
BY CABLES.

COULD BE

MADE
100 DECKS
HIGH
AND BE
COLOSSALY
BEAUTIFUL.

UP

DOWN

4D Tower Garage (Proposal for the
1933 World's Fair in Chicago), 1928
Colored pencil and graphite on paper
10 $^{15}/_{16}$ x 8 $^{3}/_{8}$ in. (27.8 x 21.3 cm)
pl.55

Charge to the account of _____ $ _____

CLASS OF SERVICE DESIRED
DOMESTIC	CABLE
TELEGRAM	FULL RATE
DAY LETTER [X]	DEFERRED
NIGHT MESSAGE	NIGHT LETTER
NIGHT LETTER	SHIP RADIOGRAM

Patrons should check class of service desired; otherwise message will be transmitted as a full-rate communication.

CHECK
ACCT'G INFMN.
TIME FILED

WESTERN UNION

R. B. WHITE
PRESIDENT

NEWCOMB CARLTON
CHAIRMAN OF THE BOARD

J. C. WILLEVER
FIRST VICE-PRESIDENT

Send the following message, subject to the terms on back hereof, which are hereby agreed to

Isamu Noguchi Care Greenwood 86 Calle Republica Columbia Mexico City

EINSTEINS FORMULA DETERMINATION INDIVIDUAL SPECIFICS RELATIVITY READS QUOTE ENERGY
EQUALS MASS TIMES THE SPEED OF LIGHT SQUARED UNQUOTE SPEED OF LIGHT IDENTICAL SPEED
ALL RADIATION COSMIC GAMMA X ULTRA VIOLET INFRA RED RAYS ETCETERA ONE HUNDRED
EIGHTY SIX THOUSAND MILES PER SECOND WHICH SQUARED IS TOP OR PERFECT SPEED GIVING
SCIENCE A FINITE VALUE FOR BASIC FACTOR IN MOTION UNIVERSE STOP SPEED OF RADIANT
ENERGY BEING DIRECTIONAL OUTWARD ALL DIRECTIONS EXPANDING WAVE SURFACE DIAMETRIC POL-
AR SPEED AWAY FROM SELF IS TWICE SPEED IN ONE DIRECTION AND SPEED OF VOLUME INCREASE
IS SQUARE OF SPEED IN ONE DIRECTION APPROXIMATELY THIRTY FIVE BILLION VOLUMETRIC
MILES PER SECOND STOP FORMULA IS WRITTEN QUOTE LETTER E FOLLOWED BY EQUATION MARK
FOLLOWED BY LETTER M FOLLOWED BY LETTER C FOLLOWED CLOSELY BY ELEVATED SMALL FIGURE
TWO SYMBOL OF SQUARING UNQUOTE ONLY VARIABLE IN FORMULA IS SPECIFIC MASS SPEED IS
A UNIT OF RATE WHICH IS AN INTEGRATED RATIO OF BOTH TIME AND SPACE AND NO GREATER
RATE OF SPEED THAN THAT PROVIDED BY ITS CAUSE WHICH IS PURE ENERGY LATENT OR RADIANT
IS ATTAINABLE STOP THE FORMULA THEREFORE PROVIDES A UNIT AND A RATE OF PERFECTION
TO WHICH THE RELATIVE IMPERFECTION OR INEFFICIENCY OF ENERGY RELEASE IN RADIANT OR
CONFINED DIRECTION OF ALL TEMPORAL SPACE PHENOMENA MAY BE COMPARED BY ACTUAL CALCU-
LATION STOP SIGNIFICANCE STOP SPECIFIC QUALITY OF ANIMATES IS CONTROL WILLFUL OR
OTHERWISE OF RATE AND DIRECTION ENERGY RELEASE AND APPLICATION NOT ONLY OF SELF
MECHANISM BUT OF FROM SELF MACHINE DIVIDED MECHANISMS AND RELATIVITY OF ALL ANIMATES
AND INANIMATES IS POTENTIAL OF ESTABLISHMENT THROUGH EINSTEIN FORMULA

BUCKY

THE QUICKEST, SUREST AND SAFEST WAY TO SEND MONEY IS BY TELEGRAPH OR CABLE.

Telegram from Fuller to Isamu Noguchi
explaining $E = MC^2$, 1936
Type ink on paper
7 x 8 1/2 in. (17.8 x 21.6 cm)

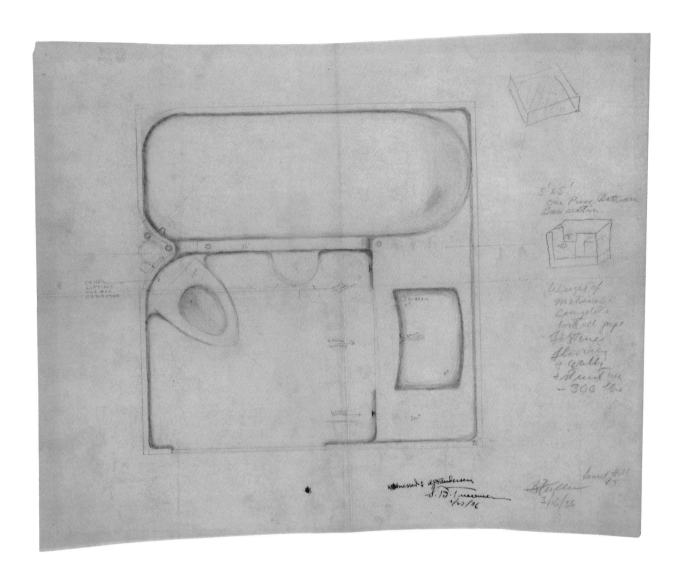

Sketch of Dymaxion Bathroom, 1936
Graphite and ink on vellum
14 3/4 x 18 1/4 in. (37.5 x 46.4 cm)
pl.57 (irregular)

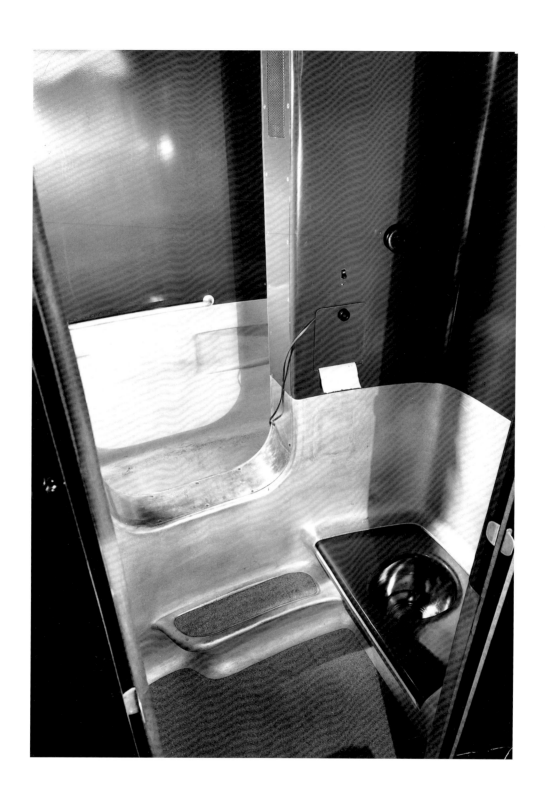

Photograph of the interior of a
Dymaxion Bathroom, 1937

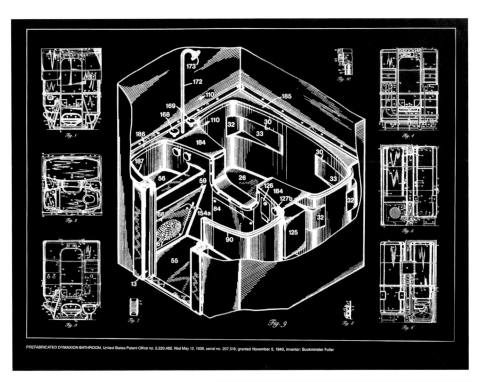

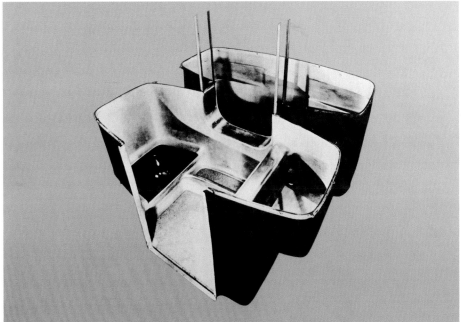

Prefabricated Dymaxion Bathroom, United States Patent Office
no. 2,220,482, filed May 12, 1938, serial no. 207,518, granted
November 5, 1940, inventor: Buckminster Fuller
From the portfolio *Inventions: Twelve Around One*, 1981
Screenprint in white ink on clear polyester film overlaid on a
Curtis plain blue backing sheet
pl.59 30 x 40 in. (76.2 x 101.6 cm)

Prefabricated Dymaxion Bathroom, United States Patent
Office no. 2,220,482, filed May 12, 1938, serial no.
207,518, granted November 5, 1940, inventor:
Buckminster Fuller
From the portfolio *Inventions: Twelve Around One*, 1981
Screenprint on Lenox paper
pl.60 30 x 40 in. (76.2 x 101.6 cm)

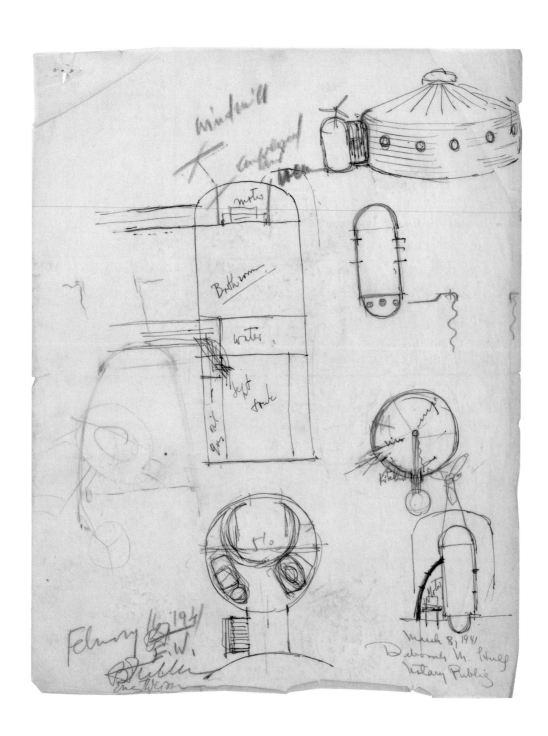

Sketch for Dymaxion Deployment Unit, 1941
Ink, graphite, and colored pencil
on paper
11 1/16 x 8 5/8 in. (28.1 x 21.9 cm)

pl.61

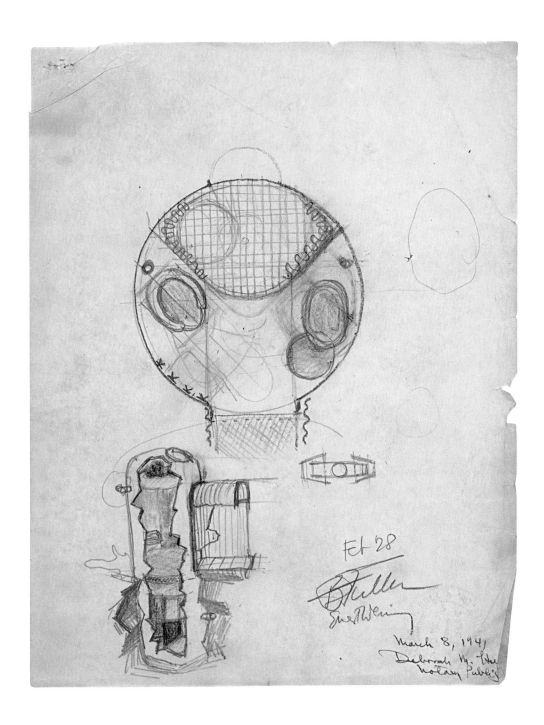

Sketch for Dymaxion Deployment Unit, 1941
Colored pencil, graphite, and ink
on paper
pl.62 11 x 8 ½ in. (27.9 x 21.6 cm)

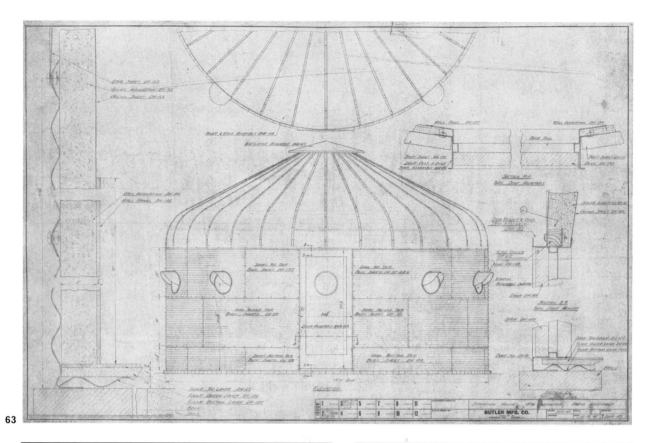

63

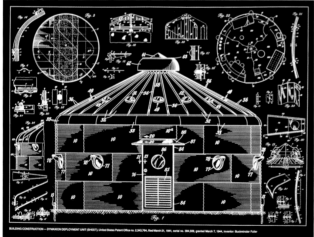

64

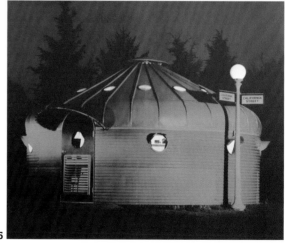

65

pl.**63** Dymaxion Deployment Unit,
18 Foot Diameter, 1941
Diazotype
22 x 34 ⅛ in. (55.9 x 86.7 cm)

pl.**64** Building Construction—Dymaxion Deployment Unit
(Sheet), United States Patent Office no. 2,343,764,
filed March 21, 1941, serial no. 384,509, granted March
7, 1944, inventor: Buckminster Fuller
From the portfolio *Inventions: Twelve Around One*, 1981
Screenprint in white ink on clear polyester film overlaid
on a Curtis plain blue backing sheet
30 x 40 in. (76.2 x 101.6 cm)

pl.**65** Building Construction—Dymaxion Deployment Unit
(Sheet), United States Patent Office no. 2,343,764,
filed March 21, 1941, serial no. 384,509, granted
March 7, 1944, inventor: Buckminster Fuller
From the portfolio *Inventions: Twelve Around One*,
1981
Screenprint on Lenox paper
30 x 40 in. (76.2 x 101.6 cm)

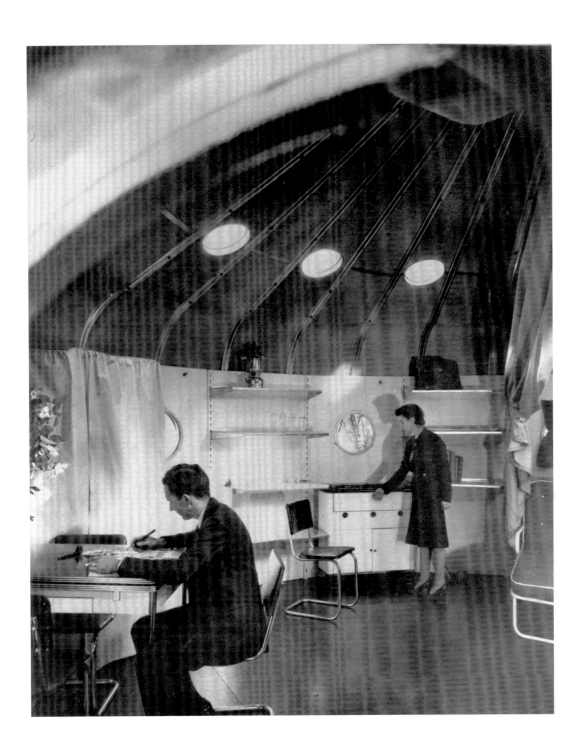

pl. **66** Marketing photograph of the interior
of the Dymaxion Deployment Unit,
1941

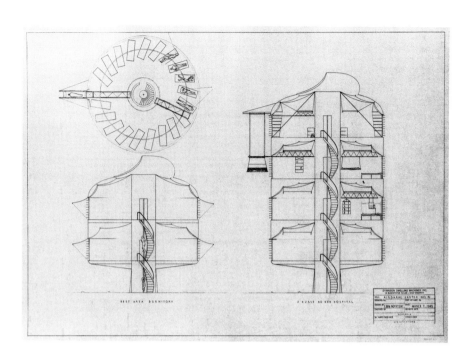

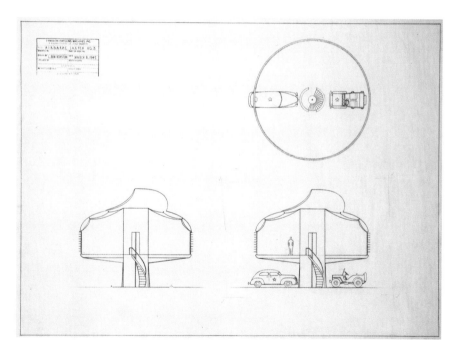

Dymaxion Airbarac, Rest Area
Dormitory/3 Nurse 60 Bed Hospital,
1945 (drawing by L. Don Royston)
Diazotype

pl. 67 26 1/8 x 36 13/16 in. (66.4 x 93.5 cm)

Wichita House: Airbarac, 1945
(drawing by L. Don Royston)
Graphite on tracing paper

pl. 68 26 1/2 x 36 1/8 in. (67.3 x 91.8 cm)

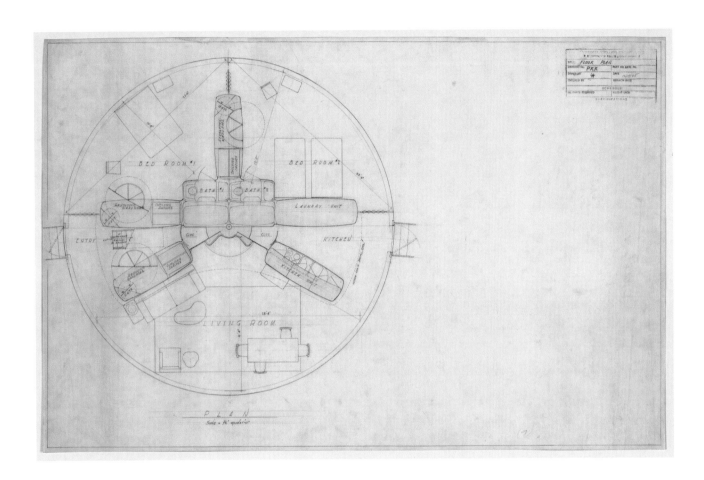

Dymaxion Dwelling Machine, Wichita House, project
Study for air circulation: floor plan, 1945
Graphite on paper
pl. 69 22 x 34 1/8 in. (55.9 x 86.7 cm)

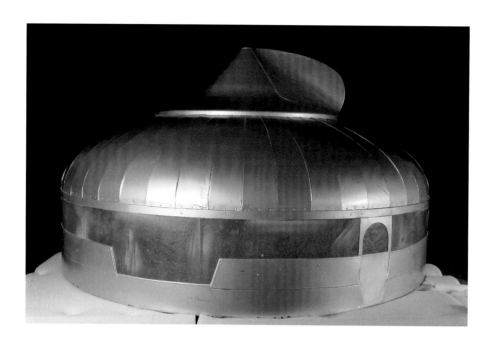

pl. **70** Dymaxion Dwelling Machine,
Wichita House, Model, 1946
Painted fiberglass
Diameter: 36 in. (91.4 cm),
height: 23 in. (48.4 cm)

pl. **71** Photograph of model of Dymaxion
Dwelling Machines community,
ca. 1946

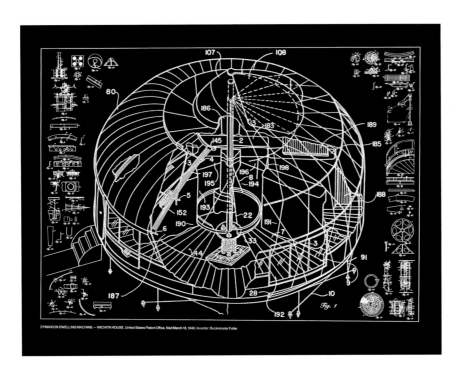

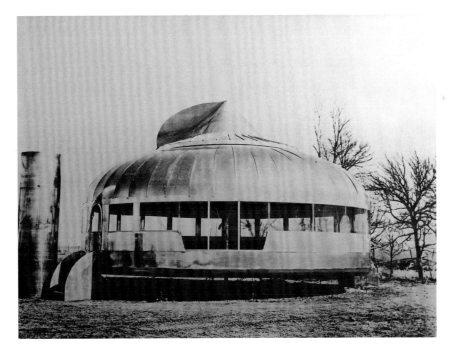

Dymaxion Dwelling Machine—Wichita House, United States Patent Office, filed March 16, 1946, inventor: Buckminster Fuller
From the portfolio *Inventions: Twelve Around One*, 1981
Screenprint in white ink on clear polyester film overlaid on a Curtis plain blue backing sheet
pl. 72 30 x 40 in. (76.2 x 101.6 cm)

Dymaxion Dwelling Machine—Wichita House, United States Patent Office, filed March 16, 1946, inventor: Buckminster Fuller
From the portfolio *Inventions: Twelve Around One*, 1981
Screenprint on Lenox paper
pl. 73 30 x 40 in. (76.2 x 101.6 cm)

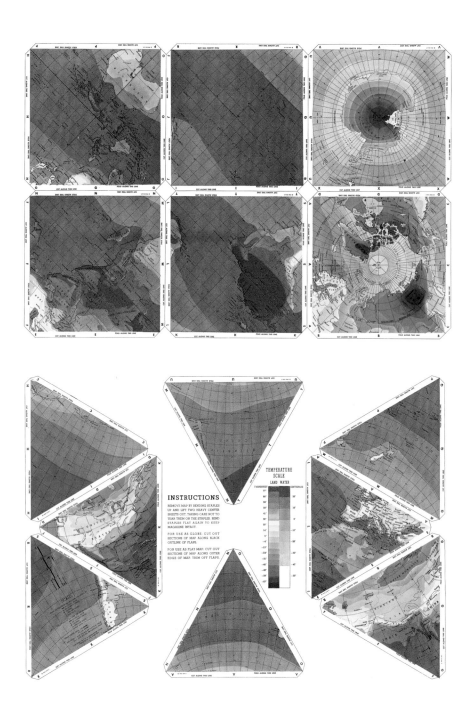

Dymaxion Map, 1943
Pull-out from *Life*
(March 1, 1943)

Dymaxion Map, 1943
Pull-out from *Life*
(March 1, 1943)

DYMAXION WORLD (continued)

HOW TO ASSEMBLE THE GLOBE

Here demonstrated is the simple procedure by which the segments of the Dymaxion World map are assembled into a visual approximation of a round globe. The opposite page is the reverse side of the second of the two heavy center sheets on which the map is printed.

First step, removal of center sheets from magazine, must be taken with care to avoid tearing map on staples. Segments cut out are best fastened together by paste or mucilage. Because they warp the paper, pins should not be used. For neatest product, sequence of assembly here illustrated should be followed. Marginal letters of triangles match marginal letters of squares.

The map, thus assembled into a 14-faced solid, has many of the advantages of a globe. Like a globe it can be viewed from any perspective to bring geographical relationships into new relief—to show that the South-ern is the water hemisphere, that Chicago and Sverdlovsk are fairly close together over the top of the world, that Dutch Harbor lies closer to the shortest San Francisco-Tokyo route than Pearl Harbor.

Before they are hidden inside globe, statistics on reverse of each segment are worth inspection. For example, the North Pole square's 8.9% of world population contrasts dramatically with the South Pole's .0004%.

BENDING OF STAPLES is first step in removing map from copy of LIFE. Bent back, staples hold copy intact.

SCORING OF MARGINS of colored face of segment with clip or dull knife facilitates folding of flaps (*right*).

FOLDING OF FLAPS should follow margin of map precisely. Flaps of segments to be joined are keyed by letters.

HOUSEHOLD PASTE or mucilage is best means for fastening flaps. It should be spread thinly to avoid warping.

PINCH CLIPS, easy to apply, permit disassembly of globe. If clips are used last segment must be taped or glued in.

CELLOPHANE TAPE is substitute for paste and clips. It must be applied inside and out to keep edges together.

POLAR SQUARE and triangles should first be assembled into unit. Care should be taken to keep edges in register.

EQUATORIAL SQUARES are then joined to polar square-triangle assembly. Key letters simplify matching.

MOST DIFFICULT is this step in which square is joined to triangle. Polar square should be held flat on table.

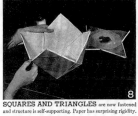

SQUARES AND TRIANGLES are now fastened and structure is self-supporting. Paper has surprising rigidity.

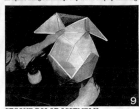

SECOND POLAR ASSEMBLY is mounted. Paste should be allowed to dry a little before the flaps are joined.

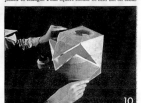

LAST TRIANGLE is left unfastened until other flaps are secured. It can then be set by pressure from the outside.

—OR YOU CAN USE SEGMENTS FOR A FLAT, MOVABLE MAP (SEE PAGE 53)

44

Instructions for assembling Dymaxion Map, 1943
Pull-out from *Life* (March 1, 1943)

pl. **76**

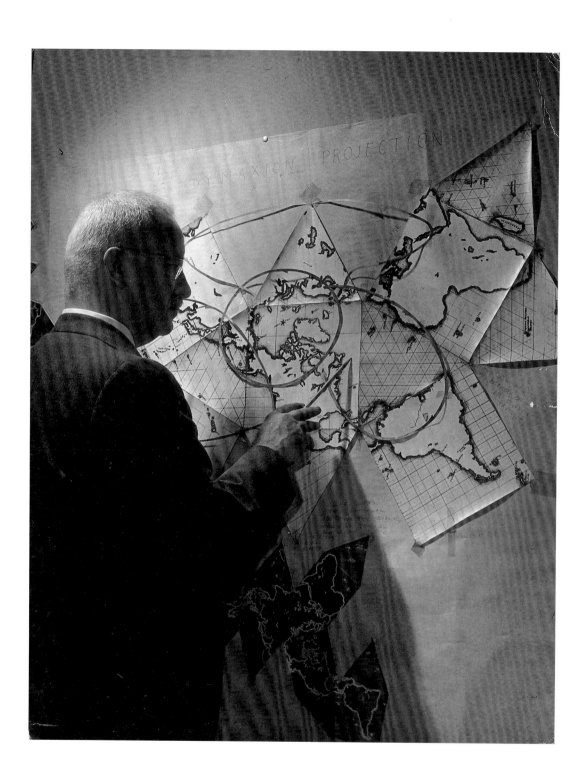

Fuller in front of various Dymaxion
Map projections, ca. 1945

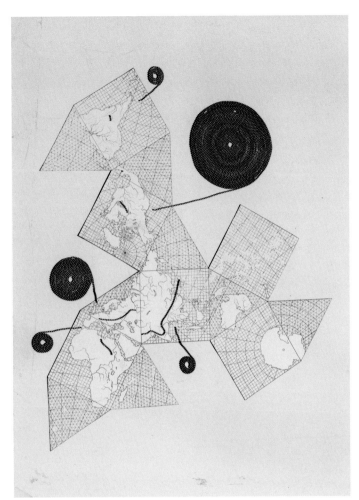

Photograph of Dymaxion Projection Map display-
ing the world distribution of "energy slaves"
Photograph by Aaron Siskind (1903–1991) for
Fuller's article "Comprehensive Designing" in
Trans/formation 1, no. 1 (1950)
Gelatin silver print

pl.78 13 15/16 x 9 3/4 in. (35.4 x 24.8 cm)

Dymaxion Projection Map displaying the world
distribution of "energy slaves" (replacement of
human labor by machines), from *World
Geo-Graphic Atlas*, 1953, edited and designed
by Herbert Bayer (1900–1985), printed privately
for the Container Corporation of America
Commercial offset print

pl.79 16 x 11 1/4 in. (40.6 x 28.6 cm) (folded)

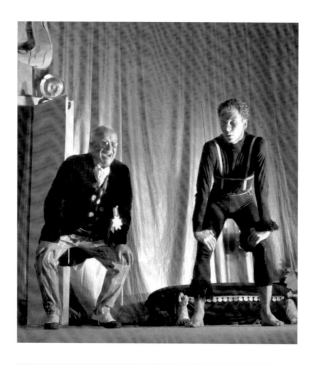

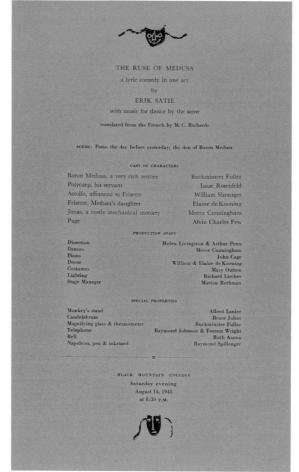

CLEMENS KALISCHER

(b. 1921)

Buckminster Fuller and Merce
Cunningham in *The Ruse of Medusa*
by Erik Satie, Black Mountain College,
August 14, 1948

pl.**80**

pl.**81** Playbill for production of *The Ruse
of Medusa* by Erik Satie, performed
at Black Mountain College, August 14,
1948

Letterpress print on coated paper
11 1/8 x 7 1/2 in. (28.3 x 19.1 cm) (folded)

JOHN CAGE (1912–1992)

"For Bucky at 85 with love," 1980

Ballpoint pen on paper

pl. **82** 15½ x 11¼ in. (39.4 x 28.6 cm)

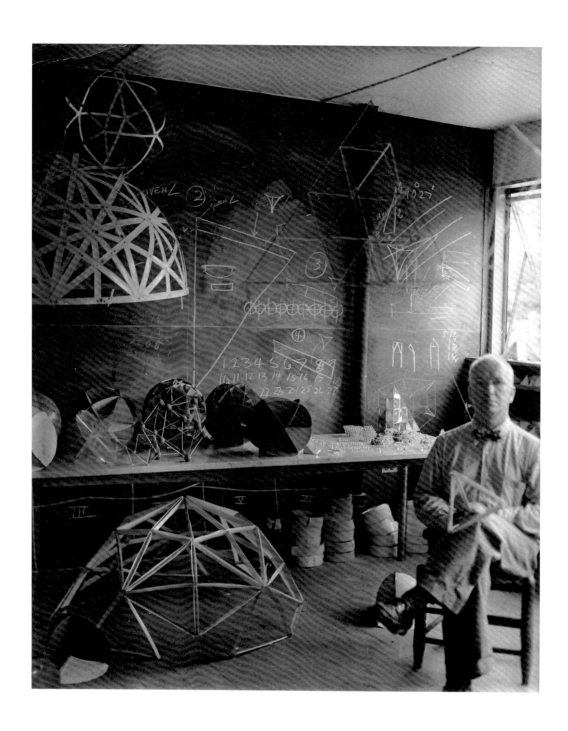

HAZEL LARSEN ARCHER
(1921–2001)
Fuller in his classroom at
pl. **83** Black Mountain College, summer 1948

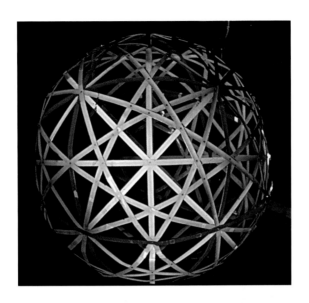

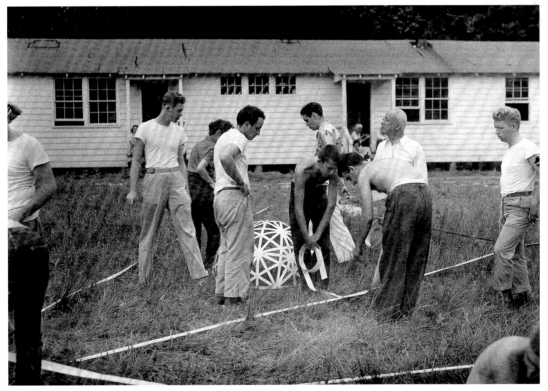

BEAUMONT NEWHALL
(1908–1993)
Fuller with students, constructing
dome from Venetian blinds at Black
Mountain College, summer 1948

pl.**84** Great circle model, ca. 1949

pl.**85**

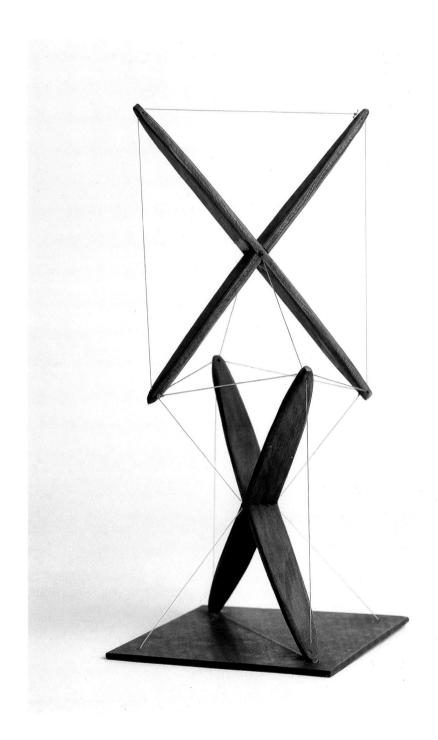

KENNETH SNELSON (b. 1927)
Early X-Piece, 1948–49 (re-created 1959)
Wood and nylon
11 1/2 x 5 3/8 x 5 3/8 in.
(29.2 x 13.7 x 13.7 cm)

pl. **86**

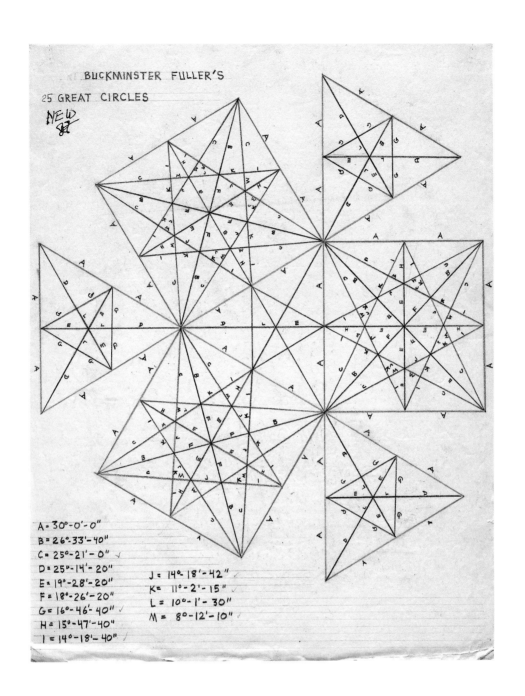

BUCKMINSTER FULLER'S
25 GREAT CIRCLES
NEW 87

A = 30°-0'-0"
B = 26°-33'-40"
C = 25°-21'-0" ✓
D = 25°-14'-20"
E = 19°-28'-20"
F = 18°-26'-20"
G = 16°-46'-40" ✓
H = 15°-47'-40"
I = 14°-18'-40"

J = 14°-18'-42" ✓
K = 11°-2'-15"
L = 10°-1'-30"
M = 8°-12'-10"

Buckminster Fuller's 25 Great Circles, n.d.
Colored pencil and graphite on paper
11 x 8 9/16 in. (27.9 x 21.7 cm)

pl. 87

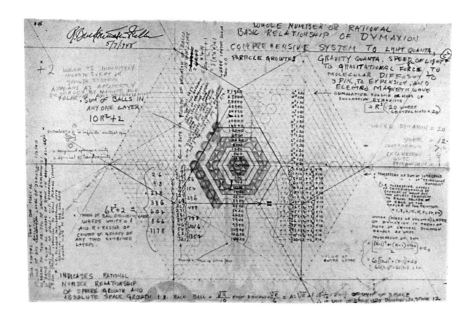

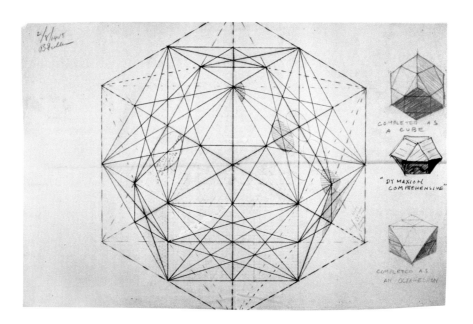

Study of Closest Packing of Spheres, 1948
Ink, colored pencil, and graphite
on paper
pl. 88 12 7/8 x 19 3/4 in. (32.7 x 50.2 cm)

Geometrical Study, 1948
Ink, colored pencil, and graphite
on paper
pl. 89 12 3/4 x 19 3/8 in. (32.4 x 49.2 cm)

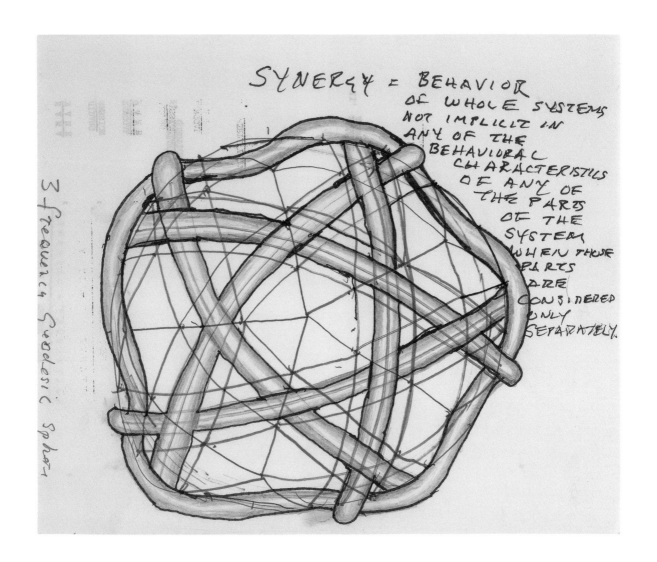

SYNERGY = BEHAVIOR OF WHOLE SYSTEMS NOT IMPLICIT IN ANY OF THE BEHAVIORAL CHARACTERISTICS OF ANY OF THE PARTS OF THE SYSTEM WHEN THOSE PARTS ARE CONSIDERED ONLY SEPARATELY.

3 Frequency Geodesic Sphere

Three Frequency Geodesic Sphere, n.d.
Felt-tip pen and graphite on paper
8 1/2 x 10 1/4 in. (21.6 x 26 cm)

pl. 90

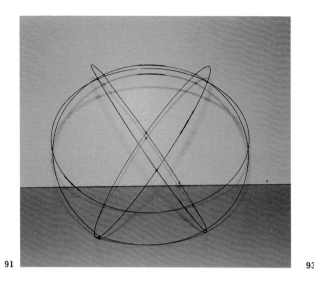

91

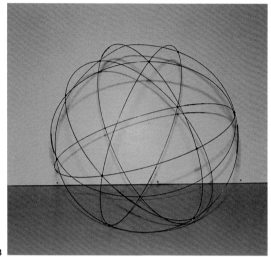

93

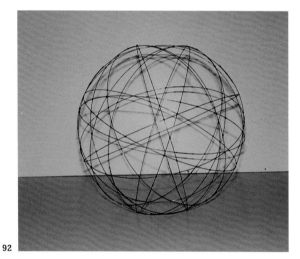

92

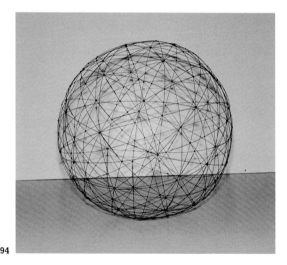

94

pl.**91** Great Circle Model, n.d.
Wire
Diameter 20 ¹/₄ in. (51.4 cm)

pl.**92** Great circle model, n.d.
Wire
Diameter 20 ¹/₄ in. (51.4 cm)

pl.**93** Great circle model, n.d.
Wire
Diameter 20 ¹/₂ in. (52.1 cm)

pl.**94** Great circle model, n.d.
Wire
Diameter 20 ¹/₄ in. (51.4 cm)

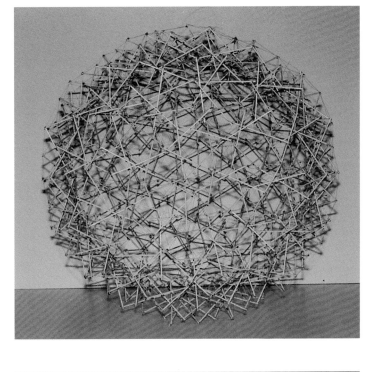

	Geometric Model, n.d.		First kinetic model demonstrating the
	Wood and twine		Jitterbug Transformation, 1948
pl. **95**	Diameter 33 in. (83.8 cm)	pl. **96**	Steel, brass, acrylic plastic, and twine
			25 1/2 x 25 1/2 x 25 1/2 in. (64.8 x 64.8 x 64.8 cm)

97

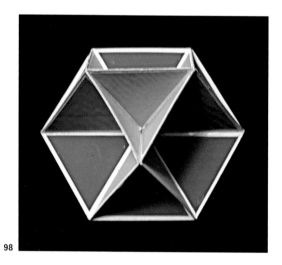

98

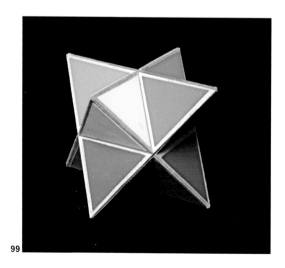

99

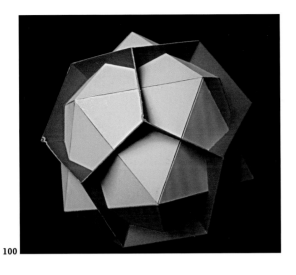

100

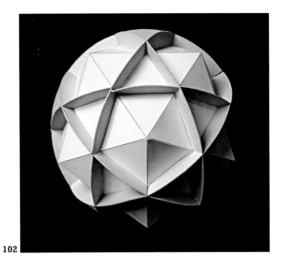

102

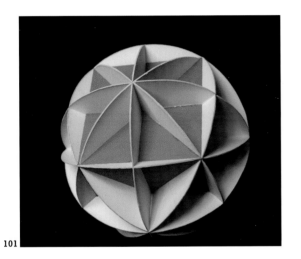

101

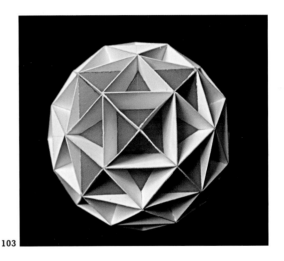

103

pl.**100** Icosahedron Dodecahedron Duality, ca. 1960–63
Paper
Diameter 7 in. (17.8 cm)

pl.**101** 9 Great Circles Spherical Nolid with Cube Inscribed, ca. 1960–63
Paper
Diameter 7 in. (17.8 cm)

pl.**102** Icosahedron with 6 Great Circle Planes, ca. 1960–63
Paper
Diameter 8 in. (20.3 cm)

pl.**103** 2 Frequency Spherical Cube with Cube Inscribed, ca. 1960–63
Paper
Diameter 8 in. (20.3 cm)

PLATES

134
135

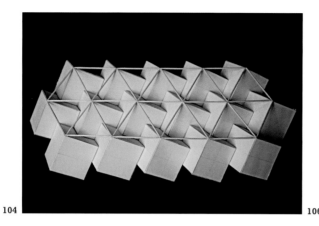

104

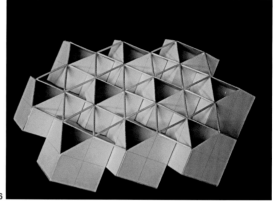

106

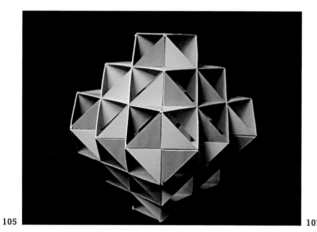

105

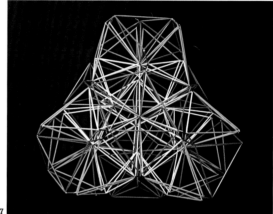

107

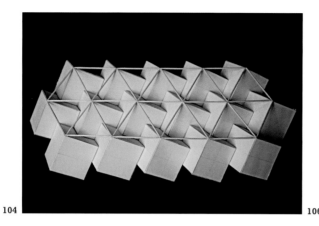

pl. 104 Cube Space Filling Triangular
Tessellation, ca. 1960–63
Paper and wood toothpicks
Diameter 16 in. (40.6 cm)

pl. 105 Close Packing of Polyhedra,
ca. 1960–63
Paper
Diameter 6 in. (15.2 cm)

pl. 106 Space Filling Polyhedra, Cube Corner
Truncation Triangular Tessellation,
ca. 1960–63
Paper and wood toothpicks
Diameter 6 in. (15.2 cm)

pl. 107 Compound Edge Tangent and
Concentric Arrangement of Multiple
Polyhedra, ca. 1960–63
Wood toothpicks
Diameter 13 1/2 in. (34.3 cm)

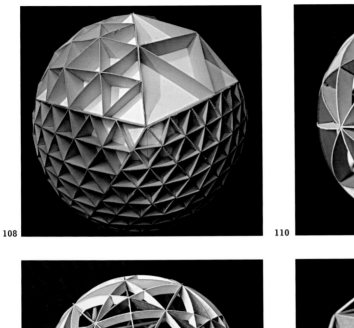

108

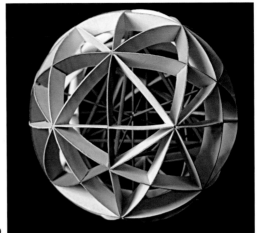

110

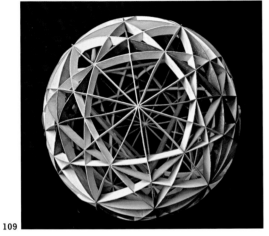

109

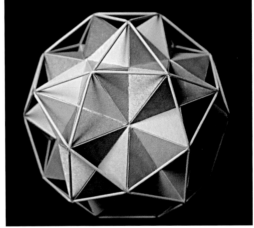

111

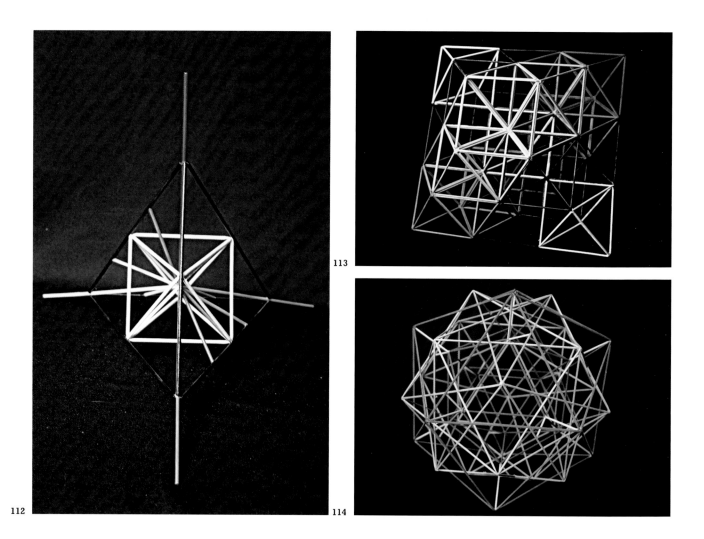

112

113

114

115

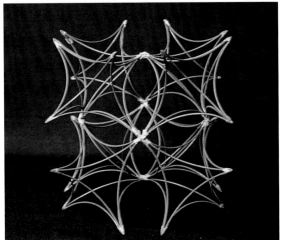

116

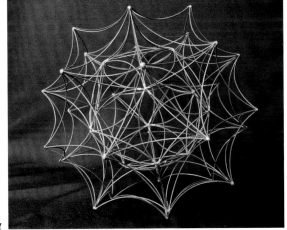

117

pl.**115** Compound Curvature, Sphere Packing
Voids, ca. 1960—63
Metal
Diameter 8 ¼ in. (21 cm)

pl.**116** Compound Curvature, Sphere Packing
Voids, ca. 1960—63
Metal
Diameter 10 in. (25.4 cm)

pl.**117** Compound Curvature, Sphere Packing
Voids, ca. 1960—63
Metal
Diameter 13 in. (33 cm)

STANDARD OF LIVING PACKAGE

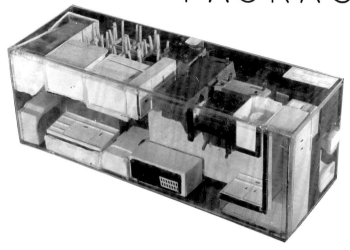

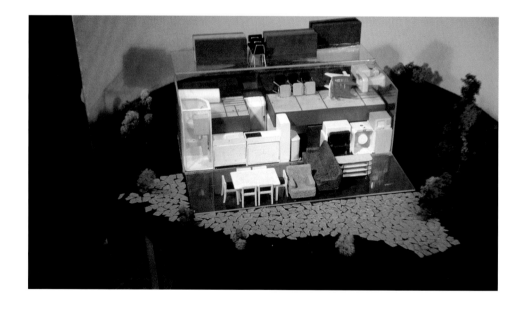

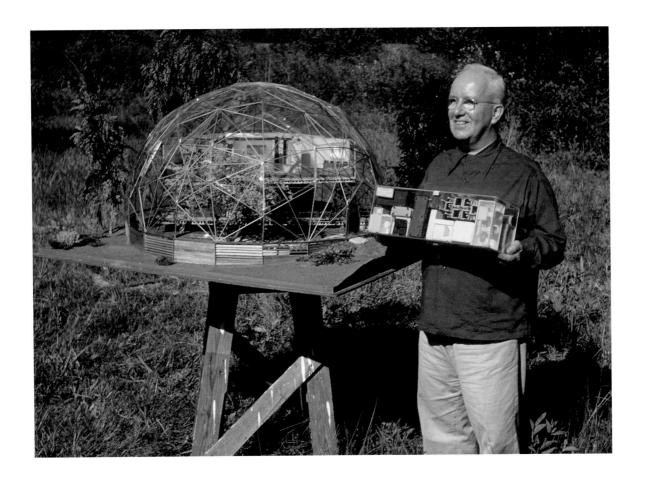

Fuller with models of Standard of Living
Package and Skybreak Dome, 1949

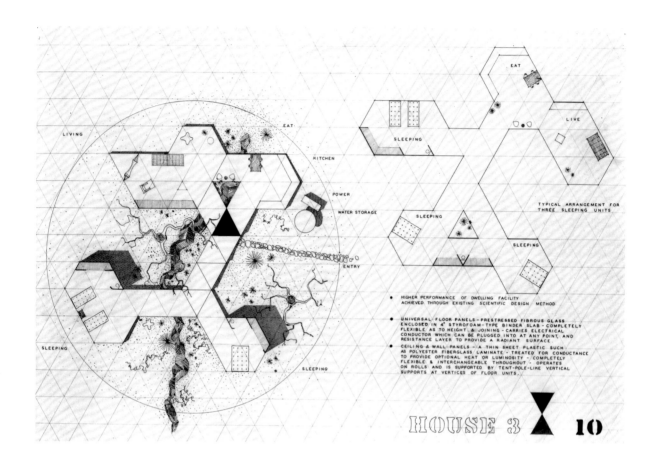

Within the image:

LIVING

EAT

KITCHEN

POWER

WATER STORAGE

ENTRY

SLEEPING

SLEEPING

EAT

LIVE

SLEEPING

SLEEPING

SLEEPING

SLEEPING

TYPICAL ARRANGEMENT FOR
THREE SLEEPING UNITS

● HIGHER PERFORMANCE OF DWELLING FACILITY
ACHIEVED THROUGH EXISTING SCIENTIFIC DESIGN METHOD

● UNIVERSAL FLOOR PANELS – PRESTRESSED FIBROUS GLASS
ENCLOSED IN 4" STYROFOAM-TYPE BINDER SLAB – COMPLETELY
FLEXIBLE AS TO HEIGHT & JOINING – CARRIES ELECTRICAL
CONDUCTOR WHICH CAN BE PLUGGED INTO AT ANY POINT, AND
RESISTANCE LAYER TO PROVIDE A RADIANT SURFACE

● CEILING & WALL PANELS – A THIN SHEET PLASTIC SUCH
AS POLYESTER FIBERGLASS LAMINATE – TREATED FOR CONDUCTANCE
TO PROVIDE OPTIONAL HEAT OR LUMINOSITY – COMPLETELY
FLEXIBLE & INTERCHANGEABLE THROUGHOUT – OPERATES
ON ROLLS AND IS SUPPORTED BY TENT-POLE-LIKE VERTICAL
SUPPORTS AT VERTICES OF FLOOR UNITS.

HOUSE 3 ▼ 10

Autonomous dome home plan,
designed by Fuller and MIT students,
ca. 1952
Ink and toned overlays on vellum
mounted on board

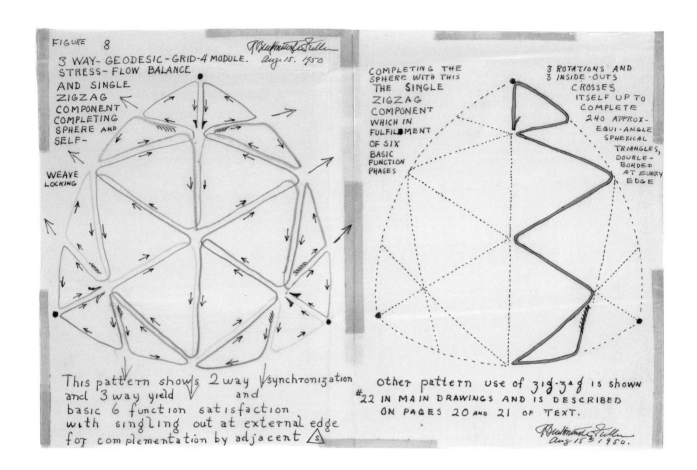

FIGURE 8

3 WAY- GEODESIC - GRID - 4 MODULE. *Aug. 15. 1950*
STRESS- FLOW BALANCE
AND SINGLE
ZIGZAG
COMPONENT
COMPLETING
SPHERE AND
SELF-

WEAVE
LOCKING

This pattern shows 2 way synchronization
and 3 way yield and
basic 6 function satisfaction
with singling out at external edge
for complementation by adjacent △S

COMPLETING THE
SPHERE WITH THIS
THE SINGLE
ZIGZAG
COMPONENT
WHICH IN
FULFILLMENT
OF SIX
BASIC
FUNCTION
PHASES

3 ROTATIONS AND
3 INSIDE-OUTS
CROSSES
ITSELF UP TO
COMPLETE
240 APPROX-
EQUI-ANGLE
SPHERICAL
TRIANGLES,
DOUBLE-
BONDED
AT EVERY
EDGE

other pattern use of zig-zag is shown
#22 IN MAIN DRAWINGS AND IS DESCRIBED
ON PAGES 20 AND 21 OF TEXT.

Aug 15 = 1950.

3-Way-Geodesic-Grid-4-Module-
Stress-Flow . . . , 1950
Ink and colored pencil on tracing
paper mounted on paper with tape
pl.122 11 x 17 in. (27.9 x 43.2 cm) overall

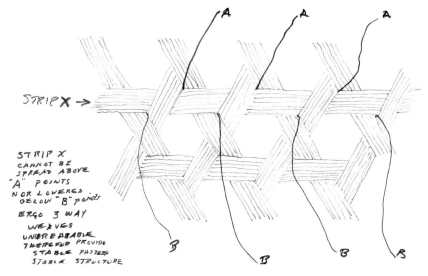

One of 30 Diamonds on Edge of
Icosahedron's 30 Edges . . . , 1950
Colored pencil and ink on paper
pl.123 8 1/2 x 11 in. (21.6 x 27.9 cm)

Strip X, n.d.
Graphite and felt-tip pen on tracing
paper
pl.124 11 1/4 x 13 in. (28.6 x 33 cm)

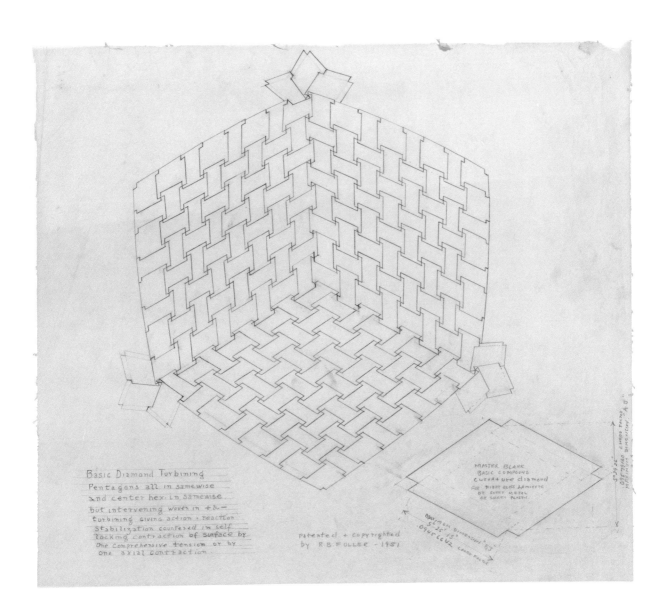

Basic Diamond Turbining

Pentagons all in samewise
and center hex in samewise
but intervening woven in +&–
turbining giving action-reaction
stabilization countered in self
locking contraction of surface by
one comprehensive tension or by
one axial contraction

patented + copyrighted
by R.B.Fuller - 1951

MASTER BLANK
BASIC COMPOUND
CURVATURE diamond
FOR FIBER GLASS LAMINATE
OR SHEET METAL
OR SHEET PLASTIC

MAXIMUM DIMENSION "B"
55° 20' 15"
.0945 CCU2 CHORD FACTOR

Basic Diamond Turbining, 1951
Graphite on tracing paper
20 1/2 x 23 5/16 in. (52.1 x 59.2 cm)

pl. 125

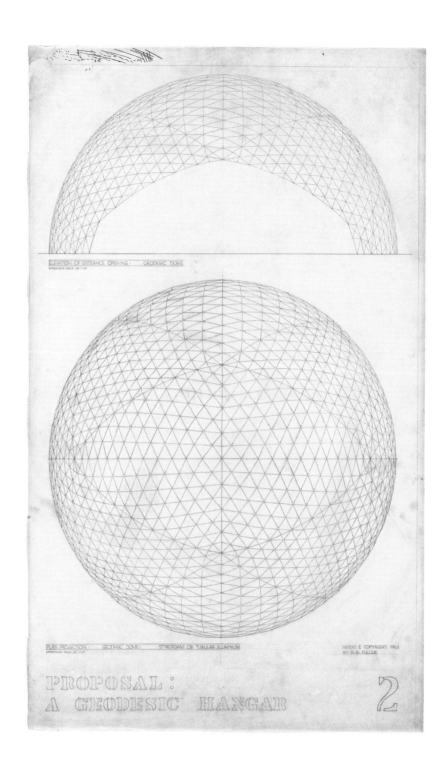

Proposal: A Geodesic Hangar, Plan
Projection, Geodesic Dome, Styrofoam
or Tubular Aluminum, 1951
Graphite on tracing paper
40 1/4 x 24 1/8 in. (102.2 x 61.3 cm)

pl. 126

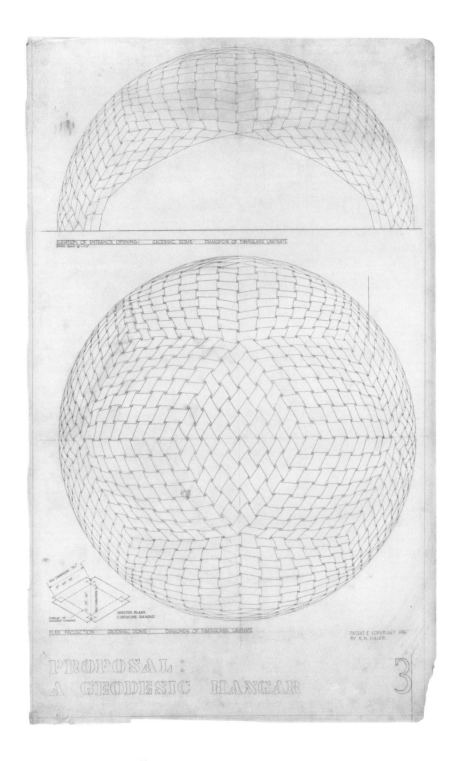

Proposal: A Geodesic Hangar, Plan
Projection, Geodesic Dome, Diamonds
of Fiberglass Laminate, 1951
Graphite on tracing paper
39 3/8 x 23 7/8 in. (100 x 60.6 cm)
pl. 127 (irregular)

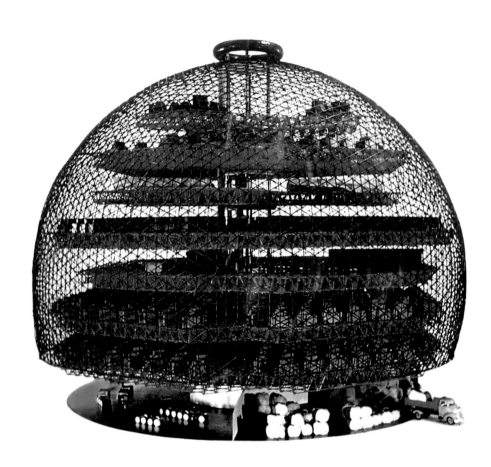

Model for 90% Automatic Cotton Mill,
designed with students at North
Carolina State College, 1951

pl. **128**

Geodesic Dome for the Ford Motor
Company, Dearborn, Michigan,
1952–53
India ink, graphite, and felt-tip pen
on tracing paper
30 1/3 x 30 in. (77.1 x 76.2 cm)

pl. 129

Geodesic Dome for the Ford Motor
Company, Dearborn, Michigan,
1952—53
Ink on paper
29 1/2 x 29 1/2 in. (75 x 75 cm)

pl. 130

Radomes (31 Foot Diameter and 50
Foot Diameter), 1954
Graphite on tracing paper

pl.131 27 1/2 x 36 in. (70 x 91.5 cm)

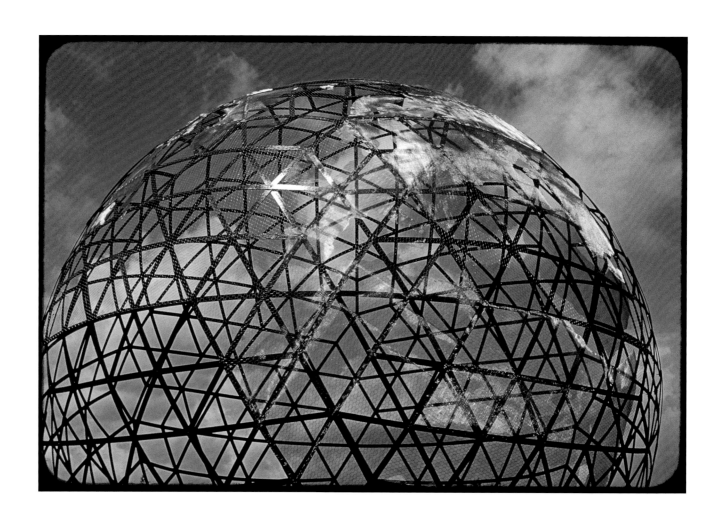

Geoscope built with students at
Cornell University, 1952
Diameter 21 ft. (6.4 m)
Land masses are represented by
pieces of mesh wire-netting

pl. 132

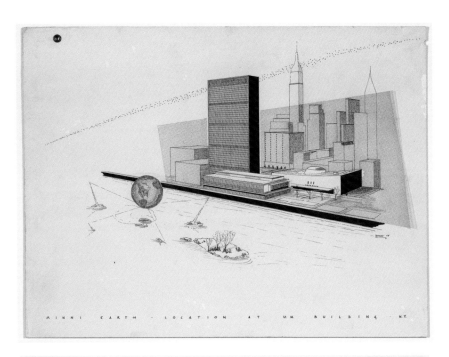

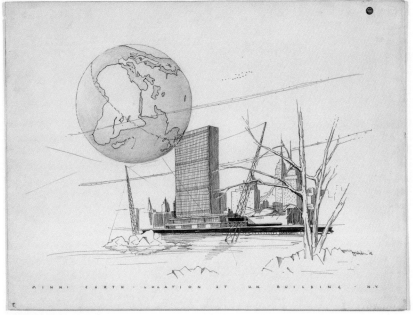

Minni Earth Location at U.N. Building,
New York, 1956 (drawing by Elston
Nelson)
Ink and graphite with plastic overlay
on paper mounted on board
pl.133 15 x 20 in. (38.1 x 50.8 cm)

Minni Earth Location at U.N. Building,
New York, 1956 (drawing by Winslow Wedin)
Ink and graphite on tracing paper
mounted on board
pl.134 15 x 20 in. (38.1 x 50.8 cm)

Roof System: Octahedron-Tetrahedron Truss,
Proposal for Service Garage for New England
Tel. & Tel. Company, Hyannis, Massachusetts, 1953
(drawing by G. Welsh)
Graphite on vellum

pl. 135 $30\,^{1}/_{16}$ x $32\,^{1}/_{2}$ in. (76.4 x 82.6 cm)

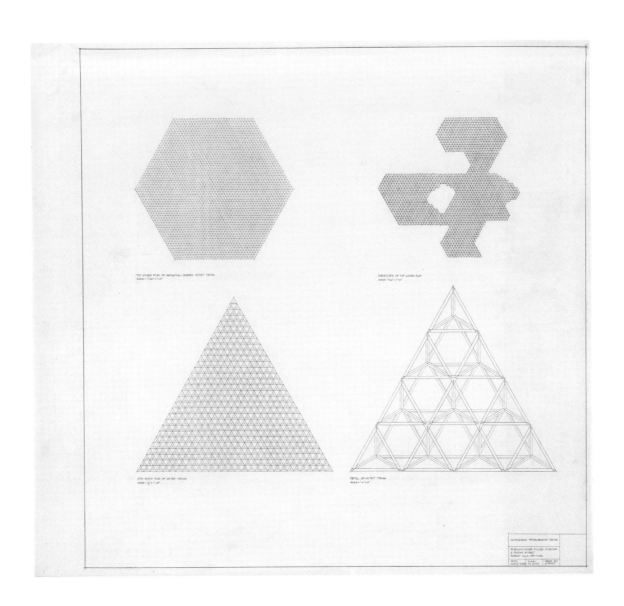

Octahedron-Tetrahedron Truss, 1953
(drawing by G. Welsh)
Graphite on vellum

30 x 32 1/2 in. (76.2 x 82.6 cm)

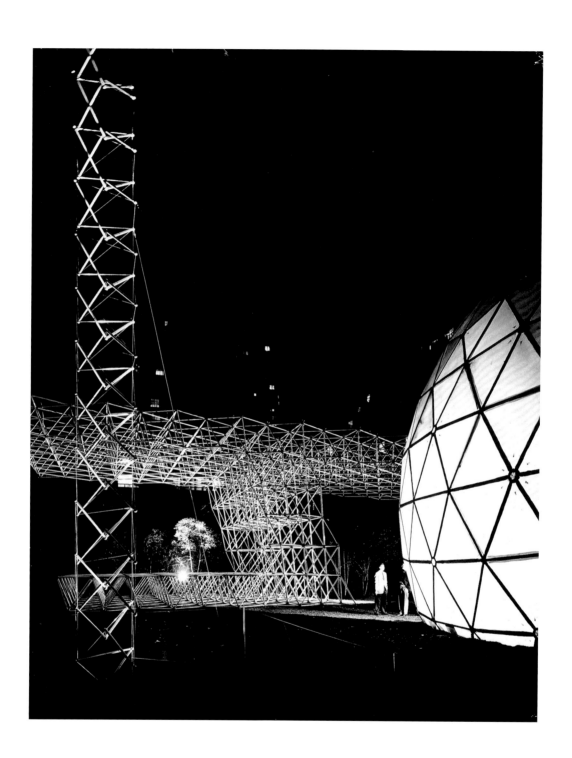

Installation view of *Three Structures by Buckminster Fuller* (September 22, 1959 – winter 1960) in the sculpture garden of the Museum of Modern Art, New York Tensegrity Mast (left), Geodesic Radome (right), Octet Truss (center)

pl. **137**

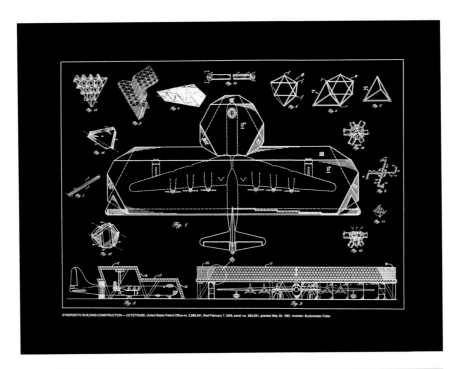

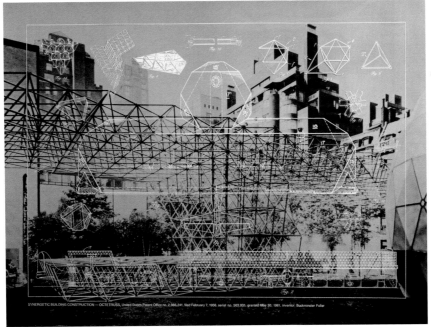

Synergetic Building Construction—Octetruss, United
States Patent Office no. 2,986,241, filed February 7,
1956, serial no. 563,931, granted May 30, 1961,
inventor: Buckminster Fuller
From the portfolio *Inventions: Twelve Around One*, 1981
Screenprint in white ink on clear polyester film
overlaid on a Curtis plain blue backing sheet
pl.138 30 x 40 in. (76.2 x 101.6 cm)

Synergetic Building Construction—Octetruss,
United States Patent Office no. 2,986,241, filed
February 7, 1956, serial no. 563,931, granted May
30, 1961, inventor: Buckminster Fuller
From the portfolio *Inventions: Twelve Around One*, 1981
Screenprint in white ink on clear polyester film
overlaid on screenprint on Lenox paper
pl.139 30 x 40 in. (76.2 x 101.6 cm)

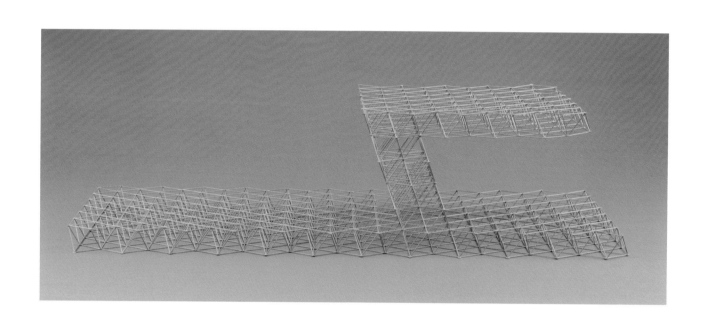

Octet Truss, project, ca. 1959
Wood struts
12 $1/2$ x 49 $1/2$ x 17 $1/2$ in.
(31.8 x 125.7 x 44.5 cm)

pl. **140**

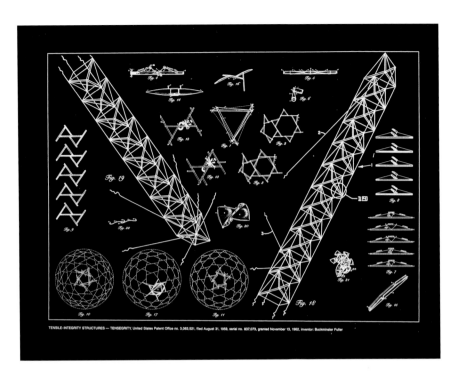

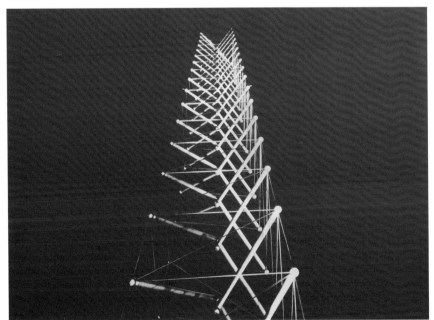

Tensile-Integrity Structures—Tensegrity, United
States Patent Office no. 3,063,521, filed August 31,
1959, serial no. 837,073, granted November 13, 1962,
inventor: Buckminster Fuller
From the portfolio *Inventions: Twelve Around One*, 1981
Screenprint in white ink on clear polyester film
overlaid on a Curtis plain blue backing sheet
pl.141 30 x 40 in. (76.2 x 101.6 cm)

Tensile-Integrity Structures—Tensegrity,
United States Patent Office no. 3,063,521, filed
August 31, 1959, serial no. 837,073, granted
November 13, 1962, inventor: Buckminster Fuller
From the portfolio *Inventions: Twelve Around One*, 1981
Screenprint on Lenox paper
pl.142 30 x 40 in. (76.2 x 101.6 cm)

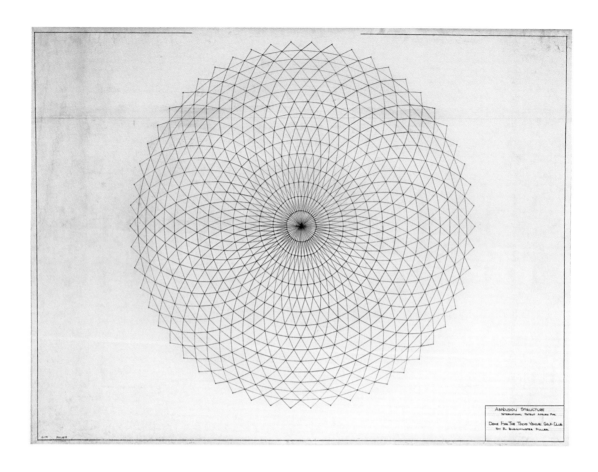

ASPENSION STRUCTURE
INTERNATIONAL PATENT APPLIED FOR

Dome For The Tokyo Yomiuri Golf Club
By R. Buckminster Fuller

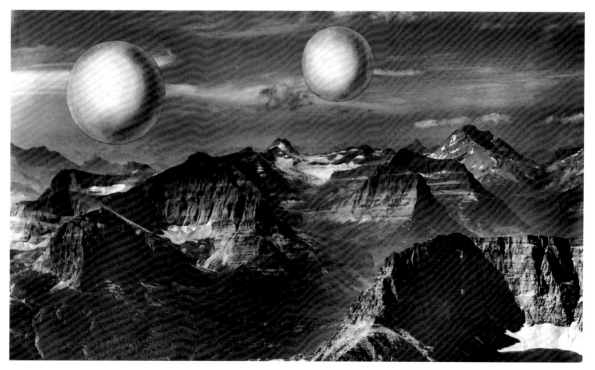

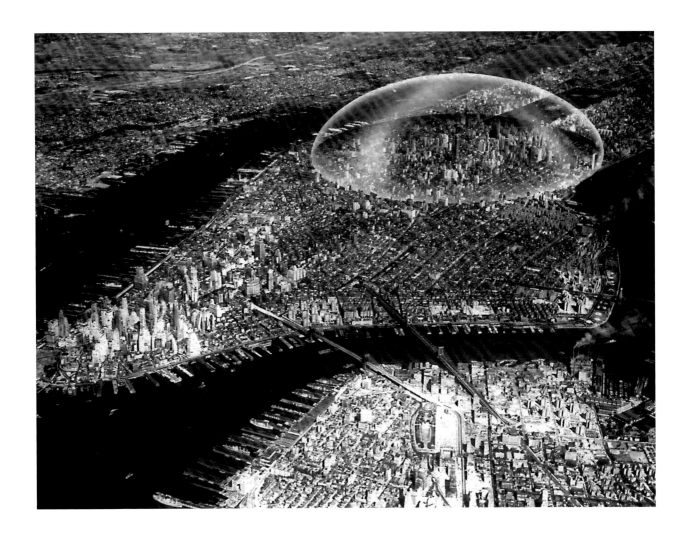

Opposite:

Geodesic Dome for the Yumiuri Golf
Club, Tokyo, Japan, 1961–63
Graphite on tracing paper
pl. 143 28 x 41 3/8 in. (71.2 x 105 cm)

pl. 144 **BUCKMINSTER FULLER**
and **SHOJI SADAO** (b. 1927)
Project for Floating Cloud Structures
(Cloud Nine), ca. 1960
Black-and-white photograph
mounted on board
15 7/8 x 19 3/4 in. (40.3 x 50.2 cm)

BUCKMINSTER FULLER
and **SHOJI SADAO**
Dome Over Manhattan, ca. 1960
Black-and-white photograph
mounted on board
pl. 145 13 3/4 x 18 3/8 in. (34.9 x 46.7 cm)

FOLLOW STAT ON L/O
FOR SIZE AND POSITION

PLAYBOY		JAN. 68	
JOB No. B-0104		PAGE 145	
COLOR		4 color	

PLAYBOY-JANUARY, 145 [CITIES OF THE FUTURE]

BUCKMINSTER FULLER
and **SHOJI SADAO**
Tetrahedron City, project, Yomiuriland,
Japan, Aerial perspective, ca. 1968
Cut-and-pasted gelatin silver
photograph on gelatin silver
photograph with airbrush
pl. 146 11 x 14 in. (27.9 x 35.6 cm)

BUCKMINSTER FULLER
and **SHOJI SADAO**
Floating Tetrahedral City planned for
San Francisco Bay, 1965
Black-and-white photograph
mounted on board
pl. 147 15 5/16 x 19 in. (38.9 x 48.3 cm)

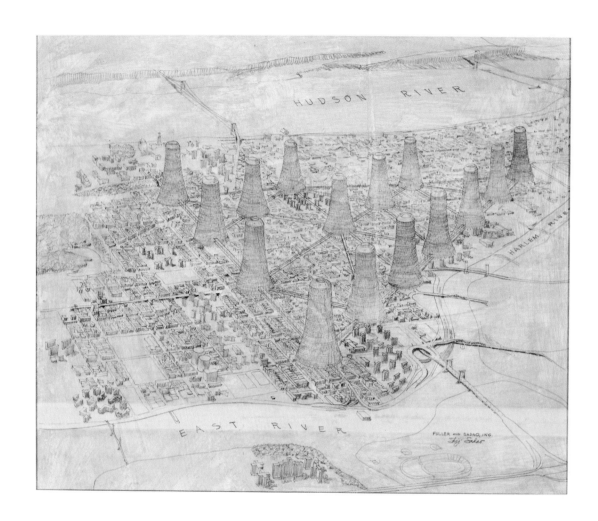

Model of Triton City, 1967
Mixed media
20 $1/2$ x 49 $1/2$ x 44 $5/8$ in.
(52.1 x 125.7 x 113.3 cm)

pl.149

pl.150 Model of Triton City, 1967
Mixed media
5 $3/4$ x 49 $1/2$ x 37 $1/2$ in.
(14.6 x 125.7 x 95.6 cm)

BUCKMINSTER FULLER
and **SHOJI SADAO**
Harlem Redesign, 1965
Graphite on tracing paper
pl.148 24 x 20 in. (61 x 50.8 cm)

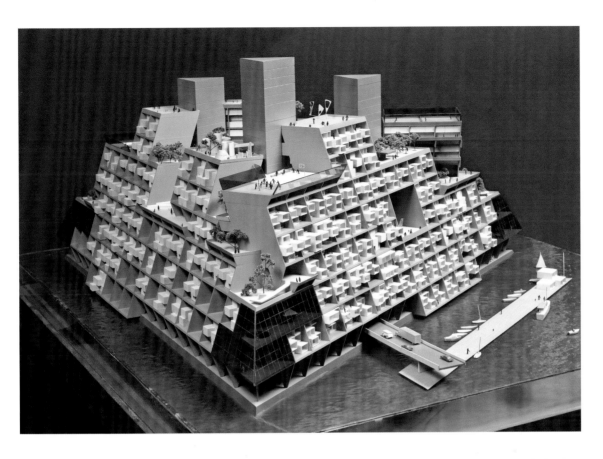

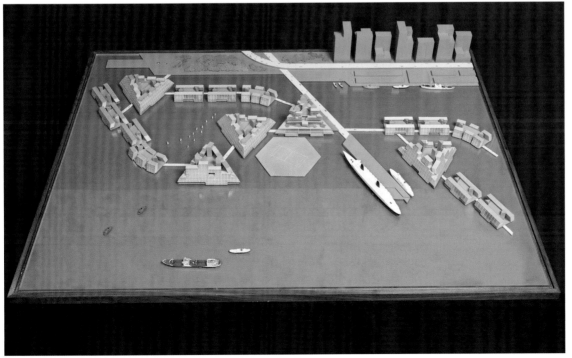

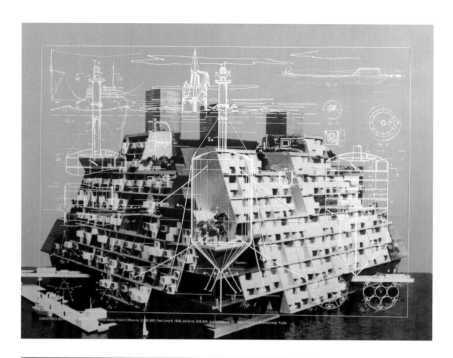

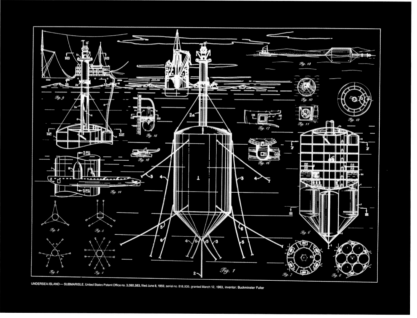

Undersea Island—Submarisle, United States
Patent Office no. 3,080,583, filed June 8, 1959,
serial no. 818,935, granted March 12, 1963,
inventor: Buckminster Fuller
From the portfolio *Inventions:*
Twelve Around One, 1981
Screenprint in white ink on clear
polyester film overlaid on a
screenprint on Lenox paper
30 x 40 in. (76.2 x 101.6 cm)

pl.151

Undersea Island—Submarisle, United States
Patent Office no. 3,080,583, filed June 8, 1959,
serial no. 818,935, granted March 12, 1963,
inventor: Buckminster Fuller
From the portfolio *Inventions:*
Twelve Around One, 1981
Screenprint in white ink on clear
polyester film overlaid on Curtis
plain blue backing sheet
30 x 40 in. (76.2 x 101.6 cm)

pl.152

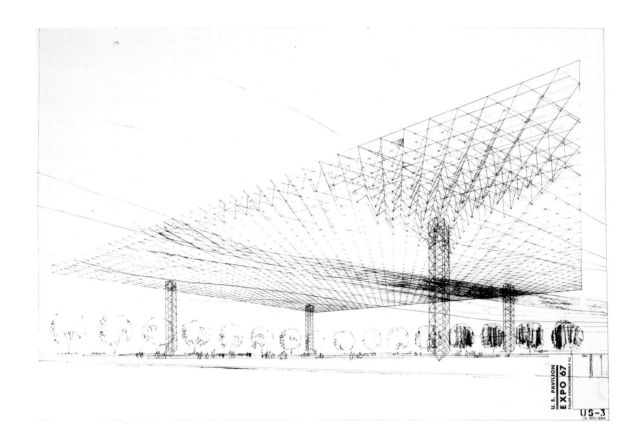

BUCKMINSTER FULLER and
SHOJI SADAO
United States Pavilion Design for
Montreal Expo 67 (Trabeated Truss), 1964
Photostat
pl.**153** 12 x 18 in. (30.5 x 45.7 cm)

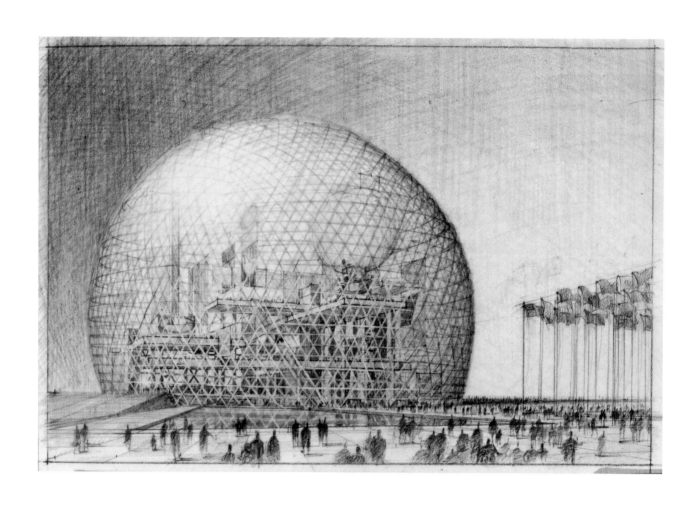

**BUCKMINSTER FULLER/FULLER AND
SADAO, INC./GEOMETRICS, INC.,
ASSOCIATED ARCHITECTS**
Rendering of U.S. Pavilion for
Montreal Expo 67, ca. 1966
Graphite on tracing paper
8 x 10 in. (20.3 x 25.4 cm)

pl. **154**

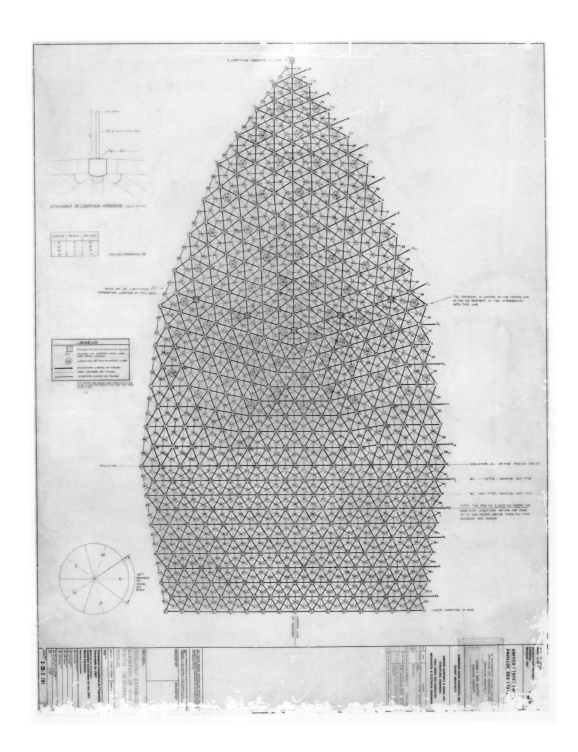

**BUCKMINSTER FULLER/FULLER AND
SADAO, INC./GEOMETRICS, INC.,
ASSOCIATED ARCHITECTS**
Developed Exterior Elevation of One-fifth Segment of Dome
for Montreal Expo 67, 1966
Ink on Mylar

44 x 34 in. (111.8 x 86.4 cm)

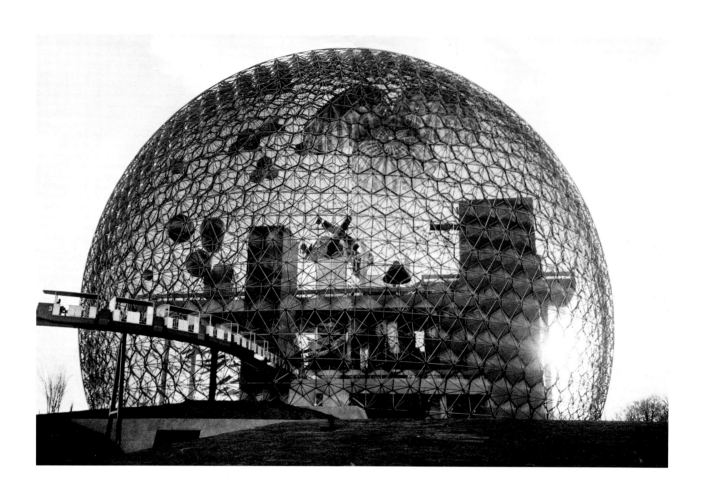

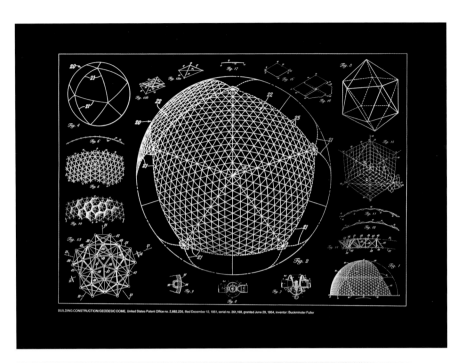

BUILDING CONSTRUCTION/GEODESIC DOME, United States Patent Office no. 2,682,235, filed December 12, 1951, serial no. 261,168, granted June 29, 1954, inventor: Buckminster Fuller

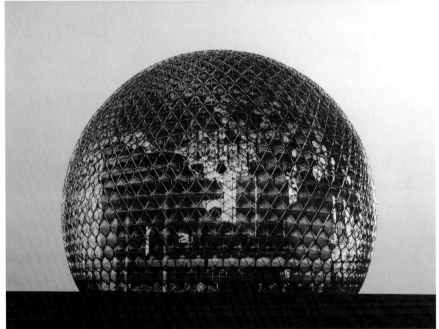

Building Construction/Geodesic Dome, United States Patent Office no. 2,682,235, filed December 12, 1951, serial no. 261,168, granted June 29, 1954, inventor: Buckminster Fuller
From the portfolio *Inventions: Twelve Around One*, 1981
Screenprint in white ink on clear polyester film overlaid on a Curtis plain blue backing sheet

PL. 157

Building Construction/Geodesic Dome, United States Patent Office no. 2,682,235, filed December 12, 1951, serial no. 261,168, granted June 29, 1954, inventor: Buckminster Fuller
From the portfolio *Inventions: Twelve Around One*, 1981
Screenprint on Lenox paper

PL. 158

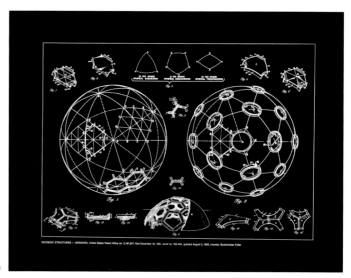

159

Geodesic Structures—Monohex,
United States Patent Office no.
3,197,927, filed December 19, 1961,
serial no. 160,450, granted August 3,
1965, inventor: Buckminster Fuller
From the portfolio *Inventions:*
Twelve Around One, 1981
Screenprint in white ink on clear
polyester film overlaid on a Curtis
plain blue backing sheet
pl. 159 30 x 40 in. (76.2 x 101.6 cm)

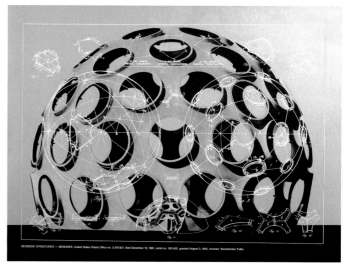

160

Geodesic Structures—Monohex,
United States Patent Office no.
3,197,927, filed December 19, 1961,
serial no. 160,450, granted August 3,
1965, inventor: Buckminster Fuller
From the portfolio *Inventions:*
Twelve Around One, 1981
Screenprint on Lenox paper
pl. 160 30 x 40 in. (76.2 x 101.6 cm)

Geodesic Structures—Monohex,
United States Patent Office no.
3,197,927, filed December 19, 1961,
serial no. 160,450, granted August 3,
1965, inventor: Buckminster Fuller
From the portfolio *Inventions:*
Twelve Around One, 1981
Screenprint in white ink on clear
polyester film overlaid on a
screenprint on Lenox paper
pl. 161 30 x 40 in. (76.2 x 101.6 cm)

161

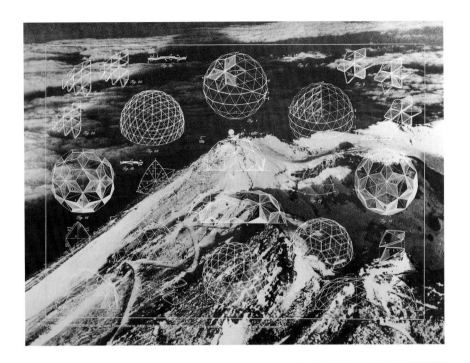

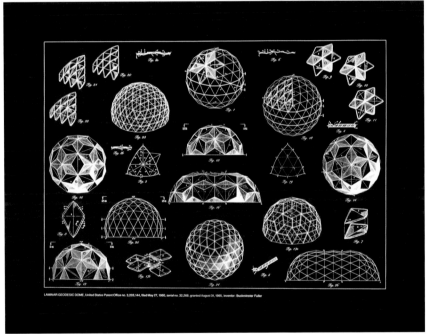

Laminar Geodesic Dome, United States Patent
Office no. 3,203,144, filed May 27, 1960, serial
no. 32,268, granted August 31, 1965, inventor:
Buckminster Fuller
From the portfolio *Inventions: Twelve Around
One*, 1981
Screenprint in white ink on clear polyester film
overlaid on a screenprint on Lenox paper

Laminar Geodesic Dome, United States Patent
Office no. 3,203,144, filed May 27, 1960, serial
no. 32,268, granted August 31, 1965, inventor:
Buckminster Fuller
From the portfolio *Inventions: Twelve Around
One*, 1981
Screenprint in white ink on clear polyester film
overlaid on a Curtis plain blue backing sheet

164

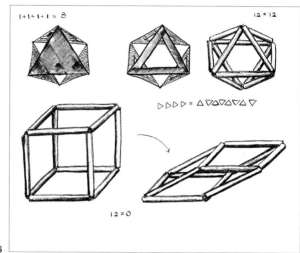

166

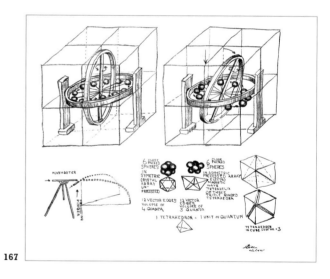

165

167

168

170

169

171

WATERCRAFT — ROWING NEEDLES, United States Patent Office no. 3,524,422, filed March 28, 1968, serial no. 716,957, granted August 18, 1970, inventor: Buckminster Fuller

Watercraft—Rowing Needles, United States
Patent Office no. 3,524,422, filed March 28,
1968, serial no. 716,957, granted August 18,
1970, inventor: Buckminster Fuller
From the portfolio *Inventions: Twelve Around
One*, 1981
Screenprint in white ink on clear polyester film
overlaid on a Curtis plain blue backing sheet
pl.**172** 30 x 40 in. (76.2 x 101.6 cm)

Watercraft—Rowing Needles, United
States Patent Office no. 3,524,422,
filed March 28, 1968, serial no.
716,957, granted August 18, 1970,
inventor: Buckminster Fuller
From the portfolio *Inventions:
Twelve Around One*, 1981
Screenprint on Lenox paper
pl.**173** 30 x 40 in. (76.2 x 101.6 cm)

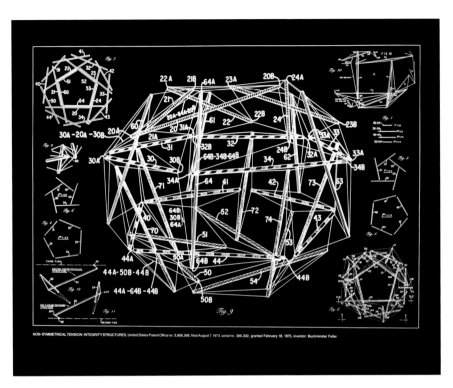

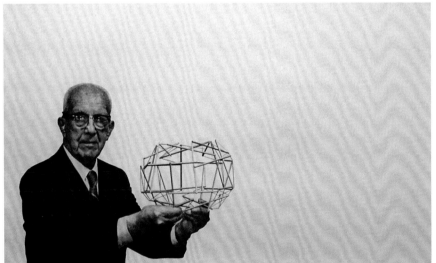

Non-Symmetrical Tension-Integrity Structures,
United States Patent Office no. 3,866,366, filed
August 7, 1973, serial no. 386,302, granted
February 18, 1975, inventor: Buckminster Fuller
From the portfolio *Inventions: Twelve Around
One*, 1981
Screenprint in white ink on clear polyester film
overlaid on a Curtis plain blue backing sheet
pl. **174** 30 x 40 in. (76.2 x 101.6 cm)

Non-Symmetrical Tension-Integrity Structures,
United States Patent Office no. 3,866,366, filed
August 7, 1973, serial no. 386,302, granted
February 18, 1975, inventor: Buckminster Fuller
From the portfolio *Inventions: Twelve Around
One*, 1981
Screenprint on Lenox paper
pl. **175** 30 x 40 in. (76.2 x 101.6 cm)

IN THE OUTLAW AREA

CALVIN TOMKINS

Originally published in *The New Yorker* (January 8, 1966)

When Richard Buckminster Fuller was in New Zealand a year ago, he spent several rewarding hours at the University of Auckland with a friend of his, a cultural anthropologist who also happens to be Keeper of the Chants of the people he belongs to, the Maoris. These chants go back more than fifty generations and constitute, in effect, an oral history of the Maoris, and Fuller, a man who is intensely interested in almost everything, undertook to persuade his friend that it was high time they were recorded on tape and made available to scholars, himself included. The anthropologist said that he had often thought of recording them, but that, according to an ancient tradition, the Keeper of the Chants was allowed to repeat them only to fellow-Maoris. Fuller thereupon launched into an extensive monologue. It was buttressed at every point by seemingly irrefutable data on tides, prevailing winds, boat design, mathematics, linguistics, archeology, architecture, and religion, and the gist of it was that the Maoris had been among the first peoples to discover the principles of celestial navigation, that they had found a way of sailing around the world from their base in the South Seas, and that they had done so a long, long time before any such voyages were commonly believed to have been made —at least ten thousand years ago, in fact. In conclusion, Fuller explained, with a straight face, that he himself had been a Maori, a few generations before the earliest chant, and that he had sailed off into the seas one day, lacking the navigational lore that gradually worked its way into the chants, and had been unable to find his way back, so that he had a personal interest in seeing that the chants got recorded. We have Fuller's assurance that the anthropologist is now engaged in recording all the chants, together with their English translations.

The somewhat overwhelming effect of a Fuller monologue is well known today in many parts of the world, and while his claim to Maori ancestry must remain open to question, even that seems an oddly plausible conjecture. An association with the origins of circumnavigating the globe would be an ideal background for his current activities as an engineer, inventor, mathematician, architect, cartographer, philosopher, poet, cosmogonist, and comprehensive designer whose ideas, once considered wildly visionary, are now influential in so many countries that he averages a complete circuit of the globe each year in fulfillment of various lecture and teaching commitments. Fuller, who was seventy last July and whose vigor seems to increase with his years, gives every indication of enjoying to the hilt his more or less constant "toing and froing," as he calls it. He often points out that man was born with legs, not roots, and that his primary natural advantage as a species is mobility. Fuller has adapted himself so well to the extreme mobility of his present life that he considers it preposterous to be asked where he lives. A New Englander by birth and heritage, descended from eight generations of Boston clergymen and lawyers, he has had his

official base of operations since 1959 in Carbondale, Illinois, where he is a professor at Southern Illinois University in what he has designated as the field of "design science," and where he and his wife occupy a plywood geodesic-dome house built according to the patented specifications of the best known and most successful of his many inventions. By agreement with the university, though, he spends only two months of the year, at most, in Carbondale, and much of that is in brief stopovers between jet flights to other cities, often on other continents. Perpetual mobility, he feels, is a perfectly satisfactory condition for a "world man," which is what he firmly believes all of us are rapidly becoming.

The worldwide enthusiasm for Fuller's ideas is by no means confined to university students, though they are currently his most fervent supporters. Professional mathematicians will undoubtedly question some of the premises of his "Energetic-Synergetic Geometry" when he finally gets around to publishing the definitive book on it that he has had in preparation for thirty-five years, but it is no longer possible to question the practical application of these same principles in such eminently satisfactory structures as the geodesic dome, which has been recognized as the strongest, lightest, and most efficient means of enclosing space yet devised by man. Over the last decade, moreover, scientists in other fields have been finding that Fuller's research into nature's geometry has anticipated some important discoveries of their own. Molecular biologists have now established that his mathematical formula for the design of the geodesic dome applies perfectly to the structure of the protein shell that surrounds every known virus. Several leading nuclear physicists are convinced that the same Fuller formula explains the fundamental structure of the atomic nucleus, and is thus the basis of all matter. As more and more people discover the comprehensive relevance of Fuller's ideas, he finds himself increasingly involved in all sorts of new areas. The government, for example, recently appointed him a "Distinguished Scientist" at the United States Institute of Behavioral Research, in Washington. While this sort of recognition is highly gratifying to one who has always been something of a maverick, working outside the scientific Establishment, it has come as no particular surprise to him. Fuller long ago reached the conclusion that nature has a basic coördinate system, and he has been convinced for a good many years that the discovery of that system would eventually reunite all the scientific disciplines.

To the younger generation, the most stimulating thing about Fuller is probably his exhilarating contention that we have arrived at the threshold of "an entirely new philosophical era of man on earth." For the first time in history, he argues, man has the ability to play a conscious, active role in his own evolution, and therefore to make himself a complete success in his environment. According to Fuller, this dazzling prospect was opened to us by Einstein's concept of energy as the basis of the universe. "Einstein shattered the Newtonian cosmos," he said recently. "In the famous first law of dynamics, Newton had said that a body persisted in a state of rest or constant

motion except as it was affected by other bodies; he was assuming that the normal condition of all things was inertia. Einstein realized that all bodies were constantly being affected by other bodies, though, and this meant that their normal condition was not inertia at all but continuous motion and continuous change. The replacement of the Newtonian static norm by the Einsteinian dynamic norm really opened the way to modern science and technology, and it's still the biggest thing that is happening at this moment in history."

More specifically, the new era was made possible by the phenomenal acceleration of science and technology in the twentieth century—a process that really began, Fuller says, during the First World War, when industry suddenly moved, in his words, "from the track to the trackless, from the wire to the wireless, from visible structuring to invisible structuring in alloys." A good example of this process can be found in the performance of chrome-nickel steel, an alloy that was used for the first time in the First World War, to make cannon barrels more durable; because of an invisible molecular pattern that is created when chromium, nickel, and iron are combined, the resultant alloy held up under conditions of intense heat that would have quickly melted all three of its components separately. Most of the major advances in science and technology since 1914 have been in this invisible realm, which Fuller calls "synergy"—a term that can be defined as the behavior of whole systems in ways unpredictable by the individual behavior of their sub-systems. So far, Fuller maintains, the newest technology has been applied principally to the development of military power, or weaponry, rather than to housing and education and other aspects of what he calls "livingry." Nevertheless, the shift of industry to the new invisible base has brought about such spectacular gains in over-all efficiency, such demonstrated ability to produce more and more goods and services from fewer and fewer resources, that mankind as a whole has inevitably profited. According to a statistical survey that Fuller made some years ago for *Fortune*, the proportion of all humanity enjoying the benefits of the highest technology has risen from less than six per cent in 1914 to twenty per cent in 1938. Today, Fuller places forty-four per cent of mankind in the category of technological "have"s, and it is his frequently stated conviction that by devoting a larger share of their industrial budget to world livingry the "have"s could very quickly bring the entire human race into contact with the highest technology, at which time the weighty problems that oppress us now—war, overpopulation, hunger, disease—would simply cease to exist.

To achieve this utopia, Fuller proposes a worldwide technological revolution. Such a revolution would not be led by politicians, and, in fact, would take place quite independently of politics or ideology; it would be carried out primarily by what he calls "comprehensive designers," who would coördinate resources and technology on a world scale for the benefit of all mankind, and would constantly anticipate future needs while they found ever-better ways of providing more and more from less and less.

One big question, of course, is whether the political and economic convulsions of the present era will allow the comprehensive designers time to carry out this kind of revolution. Fuller thinks that there is still time, but he also thinks that time is rapidly running out for humanity, and it is this belief that keeps him in virtually constant motion around the world, talking to students and training them to think comprehensively as they continue his search for nature's basic patterns.

It is probably fitting that Fuller, as a true world man, should have no real home these days—or, rather, that he should feel at home wherever he happens to be. There is, however, one spot on the globe that comes reasonably close to being a fixed point in his life. Whenever possible, he tries to spend some part of each summer in Maine, on Bear Island, which has been owned by members of his family since 1904, and he has often referred to this place as the source of most of his ideas. "My teleological stimulations first grew out of boyhood experiences on a small island eleven miles off the mainland, in Penobscot Bay of the state of Maine," he writes of Bear Island in the first chapter of "Ideas and Integrities" (Prentice-Hall), a recent volume of essays that constitutes his intellectual autobiography. With this statement in mind, I wrote to Fuller last spring in England, where he was just completing a one-month visiting professorship in the Department of Architecture at Bristol University, to ask if I could spend a few days with him on Bear Island. He wrote back immediately, inviting me to select a date in August for my visit.

Bear Island, I knew, has been preserved in virtually the same state of development as when Fuller's grandmother bought it, in 1904—no telephone, no electricity, no running water—and this strikes some of Fuller's friends as an odd setting for a man whose life is devoted to making the highest technology serve a hundred per cent of humanity. At the same time, I thought, it could be an ideal setting for someone like Fuller, who has always been interested in finding out how nature really works. The island lies approximately in the middle of East Penobscot Bay, about twelve miles east of Camden. Visitors usually take a boat over from Camden, on the mainland, but I had been staying with friends farther Down East and had therefore arranged to come over from the town of Sunset, which is only five miles from Bear on Deer Isle and can be reached by bridge from the mainland. Fuller and several members of his household had spent the afternoon buying groceries and other provisions in Stonington, the nearest town of any size on Deer Isle, and I met them all on the Sunset dock. In addition to Fuller, there was Mrs. Alphonse Kenison, a younger sister of Fuller's, who has missed only three summers of her life at Bear Island, and who, more than anyone else, has kept the place going through the years; his niece Persis and her husband, Robert Alden, a young New York radio-network executive, and their two children; another niece, Persis's sister Lucilla Marvel, and two of *her* children; and Pearl Hardie, a Maine native who lives for much of the year

on Bear Island, where he acts as caretaker for the half-dozen buildings on the island and man of all work, as his father did before him. For the first time in years, Fuller's wife, Anne, had not come to Bear Island this year; she was visiting their daughter, Mrs. Robert Snyder, in California.

Fuller put down a carton of canned goods he had been carrying, and came to greet me, smiling warmly and exposing what looked like a recently chipped front tooth. He is a rather stocky man, powerfully built, and with a massive squarish head and a stubble of white hair cut so short that it stands straight up, and he looked, I thought, about twenty years younger than someone who had celebrated his seventieth birthday the month before had any business looking. His face was almost unlined, and it was also deeply tanned from a recent Aegean cruise. Somewhat heavy features and owlish eyes, magnified enormously by thick lenses, which he has worn since boyhood, can make him appear a bit severe, and at times even forbidding, but that impression is immediately dispelled by his open, toothy, and utterly ingenuous smile.

Fog began rolling in as we finished loading the supplies aboard a motor launch, which was operated by Mr. Hardie, and by the time we had left Sunset Harbor, it was too thick for us to see much of Penobscot Bay. During the trip over, though, Fuller enthusiastically identified each landmark as it materialized through the mist. "There's Eagle," he told me, pointing out a large, wooded island. "And there's John Quinn's boarding house, where we stayed that first summer of 1904—the summer my father fell in love with Bear Island and talked his mother-in-law into buying it for the whole family. Nothing changes here, you see—that house looks exactly the same as it did then. I really think if my grandmother were to come back tomorrow she'd recognize almost everything." He went on to say that his grandmother, Caroline Wolcott Andrews, had also bought two neighboring islands, Compass and Little Spruce Head, which formed part of the same deed, but that it was on Bear, with its fine natural harbor, that they had built a large house in 1905, bringing in all the necessary materials and labor from Boston aboard the schooner Polly, a hundred-year-old vessel that had served as a privateer in the War of 1812. "I used to row over to Eagle and back every day for the mail when I was a boy here," Fuller said. "Four miles a day, often in very bad weather. It made me awfully tough—something I've never lost, by the way."

Although he scarcely looked it, Fuller admitted to me that he was feeling a little run down at the moment. His schedule had been particularly demanding lately, and he had arrived only the day before—several days later then he had planned. From Bristol he had gone to Paris, to address an international assembly of architectural students, and from there to Athens, where he took part in a symposium sponsored by Constantinos Doxiadis, the Greek city planner, on board a chartered cruise ship; then he had flown back to the United States for a round of engagements, the most recent of which had been a conference at Princeton on how to improve the level

of scientific education in the nation's secondary schools. Fuller told me that for the first time in his life—perhaps because he had turned his ankle rather badly one evening on the Greek yacht while dancing the Twist—he had actually begun to feel his age. "I gained twenty pounds on this last trip," he added confidentially. "It's one of the really big problems on this kind of schedule—big, rich dinners everywhere, and all that airline food. I really need a few weeks of this Bear Island atmosphere."

Approaching Bear Island in the fog, we could catch only occasional glimpses of its rocky shoreline. The island is about a mile long and half a mile wide, and is heavily wooded with spruce, pine, and white birch. Rounding the northernmost point, where the land rises sharply to a high bluff, we caught sight of the shingled roof of a large house, and a minute or so later Fuller pointed to an opening in the trees where we could just make out the shadowy arcs of an unfinished geodesic dome that had been, I was told, a family summer work project two years before. "I think it's marvellous coming in with the fog this way," Fuller said as we nosed slowly into the quiet harbor. "With any luck, it will clear tomorrow, and then you'll be able to see where you are. We have a seventy-five-mile sweepout here, so there's quite a lot to see." (Like many other unfamiliar words that crop up in Fuller's casual conversation, "sweepout" is a term borrowed from one of the scientific disciplines—in this case, astronomy; he used it to mean the range of activity that the eye could take in on all sides of Bear Island on a clear day.)

On the dock to meet the boat were a number of small children, most of them members of Mr. Hardie's family, and several adults, including Mrs. Leslie Gibson, another niece of Fuller's, and Professor Sidney Rosen, from the University of Illinois, and his wife. Professor Rosen, a science teacher who also writes biographies of great scientists for young readers, had been assigned by his publisher to write one of Fuller, and he was there to gather material for it. All the small children immediately began clamoring for Fuller's attention. (They all called him Uncle Bucky, and I have observed that nearly all adults who have spent more than five minutes with him find it natural to call him Bucky.) He had to ask the children to repeat their questions several times into his ear, which he cupped patiently with one hand—his hearing, damaged during the First World War, has deteriorated quite a bit in recent years. This difficulty did not appear to discourage the children in the least, or to make even the youngest ones shy of him. After a certain amount of confusion, the supplies were transferred from the launch to a weathered jeep driven by Fuller's sister, Mrs. Kenison, and the rest of us walked up to the main house, on the bluff.

When most of us had assembled in the big house before dinner, Fuller came downstairs carrying a large blue bullhorn, which he had purchased during his stay in England. He explained that he had found it a great boon at conferences and seminars, where he used it not as a loudspeaker but as a directional antenna; the horn

had an electronic amplifier that worked both ways, he said, and by pointing the cone at a speaker across the room, holding the voice box near his good ear, and pressing the amplifier button, he could hear perfectly. "I used to be a real menace at conferences," he told us. "I had to have everything repeated. People kept telling me I should get a hearing aid, but, you see, I've tried that several times, and it has convinced me that nobody really knows anything about how we hear. Hearing aids are non-selective—they just amplify *all* sounds. But I hear some sounds perfectly well —maybe even better than you do—and when those are amplified for me, it's actually painful. With this marvellous device, though, I can be selective. I can pick up sounds just by pointing." He held the horn to one ear and pointed it at Professor Rosen, across the room. "Say something in your normal voice, Sidney," he demanded. Rosen said something too low for me to catch. Fuller said he could hear him perfectly. He passed the bullhorn around the room, so that everyone could try it out, and he slung it around his neck on a white cord when we went to dinner, which was served, like all meals at Bear Island, a few hundred feet from the main house in a farmer's cottage that was on the property when Fuller's grandmother bought it. It turned out that there was not enough room at the crowded table to use the bullhorn comfortably, so he soon gave up trying. The sound of many voices reflected off a low ceiling apparently made it almost impossible for Fuller to hear what anyone said, and, sitting at one end of the table watching the others but taking little part in the conversation, he looked, in the flickering light of kerosene lamps, a little sombre and withdrawn.

When dinner was over, though, he suggested to Professor Rosen and me that we stay on at the table and listen to a few things he had to tell us. As I knew from previous meetings, there is no such thing as an ordinary conversation with Fuller. One question is enough to set him talking for an hour or more, and often a question is not even necessary. His talk follows a process that the cyberneticists call "positive feedback," in that each idea sets off a whole flock of related ideas in something like geometric progression; Fuller seems never to have forgotten anything he ever knew, and his command of statistical detail is awe-inspiring. Perhaps the most amazing aspect of these monologues is that, no matter how long and labyrinthine the digressions that crop up along the way, he invariably returns sooner or later to the primary subject of his discourse, and everything turns out to have been relevant. On that particular evening, he talked for a little longer than three hours. His voice gathered strength and momentum as he went along, and he could clearly have continued for another three hours if his listeners had been up to it. The main subject was his own system of mathematics, which he has been evolving for nearly half a century, and which underlies all his work in other fields.

Fuller began by telling us about meeting C. P. Snow in England two years ago. He said he was sympathetic to Snow's view that there is a gap between the "two cultures"—the sciences and the humanities—but he did not agree that this gap had

been caused by a spontaneous aversion to industrialization on the part of literary men. In Fuller's opinion, scientists had caused it. Soon after the discovery of electromagnetics, in the nineteenth century, he said, scientists had decided that because electrical energy was invisible, it could not be represented to the layman in the form of models, and so they had decided to stop trying to explain what they were doing in terms that the layman could understand. "That's really the great myth of the nineteenth century," he said. "I told Snow the basic reason for the split was that science gave up models."

Having made sure that this point was firmly established, Fuller set off on a survey of his self-education in mathematics. "At Milton Academy, in Massachusetts, where I went to school, I just loved mathematics," he said. "I found I could get A in it whether or not they liked my face. I was severely cross-eyed then, and not a favorite student ever, and I really believed I was getting bad marks in my other subjects because the teachers didn't like me. But they couldn't do that in mathematics. At the same time, there were certain things that the mathematics teacher was saying and doing that I didn't think were really valid, but it was a game you could learn to play, and you could do it right and get your A. For example, we'd been taught fractions, and one day the teacher—it was a woman—said, 'I am now going to teach you a better way. It's called decimals.' She didn't say why she hadn't shown us the better way to begin with. She showed us that an eighth is point one two five, and a quarter is point two five, and a third is point three three three, and so on with threes, out the window and over the hill. I noticed that some of these numbers went out the window and others stayed in the classroom, and I didn't think she really knew what she was talking about. I thought she was very pretty and appealing, and if that's the way she wanted to play the game, I'd play it her way, because I'd been brought up to believe that adults knew all the answers and that you were just supposed to shut up and learn, but I also thought she wasn't on any very profound team.

"Later on, we came to geometry. The teacher made a point on the blackboard, then erased it and said, 'That doesn't exist.' She made a row of points, and said, 'That's a line, and it doesn't exist, either.' She made a number of parallel lines and put them together to form a plane, and said it didn't exist. And then she stacked the planes one on top of the other, so that they made a cube, and she said that existed. I wondered how you could get existence out of nonexistence to the third power. It seemed unreasonable. So I asked her, 'How old is it?' The teacher said I was just being facetious. I asked her what it weighed and I asked how hot it was, and she got angry. The cube just didn't have anything that I thought was existence, but I thought I was probably being unfriendly, and so I shut up. I got A's in all my science work, and when I got to Harvard I didn't go on with mathematics, because it was so easy —just a sort of game you played. I thought I'd take something really difficult, like government or English.

"I was kicked out of Harvard. I spent my whole year's allowance in one week, and I cut classes and went out quite deliberately to get into trouble, and so naturally I got kicked out. I was sent to work in a factory in Canada making cotton-mill machinery, and I did very well there. It was a very important phase of my life, for I met shop foremen and machinists, and got to know a lot about their tools and about metals in general. I did so well that Harvard decided I was really a good boy and took me back the following year, but obviously I couldn't stay at Harvard very long. [In his autobiography, Fuller wrote that what really bothered him at Harvard was the social institutions.] So I cut classes and got fired again. This time, I enlisted in the Navy, where again I began to do very well. Well, one day in 1917 I was standing on the deck of my ship looking back at the wake—it was all white because of the bubbles—and I began wondering idly how many bubbles there were back there. Millions, obviously. I'd learned at school that in order to make a sphere, which is what a bubble is, you employ pi, and I'd also learned that pi is an irrational number. To how many places, I wondered, did frustrated nature factor pi? And I reached the decision right at that moment that nature didn't use pi. I said to myself, 'I think nature has a different system, and it must be some sort of arithmetical-geometrical coördinate system, because nature has all kinds of models.' What we experience of nature is in models, and all of nature's models are so beautiful. It struck me that nature's system must be a real beauty, because in chemistry we find that the associations are always in beautiful whole numbers—there are no fractions. And if nature can accomplish all those associations in beautiful whole numbers to make all her basic structures, I thought, then the system will turn out to be a coördinate system and it will be very, very simple. And I decided then, in 1917, that what I'd like to do was to find nature's geometry."

Instead of using points and lines and planes, which had no objective existence, Fuller decided to see what would happen if he started with vectors, or lines of force, which had appealed to him very much when he studied Galileo's diagram of forces in school. He liked vectors tremendously, he said, because they were descriptions of actual physical events. "Your vector has a length that is proportionate to the product of the velocity times the mass," he explained. "Vectors represent energy events, and they are discrete. All my geometry would therefore be discrete geometry, and you wouldn't have to worry about infinity and things going out the window all the time. I was interested in exploring a geometry of vectors, which always represent energy events and actions in respect to other energy events and actions. The vector has velocity, and time is a function of velocity, so such a geometry would automatically have a time dimension. The qualities I had wanted in the Greek cube which the Greek cube didn't have—of heat and weight and age, and so forth—would be implicit in the velocity and the mass that would be translated into energy. . . . Can you fellows go on taking this, or are you getting too tired? You're going to get awfully sleepy in this Bear Island atmosphere."

"No, no," Professor Rosen said. "We're fine."

What followed was a detailed account of the mathematical steps by which Fuller, through his study of vectors, came to the conclusion that nature's geometry must be based on triangles. "The triangle is a set of three energy events getting into critical proximity, so that each one with minimum effort stabilizes the opposite angle," he said. "Now, I found that a quadrilateral—a square, for example—will not hold its shape. No rubber-jointed polygon holds its shape except one that is based on the triangle. So I said, 'I think all nature's structuring, associating, and patterning must be based on triangles, because there is not structural validity otherwise.' *This is nature's basic structure, and it is modellable.*"

Fuller had been picking up steam right along, and by this time he was talking very rapidly. Pausing to take a Japanese felt-tipped pen from his pocket, he proceeded to illustrate the next phase of the lecture with vigorous drawings on a white pad. "Now, if I'm going to subdivide the universe with triangles, how many triangles will it take to give me a system that will have both an inside and an outside?" he asked. "I found that two triangles just fall back on each other and become congruent. I found that it takes a minimum of three triangles around a point. When you put in three triangles, with three common sides, around a point, they form a fourth triangle at the base and what you get is a tetrahedron. We know that nature always does things in the simplest and most efficient way, and structures based on tetrahedrons are the structures that nature uses—these are the only babies that count. All the metals are made up of some form of tetrahedron. All the other shapes you find in nature are only transformable states of the tetrahedron. This is what nature is really *doing*.

"All right, getting back to Snow, then, I showed him how I could make a model of any of nature's structural relationships by using triangulation as the basis. Everything was now back in modellable form, I told him. And soon after that Snow said on the radio that he believed that the chasm between the sciences and the humanities could be closed—that the conceptual bridge had been found."

A gust of wind buffeted the cottage, throwing open the doors on both sides and scattering the loose sheets of paper that Fuller had torn from the pad. It was eleven o'clock. When the doors had been secured again, Fuller poured himself a cup of tea from a large pot he had been working on ever since dinner. It was quite clear that the Bear Island atmosphere was not making *him* sleepy. He talked for a while about the immense changes that were taking place in the world, and how the really significant developments were going on quite independently of politics, and this brought him to the subject of the fourth Dartmouth Conference, held in Russia the previous summer, which he had attended.

"The Dartmouth Conference was instituted several years ago," he explained. "The first one was held at Dartmouth College, and this one, the fourth, was in Leningrad. It's supposed to be a meeting of prominent Soviet and American citizens,

in a wide variety of different fields, to talk over any and all problems. There were twenty-one Russians at our last meeting and sixteen Americans, and that's the way it's been right along—the Russians have been more thorough in appointing people from all parts of their society, most of them the top men in their field. We had some very exciting people, though. We had Paul Dudley White—the Russians told me they considered White the world's greatest cardiologist, and that they trusted him more than any other American; the poor man is so trusted by both sides that he hardly has any time to himself anymore—and we had James Michener and John Kenneth Galbraith and David Rockefeller. One of the Russians got up during the seminar and said, 'Mr. Rockefeller, I'm an old Bolshevik, and I must say you're very different from what I'd always thought of as a capitalist.' They liked him very much. It was a wonderful meeting, and it was decided that it would end with a prognostication by a Russian and a prognostication by an American.

"We had talked very frankly and freely, and we were all somewhat aghast to find that whatever we wanted to do or thought should be done about the problems between us would inevitably be defeated by the bureaucracies on both sides. The Russians, though, were convinced that they had one fundamental advantage over us. They kept saying, 'We have a singleness of purpose in Russia, while in America you're completely competitive and you're always cancelling out each other's good effects.' They said it with such earnestness—they were really convinced it was true. And some of the Americans were not able to answer right away whether it was true or not.

"At any rate, I was chosen to give the American prognostication. The Russian one took up the whole morning and I had the whole afternoon—fabulous. I always speak spontaneously, because I've found that it really is possible to think out loud. Although I seemingly go over and over the same inventory of thoughts and experiences, I find that each time I do, I learn something new, and that I have to change or rearrange what I've learned, and that I'm not allowed to carry out yesterday's myths. Anyway, I found myself standing up and talking in the following way. I said, 'I don't know why I'm talking to you here, because you're all so ignorant.' Well, they were surprised by that, and I was surprised, too. But then I had to make good on it, so I said, 'Many of you think of yourselves as scientists, and yet you go off on a picnic with your family, and you see a beautiful sunset, and you actually *see* the sun setting, going down. You've had four hundred years to adjust your senses since you learned from Copernicus and Galileo that the earth wasn't standing still with the sun going around it. I've made tests with children—you have to get them right away, before they take in too many myths. I've made a paper model of a man and glued him down with his feet to a globe of the world, and put a light at one side, and shown them how the man's shadow lengthens as the globe turns, until finally he's completely in the shadow. If you show that to children, they never see it any other way, and they can really understand how the earth revolves the sun out of sight. But

you scientists still see the sun setting. And you talk about things being "up" or "down" in space, when what you really mean is *out* and *in* in respect to the earth's surface. And you say that the wind is blowing from the northwest, which means that there must be a place called northwest that it's blowing from—being blown, I suppose, by one of those little fat-cheeked zephyrs that used to be drawn on maps. When you scientists say the wind is blowing from the northwest, what's actually happening is that there's a low-pressure area sucking it toward the southeast, pulling the air past you. So why don't you say the wind is sucking southeast, which is what it's really doing?' Well, by this time the Russians were all laughing. They were off their high horse. Next, I told them that young people were always wondering what it was like to be on a spaceship, and that my answer was always, 'Well, what *does* it feel like? Because that's what you're on.' The earth is a very small spaceship. It's only eight thousand miles in diameter, and the nearest star is ninety-two million miles away, and the next star after that is billions of miles away. This spaceship is so superbly designed that we've had men on board here for about two million years, reproducing themselves, thanks to the ecological balance whereby all the vegetation is respiring all the gases needed by the mammals and the mammals are giving off all the gases needed by the vegetation, even though they may think they're just making hot air. The bees go after the honey, which is all they're interested in, and quite inadvertently their little tails knock off the pollen that fertilizes the vegetation. And so I said that in America we're all bees, and we're all after our honey, and inadvertently our little tails knock off quite a lot of pollen, and inadvertently we've made some contributions. Well, the Russians really had a good sense of humor. They realized they were all just after honey themselves, and that their whole argument about singleness of purpose was pretty silly, and that the whole thing was working quite independently of politics.

"And so I said, 'I don't know any man who really knows anything about himself. I don't think anybody in this room can stand up and tell me what he's doing with his luncheon. And no one can stand up and say that he's consciously pushing each of his hairs out of his head in preferred shapes and colors, and I doubt whether anyone even knows why he has hair. In fact, I don't know anybody who really knows anything. But it's very important to recognize what we don't know, and to realize that so far man has been moderately successful in his environment despite his ignorance.' Then I went into Hoyle's prediction that hundreds of millions of planets are going to be discovered, and that not all the human beings on all the planets will have lived to fulfill their functions, and I said, 'I think we have a very borderline case here, and it's about time we began to make some sense.' That's where I really started my talk. My main prognostication was based on the point that, for the first time in the history of the world, man is just beginning to take conscious participation in some of his evolutionary formulations. And from this point on we're not going to be

allowed to be innocent anymore. From now on, we're going to have to be very responsible, or the show is not going to work."

Fuller broke off and looked from Rosen to me and back, a sudden smile illuminating his face. "You must find it strange to sit here all this time and hear me talk about me," he said. "But the fact is I really am pure guinea pig to me. I set out many years ago to see what would happen if an individual did certain things. Back in 1927, just after our second child was born, I committed myself to as much of a fresh start as a human being can have—to try to go back to the fundamentals and see what nature was really up to. But I was all alone, and up against the massive corporation and the massive state. 'Can the unsupported individual really get anywhere?' I asked myself. Because I'm not impractical, I'm not a blind idealist. How could I work in the system without capital backing? And I came to the following conclusion: In the universe, everything is always in motion, and everything is always moving in the directions of least resistance. That's basic. So I said, 'If that's the case, then it should be possible to modify the shapes of things so that they follow *preferred* directions of least resistance.' I made up my mind at this point that I would never try to reform man—that's much too difficult. What I would do was to try to modify the environment in such a way as to get man moving in preferred directions. It's like the principle of a ship's rudder, which is something I thought a lot about as a boy here on Bear Island. The interesting thing about a rudder is that the ship has already gone by, all but the stern, and you throw the rudder over, and what you're really doing is to make a little longer distance for the water to go round; in other words, you're putting a low pressure on the other side, and the low pressure pulls the whole stern over and she takes a new direction. The same in an airplane—you have this great big rudder up there, with a little tiny trim tab on the trailing edge, and by moving that little trim tab to one side or the other you throw a low pressure that moves the whole airplane. The last thing, after the airplane has gone by, you just move that little tab. And so I said to myself, 'I'm just an individual, I don't have any capital to start things with, but I can learn how to throw those low pressures to one side or the other, and this should make things go in preferred directions, and while I can't reform man, I just may be able to improve his environment a little. But in order to build up those low pressures I'm going to have to really know the truth.'"

Fuller broke off again, and poured himself a last cup of cold tea. The wind made a sudden restless sound in the fireplace chimney. He leaned back and stared at the ceiling. "Of course, I know that you can't get to the truth," he said slowly. "Heisenberg was right about that—the act of measuring *does* alter what's being measured. But you can always get nearer to the truth. It's something you can get closer to, even though you never get to it. And today the young people really want to know about things, they want to get closer to the truth, and my job is to do all I can to help them.

The child is really the trim tab of the future. At any rate, that's the sort of thinking that came out of Bear Island, and that's probably enough for tonight, isn't it?"

Exposure to an hour or more of Fuller's conversation can give rise to extremely varied reactions. Not infrequently, people meeting him for the first time are so taken aback by what seems to them a torrential outpouring of ego that they hear nothing he says, and go away in a state of shock. Others are convinced that, having suffered for years at the hands of people who refused to take his ideas seriously, he is simply enjoying his revenge. Such reactions are rarely experience by students, who pack lecture halls to hear him and often keep him talking long after the scheduled time. A Fuller lecture can easily run for six hours, and upon occasions he has talked, with only incidental breaks, from eight o'clock in the morning until past midnight. After the first hour, which is usually perplexing, students find themselves tuned in to the unique Fuller wave length, with its oddly necessary word coinings and its synergetic constructions. They dig his humor, which often appears as a sort of wry comment on his own verbal style—as, for example, when digressing to students at the University of London about bird ecology not long ago, he described how "the male birds fly off to sweep out areas of maximum anticipated metabolic advantage," then paused and added, reflectively, "Worms." What's more, students seem to feel that there is really very little ego involved in his monologues, that Fuller *is* pure guinea pig to Fuller, and that when he talks about himself and his experiences, his tone is that of an objective, if greatly interested, third party. Nothing irritates Fuller more than occasional implications by journalists that he is a non-stop talker who loves to hear himself hold forth; he never talks, he says, unless he is invited to do so, but he cannot limit himself to one or two aspects of a complex subject. Since 1927, which he looks back on as the critical year in his life, he has taken himself and his experiences as raw material for a series of experiments aimed at improving man's environment, and to anyone who is interested he will provide the results, in comprehensive form.

What happened in 1927 was that Fuller, at the low point of his career, gave serious consideration to the idea of committing suicide and then rejected it in favor of what he has called "a blind date with principle." For several years after he resigned from the Navy, in 1919, he had done rather well for himself. He had worked as assistant export manager for Armour & Co., and, in partnership with his father-in-law, a New York architect named James Monroe Hewlett (Fuller married Anne Hewlett in 1917), he had formed a company to exploit a building-block method of construction, patented by the two men, which was used in two hundred and forty houses and small commercial buildings over a five-year period. In 1922, the Fullers' daughter, Alexandra, had died, just before her fourth birthday, after a succession of illnesses culminating in spinal meningitis. Fuller began drinking heavily; he recalls that he used to stay up all night drinking, and still have enough energy to work

twelve or fourteen hours the next day. When his father-in-law was obliged to sell his stock in the building-block company in 1927, Fuller, a minority stockholder, was informed by the new owners that his services were no longer needed. This blow came shortly after a second daughter, Allegra, was born to the Fullers. In the belief that he had made a complete mess of his life thus far, Fuller considered what seemed to him the only two courses open to him: he could do away with himself, thereby giving his wife and new baby a chance to find someone better equipped to take care of them, or he could devote the rest of his life to the service of something greater than he was, and try to get straightened out that way. In the light of his background —eight generations of Boston idealists, Unitarian ministers, and transcendental thinkers (Margaret Fuller was his great-aunt)—the answer was never really in much doubt. In his autobiography, Fuller tells how he stood on the shore of Lake Michigan in Chicago, where he was living at the time, and found himself saying, "You do not have the right to eliminate yourself, you do not belong to you. You belong to the universe."

Fuller moved his family into a slum neighborhood in Chicago, cut himself off from contact with everyone he had known before, and began, he says, to do his own thinking. It seemed to him that, purely by chance, he had already acquired a great deal of valuable experience, having repeatedly found himself working in areas that gave him an insight into the new world of accelerating technology. In the Navy, particularly, his exposure to the principles of ballistics, logistics, radio electronics, and naval aviation had given him a glimpse of future industrial developments that would make it possible—through the use of the new alloys, for example—to do more and more with less and less. This sort of technological movement seemed even then to promise, if carried far enough, a reversal of the old Malthusian concept of the economic forces at work in the world. Malthus had said that the world's population would always multiply more rapidly than the available food supply, and Darwin's theory of the survival of the fittest had seemed to provide a melancholy solution to this perennial problem, and also an ecological justification of war. But if technology could provide more and more goods from fewer and fewer resources, it was conceivable that man could convert himself from an inherent failure, as Malthus had depicted him, into a success in his environment. Technology, of course, is dependent on science, for it requires the discovery by science of certain basic patterns in nature that can be isolated and reproduced by industrial processes. In 1927, then, Fuller dedicated himself to a search not only for these patterns but also for ways in which they could be made to benefit his fellow-man. He is almost alone among twentieth-century scientists in having thus concerned himself at all times with the social implication of his discoveries.

Although society has not always been ready to accept what Fuller has come up with since then, he insists that not one of these inventions has been a failure. His first Dymaxion house, a circular dwelling unit suspended by cables from a central mast,

was a successful exploitation of the discovery that the tensile strength of certain metals and alloys is far greater than the strength of the same materials when used in compression. (The term "Dymaxion," with its overtones of "dynamic" and "maximum," was coined by a pair of public-relations men for Marshall Field's, the Chicago department store, where the house was first exhibited, in 1929.) Fuller's Dymaxion three-wheeled automobile, of which three prototypes were built between 1933 and 1935, could turn in its own length; it could also develop a speed of a hundred and twenty miles per hour using a standard ninety-horsepower Ford engine. His 1943 Dymaxion Airocean World Map was the first cartographic system to receive a United States patent, and was one of the first Fuller inventions to arouse the serious interest of other scientists; it shows the whole surface of the earth in a single flat view with no visible distortion. In 1944, the government agreed to release high-priority aluminum alloys for Fuller's Wichita House, a new version of the Dymaxion circular unit. It was to sell for sixty-four hundred dollars, and was scheduled to go into mass production as an emergency solution to the postwar housing shortage, but with the end of the war and the end of rationing the arrangement fell apart. Like a die-stamped, mass-producible bathroom unit that Fuller had designed earlier, the Wichita House was ultimately the victim of caution and inertia in the building industry. Fuller had decided long before that housing was technologically the most backward of all the major industries, and he continued to concentrate his efforts in the field of shelter.

In 1947, Fuller produced the discovery that made him famous—the geodesic dome whose basic, patented formula comes straight from nature's geometry. For a while, all geodesic domes were manufactured by two companies Fuller set up for that purpose, Synergetics, Inc., and Geodesics, Inc. But now he has licensed about two hundred construction and other firms to do the actual manufacturing and building under his patent, and for every dome sold he receives a royalty of five per cent of the selling price. Fuller's domes are now spread throughout the world—more than three thousand of them, according to a recent count. They range in size from small living units to a huge maintenance and repair shed, three hundred and eighty-four feet in diameter, that was put up in 1958 for the Union Tank Car Company in Baton Rouge, and they are just as suitable in the Arctic, where geodesic Radomes house the listening devices of the Air Force's Distant Early Warning Line, as in Equatorial Africa, where Fuller has taught natives to make them out of bamboo, or on the top of Mount Washington, exposed to the highest wind velocities on the North American continent. The Marine Corps has adopted air-liftable geodesic domes as its advance-base shelters, and the Department of Commerce has been using them since 1956 to house its exhibits at international trade fairs. Fuller's domes are a product of his geometry of vectors, their prodigious strength arising from a patented formula that combines interlocking tetrahedrons and icosahedrons so as to balance the forces of tension and compression and thus distribute stresses evenly throughout the

structure. Because their strength is all in the invisible mathematics, they can be made of almost any material, including paper, and because the basic structural formula is simple, they can be assembled by unskilled labor, using color-coded parts, in unbelievably short order; in Hawaii, for example, a hundred-and-forty-five-foot-in-diameter dome was assembled in one day by the Kaiser Aluminum company, in time for a symphony orchestra to give a concert inside it that same evening. Although Fuller has farmed out the production of his domes to individual licensees, he has more requests than he can handle to adapt the basic design for various purposes. Right now, he is designing several domes for the 1968 Olympics in Mexico City, a huge dome to cover the Mexico City Plaza de Toros, and a huge geodesic sphere to serve as the United States Pavilion at the 1967 Montreal World's Fair. (Fuller was named the official architect for the United States Pavilion in Montreal, although he has no architect's license and must have all building contracts signed by an associate, a young man named Shoji Sadao.) The domes have brought Fuller wealth and fame, but there are times when he grows a little tired of hearing about them. They are, after all, only one application of a lifetime's research. He once told his friend and biographer Robert W. Marks, "I did not set out to design a house that hung from a pole, or to manufacture a new type of automobile, invent a new system of map projection, develop geodesic domes or Energetic Geometry. I started with the universe—as an organization of regenerative principles frequently manifest as energy systems of which all our experiences, and possible experiences, are only local instances. My objective was humanity's comprehensive success in the universe. I could have ended up with a pair of flying slippers."

Although, technically speaking, Fuller is not an architect, he has come to be recognized as a powerful force in contemporary architecture. Leading architects here and abroad often make a point of praising his contributions in their field, even though what he has done, in a sense, has been to challenge the whole basis of their aesthetic, pointing out that the supposedly modern and functional Bauhaus-derived architecture of our time is only superficially functional and not modern at all. It is almost as though the architectural profession had chosen to avoid Fuller's challenge by pretending to agree with what he says.

At breakfast the morning after the three-hour lecture on mathematics and other matters, Fuller, seeming not in the least winded, talked for quite a while about the deficiencies of contemporary architecture. He had come to breakfast in a bright-orange slicker, looking somewhat disconsolate, with the announcement that only about ten per cent of the runoff from a brief, hard rain that had taken place during the night had gone into the cisterns; he had been out checking the gutters and rainspouts, and had found most of them badly clogged. This bit of non-functionalism—the drinking water on Bear Island comes from a spring, but water for washing is col-

lected as runoff—led him, by way of a chance remark, to a discussion of the Bauhaus idea and how it differed from his own work.

"You see, the very essence of the Bauhaus was what happened to Germany as a consequence of the First World War," Fuller said. "Having lost the war and suffered so much destruction, the Germans had the problem of rebuilding with very little money. Obviously, one of the things they could do without was decoration. Walter Gropius and those people looked at American industrial engineering about this time, and decided maybe they could turn that into an aesthetic. They didn't make any engineering contributions. These men simply used the hard edge that had been developed in engineering. They didn't invent a new window or a new structural principle, or anything like that; they didn't go in back of the walls and take a look at the plumbing, for example. Mies van der Rohe, who was the most perceptive of all of them, saw the glasswork in the American stores and began making drawings of buildings that were all glass. Now, I was proposing something completely different at the time. I was saying that the same science that had gone into weaponry and the development of the advanced technology of the aircraft industry had also made it possible to make very much lighter and more powerful structures. I had come to the conclusion in 1927 that Malthus might be wrong, you see, because I'd realized that real wealth is *energy*, not gold, and that it is therefore without practical limit. Einstein and Max Planck demonstrated once again that energy could neither be created nor lost and that it left one system only to join another—the famous law of conservation of energy. And this meant that wealth was not only without practical limit but indestructible. Man's intellect, his ability to tap the cosmic resources of energy and make them work for him, had really caused wealth to be regenerative, or self-augmenting. The main thing, then, was to use this great energy-wealth to help man instead of to kill him—for example, in designing ways to house the third of humanity that was without adequate shelter. At any rate, that was very different from what Gropius taught his students. And now Mies tries to confuse me by saying 'Less is more'— meaning, I suppose, that less decoration is more effective. But that's hardly the same as doing more with less in making an airplane."

After a moment's reflection, Fuller continued, "Architects, engineers, and scientists are all what I call slave professions. They don't go to work unless they have a patron. But architects are the most slavish of all, and they work under a system that hasn't changed since the time of the Pharaohs. When you're an architect, the patron tells you where he's going to build, and just what he wants to do. And he says, 'My brother's in the hardware business, and my wife wants this, and here's the building code, and the labor laws, and here are the zoning regulations, and here's Sweet's catalogue. I don't want anything special outside of it.' So the architect is really just a tasteful purchasing agent. He discovers he's inherited a skeleton frame and guts, and all he can do is put in curtain walls—what I call exterior decorating. And for

this you don't really need an architect at all. Only about four per cent of the building done in America involves architects, in fact. So who does design what you build? I've found that the real design initiative comes from way, way out, and gets into the prime contracts for hardware and so forth, and I've also found that the important hardware comes originally from those people who are producing the weaponry—battleships and airplanes. The first electric-light bulbs were developed for use on board battleships. The same thing with refrigeration and desalinization plants, which the Navy has had for half a century.

"You see, it surprises people when you tell them that since the last ice age three-quarters of the earth has been water, and that of the one-quarter that is land very little has been lived on. Ninety-nine per cent of humanity has lived on only about five per cent of the earth—a few little dry spots. Now, the law has always been applicable only to this five per cent of the earth, and anyone who went outside of it—the tiny minority that went to sea, for example—immediately found himself outside the law. And the whole development of technology has been in the outlaw area, where you're dealing with the toughness of nature. I find this fascinating and utterly true. All improvement has to be made in the outlaw area. You can't reform man, and you can't improve his situation where he is. But when you've made things so good out there in the outlaw area that they can't help being recognized, then gradually they get drawn in and assimilated. A good example of what I mean is going on right now in the space program. I'm on the advance research team of NASA, on a consultant basis, working with some very good people on this problem of how to keep man in space. Now, the real purpose of the space programs at the present time is simply to get the highest weapons advantage, and the side that gets it will rule the universe. This is greatly hidden from people by all the talk of getting to the moon, but the space platform, the military advantage, is really *it*. In order to maintain advantage in space, though, where there's no atmosphere and no water and no sewer lines and no berries to eat, for the first time in history you have to look out for man. Not just for the weapon but for the individual. And this is really the most significant part of the whole thing, as far as I'm concerned. Until now, making more effective weapons on earth never involved making life better for man. The little container that sustains man in space will actually be the first scientific house in history. Inadvertently, man is trying for the first time to learn how to make man a success. It's inadvertent, but it's being done."

The whole question of design initiative is central to Fuller's vision of utopia. The initiative must be wrested from the military strategists by comprehensive designers, he says, if we are to escape destruction. And where are the comprehensive designers to come from? Despite his reservations about most modern architects, Fuller is convinced that the leaders of the great new technological revolution will come from the architectural profession, which, in an over-specialized age, is almost

the only profession that is trained to put things together and to think comprehensively. Architectural training must first be thoroughly overhauled and placed on a new footing, however, and Fuller has been doing quite a good deal lately, trim-tab fashion, toward that end. For some time, he has urged the creation of research centers at leading architectural schools, where students and professional architects can work together in anticipation of future needs, and within the last few years a number of universities in this country and abroad have set up such centers, which are often under Fuller's direct guidance. Fuller has visited a hundred and seventy-three colleges and universities, all told, and architectural students at a great many of them now exchange information and keep in touch with each other and with a "World Resources Inventory" that Fuller has set up at Southern Illinois University—a vast compilation of data on raw and organized resources, human trends, and projected human needs. These developments encourage Fuller to believe that the comprehensive design initiative is finally getting into the right hands. He devotes a large proportion of his time and energy now to coördinating this worldwide student movement, which remains, at his insistence, loosely organized and resolutely non-political. In Paris last June, at an assembly for architectural students held in conjunction with the International Union of Architects' Eighth Biennial World Congress, the students adopted a proposal by Fuller that the years from 1965 to 1975 be designated as a World Design Science Decade. The goal, simply stated, is "to render the total chemical and energy resources of the world, which are now exclusively preoccupied in serving only 44 per cent of humanity, adequate to the service of 100 per cent of humanity at higher standards of living and total enjoyment than any man has yet experienced."

By the time Fuller had concluded his remarks on architecture and the design initiative, it was nearly one o'clock. The weather had cleared during the morning. A benign sun presided over the blue water and dark-green islands of the bay, and the seventy-five-mile sweepout left one's eyes feeling freshly washed. Following the custom of summer people in all latitudes, several members of the family came to lunch with the observation that it had turned into "a real Bear Island day."

Later that afternoon, I set off with Fuller for a tour of the island. The weather was magnificent and he took deep breaths as he walked, stopping short when he wanted to say something, then forging ahead rapidly with short, vigorous strides. He had his two-way bullhorn slung around his neck, but he scarcely ever bothered to use it. "I really feel quite wonderful," he announced at one point. "When I got here, three days ago, I was in terrible shape, and already I'm getting my energy back."

We crossed a long meadow sloping away from the main house and past the dining cottage, and headed toward the heavily wooded southern end of the island. On the way, Fuller stopped to show me a small graveyard—three headstones in a neatly fenced plot. "When my grandmother bought this island," he said, "the settlers

were down to two families—the Parsons and the Eatons, both fishermen-farmers. They moved back to the mainland, and we agreed to keep up their little burial ground. We've found gravestones all over the island, you know, some of them going back a century and a half, and we've also found eleven cellar holes, which shows you how much life there's been here. These islands have been lived on for generations. The earliest settlers from England were massacred when they tried to build on the mainland, but islands were easier to defend. You'll find that the British charts of 1765, or thereabouts, show all the Penobscot Bay islands, many with the same names they have today. You must get my sister Rosie to tell you about the early history of the island sometime. She knows a lot about it. Get her to tell you about the time the Seventh-Day Adventists came here to wait for the end of the world." (I did ask Mrs. Kenison about the Adventists that evening, and she told me that in 1901, or thereabouts, all the members of this sect in Bangor had rowed over to Bear Island one day, climbed trees, and settled down to wait for the end of the world, which they expected momentarily. No one knew why they had picked Bear Island. When the scheduled event failed to take place, they climbed down and rowed back.)

We pushed on into the woods. Fuller paused at frequent intervals to sniff the wild raspberry and balsam and other forest scents, which he said were especially delicious just after a rain. His hearing and eyesight were not all they might be, he said, but his sense of smell had always been very good. Our path, which had followed the edge of the high bluff at the northern end of the island for a while, now descended until we were only a few feet above the sea, which sparkled brightly through a green curtain of spruce. We passed a rocky beach and continued around a point, until Fuller led the way down to a smaller beach consecrated to nude male bathing (the ladies' beach is nearer to the main house and similarly secluded.) Fuller stood facing the water, smiling his toothy smile. "Everything I can really remember begins here," he said happily. "There's Eagle Island, where I used to row for the mail every day. And there's Butter, and Fling, and Burnt, and Dagger, and Sheep, and Oak, and around there is Horse Head and Colt Head. Time and time again, the views of this bay are in my mind as I go around the world. And the atmospheric conditions, the sudden changes you get. That northwest wind that came in last night and pushed the doors open—it always comes suddenly that way. It just cleans everything out. You can understand how it was on an island, can't you, old man? All the things that had to be done, all the chores. And then I often felt like being by myself, so I started making experimental houses on different parts of the island. I didn't have any regular allowance, but I'd have money left over from birthdays and things, and I'd buy a hammer and some nails and start making a house. . . . Well, I think if we're going to swim we'd better do it now."

Fuller started to remove his clothes, laying them out carefully on the warm, jagged rocks, which he identified for me as the top of the Allegheny range and prob-

ably among the oldest geological formations in existence anywhere. As he was untying his sneakers, he reached down and picked up a pebble that was almost a perfect tetrahedron. A moment later, he found another, and then another. It was amazing, he said, how often you came across this shape on the beach. Fuller took off his socks and then put his sneakers back on, and warned me to do the same; the tide was out, and the bottom would be strewn with sea urchins. His next bit of instruction concerned the art of swimming in Maine water. By going in and out very quickly several times, he said, and warming up between plunges, one could build up a tolerance to the cold. On our fourth entry, the crystalline water actually did seem a trifle less numbing, and I was prepared to believe that after a while it might become almost comfortable. Fuller warmed up between plunges by skipping stones on the water. He claimed he could skip any stone I found, whether it was flat or not, and he had no failures. Just as we were coming out of the water for the last time, a big seal surfaced near the rocky point some twenty yards away; he gave us a long, incredulous look and then vanished silently.

I had asked earlier to see Fuller's new dome. We went there directly from the beach, retracing our path through the woods and then cutting in back of the dining cottage. The dome stands above the harbor on a high point of land, looking out toward one of the other two Fuller-owned islands, Compass, and, beyond that, to the Camden Hills, on the mainland. Put up two summers ago to replace an earlier, paperboard dome that had been destroyed by a falling tree in a storm, this one is what Fuller terms a "tensegrity" structure—meaning, he said, that the forces of discontinuous compression and continuous tension that hold it together are entirely differentiated, or separate. The compression members are two-by-four timbers. They are held apart—not joined together—by the tension members, light Dacron cords, in such a manner that a stress exerted anywhere on the surface is immediately distributed throughout the entire structure, rendering the whole construction immensely strong. As I stood inside the dome, which Fuller had not yet got around to covering with a plastic skin, the sense of lightness, grace, elegance, and unseen strength was strangely exhilarating. It was easy to understand why Fuller, throughout his career, has had the immediate and enthusiastic support of artists, if not of engineers and architects. While he greatly appreciates this sort of recognition, and values highly his long and close friendships with such artists as Isamu Noguchi and Alexander Calder, he makes it clear that in his own work aesthetics plays only an incidental role. "I never work with aesthetic considerations in mind," he told me that afternoon. "But I have a test: If something isn't beautiful when I get finished with it, it's no good."

Our path back to the main house led past a sturdy little farmer's cottage, which Mr. and Mrs. Kenison and their children now occupy each summer. Mrs. Kenison asked us in to have a cup of tea and to inspect a new room that Mr. Hardie had nearly finished building for them, and a little later I left Fuller there, chatting

contentedly in his sister's parlor. His affection for every member of the family is apparent at all times, but it had struck me that he reserves a special fondness for Mrs. Kenison, as she does for him. "Bucky really became the head of our family after our father died, in 1910," Mrs. Kenison told me that evening, after she had filled me in on the Seventh-Day Adventists. "He was both father and brother to me, and I just adored him always. Of course, he did worry Mother. Mother was left with four children and very little money when Father died, and Bucky's improvidence was her despair. I can remember how night after night she used to bawl him out and I'd sit in the next room just shivering. And then she would get the husbands of her friends to bawl him out. He had a terrible time in school, you know, although he always got good marks. He couldn't play games, because of his glasses, and he was almost always in trouble. Mother so wanted him to be a success, and I'm afraid she died without knowing that he ever would be."

Actually, Fuller came rather close to a major success in 1933, the year before his mother died. His first three-wheeled Dymaxion car, built by a team of hand-picked mechanics in Bridgeport, had stopped traffic in New York and other cities and drawn considerable publicity nationally, and some engineers believe that it might very well have revolutionized the automobile industry if it had not suffered a stroke of exceptionally bad luck. Just outside the main gate of the Chicago World's Fair, the Dymaxion car was rammed by a conventional vehicle, which happened to belong to a city official. The Dymaxion was overturned and its driver was killed. The other car was immediately towed away from the scene, and its involvement completely escaped the notice of reporters, who subsequently ascribed the accident to the Dymaxion car's "freak" design. ("THREE-WHEELED CAR KILLS DRIVER," ran a headline in one paper.) A later investigation disclosed the true facts, but the stigma remained, and in order to erase it, Fuller put his whole inheritance from his mother's estate into the production of two more automobile prototypes. Unfortunately, when the two new Dymaxion cars had been completed and sold—one to a racing driver, the other to Leopold Stokowski—two of the subcontractors whom Fuller had engaged presented a bill for a great deal more than the sum he thought they had originally agreed on, and then sued for the difference. Fuller, dead broke, was unable to pay. He held a one-eighth interest in Bear Island, and the two men then came to Maine and pressed a claim to it. A local judge awarded it to them. Several years later, Mrs. Kenison managed to buy back her brother's share, and Fuller paid her back as soon as he could.

During my talk with Mrs. Kenison after dinner, the whole family gathered in the living room of the main house to watch Fuller put on a visual demonstration of his mathematics. He went upstairs to his room and returned with a bag full of bright-colored plastic rods and rubber elbow joints, which he had had a toy manufacturer make up for him, and proceeded to construct out of them five geometrical shapes—a dodecahedron, a cube, a tetrahedron, an octahedron, and an icosahedron.

Seated gnomically on a bench by a window, with his audience gathered in a half circle around him, he took up each shape in turn and showed us that the cube and the dodecahedron, no matter how you tried to prop them up, invariably collapsed, while the other three, whose structural basis was the triangle, held their shape. The accompanying explanation was rather complex, and it was close to midnight by the time he had finished it. He was then prevailed upon to sing, in a faltering but dogged tenor, some lyrics he had once written to the tune of "Home on the Range." They began like this:

> There once was a square, with a romantic flair,
> Pure Beaux-Arts, McKim, Mead & White,
> Then modern ensued; it went factory-nude—
> Mies, Gropius, Corbu, and Wright.
>
> Roam, home to a dome, where Gothic and Roman once stood.
> Now chemical bonds alone guard our blonds,
> And even the plumbing looks good.
>
> Let architects sing of aesthetics that bring
> Rich clients in hordes to their knees;
> Just give me a home in a great circle dome
> Where the stresses and strains are at ease. . . .

Several of Fuller's listeners took the end of his song as an opportunity to retire. The rest of us followed him outdoors to look at the full moon and feel the earth's rotation. If you stood with your feet wide apart and faced the North Star, he explained, you would, after a certain length of time, begin to sense the motion of the earth in the night sky as it turned with you aboard. You could actually feel it, he said, as a pressure on your left foot. After about fifteen minutes, several of us said that we were beginning to get something like the sensation he meant, and this pleased him enormously. When I finally left to go to bed, Fuller was explaining triangulation more fully to one of his nieces, out there under the great dome of the stars.

During the four days that I spent on Bear Island, it often occurred to me that the highly stimulating and occasionally exhausting "Bear Island atmosphere" that Fuller had talked about the first night was more or less directly the product of his own presence there. He never seemed to tire, although he seldom went to bed before two in the morning—four hours' sleep, he said, was his usual quota. When the rest of the family got together for cocktails in the late afternoon, Fuller might go upstairs to his room to work on one of several articles or books he was writing; he gave up alcohol

during the Second World War, he told me, not because he could not handle it but because he had decided that people who did not want to take his ideas seriously often ascribed them to his drinking habits. One of the writing projects that occupied him during my visit was a personal summing up of what he had learned from life, which had been commissioned by the editor of the *Saturday Review*, Norman Cousins. Fuller had decided to cast it in a unique quasi-poetic form that he refers to as "mental mouthfuls and ventilated prose." He has written a number of things in this form, including an unfinished "Epic Poem on the History of Industrialization." It all began in 1936, when he was asked to write a technical paper for the Phelps Dodge Corporation. A director of the company found the paper totally incomprehensible, and said so. Somewhat miffed, Fuller gained an audience with the man and proceeded to read the paper aloud to him in carefully metered doses, watching his face to make sure that each portion was understood before he went on to the next. "Why don't you write it that way?" the director asked when he had finished reading. Fuller went home, rewrote the paper in metered doses, and resubmitted it. "This is lucid," the director said. "But it is poetry, and I cannot possibly hand it to the president of the corporation for submission to the board of directors." Fuller insisted that it wasn't poetry at all but simply a chopped-up version of the original prose report. The director said he was having two poets to dinner at his house that night, and would show the paper to them and ask their opinion. The following morning, he called Fuller into his office again, and said, "It's too bad—they say it's poetry." The report was finally put back into prose form, though with a great many dots, dashes, and asterisks to separate the mental mouthfuls. Ever since that time, however, Fuller has frequently found himself putting down his thoughts in the ventilated form. He showed me the rough draft of his article for the *Saturday Review*, and I saw that it contained a number of ideas he had been discussing at somewhat greater length during the last few days. At one point, I read:

> Fission verified Einstein's hypothesis
> Change is normal
> Thank you Albert!

And, a little farther on:

> Nature never "fails."
> Nature complies with her own laws.
> *Nature is the law*.

Nature as it presented itself on Bear Island certainly offered unlimited stimulation to Fuller's thought processes. I was constantly fascinated to see how, his interest having

been piqued by some bit of flora or fauna, he could suddenly take off on long and adventurous flights of erudition. The simple act of cutting out a spruce sapling that had elected to seed itself in a stone retaining wall started Fuller thinking about pruning as an art—the art, he said, of "killing without killing." This led him, by a lightning transition, to a discussion of the whales that came up through the Bering Strait each year, and of the Eskimos who spoke of the whale with love as their great brother and said that the great brother asked them to kill him very expertly, so that he would return in great numbers the following year. "And all this, by the way, is very close to the ancient bull worship in Crete," Fuller added. "The bull is, of course, the male fertility, and the killing of the bull in Crete was something that had to be done very beautifully and expertly, which is really what goes on today in the bull ring, although in a debased form. The Cretans played games of jumping over the horns and doing acrobatics on the back of the bull and dancing around him all day long." Fuller went on to describe the clothing worn by the Cretans at these ancient bull festivals, and then said that it had been taken over by gypsies from northwestern India on their way to Spain, and this brought him, quite naturally, to the true history of flamenco dancing, which, he said, the gypsies had also taken over from the Cretans. Flamenco, he explained, had originated on shipboard. It had grown out of the sounds made on the hard decks of Cretan ships—sounds echoed in the staccato clatter of the dancer's heels in the classical flamenco. Fuller demonstrated a flamencolike dance step, which he had learned, he said, from a South American Indian.

Once Fuller has embarked on one of his verbal flights, I found, he is virtually impervious to distraction or discomfort. As we were coming out of the water rather late one afternoon, while the last rays of the sun lingered on the men's beach, the subject of New Zealand came up, and in short order he was well launched on the story of his visit to the Maori anthropologist who was also Keeper of the Chants, and his theory of how the Maori navigators had discovered the prevailing wind patterns in the southern latitudes known as the roaring forties, and had used them in sailing around the world as long as ten thousand years ago. It was an interesting story, but by the time he had come to the end of it, the sun was well down behind the trees and a cool breeze was blowing from the northeast (or sucking, rather, from the southwest). Suddenly noticing that I looked a little chilly—I had felt that it would somehow be in poor taste to get dressed before Fuller did, and while he was talking —he quickly put his clothes back on and then led the way to the house at a fast trot, pausing only to pick up an exceptionally good example of "our friend tetrahedron." Fuller himself was not a bit cold.

The whole story, as Fuller sees it, of the tie-in between the earliest history of navigation and the development of mathematics emerged the next morning. Fuller rowed me over in his dinghy to Little Spruce Head—a thickly wooded island, which he now

owns outright, having bought out the rest of the family's shares in it—and we spent the morning exploring it. On the way over, he talked nostalgically about the Swedish-built Nagala, a thirty-metre sloop he had owned, describing her as the most beautiful boat ever designed. He had sold her the year before (retaining the dinghy, in which we were at the moment afloat), because he used her seldom, but he still dreamed about the boat and often thought of buying her back. She was a needle, a wraith, he said, and the emotions you felt about her were of the same kind as the emotions you felt about a beautiful woman. I asked how she had come by her name. He explained that in most languages "na" was the ancient word for the sea—the root of all marine words like "navigation" and "navy" and "nautical"—and that Naga had been the great serpent god of the sea in prehistoric times. When man took the tremendous risk of going to sea in boats, Fuller said, he gradually learned that by making a snake's path in the water—that is, tacking—he could navigate against the wind, and this was really the beginning of science and technology, and the beginning of the idea, which we now associate with the Western cultural tradition, though it was born in the South Seas of the Pacific, that nature could be studied and made to serve man's needs and desires. "Nagala," of course, was simply the feminine form of "Naga."

On the way back to Bear Island, I took the oars and asked Fuller to go on talking about the early history of navigation, and he outlined his theory on the subject, which is nothing less than comprehensive. At the beginning, he said, when men first put to sea, on rafts, they just drifted away from the mainland of Asia on the Japan Current, going where God seemed to will. Much of the philosophy of the Orient may have stemmed from this willing submission to fate as sensed in nature, he said—this drifting away and never coming back. Then, after many centuries, successors of these earliest seagoing drifters who had found their way to the South Seas, and who may very well have been Maoris, learned how to steer their rafts with crude log rudders and, eventually, how to put up masts in the form of live trees, whose leaves caught the wind, and gradually there evolved the proa, with a mast and sail that could be moved from one end of the boat to the other, and this led, in turn, to the philosophically and technically enormous step of into-the-wind sailing. The men who dared go against God's will and sail into the wind, Fuller said, also wanted to be able to come back where they had started from, and this was the real beginning of navigation. The sailors of the South Seas made the world's first navigating devices, which were crude combinations of notched sticks that could be used to plot the position of a boat between two fixed stars—the only visible points of reference. And this early three-point navigation, Fuller said, was the beginning of mathematics —the first system of true calculation, as opposed to the simple scratchings on rock that landlubbers used in counting their livestock.

Gathering verbal momentum but still managing to direct my own somewhat serpentine rowing efforts, Fuller described how the earliest navigators gradually

spread throughout the island world of Micronesia, and how they had gained great influence, because of their seemingly magic power to go great distances and return with treasure from no one knew where; they guarded the secrets of navigation, he said, and even lived apart from the other members of their tribe while they were onshore. They became the high priests and witch doctors and spiritual leaders of their people, and they continued to develop their secret mathematical knowledge, and their successors grew more and more proficient at mathematics and astronomy, and more and more daring in their navigation. They reached India, where they built tall star-sighting towers on the mainland, and they learned how to ride the monsoons across the Indian Ocean in dhows until eventually they went overland to the Mediterranean. The descendants of these navigators formed the priesthood of the Babylonian and Egyptian civilizations, became famous as Pheonician navigators, and established the brilliant and powerful Minoan civilization on Crete, still without relinquishing the secrets of the mathematical knowledge that was the source of their power, and *their* descendents, in turn, pushed on, in bigger and more seaworthy boats, all the way up the Atlantic coast of Europe to England and Scandinavia, where they became known as Vikings, and down the rivers of Russia and out across the North Atlantic to Greenland and America. When the Ionian Greeks overwhelmed the Minoan civilization at Knossos, on Crete, however, the secret mathematical code was finally broken, and immediately afterward, to the amazement of all subsequent historians unacquainted with Fuller's theory, Greek science suddenly blossomed forth with quadratic equations and other highly advanced methods of calculation. "And now," Fuller said, "we come to the Garden of Eden story in the Old Testament, and we find that Eve was created out of Adam's rib, and I am going to tell you that Eve was not a woman at all—she was the boat. Boats have been feminine from the beginning, and Eve was the ribbed, deep-sea ship that took the man Adam into the great globe-girdling experience that proved to him the earth was round and therefore finite. And the apple from the tree of knowledge represented the earth, and the serpent was Naga, the great god of the sea, and this is really the very, very long-hidden story."

As Fuller told it, the whole rousing saga sounded absolutely irrefutable. He expects to write a book about it within the next year or so—one of five books by him that the Macmillan Company has contracted to publish—and the film director John Huston, a friend of his, has said he wants to make it into a motion picture.

There is no doubt whatever in Fuller's mind that the whole development of modern science and technology has resulted from a willingness on the part of a very few men to sail into the wind of tradition, to trust in their own intellect, and to take advantage of their natural mobility. According to Fuller, the influence of this tiny minority, the navigator-priests of pre-history who ventured into the outlaw area and returned with the new wealth that was knowledge, was always far greater than that of the kings or other rulers to whom they were officially subject, and the situation is

IN THE OUTLAW AREA

206
207

no different today; it is modern technology, rather than political leadership, that directs the real movement of contemporary history. "Take away the energy-distributing networks and the industrial machinery from America, Russia, and all the world's industrialized countries, and within six months over two billion swiftly and painfully deteriorating people will starve to death," he has written. "Take away the politicians, all the ideologies and their professional protagonists from those same countries and give them their present energy networks, industrial machinery, routine production, and distribution personnel, and no more humans will starve nor be afflicted in health than at present."

The colossal irony of our time, of course, is that the scientific knowledge that has made utopia possible has also made world suicide a distinctly plausible alternative. As Fuller once put it, "Either war is obsolete or men are." The issue will be decided one way or another within the next thirty years, he believes—but not by the politicians. Much as the political leaders in Russia and America might like to divert science and technology from weaponry to livingry, they are prevented from doing so by the opposition leaders within their own systems, who would use any relaxation of the national military posture as evidence of weakness or treason. "It comes to those who discover it, all round the world, as a dismaying shock, to realize that continuation of the weapons race and of cold and hot warring are motivated only by intramural party fear of local political disasters," Fuller wrote last spring. "The world's political fate does not rest with leaders at the summit, expressing the will of world people, but with the local ambitions and fears of lower-echelon political machines, within the major weapons-possessing nations, whose vacillation is accompanied by an increasing spread of the atomic weapons-possessing nations. . . . All political machine professionals of all political states will always oppose loss of sovereignty for their own state. Solution of the impasse, if it comes at all, must clearly come from other than political initiative."

Fuller is sure that the solution can come only from a design revolution to be carried out by today's students. Time after time during my stay on Bear Island, he returned to the subject of the student movement, on which he pins all his hopes for the future, and he returned to it once more in the last conversation I had with him before leaving. We had gone for a swim that morning, and were thawing out on the warm rocks and talking about automation. Fuller has a lot of thoughts about automation (which he prophesied many years ago), and he has recently published a little book called "Education Automation" (Southern Illinois University Press), about coming changes in the educational process, that is creating quite a stir in academic circles. The essence of his theory is that education will be the major industry of the future, for automation increasingly will make the old concept of work obsolete and everyone will spend more and more of his non-leisure time in research and reëducation to keep up with a constantly accelerating technology. "Everybody will be going

back to school periodically," he told me. "But, of course, the university itself won't be anything like what it is now. We'll get rid of all the teachers who are just holding on to their jobs in order to eat—all the deadwood, which is the biggest problem in a university anyhow. The deadwood will get fellowships to study or work on their own, and TV will come in to take over most of the actual teaching. There will be a large technical staff making documentary movies. The university is going to become a really marvellous industry, with tools like individually selected and articulated two-way TV that will permit any student anywhere in the world to select from a vast stockpile of documentaries on any subject and watch it over his own TV set at home. The individual is going to study mainly at home. And the great teachers won't have to spend their time delivering the same lectures over and over, because they'll put them on film. The teachers and scholars will be free to spend their time developing more and more knowledge about man's whole experience—past, present, and future."

"But what about the students?" I asked. "How will they react to being cast adrift in a world of impersonal educational machinery? Isn't part of the answer implied in the recent disorders at modern multiversities such as U.C.L.A.?"

Fuller considered the question. "You know, young people sometimes have an infallible sense about these things," he said, at last. "In my youth, we used to talk about 'square shooters.' Today, when a student calls somebody a 'square' he means something entirely different. It doesn't imply that he's lost respect for integrity, or anything like that. A 'square' these days is somebody who's static, immobilized, obsolete —as obsolete as the square box in architecture. Today's student knows instinctively that his world is dynamic, not static, and that the normal state of affairs is constant change and evolution. He also knows that a great many of our venerated institutions, educational and otherwise, are obsolete, and these are what he's reacting against all over the world, sometimes rather violently. Look here, old man, the present crop of university students are the Second World War's babies, and they're astonishingly different from any previous generation. A lot of them were born when their fathers were away at war, and a lot of them were looked after by baby-sitters while their mothers worked in munitions factories. Besides which, they are the first humans to be reared by what I call the third parent—television—which helped them from the very beginning to think 'world.' And look what's happened in the world since they were born. First off, the atomic bomb. When they were about four years old, the giant computers began commercial operation. When they were eight, men climbed Mount Everest. When they were ten, they were immunized against polio. When they were twelve, Sputnik went up and the first civilian nuclear reactor went into operation. When they were thirteen, the atomic submarine Nautilus crossed from the Pacific to the Atlantic under the North Polar ice. When they were fourteen, a Russian rocket photographed the far side of the moon and returned to earth. When they were fifteen, the bathyscaphe took men down to photograph the bottom of the

Pacific Ocean's deepest hole. When they were sixteen, a Russian orbited the earth in a rocket. When they were seventeen, the DNA genetic code for the control of the design of all life was discovered. This generation *knows* that man can do anything he wants, you see. These people know that wealth is not money—that it's a combination of physical energy and human intellect—and they know that energy can be neither created nor destroyed and that intellectual knowledge can only increase, and that therefore total wealth cannot help but increase. They also know that they can generate far more wealth by coöperation on a global scale than by competition with each other. And they realize—or at least they sense—that utopia is possible now, for the first time in history. All past ideas of utopia were unrealistic, because it was assumed that Malthus was right and there would never be enough physical resources for more than a tiny proportion of humanity to live in comfort. No one ever thought of invisible technology doing more with less. Previous utopians didn't think in terms of airplanes getting to increase their power thousands of times over while reducing their engine and airframe weights per horsepower by ninety-nine per cent. No one thought of communications going from wire to wireless. No one thought of a communications satellite weighing a tenth of a ton and outperforming seventy-five thousand tons of transatlantic cables. For the present generation of students, though, these are the facts of life. And yet they see their political leaders locked in the same old static mentality, still putting everything into weaponry, although it's perfectly obvious where that's taking us."

Fuller fell silent. After a moment or so, he got up and walked to the edge of the water and stood there, looking across at Eagle Island, and then, with a quick motion, he stooped to pick up a stone and send it skipping fifty feet out into the bay. I looked at my watch and saw that it was nearly two o'clock. The boat taking me over to Sunset was to leave at two-thirty, so we headed back toward the main house. On the way, I asked Fuller whether he felt that there was anyone in his own generation working in the same direction he was. He stopped to ponder the question. He stood stock-still, and then said, "No, not really. I've been hopeful at times, but I find they don't really take the fundamental initiative. I just seem to be a maverick in that respect. And I didn't decide to take the initiative because I thought I was so good, either—it was only because no one else was doing it."

We walked on up the path, and came out into the meadow below the main house. As I caught up with Fuller, I saw that he was smiling his chip-toothed smile. "You know, in Greece last month, Doxiadis gave a big dinner party, at which he asked me to make a speech," he said. "And when it got to be time for the speech, Doxiadis got up from the table and said that he was not going to introduce me—he was going to leave that to a member of my own generation. And up to the platform stepped his daughter, who graduated two years ago from Swarthmore. Lovely girl. Well, I sort of liked that. And then, after dinner, this same girl asked me if I would speak to a group

of young postgraduate-student friends of hers from the university of Athens—young scientists and mathematicians—and naturally I said I'd be glad to. It turned out to be one of the most fascinating evenings of my life. I found that all these young people were really *thinking.* Their questions were brilliant, and they had such a clear grasp of the important issues, and their interest and their enthusiasm were so great—it was a strange thing, but I felt as though all the centuries had rolled back and I was really talking to the young thinkers of ancient Greece. We didn't break up until three-thirty in the morning. I don't believe I've ever felt such a spirit as I did that night, just two weeks ago. It's this sort of thinking that makes me so sure we're going to come through. Everything centers more and more on the young people, but they're up to it. World is going to work for world, that's all."

After I had said my goodbyes at the main house, Fuller insisted on walking down to the dock with me. On the way, he invited me to join a contest he was sponsoring, with a substantial prize for the person who came up with the best substitute for the word "sunset." It bothers him quite a bit that his summer mailing address—c/o Sunset Post Office, Maine—happens to involve a term of which he disapproves on scientific grounds, although he ruefully admits that it will not be easy to hit on a satisfactory replacement for "sunset," with its entrenched poetic associations. I said I would do my best.

Mr. Hardie had the engine of the launch warming up when we arrived. I put my suitcase aboard, and turned around to find that Fuller had gone off to look for something on the little strip of beach near the dock. He returned in a few moments, smiling broadly, and handed me a rather lumpy but undeniably tetrahedron-shaped stone. "Goodbye, old man," he said, raising his voice above the noise of the engine. We shook hands, and I climbed aboard. He stood at the end of the dock until the launch was far out in the bay, waving energetically from time to time, and looking, for the moment, as though there were absolutely nothing in the world that he had to do.

DYMAXION
CHRONOFILE
R BUCKMINSTER FULLER
1895 - 1915
VOL. 1

DYMAXION
CHRONOFILE
R BUCKMINSTER FULLER
1915 - 1916
VOL. II

DYMAXION
CHRONOFILE
R BUCKMINSTER FULLER
1916
VOL. III

DYMAXION
CHRONOFILE
R BUCKMINSTER FULLER
1916
VOL. IV

DY
CHR
R BUC

SELECTED CONTEXTUAL CHRONOLOGY

COMPILED BY JENNIE GOLDSTEIN

1895 Richard Buckminster Fuller Jr. is born on July 12 in Milton, Massachusetts, the second of four children, to Richard Buckminster Fuller Sr. and Caroline Wolcott (née Andrews) Fuller. The Fuller family had been in New England since the mid-seventeenth century. Bucky's great-aunt was the transcendentalist feminist writer Margaret Fuller, cofounder, with Ralph Waldo Emerson, of the magazine *The Dial*.

Wilhelm Röntgen discovers a new type of electromagnetic radiation. Because its nature is unknown, he names the rays X-rays.

1899 During his early schooling Fuller builds what he later defines as his first octet truss using dried peas and toothpicks. He refers to this experience as the one that initiated his interest in the structure of nature.

Fuller is diagnosed as nearsighted and receives glasses. For the first time he can see clearly.

1903 Orville and Wilbur Wright successfully fly the first powered airplane in Kitty Hawk, North Carolina.

1904 Summer: Maternal grandmother purchases Bear Island in Penobscot Bay, Maine. Fuller's summers in Maine will inspire his lifelong fascination with boats.

Enters Milton Academy.

1907 Fuller begins compiling his correspondence and other paperwork such as notes, sketches, doodles, and bills, including material from previous years. Continues this project, which he names the Dymaxion Chronofile, for the remainder of his life. It is eventually bound and numbers 847 volumes.

1908 Henry Ford manufactures the first Model T car. The company's assembly-line production will make Ford's car the most successful in the industry.

1910 July 12: Richard Buckminster Fuller Sr. dies on Fuller's fifteenth birthday.

Fuller graduates from Milton Academy.

Fall: Enters Harvard University, class of 1917, the fifth consecutive generation of Fuller men to attend.

1914 Skips his first midyear exams and instead travels to New York City, where he squanders his funds for the entire school year. Expelled from Harvard, he is sent by his family to work at a cousin's cotton mill in Sherbrooke, Quebec. Arrives in February as an apprentice millwright and learns about machinery and manufacturing.

Summer: World War I breaks out in Europe.

Fall: Fuller is reinstated at Harvard.

1915 Expelled from Harvard for the second time, Fuller goes to work for Armour & Company, a meatpacking company in Manhattan.

Summer: Meets Anne Hewlett on Long Island.

Albert Einstein publishes his general theory of relativity.

1916 Summer: Fuller and Anne become engaged. Fuller attends U.S. Naval training
 camp in Plattsburgh, New York.

1917 April: United States declares war on Germany.

 Fuller enlists in the U.S. Navy Reserve Force and volunteers his mother's boat,
 the *Wego*, to patrol the Maine shoreline.

 Fuller and Anne marry on July 12 (Fuller's twenty-second birthday) while he
 is on three-day leave from the U.S. Navy.

 D'Arcy Wentworth Thompson publishes *On Growth and Form*.

1918 June: Attends training course at the U.S. Naval Academy in Annapolis. Upon
 completion Fuller gets discharged from the U.S. Naval Reserves and enlists in
 the U.S. Navy.

 November: Germany and the Allies sign an armistice, and World War I ends.

 December 12: Alexandra, Fuller and Anne's first child, is born.

1919 September 2: Fuller resigns from the U.S. Navy after reaching the rank of lieu-
 tenant, junior grade, to spend more time with his family. Resumes working for
 Armour & Company and advances within the corporation.

 Fuller meets Romany Marie, proprietor of a Greenwich Village tavern.

1921 Alexandra suffers from numerous health problems, including pneumonia and
 spinal meningitis. Anne takes her to Bermuda to escape the New York winter.

1922 ca. January: Leaves Armour & Company for a higher-paying job at the Kelly-
 Springfield Truck Company, though he is only employed for a short time.

 Summer: Fuller's father-in-law, James Monroe Hewlett, approaches him about
 forming the Stockade Building System, a building supply and construction
 company specializing in lightweight materials. Stockade is officially incorpo-
 rated in January 1923.

 November 14: Alexandra dies, less than one month before her fourth birthday,
 on Long Island.

1925 Walter Gropius, architect and current director of the Bauhaus, relocates the
 school of art, design, and architecture from Weimar to Dessau, Germany. A
 new campus is complete by the following year.

1926 June: Fuller leaves Long Island for Chicago to start the Stockade Midwest
 Corporation, one of five franchises. Anne stays behind.

1927 May 20–21: Charles Lindbergh, in the *Spirit of St. Louis*, becomes the first pilot
 to fly solo across the Atlantic Ocean.

 August 7: Anne, pregnant with their second child, leaves Long Island and joins
 Fuller in Chicago.

 August 28: Their daughter, Allegra, is born.

November: Fuller is ousted as president of the Stockade Midwest Corporation by new owners and takes a job as a flooring salesman for F. R. Muller Co.

Begins planning a new business to support his invention, industrially mass-produced, self-sufficient housing, which he calls Fuller Houses.

1928 January 30: Fuller reads Le Corbusier's *Towards a New Architecture* (*Vers une architecture*, 1923; English translation, 1927).

Changes the name of his project from Fuller Houses to 4D, for fourth dimension, which he defines as time.

Works on a patent application for early version of the 4D House; he will ultimately abandon the patent application.

May: Travels to Saint Louis, Missouri, and makes his first unofficial presentations on the 4D House at the annual convention of the American Institute of Architects. It is unlikely he took a model.

Fuller distributes 200 mimeographed copies of his essay *4D Time Lock*—a business proposal outlining his plan for industrially produced housing—to friends, family, acquaintances, and people he admires in various fields. He receives numerous responses, but no offers for investment in the project.

Le Corbusier receives commission for the Villa Savoye, in Poissy, near Paris.

1929 April 6–20: Fuller displays a model of the 4D House for the first time in the Interior Decorating Galleries at the Marshall Field's department store in Chicago, where he also delivers short lectures. Store promotion staff encourages him to rename the project Dymaxion, a combination of *dynamic*, *maximum*, and *ion* (credited to Waldo Warren, who coined it after listening to Fuller describe the project).

May 20–25: Exhibition of model and drawings at the Harvard Society for Contemporary Art, Harvard University.

June 21—Summer: Exhibition of model at the Architectural League of New York.

July: Family returns to New York. Fuller spends most of his time in Manhattan, while Anne and Allegra stay on Long Island with Anne's family.

Fall: Fuller meets sculptor Isamu Noguchi at Romany Marie's in Manhattan.

September–December: Fuller presents the Dymaxion House model and gives lectures at various locations including the studios of sculptors Antonio Salemme and Isamu Noguchi, as well as at Romany Marie's tavern.

Fuller designs the interior of Romany Marie's tavern on Minetta Street in Greenwich Village in Manhattan. He uses aluminum paint for the walls, builds the furniture, and insists on bright lighting (see fig. 1 and plate 22).

October: Wall Street Crash of 1929.

1930 Moves into the Starrett-Lehigh Building, a large warehouse on West Twenty-sixth Street in Manhattan. Hosts rooftop parties attended by friends from Romany Marie's.

February: Exhibits a larger and more detailed Dymaxion House model at the Architectural League of New York for one week.

March: The Harvard Society for Contemporary Art invites Fuller to exhibit his model for two weeks at Harvard University's Old Fogg Museum. He gives lectures March 12, 13, and 14.

Continues to regularly present the 4D or Dymaxion House and give lectures throughout the Northeast and in Chicago for the next two years.

1932 Fuller contributes to the February issue of *T-Square*, an architecture magazine focused on contemporary practice. Soon after, he cashes in his life insurance policy to gain financial control of the journal, changes the name to *Shelter* (see plate 40), and discontinues advertising. He later described his role in the publication variously as owner, publisher, and editor, but considered the May and November issues representative of his viewpoint. After the November printing *Shelter* folds.

Three years after its opening in 1929 the Museum of Modern Art, New York, organizes its first architecture exhibition (*Modern Architecture: International Exhibition*, February 10–March 23) and founds the first museum department devoted to architecture and design, headed by Philip Johnson.

1933 Fuller rents a defunct auto plant in Bridgeport, Connecticut, and with the assistance of Starling Burgess, a yacht designer, develops the first and second of three 3-wheeled Dymaxion cars (see plate 49).

October: The first prototype of the Dymaxion car, recently purchased by the Gulf Oil Company, is displayed at the Century of Progress International Exposition in Chicago. The car is involved in a fatal accident, which mars its reputation.

1934 Fuller's mother dies, and he uses his inheritance to finance the production of a third Dymaxion car.

May: The Chicago exposition reopens for an additional season, and the third Dymaxion car model is exhibited. Unable to financially sustain production, Fuller closes the plant.

Fullers move from Bridgeport, Connecticut, to Manhattan.

1936 Fuller completes the book *Nine Chains to the Moon*; however, according to Fuller, the publishers will not print it without Albert Einstein's acknowledgment of Fuller's accurate interpretations of his work. Fuller appeals to the scientist and secures the approval he needs.

Sends telegram to Isamu Noguchi in Mexico City explaining Einstein's equation $E = mc^2$ (see plate 56).

Collaborates with the copper company Phelps Dodge Corporation on prototypes of the Dymaxion Bathroom, an easily installed, lightweight, four-part unit Fuller envisions incorporating into Dymaxion Houses. They do not go into production; however, the existing samples (roughly one dozen) are purchased and installed in homes (see plates 57 and 58).

Fuller is a guest on experimental CBS television broadcasts.

Triggered by the Great Depression, Frank Lloyd Wright builds the first Usonian house near Madison, Wisconsin (fig. 2). Constructed from prefabricated parts, his kit format is successful, and dozens more will be built during the following decades. He also completes the Hanna House, which incorporates a hexagonal, or honeycomb, floor plan, in Palo Alto, California.

1938 *Nine Chains to the Moon* is published. The title derives from Fuller's estimate that the planet's population stretched head-to-toe would cover the distance from earth to the moon nine times.

Fuller joins *Fortune* editorial staff as a technical consultant.

1939 Dymaxion House model and Dymaxion Bathroom included in *Art in Our Time* (May 10–September 30), an exhibition celebrating the opening of the new building of the Museum of Modern Art, New York.

1940 Summer: Fuller travels throughout the Midwest with close friend, writer Christopher Morley. Noticing metal grain bins on the farmland, Fuller decides they could be transformed into low-cost, single-family shelters.

Fuller leaves *Fortune* to work with the Butler Manufacturing Company of Kansas City on the development of Dymaxion Deployment Units, or DDUs, which the U.S. military uses to house radar equipment and troops in isolated locations.

1941 Two connected Dymaxion Deployment Units are exhibited in the Sculpture Garden at the Museum of Modern Art (October 10, 1941–April 1, 1942; fig. 3).

December 7: Japanese bomb Pearl Harbor. United States and Great Britain declare war on Japan the following day.

1942 Dymaxion Deployment Unit model included in *Shelter in Transit and Transition: An Exhibition Revealing a New Phase of Architectural Activity* (November 10– December 6) at the Cincinnati Art Museum.

1943 *Life* publishes a full-color reproduction of Fuller's Dymaxion Air-Ocean World Map in its March 1 issue. A projection of the earth comprising eight triangles and six squares, the reproduction could be removed from the magazine, cut out, and assembled into either a three-dimensional version of the globe or various flat configurations (see plates 74–76).

Fuller is appointed to the mechanical engineering section of the Board of Economic Warfare, and relocates with his family to Washington, D.C.

1944 June 6: Allies invade Normandy, D-day.

Aware that the war's end will lead to a surplus of companies producing military equipment, Fuller recognizes an opportunity to pursue transforming wartime facilities into manufacturers of low-cost, mass-produced civilian housing.

October: Fuller moves to Wichita, Kansas, to collaborate with the Beech Aircraft Company on two prototypes of the Dymaxion Dwelling Machine (see plate 70).

1945 August: United States drops atomic bombs on Hiroshima and Nagasaki. Japan surrenders, and the end of World War II is declared.

FRANK LLOYD WRIGHT
(1867–1959)
2 Jacob House, Madison, Wisconsin, 1936

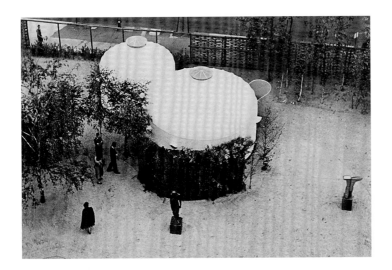

October: A prototype of the Dymaxion Dwelling Machine, nicknamed the Wichita House, is completed. Fuller and Beech Aircraft receive several thousand orders.

1946 Fuller Houses, Inc., the company Fuller started to oversee the manufacture of Dymaxion Dwelling Machines, falters before production begins. A local investor, William Graham, purchases the completed Wichita House and the parts of the unbuilt second prototype and combines them, in 1948, into one lakeside house.

1948 Fuller teaches at Black Mountain College in North Carolina for the first of two summer sessions, and working with students, he attempts to construct the first large-scale geodesic structure using aluminum venetian blinds (see plate 85).

Fall: Fuller teaches at the Institute of Design in Chicago, where he works with his students on the Standard of Living Package, a complete set of portable furnishings designed to unpack inside a geodesic dome (see plate 119).

Eero Saarinen wins Jefferson National Expansion Memorial architectural competition with his proposal for the Gateway Arch, a 630-foot stainless-steel structure in Saint Louis. Construction does not begin until 1963.

1949 Fuller teaches and collaborates with students at the Massachusetts Institute of Technology, returning regularly until 1956. He will continue to visit university campuses in different capacities and for varying lengths of time for the rest of his life.

Federal program Title 1, part of the U.S. Housing Act of 1949 providing federal subsidies for redevelopment, begins. Robert Moses, chairman of the Mayor's Committee on Slum Clearance in New York City, secures grants for thirty-two urban renewal projects between 1949 and 1960.

Philip Johnson builds the Glass House in New Canaan, Connecticut.

1951 Fuller collaborates with students at North Carolina State College (now North Carolina State University) on the 90% Automatic Factory, a geodesic cotton mill (see plate 128).

1952 Fuller teaches at Cornell University's School of Architecture and works with students, including Shoji Sadao, to construct the first Geoscope (see plate 132).

Summer: John Cage, working with Robert Rauschenberg and Merce Cunningham, presents the first "happening," later titled *Theater Piece No. 1*, at Black Mountain College.

1953 June: Fuller designs the first practical application of the geodesic dome for the Ford Motor Company Rotunda in Dearborn, Michigan.

Louis I. Kahn completes the Yale University Art Gallery, New Haven, Connecticut (fig. 4).

Francis Crick and James Watson aid in the discovery of the double helix structure of DNA.

1954 January: U.S. Defense Department Marine Corps experiments successfully with airlifting and delivering of small geodesic domes by helicopter for use as emergency shelter or as protection for equipment.

Fuller receives first honorary degree, doctor of design, from North Carolina State University. He will eventually accrue more than forty.

June 29: Fuller receives patent for geodesic domes. More than 300,000 domes will be built around the world for various purposes over the next thirty years.

Summer: Collaborates with the Container Corporation of America on the manufacture of two lightweight domes, constructed from corrugated cardboard for the Milan Triennale.

1955 Walter O'Malley, owner of the Brooklyn Dodgers, works with Fuller to design the first domed stadium for his team. Fuller develops plan and builds models with students at Princeton University. Unable to secure the land he wants, O'Malley moves the Dodgers to Los Angeles in 1957 (fig. 5).

1956 July: Fuller designs geodesic dome for the U.S. Government Pavilion for an international trade fair in Kabul, Afghanistan. The parts are flown in and erected in forty-eight hours by inexperienced workers.

Alison and Peter Smithson design the House of the Future, which, similar to Fuller's Dymaxion Bathroom, could be mass-produced as a single unit (fig. 6).

This Is Tomorrow opens at the Whitechapel Art Gallery, London (August 9–September 9). Organized by the Independent Group of Great Britain, the exhibition's installations result from the collaborative efforts of twelve "teams" of artists and architects, including Richard Hamilton, John McHale, and Alison and Peter Smithson.

1957 Geodesic domes are manufactured for playground equipment.

October 4: Soviet Union successfully launches *Sputnik I*, the world's first artificial satellite, which instigates the space race between the United States and the USSR.

1958 Fuller completes the largest dome to date for the Union Tank Car Company, railroad car manufacturers in Baton Rouge, Louisiana.

LOUIS I. KAHN (1901–1974)
Yale University Art Gallery, Louis Kahn Building, second floor; interior view of Asian Art installation, 2006

4

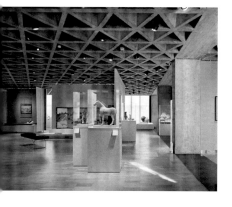

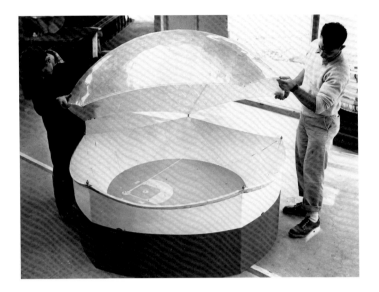

1959 Southern Illinois University, Carbondale, offers Fuller a research professorship. Carbondale becomes Fuller's home base, though he continues traveling extensively.

Form Givers at Mid-Century at the Metropolitan Museum of Art, New York (June 9–September 6), includes a model for the Union Tank Car Company dome, a tensegrity model, and documentary photographs, as well as works by E. D. Stone, Louis Sullivan, Frank Lloyd Wright, and Le Corbusier, among others.

July: A gold-anodized aluminum dome houses the American National Exhibition in Moscow. Inside, Charles and Ray Eames display their film *Glimpses of the USA*—comprising thousands of images representing everyday American life—on seven screens.

September 22–winter 1960: *Three Structures by Buckminster Fuller* opens in the sculpture garden of the Museum of Modern Art, New York, and features an Octet Truss, a geodesic dome called a Rigid Radome, and a Tensegrity Mast (see plate 137). A supplementary exhibition of models, photographs, and drawings, housed inside the museum, opens shortly after (October 27–November 22).

June 3, 1959: Yves Klein gives lecture titled "The Evolution of Art towards the Immaterial" at the Sorbonne and presents for the first time his theory of air architecture, which he began developing with architect Werner Ruhnau in 1957. In his manifesto, Klein describes this new architecture as flexible, spiritual, and immaterial, with spaces protected by flowing air, and walls built of fire and water. Ruhnau would later cite Fuller as a direct influence.

Frank Lloyd Wright completes the Solomon R. Guggenheim Museum in New York.

1960 Evening, March 17: Jean Tinguely presents *Homage to New York*, a self-destructing sculptural machine in the Museum of Modern Art's Sculpture Garden. It was constructed over a three-week period inside Fuller's dome.

May 15–June: The Walker Art Center, Minneapolis, organizes a small exhibition of enlarged photographs of Fuller's projects on loan from his office in the

Department of Design, Southern Illinois University, Carbondale, as well as several models on loan from Fuller's office in Raleigh, North Carolina.

Visionary Architecture (September 29–December 4), at the Museum of Modern Art, New York, features various projects too idealistic or impractical to execute, including Fuller's plan to put a dome over part of Manhattan and Frederick Kiesler's Endless House.

1961 Russian cosmonaut Yuri Gagarin is the first human in space.

1962 Fuller is one of three corecipients of the Charles Eliot Norton Professorship of Poetry at Harvard University, along with Italian architect Pier Luigi Nervi and Mexican architect Felix Candela. Fuller delivers lectures in February and March.

Fuller's increased popularity and visibility allow him to publish *Untitled Epic Poem on the History of Industrialization* and *Education Automation*, followed the next year by *Ideas and Integrities, A Spontaneous Autobiographical Disclosure*, and *No More Secondhand God and Other Writings*, his first books since *Nine Chains to the Moon* (1938).

Marshall McLuhan publishes *The Gutenberg Galaxy*.

1963 President John F. Kennedy is assassinated in Dallas, Texas.

1964 Cover story on Fuller appears in January 10 issue of *Time*. Boris Artzybasheff designs the cover image, which depicts Fuller's head as a geodesic dome surrounded by his myriad inventions (see plate 1).

Twentieth Century Engineering (June 3–September 13) at the Museum of Modern Art includes large-scale photographs and plans of various architecture and engineering projects from around the globe. Several of Fuller's dome projects are represented. Exhibition travels around the country for the next seven years.

Fuller is invited by the U.S. Information Agency (USIA) to propose a design for the U.S. Pavilion for the upcoming Montreal Expo 67.

Two Urbanists: The Engineering-Architecture of R. Buckminster Fuller and Paolo Soleri (December 21, 1964–January 17, 1965) is exhibited at the Rose Art Museum, Brandeis University, Waltham, Massachusetts.

Mounting frustrations over issues such as job opportunities, school desegregation, and housing conditions lead to riots in Harlem.

U.S. involvement in the Vietnam War escalates.

1965 Fuller collaborates with John McHale on the World Design Science Decade, a ten-year project focusing on the allocation and use of the world's resources.

April issue of *Esquire* features article on Fuller and Sadao's proposal for reimagining Harlem. The design consists of fifteen elevated conical structures supported by a central mast, each with one hundred levels comprising dwelling units, parking, and mixed-use space (see plate 148).

May: Drop City, a counterculture commune, artist's colony, and site of architectural experimentation, is founded near Trinidad, Colorado, and inhabited until 1973. Droppers, as the dwellers were called, built domes based on Fuller's principles using found and stolen materials (fig. 7).

President Lyndon Johnson creates the National Endowment for the Arts and Humanities, deeming that the arts should receive funding similar to the sciences.

1966　Stewart Brand, who had been working with the artist collective USCO (short for the U.S. Company), ponders Fuller's argument that people perceive the earth as flat and therefore consider its resources to be unlimited. Brand decides that photographs of the earth from outer space—not yet available to the public—would help people fully understand that the planet is a sphere. He prints buttons that read, "Why Haven't We Seen a Photograph of the Whole Earth Yet?" and sells them on the University of California, Berkeley, campus (fig. 8).

The Jewish Museum in New York organizes *Primary Structures: Younger American and British Sculptors* (April 27–June 12).

October 14–23: *9 Evenings: Theatre and Engineering*, a series of multimedia performances spearheaded by Billy Klüver, an engineer at Bell Telephone Laboratories, and featuring collaborations between ten artists and approximately thirty engineers, is held at the 69th Regiment Armory in New York.

November: Klüver cofounds (along with artists Robert Rauschenberg and Robert Whitman and engineer Fred Waldhauer) Experiments in Art and Technology, or E.A.T.

1967　The 1965 floating tetrahedral city planned for San Francisco Bay is included in the exhibition *Projects for Macrostructures* at the Richard Feigen Gallery in New York, and appears on the cover of the March issue of *Arts Magazine*, which is titled "A Minimal Future?"

April 28: The U.S. Pavilion of Montreal Expo 67, a three-quarter geodesic dome designed with Sadao and Geometrics, Inc., opens. Cambridge Seven Associates design the interior platforms, and curator Alan Solomon organizes the exhibition *American Painting Now* (see plate 156).

Summer issue of *Artforum* includes Sol LeWitt's essay "Paragraphs on Conceptual Art."

American Painting Now, sponsored by the Institute of Contemporary Art, Boston, travels to Horticultural Hall in Boston (December 15, 1967–January 10, 1968).

1968　Stewart Brand founds the *Whole Earth Catalog*, a disparate, original magazine that he produces with his wife, Lois, for the next four years.

Fuller develops plan for Triton City, floating neighborhoods that would house thousands of people off the coast of major cities, with the support of the U.S. Department of Housing and Urban Development (see plates 149 and 150).

Dymaxion Car is exhibited in *The Machine as Seen at the End of the Mechanical Age* at the Museum of Modern Art, New York (November 25, 1968–February 9, 1969; travels to Houston and San Francisco in 1969). Organized by K. G. Pontus Hultén, the exhibition includes works by Leonardo da Vinci, Eadweard Muybridge, Francis Picabia, Man Ray, Marcel Duchamp, Claes Oldenburg, and Robert Rauschenberg, among others.

Apollo 8 circles the moon and returns with the first photograph of the whole planet, often called *Earthrise*, though it is partially obscured in shadow. An astronaut will not take an unobstructed photograph of the entire earth until *Apollo 17* in 1972 (fig. 9).

Martin Luther King Jr. is assassinated in Memphis, Tennessee.

1969 July: Fuller leads first public World Game workshop, an educational game concerned with global resource allocation, at Southern Illinois University, Carbondale.

Two members of Ant Farm, an alternative architecture collective, decide to "abduct" Fuller, who had been invited to give a lecture at the University of Houston, College of Engineering. Claiming to be representatives of the engineering department, they meet Fuller at the airport and take him to see the Dymaxion car displayed in Houston.

Anti-Illusion: Procedures/Materials (May 19–July 6) opens at the Whitney Museum of American Art, New York. Includes Postminimalist and Process sculptures and installations by Carl Andre, Lynda Benglis, Eva Hesse, Robert Morris, Bruce Nauman, Robert Ryman, and Richard Tuttle, among others.

1970 Contributes foreword to the exhibition catalogue for *Projections: Anti-Materialism*, organized by the La Jolla Museum of Art (May 15–July 5).

April 22: Earth Day inaugurated; celebrations take place across the country. By December, the Environmental Protection Agency (EPA) is founded.

1971 Fuller collaborates on a proposal called Old Man River, a large dome-covered, low-cost housing complex for East Saint Louis, Illinois.

First e-mail is sent over ARPANET, a military network developed by the Department of Defense in 1969.

1972 Fuller accepts a unique professorship, called World Fellow in Residence, for a consortium of Philadelphia-area universities and institutions. He and Anne relocate, and Philadelphia remains Fuller's headquarters for the rest of his life.

1973 The Museum of Science and Industry in Chicago organizes *The Design Science of R. Buckminster Fuller* (May 7–August 31). The exhibition includes the Dymaxion car and a geodesic dome furnished with chairs and tables by Ludwig Mies van der Rohe and Eero Saarinen and is canopied by a large-scale octet truss. They will present a similar exhibition of the same name again in 1977 (fig. 10).

Petroleum shortages and the Arab oil embargo lead to a massive energy crisis.

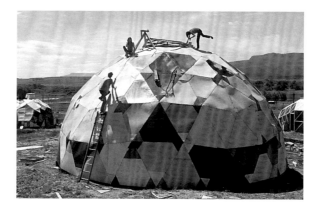

1974 Watergate scandal, facts of which had been published by newspapers in 1972, deepens, revealing President Richard M. Nixon's involvement and cover-up. The House of Representatives begins the impeachment process, and Nixon resigns.

1975 January: Records series of lectures on his life's work, approximately forty-two hours in length, called "Everything I Know."

Fuller begins working on Tetrascroll at ULAE (Universal Limited Art Editions), a lithography print workshop in West Islip, Long Island. Based upon variations on "Goldilocks and the Three Bears" he told to Allegra decades prior, the book of lithographic prints consists of twenty-six pages of thirty-six-inch equilateral triangles (see plates 164–71).

Fuller publishes *Synergetics*, detailing his decades of exploration into what he calls synergetic geometry. Recognizing the dense nature of the massive book, Fuller begins working on *Synergetics 2*, a continuation and explanation of the first volume, which is published in 1979.

The term *personal computer* is first used.

1976 May: Fire destroys the transparent acrylic outer covering of the Expo 67 dome in Montreal. The skin is not replaced, and access to the site is prohibited.

Fuller contributes section on synergetics to *Man Transforms: Aspects of Design* (October 7, 1976–February 6, 1977), the inaugural exhibition for the reopening of the Cooper-Hewitt National Design Museum, Smithsonian Institution, in New York.

Collaborates with Noguchi on an unrealized theater for Martha Graham's dance company.

1977 Fuller's Tetrascroll is exhibited at the Museum of Modern Art, New York, as part of the Projects series (January 28–March 6). A simultaneous exhibition of the Tetrascroll, with a different configuration of its components, is on view at the Ronald Feldman Gallery, New York (January 29–February 26).

Tetrascroll is also on view at the Fendrick Gallery in Washington, D.C., in *The Book As Art II* (February 14–March 12), the second of two exhibitions about artists' books.

More than fifty Fuller drawings spanning from 1927 to 1977 are exhibited at the Ronald Feldman Gallery in New York (December 1, 1977–January 14, 1978).

1978 Drawings of Fuller projects included in *Architecture: Service, Craft, Art* at the Rosa Esman Gallery, New York, which travels to two other venues. The exhibition includes other architects, planners, and landscape architects such as Peter Cook, Louis I. Kahn, Richard Meier, Anne Griswold Tyng, and Venturi and Rauch.

1979 Dymaxion Dwelling Machine, 1944–46, is exhibited along with Paul Nelson's Suspended House, 1936–38, and David Jacob's Simulated Dwelling for a Family of Five, 1970, in *Three Houses* at the Museum of Modern Art, New York (April 21–May 20).

1980 Fullers relocate to Pacific Palisades, California, to be closer to their daughter, Allegra, and her family. Fuller maintains his Philadelphia office and active travel and lecture schedule.

Button designed by
STEWART BRAND
8 (b. 1938)

9 Photograph of earth taken by astronaut aboard *Apollo 17*, 1972

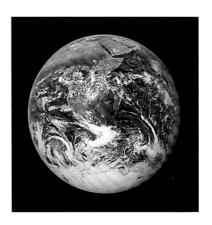

Installation view of *The Design Science of R. Buckminster Fuller* (May 7–August 31, 1973), Museum of Science and Industry, Chicago

1981 Fuller produces, in association with Carl Solway Gallery, Cincinnati, *Buckminster Fuller: Inventions: Twelve Around One*, a portfolio of thirteen prints and text of thirteen projects spanning his career.

1983 February: President Ronald Reagan presents Fuller with the Medal of Freedom, the nation's highest civilian award.

July 1: Fuller suffers a massive heart attack and dies in Los Angeles, while visiting Anne, who had slipped into a coma after being hospitalized in June. Anne never recovers and dies July 3, just thirty-six hours after her husband.

The R. Buckminster Fuller Institute is founded by Fuller's daughter, Allegra Fuller Snyder, and grandson, Jaime Snyder, to maintain Fuller's extensive archive and continue his legacy.

1984 *MetaManhattan*, organized by the Whitney Museum of American Art's Independent Study Program at the Whitney's Downtown Branch at Federal Hall (January 12–March 15), includes a photomontage of Fuller's Dome Over Manhattan.

1985 Robert F. Curl, Harold W. Kroto, and Richard E. Smalley discover that the structure of the C^{60} molecule resembles a geodesic dome. They name their discovery buckminsterfullerene in Fuller's honor and in 1996 receive the Nobel Prize in Chemistry for their work.

1990 *Buckminster Fuller: Harmonizing Nature, Humanity, and Technology*, a large-scale exhibition of Fuller's work, including models, drawings, photographs, and objects from his personal collection (such as crystals and starfish), is at the Edith C. Blum Art Institute at Bard College, Annandale-on-Hudson, New York (April 1– June 17), before traveling to three other venues through the end of 1991.

1995 Original interior of the Expo 67 geodesic dome is re-created, and the U.S. Pavilion reopens as Biosphère, a museum focusing on water and the Great Lakes and Saint Lawrence River ecosystems.

1999 *Your Private Sky: R. Buckminster Fuller, the Art of Design Science* opens at the Museum für Gestaltung, Zurich (June 18–September 12), and travels to seven additional venues in Europe and Japan.

Stanford University Libraries acquires the R. Buckminster Fuller Archive from the Buckminster Fuller Institute.

2001 The installation of the Dymaxion Dwelling Machine, or Wichita House, at the Henry Ford Museum in Dearborn, Michigan, opens to the public after several years of conservation.

2002 *The Changing of the Avant-Garde: Visionary Architectural Drawings from the Howard Gilman Collection* (October 24, 2002–January 6, 2003) opens at the Museum of Modern Art's temporary Queens facility and includes several drawings related to the Dymaxion House.

2004 July 12: The U.S. Postal Service issues a postage stamp honoring Fuller, with a commemoration at Stanford University, coinciding with the fiftieth anniversary of Fuller's geodesic dome patent and the date of his birth and wedding anniversary. Design is taken from Artzybasheff's painting, which originally appeared on the cover of *Time* in 1964.

2005 Black Mountain College Museum and Arts Center in Asheville, North Carolina, organizes *Ideas and Inventions: Buckminster Fuller and Black Mountain College* (July 15–November 26).

2006 Shoji Sadao organizes *Best of Friends: R. Buckminster Fuller and Isamu Noguchi* at the Noguchi Museum, Long Island City, New York (May 19–October 15). A version of the exhibition travels to the Henry Ford Museum, Dearborn, Michigan (November 3, 2007–January 15, 2008).

Buckminster Fuller and John Cage: Geodesic Mathematics and Random Chaos (August 28–September 29) opens at the Jack Olson Gallery, Northern Illinois University, School of Art.

The biographical information in this chronology is culled from various sources including published material and documents from the R. Buckminster Fuller Papers. For the years 1915 through 1930, many of the biographical details are drawn from Loretta Lorance, Building Values: Buckminster Fuller's Dymaxion House in Context *(Ph.D. diss., City University of New York, 2004).*

Selected Bibliography

COMPILED BY JENNIE GOLDSTEIN

Books by R. Buckminster Fuller
(in chronological order)

4D Time Lock. Chicago: privately printed, 1928. Reprint, Albuquerque, N.Mex.: Biotechnic Press/Lama Foundation, 1972.

Universal Architecture. Reprinted from *T-Square*, February 1932. Philadelphia: privately printed, 1932.

Nine Chains to the Moon. New York: J. B. Lippincott, 1938. Reprint, Garden City, N.Y.: Anchor, 1971.

Designing a New Industry: A Composite of a Series of Talks. Wichita, Kans.: Fuller Research Institute, 1946.

Dymaxion Index: Bibliography and Published Items Regarding Dymaxion and Richard Buckminster Fuller, 1927–1953. Forest Hills, N.Y.: Fuller Research Foundation, 1953.

Buckminster Fuller. Hilversum, Netherlands: Steendrukkerij de Jong, [1958].

Untitled Epic Poem on the History of Industrialization. New York: Simon & Schuster, 1962.

Education Automation: Freeing the Scholar to Return to His Studies. Carbondale: Southern Illinois University Press, 1962.

Ideas and Integrities: A Spontaneous Autobiographical Disclosure. Ed. Robert W. Marks. Englewood Cliffs, N.J.: Prentice Hall, 1963.

No More Secondhand God and Other Writings. Carbondale: Southern Illinois University Press, 1963.

Operating Manual for Spaceship Earth. Carbondale: Southern Illinois University Press, 1969.

Fuller, R. Buckminster, and John McHale. *World Design Science Decade, 1965–1975: Five Two Year Phases of a World Retooling Design Proposed to the International Union of Architects for Adoption by World Architectural Schools*. 6 vols. Carbondale: World Resources Inventory, Southern Illinois University, 1963–67.

50 Years of Design Science Revolution and the World Game. Carbondale: World Resources Inventory, Southern Illinois University, 1969.

Utopia or Oblivion: The Prospects for Humanity. New York: Bantam, 1969; London: Allen Lane/Penguin, 1970.

World Game Report. New York: New York Studio School of Painting and Sculpture, 1969.

Fuller, R. Buckminster, Eric A. Walker, and James R. Killian Jr. *Approaching the Benign Environment*. Edited by Taylor Littleton. University: University of Alabama Press; New York: Collier, 1970.

The Buckminster Fuller Reader. Ed. James Meller. London: Penguin, 1972.

I Seem to Be a Verb. With Jerome Agel and Quentin Fiore. New York: Bantam, 1970.

Buckminster Fuller to Children of Earth. Edited by Cam Smith. Garden City, N.Y.: Doubleday, 1972.

Intuition. New York: Doubleday, 1972. Reprint, San Luis Obispo, Calif.: Impact, 1983.

Earth, Inc. Garden City, N.Y.: Anchor Books, 1973.

Synergetics: Explorations in the Geometry of Thinking. In collaboration with E. J. Applewhite. New York: Collier, 1975.

Tetrascroll: Goldilocks and the Three Bears; A Cosmic Fairy Tale. New York: St. Martin's Press, 1975.

And It Came to Pass—Not to Stay. New York: Macmillan, 1976.

Pound, Synergy, and the Great Design. Moscow: University of Idaho, 1977.

Kahn, Robert D., and Peter H. Wagschal, eds. *R. Buckminster Fuller on Education*. Amherst: University of Massachusetts Press, 1979.

Synergetics 2: Explorations in the Geometry of Thinking. In collaboration with E. J. Applewhite. New York: Macmillan, 1979.

Snyder, Robert, ed. *Buckminster Fuller: An Autobiographical Monologue/Scenario*. New York: St. Martin's Press, 1980.

R. Buckminster Fuller Sketchbook. Philadelphia: University City Science Center, 1981.

Critical Path. With Kiyoshi Kuromiya. New York: St. Martin's Press, 1981.

Inventions: Twelve Around One. Cincinnati, Ohio: Carl Solway Gallery, 1981.

Grunch of Giants. New York: St. Martin's Press, 1983.

Humans in Universe. With Anwar Dil. New York: Mouton, 1983.

Inventions: The Patented Work of Buckminster Fuller. New York: St. Martin's Press, 1983.

Cosmography: A Posthumous Scenario for the Future of Humanity. With Kiyoshi Kuromiya. New York: Macmillan, 1992.

Guinea Pig B: The 56 Year Experiment. Introduction by Allegra Fuller Snyder. Clayton, Calif.: Critical Path, 2003.

Introductions, Forewords, and Contributions by R. Buckminster Fuller
(in chronological order)

"Conceptuality of Fundamental Structures." In *Structure in Art and in Science*, edited by Gyorgy Kepes, 66–88. New York: George Braziller, 1965.

"City of the Future." In *Project Survival*, by the editors of *Playboy*, 221–38. Chicago: Playboy Press, 1971. First published in *Playboy* 15, no. 1 (January 1968): 166–68.

"How Little I Know." In *What I Have Learned: A Collection of Twenty Autobiographical Essays by Great Contemporaries from the "Saturday Review,"* 71–134. New York: Simon & Schuster, 1968.

"An Operating Manual for Spaceship Earth." In *Environment and Change: The Next Fifty Years*, by William R. Ewald Jr., 341–89. Bloomington: Indiana University Press, 1968.

Foreword to *Projections: Anti-Materialism*. La Jolla, Calif.: La Jolla Museum of Art, 1970.

Introduction to *Charles Fort: Prophet of the Unexplained*, by Damon Knight. Garden City, N.Y.: Doubleday, 1970.

Introduction to *Expanded Cinema*, by Gene Youngblood. New York: E. P. Dutton, 1970.

Introduction to *A Question of Priorities: New Strategies for Our Urbanized World*, by Edward Higbee. New York: William Morrow, 1970.

Introduction to *Generation of Narcissus*, by Henry Malcolm. Boston: Little, Brown, 1971.

"Man's Changing Role in Universe." In *Liberations: New Essays on the Humanities in Revolution*, edited by Ihab Hassan, 197–214. Middletown, Conn.: Wesleyan University Press, 1971.

Foreword to *Symbol Sourcebook: An Authoritative Guide to International Graphic Symbols*, by Henry Dreyfuss. New York: McGraw-Hill, 1972.

Introduction to *The Confessions of a Trivialist*, by Samuel Rosenberg. Baltimore: Penguin, 1972.

"Technology and the Human Environment." In *The Futurists*, edited by Alvin Toffler, 298–306. New York: Random House, 1972.

Introduction to *Charas: The Improbable Dome Builders*, by Syeus Mottel. New York: Drake, 1973.

Foreword to *Guide to Alternative Colleges and Universities*, edited by Wayne Blaze et al. Boston: Beacon Press, 1974.

Foreword to *This or Else: A Master Plan for India's Survival*, by Dinshaw J. Dastur. Bombay: Jaico, 1974.

Foreword to *Energy, Earth and Everyone*, by Medard Gabel. San Francisco: Straight Arrow Books, 1975.

Foreword to *Out of This World: American Space Photography*, by Paul Dickson. New York: Delacorte Press, 1977.

Introduction to *Non-Being and Somethingness: Selections from the Comic Strip "Inside Woody Allen,"* by Stuart Hample. New York: Random House, 1978.

"Learning Tomorrows: Education for a Changing World." In *Learning Tomorrows: Commentaries on the Future of Education*, edited by Peter H. Wagschal, 1–26. New York: Praeger, 1979.

Introduction to *Industrialization in the Building Industry*, by Barry James Sullivan. New York: Van Nostrand Reinhold, 1980.

Introduction to *Three Mile Island: Turning Point*, by Bill Keisling. Seattle: Veritas, 1980.

Untitled chapter. In *Our Harvard: Reflections on College Life by Twenty-two Distinguished Graduates*, edited by Jeffrey L. Lant, 1–23. New York: Taplinger Press, 1982.

Foreword to *Uncommon Sense*, by Mark Davidson. Los Angeles: J. P. Tarcher, 1983.

Selected Books about R. Buckminster Fuller
(in alphabetical order by author)

Aaseng, Nathan. *More with Less: The Future World of Buckminster Fuller*. Minneapolis: Lerner, 1986.

Applewhite, E. J. *Cosmic Fishing: An Account of Writing* Synergetics *with Buckminster Fuller*. New York: Macmillan, 1977.

_____, ed. *Synergetics Dictionary: The Mind of Buckminster Fuller*. 4 vols. New York: Garland, 1986.

Auer, Michael J. "The Dymaxion Dwelling Machine." In *Yesterday's Houses of Tomorrow: Innovative American Homes, 1850 to 1950*, edited by H. Ward Jandl, 82–99. Washington, D.C.: Preservation Press, 1991.

Baldwin, J. *BuckyWorks: Buckminster Fuller's Ideas for Today*. New York: John Wiley & Sons, 1996.

Banham, Reyner. *Theory and Design in the First Machine Age*. New York: Praeger, 1960. Reprint, Cambridge, Mass.: MIT Press, 1980.

Bayer, Herbert, ed. *World Geo-Graphic Atlas*. Chicago: privately printed for Container Corporation of America, 1953.

Bell, Gwen, and Jaqueline Tyrwhitt, eds. *Human Identity in the Urban Environment*. Harmondsworth, England: Penguin, 1972.

Brenneman, Richard J. *Fuller's Earth: A Day with Bucky and the Kids*. New York: St. Martin's Press, 1984.

Cage, John. *A Year from Monday: New Lectures and Writings*. Middletown, Conn.: Wesleyan University Press, 1967.

Cetica, Pier Angelo. *R. B. Fuller: Uno spazio per la tecnologia*. Padua, Italy: Antonion Milani, 1979.

Chu, Hsiao-Yun, and Roberto Trujillo, eds. *New Views on R. Buckminster Fuller*. Palo Alto, Calif.: Stanford University Press, forthcoming.

Danilov, Victor J., ed. *The Design Science of R. Buckminster Fuller.* Chicago: Museum of Science and Industry, 1973.

Duberman, Martin. *Black Mountain: An Exploration in Community.* New York: Anchor Press, 1973.

Eastham, Scott. *American Dreamer: Bucky Fuller and the Sacred Geometry of Nature.* Cambridge, England: Lutterworth Press, 2007.

Edmondson, Amy C. *A Fuller Explanation: The Synergetic Geometry of R. Buckminster Fuller.* Boston: Birkhäuser, 1987.

Emili, Anna Rita. *Richard Buckminster Fuller e le neoavanguardie.* Rome: Edizioni Kappa, 2003.

Gabriel, J. François, ed. *Beyond the Cube: The Architecture of Space Frames and Polyhedra.* New York: John Wiley & Sons, 1997.

Garver, Thomas H. *Two Urbanists: The Engineering-Architecture of R. Buckminster Fuller and Paolo Soleri: A Loan Exhibition of the Poses Institute of Fine Arts.* Waltham, Mass.: Rose Art Museum, Brandeis University, 1964.

Gerber, Alex, Jr. *Wholeness: On Education, Buckminster Fuller, and Tao.* Kirkland, Wash.: Gerber Educational Resources, 2001.

Goodman, M. Louis. *Architecture: Service—Craft—Art.* New York: Enterprise Press, 1978.

Gorman, Michael John. *Buckminster Fuller: Designing for Mobility.* Milan: Skira, 2005.

Grimaldi, Roberto. *R. Buckminster Fuller, 1895–1983.* Rome: Officina Edizioni, 1990.

Hafner, Katie, and Matthew Lyon. *Where Wizards Stay Up Late: The Origins of the Internet.* New York: Simon & Schuster, 1996.

Harris, Mary Emma. *The Arts at Black Mountain College.* Cambridge, Mass.: MIT Press, 1987.

Harris, Mary Emma, Christopher Benfey, Eva Diaz, Edmund de Waal, and Jed Pearl. *Starting at Zero: Black Mountain College, 1933–57.* Cambridge, England: Arnolfini/Kettle's Yard, 2005.

Harvard Society for Contemporary Art. *4D: Buckminster Fuller's Dymaxion House.* Cambridge, Mass.: Harvard Society for Contemporary Art, 1930.

Hatch, Alden. *Buckminster Fuller: At Home in the Universe.* New York: Crown, 1974.

Hollein, Hans. *Man Transforms: Aspects of Design.* Washington, D.C.: Smithsonian; New York: Cooper-Hewitt Museum, 1976.

———. *Design: Man Transforms; Konzepte einer Austellung/Concepts of an Exhibition.* Vienna: Löcker Verlag, 1989.

Huddle, Norie. *Surviving the Best Game on Earth.* New York: Schocken, 1984.

Kahn, Lloyd, ed. *Domebook 2.* Bolinas, Calif.: Pacific Domes, 1971.

Katz, Vincent, ed. *Black Mountain College: Experiment in Art.* Cambridge, Mass.: MIT Press, 2002.

Kenner, Hugh. *Bucky: A Guided Tour of Buckminster Fuller.* New York: William Morrow, 1973.

———. *Geodesic Math and How to Use It.* Berkeley and Los Angeles: University of California Press, 1976.

Krausse, Joachim, and Claude Lichtenstein, eds. *Your Private Sky: R. Buckminster Fuller: The Art of Design Science.* Zurich: Lars Müller, 1999.

———. *Your Private Sky: R. Buckminster Fuller: Discourse.* Zurich: Lars Müller, 2001.

Krohn, Carsten. *Buckminster Fuller und die Architekten.* Berlin: Dietrich Reimer Verlag, 2004.

Lane, Mervin, ed. *Black Mountain College: Sprouted Seeds: An Anthology of Personal Accounts.* Knoxville: University of Tennessee Press, 1990.

Laycock, Mary. *Bucky for Beginners: Synergetic Geometry.* Hayward, Calif.: Activity Resources, 1984.

Lorance, Loretta. "Building Values: Buckminster Fuller's Dymaxion House in Context." Ph.D. diss., City University of New York, 2004.

Lord, Athena V. *Pilot for Spaceship Earth: R. Buckminster Fuller, Architect, Inventor, and Poet.* New York: Macmillan, 1978.

Macy, Christine, and Sarah Bonnemaison. "Closing the Circle: The Geodesic Domes and a New Ecological Consciousness, 1967." In *Architecture and Nature: Creating the American Landscape,* 293–346. New York: Routledge, 2003.

Marks, Robert W. *The Dymaxion World of Buckminster Fuller.* New York: Reinhold, 1960.

McHale, John. *R. Buckminster Fuller.* New York: George Braziller, 1962.

Pawley, Martin. *Buckminster Fuller.* New York: Taplinger, 1990.

Ranells, Molly, ed. *American Painting Now.* Boston: Institute of Contemporary Art, 1967.

Rheingold, Howard. *The Virtual Community: Homesteading on the Electronic Frontier.* Reading, Mass.: Addison-Wesley, 1993.

Robertson, Donald W. *Mind's Eye of Richard Buckminster Fuller.* New York: Vantage Press, 1974.

Rosen, Sidney. *Wizard of the Dome: R. Buckminster Fuller, Designer for the Future.* Boston: Little, Brown, 1969.

Sadao, Shoji. "Geodesic Domes." In *Encyclopedia of Architecture: Design, Engineering & Construction,* edited by Joseph A. Wilkes, 577–85. New York: John Wiley & Sons, 1988.

Sieden, Lloyd Steven. *Buckminster Fuller's Universe.* Cambridge, Mass.: Perseus, 1989.

Van Ael, Peter, Angela Stickler, and Heidi Allaway. *Buckminster Fuller and John Cage: Geodesic Mathematics and Random Chaos*. DeKalb, Ill.: Jack Olson Gallery/Northern Illinois University, 2006.

Vance, Mary. *Richard Buckminster Fuller: A Bibliography*. Architecture Series: Bibliography, no. A-223. Monticello, Ill.: Vance Bibliographies, April 1980.

Wachsmann, Konrad. *Wendepunkt im Bauen*. Wiesbaden: Otto Krauskopf Verlag, 1959. Translated by Thomas E. Burton as *The Turning Point of Building* (New York: Reinhold, 1961).

Ward, James, ed. *The Artifacts of R. Buckminster Fuller: A Comprehensive Collection of His Designs and Drawings in Four Volumes*. New York: Garland, 1985.

Wong, Yunn Chii. "The Geodesic Works of Richard Buckminster Fuller, 1948–68 (The Universe as a Home of Man)." Ph.D. diss., Massachusetts Institute of Technology, 1999.

Zung, Thomas T. K., ed. *Buckminster Fuller: Anthology for a New Millennium*. New York: St. Martin's Press, 2001.

Selected Articles by R. Buckminster Fuller
(in chronological order)

"The Dymaxion House." *Architecture* (New York) 59, no. 6 (June 1929): 335–40.

"Universal Architecture." *T-Square* 2, no. 2 (February 1932): 22–25, 34–41.

"Universal Architecture, Essay No. 2." *Shelter* 2, no. 3 (April 1932): 30–36.

"Universal Architecture, Essay 3." *Shelter* 2, no. 4 (May 1932): 31–41.

Shelter 2, no. 5 (November 1932): entire issue.

"Dymaxion Houses: An Attitude." *Architectural Record* 75, no. 1 (January 1934): 9–11.

"Industrially Reproducible Architecture." *Trend* 2 (May–June 1934): 117–23.

"Alloys Bring New Forms." *Technical America* 5, no. 8 (August 1938): 3–4, 19.

"Fluid Geography." *American Neptune* 4, no. 2 (April 1944): 119–36.

"Comprehensive Designing." *Trans/formation* 1, no. 1 (1950): 18–23.

"The Comprehensive Designer." *Arts and Architecture* 68, no. 2 (February 1951): 22–23.

"Buckminster Fuller." *Perspecta* 1 (1952): 28–37.

"The Cardboard House." *Perspecta* 2 (1953): 28–35.

"No More Second Hand God." *Student Publications of the School of Design* (North Carolina State College, Raleigh) 4, no. 1 (Fall 1953): 16–24.

"Fluid Geography: A Primer for the Airocean World." *Student Publications of the School of Design* (North Carolina State College, Raleigh) 4, no. 2 (Winter 1954): 41–47.

"Considerations for a Curriculum." *Student Publications of the School of Design* (North Carolina State College, Raleigh) 4, no. 3 (October 1954): 14–18.

"Architecture Out of the Laboratory." *Student Publication* (College of Architecture and Design, University of Michigan, Ann Arbor) 1, no. 1 (Spring 1955): 9–34.

"The R.I.B.A. Discourse, 1958: Experimental Probing of Architectural Initiative." *Journal of the Royal Institute of British Architects* 65, no. 12 (October 1958): 415–24.

"Here Is a Look at the End of the '60s." *House and Home* 17, no. 1 (January 1960): 164.

"Prime Design." *Arts and Architecture* 77, no. 9 (September 1960): 22–23.

"The Architect as World Planner." *Architectural Design* 31, no. 8 (August 1961): facing A/68.

"Bug-Eye Dome Projects for Yomiuri Golf Club House." *Kokusai Kentiku* 29, no. 6 (June 1962): 27–32.

"Philosophy and Structure." *The Architects' Journal* 136, no. 23 (December 5, 1962): 1262–64.

"Planification des Ressources Mondiales/Redesigning World Resources." *UIA: Revue de l'Union Internationale des Architectes* 26 (April 1964): 27–29.

"The Prospect for Humanity." *Saturday Review* 47, no. 35 (August 29, 1964): 43–44, 180, 183.

"The Prospect for Mankind." *Saturday Review* 47, no. 38 (September 19, 1964): 26–27.

"The Case for a Domed City." In *Challenges and Choices: The State of Man in an Anxious Era*, special suppl. to the *St. Louis Post-Dispatch*, September 26, 1965, 39–41.

"The Prospects of Humanity, 1965–1985." *Ekistics* 18, no. 107 (October 1964): 232–42.

"Notes on the Future." *Saturday Review* 47, no. 40 (October 3, 1964): 26.

"Why I Am Interested in Ekistics." *Ekistics* 20, no. 119 (October 1965): 180–81.

"Planners May Be Left Behind by Technological Revolution." *American Institute of Planners: Proceedings of 1965 Annual Conference in St. Louis, Missouri, December 1965* (Washington, D.C.: American Institute of Planners, 1965), 21–24.

"Bucky Fuller Talks on Design Science." *Journal of Environmental Design* (1966): 9.

"Vision 65 Summary Lecture." *American Scholar: A Quarterly for the Independent Thinker* 35, no. 2 (Spring 1966): 206–18.

"How Little I Know." *Saturday Review* 49, no. 46 (November 12, 1966): 29–31, 67–70.

"Prospects for Humanity-Human Trends and Needs." *Bau* 22, nos. 4–5 (1967): 84–102.

"Vision '65 Summary Lecture." *Perspecta* 11 (1967): 59–63.

"An Address Given at the Second Annual Meeting of the Industrial Designers Society of America at Which Time IDSA Presented Bucky an Award of Achievement." *Journal of Environmental Design* 2, no. 2 (January 1967): entire issue.

"Notes in Passing." *Arts and Architecture* 83, no. 12 (January 1967): 9.

"Profile of the Industrial Revolution." *Architectural Design* 37, no. 2 (February 1967): 60–61.

"The Year 2000." *Architectural Design* 37, no. 2 (February 1967): 62–63.

"Man with a Chronofile." *Saturday Review* 50, no. 13 (April 1, 1967): 14–18.

"What I Am Trying to Do." *Athens Technological Institute/Athens Center of Ekistics Newsletter* 3, no. 27 (September 15, 1967): 4.

"Report on the 'Geosocial Revolution.'" *Saturday Review* 50, no. 36 (September 16, 1967): 31–33, 63.

"City of the Future." *Playboy* 15, no. 1 (January 1968): 166–68, 228–30.

"Goddesses of the Twenty-first Century." *Saturday Review* 51, no. 9 (March 2, 1968): 12–14, 45–46.

"Why Women Will Rule the World." *McCalls*, March 1968, 10–11.

"A Theatre." With Shoji Sadao. *The Drama Review (TDR)* 12, no. 3 (Spring 1968): 117–20.

"What Quality of Environment Do We Want?" *Archives of Environmental Health* 16, no. 5 (May 1968): 685–99.

"La prima idea di Fuller per il padiglione USA a Montreal." *Domus* 464 (July 1968): 2–3.

"The Age of Astro-Architecture." *Saturday Review* 51, no. 28 (July 13, 1968): 17–19, 42.

"An Extraordinary Conversation." *Building Research* 5, no. 3 (July–September 1968): 9–17.

"R. Buckminster Fuller Talks about Transparency." *House Beautiful* 110, no. 9 (September 1968): 92–94, 209.

"Man and the Total Environment." *UIA: Revue de l'Union Internationale des Architectes* 52 (November 1968): 7–11.

"Design Science-Engineering, an Economic Success of All Humanity." *Zodiac* 19 (1969): 58–74.

"On Change." *Manhattan College Magazine* 1 (1969): 27–32.

"Letter to Doxiadis." *Main Currents in Modern Thought* 25, no. 4 (March–April 1969): 87–97.

"Design Responsibility." *Industrial Design* 16, no. 3 (April 1969): 72–75.

"The Age of the Dome." *Build International* 2, no. 6 (July–August 1969): 7–15.

"Word Meanings." *Ekistics* 28, no. 167 (October 1969): 221–22.

"The World Game." *Ekistics* 28, no. 167 (October 1969): 286–92.

"Vertical Is to Live—Horizontal Is to Die." *American Scholar* 39, no. 1 (Winter 1969–70): 27–47.

"Vertical Is to Live, Horizontal Is to Die." *Architectural Design* 39, no. 12 (December 1969): 660–62.

"R. Buckminster Fuller: Pirated Transcription of Interview Videotaped by Raindance Corporation." *Radical Software* 1, no. 1 (Spring 1970): 5.

"The Forecast for the 1970s/ Buckminster Fuller." *Japan Architect* 45, no. 7 (July 1970): 48–49.

"Intuition: A Metaphysical Mosaic." *Ekistics* 30, no. 179 (October 1970): 256–60.

"The Earthians' Critical Moment." *New York Times*, December 11, 1970, 47.

"Planetary Planning." *American Scholar* 40, no. 1 (Winter 1970–71): 29–63.

"Take a Chance on Democracy." *Saturday Evening Post* 243, no. 3 (Winter 1971): 58.

"Planetary Planning: Part Two." *American Scholar* 40, no. 2 (Spring 1971): 285–304.

"A Poem by Buckminster Fuller." *New York Times*, March 27, 1971, 29.

"A Portion of His Address at the 1971 Wisconsin Chapter, AIA, Convention." *Wisconsin Architect* 42, no. 6 (June 1971): 9–11, 18–19, 26, 28; no. 7–8 (July–August 1971): 8b, 19–20; no. 9 (September 1971): 14; no. 10 (October 1971): 18–19; no. 11 (November 1971): 19.

"Now and When." *Harper's Magazine* 244, no. 1463 (April 1972): 58–66.

"My New Hexa-Pent Dome: Designed for You to Live In." *Popular Science* 200, no. 5 (May 1972): 128–31.

"Intuition by Buckminster Fuller: Interview." *House and Garden* 141, no. 5 (May 1972): 116–17, 198–99, 202.

"La Ville Totale." With Kenzo Tange, Nicholas Negroponte, and Yona Friedmann. *2000: Revue de l'aménagement du territoire* 24 (1st trimester, 1973): 5–7.

"Geoview: Ethics." *Saturday Review World* 1, no. 5 (November 6, 1973): 36.

"Energy through Wind Power." *New York Times*, January 17, 1974, 39.

"Written on the Wind." *Harper's Magazine* 248, no. 1489 (June 1974): 101.

"Why Yours Truly? A Poem by R. Buckminster Fuller." *Saturday Review World* 1, no. 22 (July 13, 1974): 13.

"Cutting the Metabilical Cord." *Saturday Review* 2, no. 1 (September 21, 1974): 12, 55–57.

"Remapping Our World." *Today's Education* 63, no. 4 (November–December 1974): 40–44, 107, 109–10.

"2025, If . . ." *Coevolution Quarterly*, no. 5 (Spring 1975): 8–9.

"Time Present." *Harper's Magazine* 250, no. 1498 (March 1975): 72–76.

"The Meaning of Wealth." *Banker's Magazine* 219, no. 1573 (April 1975): 42–43.

"Using Technology for the World." *Current* 185 (September 1976): 13–15.

"Habitat: The UN Conference on Human Settlements Plenary session, June 8, 1976." *Ekistics* 42, no. 252 (November 1976): 251.

"Fifty Years Ahead of My Time." *Saturday Evening Post* 249, no. 2 (March 1977): 44, 104.

"Buckminster Fuller on 'Minds Instead of Muscle.'" *U.S. News and World Report* 83, no. 23 (December 5, 1977): 49.

"Accommodating Human Unsettlement." *Town Planning Review* 49, no. 1 (January 1978): 51–60.

"Josef Albers, 1888–1976." *Leonardo* 11, no. 4 (Autumn 1978): 310–12.

"An Open Letter to the Architects of the World." *Inside/Outside: The Indian Design Magazine*, April/May 1980, 13, 16.

"Last Words." *RIBA Journal* 90, no. 8 (August 1983): 38–39.

Selected Articles about R. Buckminster Fuller
(in alphabetical order by author)

Aigner, Hal. "Relax—Bucky Fuller Says It's Going to Be All Right." *Rolling Stone*, June 10, 1971, 34–38.

Aldersey-Williams, Hugh. "Finding Eden." *I.D. Magazine* 48, no. 7 (November 2001): 66–70.

———. "Fuller's Legacy." *International Design Magazine* 48, no. 7 (November 2001): 71.

Alpert, Barry. "Post-Modern Oral Poetry: Buckminster Fuller, John Cage, and David Antin." *Boundary 2* 3, no. 3 (Spring 1975): 665–82.

"American Steel Defence Houses." *Architect and Building News* 176, no. 3914 (December 24, 1943): 187.

"An All-Steel, Four-Piece Prefabricated Bathroom, Designed by Buckminster Fuller and Built Experimentally by the Phelps-Dodge Research Laboratory, 1937: [Views]." *Architects' Journal* 97, no. 2525 (June 17, 1943): 393.

"Architect Sees Hanging Homes, Moved at Will." *New York Herald Tribune*, November 6, 1929.

Architectural Record. Unsigned review of *Ideas and Integrities: A Spontaneous Autobiographical Disclosure*, by Buckminster Fuller. *Architectural Record* 134, no. 2 (August 1963): 52.

Arnow, Joshua. "The Buckminster Fuller Institute: Twenty Years of Design Science Education." *Imprint* 22, no. 2 (Fall–Winter 2003–4): 37–45.

Ashton, Dore. "Historicism and Respect for Tradition." *Studio International* 171, no. 878 (June 1966): 275–79.

Auchincloss, Douglas. "The Dymaxion American." *Time Magazine*, January 10, 1964, 46–51.

Baker, Bob. "'Planetary Planner' in West Hollywood Stays in Orbit with Buckminster Fuller." *Los Angeles Times*, February 26, 1981.

Baldwin, Jay. "The Legacy of Guinea Pig B: Buckminster Fuller Left a Forty-five-Ton Archive, but His Most Valuable Artifacts Are Weightless." *Imprint* 22, no. 2 (Fall and Winter 2003–4): 25–36.

Banham, Reyner. "The Dymaxicrat." *Arts Magazine* 38, no. 1 (October 1963): 66–69.

Baracks, Barbara. "Buckminster Fuller, Carl Solway Gallery." *Artforum* 15, no. 6 (February 1977): 65–66.

Baro, Gene. "American Sculpture: A New Scene." *Studio International* 175, no. 896 (January 1968): 9–18.

Battcock, Gregory. "Kenneth Snelson: Dialogue between Stress and Tension at the Dwan." *Arts Magazine*, February 1968, 27.

Battistoni, Gnecchi M. "Fuller e la gang." *Casabella* 385 (January 1974): 10–12.

Ben-Eli, Michael, ed. "Buckminster Fuller Retrospective." Special issue, *Architectural Design* 42, no. 12 (December 1972).

Benthall, Jonathan. "An Interview with Buckminster Fuller." *Studio International* 179, no. 922 (May 1970): 199–200.

Blake, Peter. "Five Shapers of Today's Skyline." *New York Times*, October 21, 1962, 28.

———, ed. "The World of Buckminster Fuller." *Architectural Forum* 136, no. 1 (January–February 1972): 49–96.

Bottero, Maria. "Astrazione scientifica e ricerca del concreto nell'utopia di Buckminster Fuller." *Zodiac* 19 (1969): 50–57.

Brand, Stewart. "Fuller." *Whole Earth Catalog*, Fall 1970, 8.

Bravo, Amber. "Higher Education." *Dwell*, July–August 2007, 111–16.

"R. Buckminster Fuller." *Journal of Environmental Design* (1966): 7–8.

Mme. X [pseud.]. "Buckminster Fuller Explains His New Housing Invention." *Chicago Daily Tribune*, May 18, 1930.

"Bucky Fuller Finds a Client." *Architectural Forum* 98, no. 5 (May 1953): 106–11.

"Bucky Fuller: Floatable Breakwater." *Domus* 548 (July 1975): 23–24.

"Buckminster Fuller: Le grand projet." *L'Architecture d'aujourd'hui* 91–92 (September–October–November 1960): 76–77.

"Bucky Fuller nel Pantheon." *L'Architettura* 37, no. 7 (November 1958): 498.

"Bucky Fuller Spoke at Detroit Meeting." *Michigan Society of Architects Monthly Bulletin* 25, no. 10 (October 1951): 6–7.

"Bucky's Biggest Bubble." *Architectural Forum* 124, no. 6 (June 1966): 74–78.

"Bucky's Biggest by Far at Baton Rouge." *Progressive Architecture* 39 (November 1958): 32–33.

"Building for Defense . . . 1,000 Houses a Day at $1,200 Each." *Architectural Forum* 74, no. 6 (June 1941): 425–29.

Canaday, John. "New Directions in Architecture." *New York Times*, September 22, 1959.

———. "Constructions on the 'Tensegrity' Principle." *New York Times*, April 16, 1966.

———. "Exorcism in Montreal." *New York Times*, April 30, 1967.

Cheever, Susan. "A Buckminster Fuller Survival Kit." *Queen Magazine* (London) 435 (1970).

Christy, Marian. "Bucky Fuller: Courage Born of Crisis." *Boston Globe*, April 10, 1981.

Clark, George. "The Large-Sized Thoughts of Buckminster Fuller." *Think* 30, no. 5 (September–October 1964): 8–[12].

Cliff, Ursula. "Designers of Human Settlements." *Design and Environment* 7, no. 1 (Spring 1976): 18–35.

Collin, Bradley, and Philip Hamburger. "The Talk of the Town." *New Yorker* 22, no. 7 (March 30, 1946): 21–22.

Colomina, Beatriz. "Information Obsession: The Eameses' Multiscreen Architecture." *Journal of Architecture* 6 (Autumn 2001): 205–23.

———. "Enclosed by Images: The Eameses' Multimedia Architecture." *Grey Room*, no. 2 (Winter 2001): 6–29.

———. "DDU at MoMA." *ANY* 17 (1997): 48–53.

Critchlow, Keith. "R. Buckminster Fuller" in "Whatever Happened to the Systems Approach?" *Architectural Design* 46, no. 5 (May 1976): 267–303.

"Cycle of Evolution: The Work of R. Buckminster Fuller." *Architectural Record* 117, no. 6 (June 1955): 155–62.

Darrach, Betsy. "Places of Worship." *Interiors* 117, no. 5 (December 1957): 84–104.

Davies, Colin. "More Than an Inventor." *Architects' Journal*, July 6, 2000, 53.

De Kooning, Elaine. "Dymaxion Artist." *Art News* 51, no. 5 (September 1952): 14–17.

Delarue, Jean-Marie. "Le Pli, source de formes et de sens." *Cahiers de la recherche architecturale* 40 (2nd trimester, 1997): 39–46.

Deschin, Jacob. "Photography at Montreal's Expo 67." *New York Times*, December 4, 1966.

Dessauce, Marc. "Contro lo Stile Internazionale: *Shelter* e la stampa architettonica Americana." *Casabella* 604 (September 1993): 46–53, 70–71.

"Dodger Dome Generates City Center Proposal." *Architectural Record* 119, no. 4 (April 1956): 217–20.

Donat, John. "Buckminster Fuller: A Personal Assessment." *Studio International* 179, no. 923 (June 1970): 242–45.

Drexler, Arthur. "Three Structures by Buckminster Fuller." *Arts and Architecture* 76, no. 11 (November 1959): 25–27.

"Dymaxion." *Harvard Crimson*, May 22, 1929.

"Dymaxion House." *Architectural Forum* 56, no. 3 (March 1932): 285–88.

Ector, Joost. Review of *Your Private Sky: Discourse*, by R. Buckminster Fuller. *Archis* 1 (2002): 106–7.

Elliott, Donald H. "An Interview with R. Buckminster Fuller." *Neighborhood* 1, no. 2 (June 1978): 2–5.

"Expo 67." *Architectural Design* 37 (July 1967): 333–47.

"Expo 67." *New York Times*, April 28, 1967.

"Exposition Buckminster Fuller: Jardin des Tuileries, Paris, 2–9 Juillet 1965." *L'Architecture d'aujourd'hui* 121 (June–July 1965): 12.

Farrell, Barry. "The View from the Year 2000." *Life* 70, no. 7 (February 26, 1971): 46–58.

Fitzsimmons, James. "Two Houses: New Ways to Build." *Art Digest* 27, no. 1 (October 1, 1952): 15–16.

"For Fuller Living." *Interiors* 105, no. 10 (May 1946): 66–[69], 118.

"Forum." *Architectural Forum* 131, no. 2 (September 1969): 31–32.

Fournier, Colin. "Journées et exposition Buckminster Fuller." *UIA: Revue de l'Union Internationale des Architectes* 36 (November 1965): 25–27.

"Richard Buckminster Fuller's Four Ton House." *Architects' Journal* 104, no. 2691 (August 22, 1946): 138–41.

Frackman, Noel. "Buckminster Fuller." *Arts Magazine* 51, no. 8 (April 1977): 18.

Frankel, Max. "Johnson Flies to Expo 67 and Confers with Pearson." *New York Times*, May 25, 1967.

"Fuller Deplores Stress on Specialization." *Statesman* (Delhi), November 14, 1969.

Fuller, Edmund. "The Universe as a Scenario." *Wall Street Journal*, April 8, 1975.

"Fuller Group Completes Study of Geodesic 'Mini-earth.'" *Architectural Record* 121, no. 7 (June 1957): 16.

"The Fuller House—Designed for Mass-Production in Airplane Plants." *Prefabricated Homes* 7 (April 1946): 16–18, 27.

"Fuller House: Newest Answer to Housing Shortage Is Round, Shiny, Hangs on a Mast and Is Made in an Airplane Factory." *Life* 20, no. 13 (April 1, 1946): 73–76.

"Fuller Keynotes Industrialized Building Congress." *Architectural Record* 149, no. 1 (January 1971): 36.

"Fuller's House: It Has a Better Than Even Chance of Upsetting the Building Industry." *Fortune* 33, no. 4 (April 1946): 167–72, 174, 176, 179.

"Fuller, Students, Build Geodesic 'Pine Cone.'" *Architectural Record* 122, no. 4 (October 1957): 269.

"Geodesic Dome for a Sculptor's Studio." *National Sculpture Review* 19, no. 1 (Spring 1970): 17, 27.

"Geodesic Dome." *Architectural Forum* 95, no. 2 (August 1951): 144–51.

"Geodesic Domes: Public Acceptance Grows Slowly for These Unconventional 'Buildings of the Future.'" *Building Official and Code Administrator* 7, no. 11 (November 1973): 10–13, 18.

Glueck, Grace. "Art Notes: Expo au Go-Go." *New York Times*, August 20, 1967.

_____. "Malevich through Minimal Eyes." *New York Times*, February 25, 1968.

_____. "Tomorrow, the World." *New York Times*, May 11, 1969.

Goldstein, Richard. "Gladly the Dymaxion Cross I'd Bear." *Village Voice*, February 1, 1973, 7–8.

Graham, Dan. "Models and Monuments." *Arts* 41, no. 5 (March 1967): 32–35.

Grimshaw, Nicholas, Theo Crosby, Richard Llewellyn-Davies, Z. S. Makowski, and James Meller.

"Buckminster Fuller: Royal Gold Medallist, 1968." *RIBA Journal* 75, no. 6 (June 1968): 269–71.

Gueft, Olga. "A Place Called Expo." *Interiors* 126, no. 11 (June 1967): 77–119.

Hardison Jr., O. B. "Ain't Nature Grand." *New York Times Book Review*, June 29, 1975.

Harriman, George. "Aluminum-Rundhäuser vom Fließband." *Der Bauhelfer*, no. 2 (July 1946): 12–14.

Harris, Ruth Green. "Art in Our Daily Lives." *New York Times*, May 1, 1938, 158.

"Harvard Names Bucky Fuller Norton Professor of Poetry." *Architectural Record* 129, no. 1 (January 1961): 58.

Hellman, Geoffrey T., and Harold Ross. "The Talk of the Town." *New Yorker* 17, no. 34 (October 4, 1941): 14.

Hellman, Geoffrey T. "The Talk of the Town." *New Yorker* 35, no. 34 (October 10, 1959): 34–36.

Hine, Thomas. "Bucky Fuller: His Ideas Mark Our Surroundings." *Philadelphia Inquirer*, February 24, 1974.

Hoffman, Marilyn. "'Fuller Is a Far-Out Guy.'" *Christian Science Monitor*, March 30, 1971.

Holert, Tom. "Geographie der Intention: Jasper Johns' 'Map (Based on Buckminster Fuller's Dymaxion Airocean World),' 1967–1971." *Wallraf-Richartz-Jahrbuch* 50 (1989): 271–305.

"Homestyle Center: New Forms, New Plans, New Details." *House and Home* 10, no. 5 (November 1956): 156–59.

Horsbrugh, Patrick. "Buckminster Fuller's Domes." *Architect and Building News* 212, no. 5 (August 1, 1957): 151–57.

"How the Pavilions Were Designed: Power of the Individual Detail." *Progressive Architecture* 48 (June 1967): 133–49.

Huxtable, Ada Louise. "Sculptor of Fantasy." *New York Times*, September 24, 1961.

"Ignoring the Past, Embracing Today, Will This Round Prefab Capture Tomorrow?" *Architectural Forum* 82, no. 3 (March 1945): 8–9.

Ingber, Donald E. "The Architecture of Life." *Scientific American* (January 1998): 48–57.

Inman, Virginia. "If You've Got 43 Hours, Mr. Fuller Will Tell You All That He Knows." *Wall Street Journal*, July 30, 1982, 21.

Jacobs, David. "An Expo Named Buckminster Fuller." *New York Times*, April 23, 1967.

Joseph, Branden. "Hitchhiker in an Omni-Directional Transport: The Spatial Politics of John Cage and Buckminster Fuller." *ANY* 17 (1997): 40–44.

Kenner, Hugh. "Bucky Fuller and the Final Exam." *New York Times Magazine*, July 6, 1975, 151.

_____. "Fuller's Follies." Review of *Critical Path*, by R. Buckminster Fuller. *Saturday Review* 8, no. 2 (February 1981): 58–59.

Knapp, Bell. "Grain Bin House," letter to the editor. *Architectural Forum* 75, no. 1 (July 1941): 22, 68.

Kostelanetz, Richard. "American Architecture, 1945–1965." *Bennington Review*, no. 1 (April 1978): 28–36.

Kramer, Hilton. "Isamu Noguchi: A Selective Anthology." *New York Times*, April 21, 1968.

Krausse, Joachim. "Gebaute Weltbilder von Boullée bis Buckminster Fuller." *ARCH+* 116 (March 1993): 20–84.

Kurgan, Laura. "Threat Domes." *ANY* 17 (1997): [31]–34.

Kurtz, Stephen A. "Kenneth Snelson: The Elegant Solution." *Art News* 67, no. 6 (October 1968): 48–51.

Kwinter, Sanford. "Fuller Themselves." *ANY* 17 (1997): 62.

Lada-Mocarski, Polly, Richard Minsky, and Peter Seidler. "Book of the Century: Fuller's Tetrascroll." *Craft Horizons* 37, no. 5 (October 1977): 18–21, 60.

Lang, Tony. "Whole Earth Man." *Enquirer Magazine* (Sunday magazine of the *Cincinnati Enquirer*), November 11, 1973, 36–37, 42–43, 45–46, 49.

Leslie, Thomas W. "Energetic Geometries: The Dymaxion Map and the Skin/Structure Fusion of Buckminster Fuller's Geodesics." *arq: Architectural Research Quarterly* 5, no. 2 (2001): 161–70.

"Living Arts Drive Urged." *New York Times*, January 31, 1962, 28.

Lönberg-Holm, Knud. "The Weekend House." *Architectural Record* 68, no. 2 (August 1930): 175–92.

Lord, Athena. "Bucky Fuller: From Harvard Dropout to 'The Leonardo of Our Age.'" *Science Digest* 84, no. 5 (November 1978): 78–81.

Louchheim, Aline B. "New Ways of Building." *New York Times*, August 31, 1952.

Love, John. "The Geodesic World of Buckminster Fuller." *Detroit News Magazine*, September 20, 1981, 12–13, 17–18, 20, 22, 26, 29.

Lowood, Henry. "Introduction." *Imprint* 22, no. 2 (Fall and Winter 2003–4): 4–5.

MacBride, Bob. "Tetrahedral Architect Meets Tetrahedral Artist: Buckminster Fuller." *Interview* 9, no. 4 (April 1979): 58–59.

Marks, Robert W. "The Breakthrough of Buckminster Fuller." *New York Times*, August 23, 1959.

————. "Planet Earth: Buckminster Fuller's Hometown." *Britannica Yearbook of Science and the Future*, 1971, 338–49.

Marlin, William. "The Non-Dymaxion World of Buckminster Fuller." *Journal of the AIA Journal* 53, no. 6 (June 1970): 67–70.

————. "Following the Trail of Fuller Intellect." *Christian Science Monitor*, May 19, 1978, 21.

Martin, Reinhold. "Crystal Balls." *ANY* 17 (1997): 35–39.

————. "Forget Fuller?" *ANY* 17 (1997): 14–15.

Massey, Jonathan. "Buckminster Fuller's Cybernetic Pastoral: The United States Pavilion at Expo 67." *Journal of Architecture* 11, no. 4 (September 2006): 463–83.

Matson, Barb. "Dome People: *Dome* Talks with Allegra Fuller Snyder." *Dome* 8, no. 2 (Winter 1995–96): 20–42.

McBride, James. "The Global View of Bucky Fuller." *Boston Globe*, July 30, 1982.

McBride, Stewart Dill. "Journey into the Inner Space of Buckminster Fuller." *Christian Science Monitor*, March 9, 1977.

McHale, John. "Total Design: An Essay on Buckminster Fuller." *Architecture and Building* 33, no. 7 (July 1958): 244–51.

————. "Richard Buckminster Fuller, a Special Feature to Coincide with the International Union of Architects Congress, South Bank, London." *Architectural Design* 31, no. 7 (July 1961): 290–319.

————. "Education in Process: Design Department, Southern Illinois University." *Architectural Design* 31, no. 7 (July 1961): 320–22.

————. "Les structures de Buckminster Fuller." *L'Architecture d'aujourd'hui* 99 (December 1961–January 1962): 50–[55].

————. "The Geoscope." *Architectural Design* 34, no. 12 (December 1964): 632–35.

————. "Toward the Future." *Design Quarterly* 72 (1968).

"La Maison 'Dymaxion.'" *L'Architecture d'aujourd'hui* 6 (May–June 1946): 78–79.

Mendini, A. "Programma mondiale di ricerca, 1965–1975." *Casabella* 308 (August 1966): 10–15.

Meyer, June. "Instant Slum Clearance." *Esquire* 63, no. 4 (April 1965): 108–11.

Miller, Judith Ransom. "Fuller's Latest Dome Arises." *Industrial Design* 8, no. 2 (February 1961): 64–68.

Mumford, Lewis. "Mass-Production and the Modern House." *Architectural Record* 67, no. 1 (January 1930): 13–20.

Murphy, Charles J. V. "The Polar Watch." *Fortune* 56, no. 6 (December 1957): 118–27, 245, 246, 250, 252, 255.

"Names: R. Buckminster Fuller." *Architectural and Engineering News* 3, no. 6 (June 1961): 67.

Nordenson, Guy. "Notes on Bucky: Patterns and Structure." *ANY* 17 (1997): 54–55.

Noyelle, Thierry, and Robert Wilson. "Interview: R. Buckminster Fuller." *Metropolis* 2, no. 7 (September 1975): 59–63.

Olds, Glenn A., and William Marlin. "Fuller's Earth: At the Crest of the Wave." *Saturday Evening Post* 245, no. 2 (March–April 1973): 72–73, 132, 142, 149–54.

"One of the World's Outstanding Architectural and Engineering Curios." *Michigan Architect and Engineer* 28, no. 6 (June 1953): 9–12.

Opat, Ellen-Jane. "Better Housing through Self-Help." *Design and Environment* 7, no. 1 (Spring 1976): 36–47.

Panati, Charles. "Almighty Tetrahedron." *Newsweek*, April 21, 1975, 98–99.

Parks, Steve. "Making the World Work —for Everyone." *Baltimore Sun*, April 16, 1979.

Passlof, Pat. "1948." *Art Journal* 48, no. 3 (Fall 1989): 229.

"Pavilion des États-Unis a l'Exposition Internationale de Montreal 1967." *L'Architecture d'aujourd'hui* 122 (September–November 1965): [103].

Pawley, Martin. "Far-sighted Fuller Contributed More Than Modernism Ever Did." *Architects' Journal* 211 (June 22, 2000): 26.

Peck, Stacey. "Anne and Buckminster Fuller." *Los Angeles Times Home*, March 15, 1981, 36–37, 41, 43.

Perlberg, Deborah. "Snelson and Structure." *Artforum* 15, no. 9 (May 1977): 46–49.

Pettena, Gianni. "Un viaggio in Treno: Conversazione con Buckminster Fuller da Londra a York." *Domus* 544 (March 1975): 29–32.

———. "Una vita per ridisegnare il pianeta." *Modo* 10 (June 1978): 15–17.

———. "Bucky Fuller e la prefabbri-cazione." *Domus* 596 (July 1979): 11–15.

Phillips, Patricia C. "Buckminster Fuller: Bard College." *Artforum* 29, no. 3 (November 1990): 172.

Pica, Agnoldomenico. "I propositi di Buckminster Fuller." Review of *World Design Science Decade, 1965–1975*, by R. Buckminster Fuller and John McHale. *Domus* 435 (February 1966): n.p.

Picon, Antoine. "Fuller's Promised Land." *ANY* 17 (1997): [28–30].

———. "Une Utopie américaine: Le Monde de Buckminster Fuller." *Les Cahiers de la recherche architecturale* 40 (2nd trimester, 1997): 101–12.

———. "Review of *Your Private Sky*, by R. Buckminster Fuller." *Harvard Design Magazine* 13 (Winter–Spring 2001): 89–91.

Piel, Gerard, Richard F. Babcock, Isaac Asimov, Buckminster Fuller, and Edmund N. Bacon. "Five Noted Thinkers Explore the Future." *National Geographic* 150 (July 1976): 68–74.

"Plastic Dome Due at Modern Museum." *New York Times*, June 20, 1959.

"Playboy Interview: R. Buckminster Fuller." *Playboy* 19, no. 2 (February 1972): 59–70, 194–204.

Price, Cedric. "Buckminster Fuller, 1895–1983." Obituary. *Architectural Review* 174, no. 1038 (August 1983): 4.

Prinz, Jessica. "The 'Non-Book': New Dimensions in the Contemporary Artist's Book." *Visible Language* 25, nos. 2–3 (Spring 1991): 283–302.

Quimby, Sean. "Personality by Design: R. Buckminster Fuller and His Archive." *Imprint* 22, no. 2 (Fall and Winter 2003–4): 19–24.

"R. Buckminster Fuller's Dymaxion World." *Life*, March 1, 1943, 41–55.

"R. Buckminster Fuller: Recent Works." *Zodiac* 19 (1969): 75–89.

"Reflections on a Few Hours Spent with Dr. R. Buckminster Fuller." *Wisconsin Architect* 42, no. 3 (March 1971): 7, cover illus.

"Remodeled Town House for Jasper Morgan, New York." *Architectural Forum* 69 (September 1938): 210–12.

"Richard Buckminster Fuller in London." *Architects' Journal* 135, no. 7 (February 14, 1962): 352–54.

Richards, Allan. "The Plowboy Interview: R. Buckminster Fuller." *Mother Earth News* no. 9 (May 1971): 6–9.

Ripley, Hubert G. "Back to Pithecanthropus Erectus: Some Notes on the Igloo House." *Michigan Society of Architects Weekly Bulletin* 16, no. 1 (January 6, 1942): 1, 4–5.

Rohan, Timothy M. "From Microcosm to Macrocosm: The Surface of Fuller and Sadao's US Pavilion at Montreal

Expo '67." *Architectural Design* 73, no. 2 (March–April 2003): 50–56.

Roy, Lindy. "Geometry as a Nervous System." *ANY* 17 (1997): 24–27.

"Royal Gold Medal for Architecture 1968." *Architect and Building News* 233, no. 10 (March 1968): 355.

Saarinen, Aline B. "Our Cultural Pattern: 1929—and Today." *New York Times*, October 17, 1954.

Sadao, Shoji. "Nouvelles Structures de R. Buckminster Fuller." *L'Architecture d'aujourd'hui* 122 (September 1965): 45.

———. "Buckminster Fuller's Floating City." *Futurist* 3, no. 1 (February 1969): 14–16.

Sadler, Simon. "Drop City Revisited." *Journal of Architectural Education* 59, issue 3. (February 2006): 5–14.

Scott, Felicity D. "On Architecture under Capitalism." *Grey Room*, no. 6 (Winter 2002): 44–65.

———. "Acid Visions." *Grey Room*, no. 23 (Spring 2006): 22–39.

Shepard, Richard F. "John Cage Holds a Jewish Happening." *New York Times*, July 24, 1967.

Smith, Stephanie. "The Good Guide to R. Buckminster Fuller." *Good*, no. 6 (September–October 2007): 89–94.

Snyder, Allegra Fuller. "Growing up with Buckminster Fuller." *Imprint* 22, no. 2 (Fall–Winter 2003–4): 7–18.

———. "Buckminster Fuller: Experience and Experiencing." *Dance Chronicle* 19, no. 3 (1996): 299–308.

Snyder, Allegra Fuller, and Victoria Vesna. "Education Automation on Spaceship Earth: Buckminster Fuller's Vision—More Relevant than Ever." *Leonardo* 31, no. 4 (1998): 289–92.

"Sperry: The Gyroscope." *Fortune* 21, no. 5 (May 1940): 57–64, 112, 114, 116, 118, 121.

St. Pierre, Carol. "Health Planning and R. Buckminster Fuller's World Game." *Ekistics* 37, no. 220 (March 1974): 180–83.

Staber, Margit. "The United States Pavilion." *Graphis* 23, no. 132 (1967): 378–83.

Suzuki, Eturo. "Variety of R. B. Fuller's Tensegrity Dome." *Kokusai-Kentiku* 29, no. 6 (June 1962): 33–36.

Taubman, Howard. "Children and the Arts." *New York Times*, November 28, 1967.

Taylor, Harold. "Inside Buckminster Fuller's Universe." *Saturday Review* 53, no. 18 (May 2, 1970): 56–57, 69–70.

Temple, Truman. "Spaceship Earth: Is It in Trouble?" *EPA Journal* 5, no. 10 (November–December 1979): 18–20, 27.

"Tensegrity on 53rd Street." *Art News* 58, no. 6 (October 1959): 29.

"The Dome Goes Commercial." *Architectural Forum* 108, no. 3 (March 1958): 120–25.

"The 8,000 Lb. House." *Architectural Forum* 84, no. 4 (April 1946): 129–36.

"The Fuller House." *Builder* 170, no. 5392 (June 7, 1946): 558–59.

"The Mechanical Wing." *Architectural Forum* 73, no. 4 (October 1940): 273, 92.

"The 90 Percent Automatic Factory." *Student Publications of the School of Design* (North Carolina State College, Raleigh) 2, no. 1 (Fall 1951): 29–33.

Theroux, Phyllis. "Bucky Fuller's Global Game." *Washington Post*, Monday, July 19, 1982.

———. "Spaceship Fuller." *International Herald Tribune*, July 24–25, 1982.

"The 'Vasari' Diary: Goldilocks' Cosmic Teach-in." *Art News* 76, no. 3 (March 1977): 19–21.

"Thin-Shell Concrete and Fuller Domes May Displace Huts in Jungles of Pacific." *Western Architect and Engineer* 221, no. 2 (February 1961): 43–45.

Tomkins, Calvin. "In the Outlaw Area." *New Yorker* 41, no. 47 (January 8, 1966): 35–97.

———. "Social Concern." *New York Times*, January 21, 1968.

"Today Greenwich Village, Tomorrow the World." *Think* 35, no. 6 (November–December 1969): 27–29.

Trow, George W. S. "The Talk of the Town." *New Yorker* 47, no. 4 (March 13, 1971): 32–33.

"Two Thirds of the Planet . . ." *Design and Environment* 7, no. 1 (Spring 1976): 15–17.

"Unique Dynamic House of Arborial Design Will Solve Future Dwelling Problems—Inventor Claims Harmony with Nature." *Harvard Crimson*, May 21, 1929.

"Unit Bathroom—View, Diagram." *Architects' Journal* 85, no. 2195 (February 11, 1937): 282.

"The United States Pavilion." Special issue, *Japan Architect* (August 1967): 38–45.

Urbahn, Max O., et al. "The 1968 Honor Awards." *Journal of the American Institute of Architects* 49 (June 1968): 44, 84–104.

"U.S. Industrialization." *Fortune* 21, no. 2 (February 1940): 50–57.

"U.S. Pavilion at Expo 67 Opens with Space and Art Displays." *New York Times*, April 24, 1967.

"Vertical Textile Mill." *Architectural Forum* 96, no. 5 (May 1952): 136–41.

Vesna, Victoria. "Bucky Beat." *Artbyte* 1, no. 3 (August–September 1998): 22–29.

Wallach, Amei. "Bucky and Tatyana." *Newsday*, February 6, 1977.

Warshofsky, Fred. "Meet Bucky Fuller, Ambassador from Tomorrow." *Reader's Digest*, November 1969, 199–206.

Weintraub, Linda. "I Seem to Be a Verb: R. Buckminster Fuller as Pioneering Eco-Artist." *Art Journal*, Spring 2006, 65–66.

White, Leigh. "Buck Fuller and the Dymaxion World." *Saturday Evening Post* 217, no. 16 (October 14, 1944): 22–23, 71–73.

Wigley, Mark. "Planetary Homeboy." *ANY* 17 (1997): [16]–23.

———. "Network Fever." *Grey Room*, no. 4 (Summer 2001): 82–122.

Wilson, Robert Anton. "Interview: R. Buckminster Fuller." *High Times* 69 (May 1981): 33–39, 78.

———. "Bucky Fuller: Synergistic Savior." *Science Digest* 89, no. 10 (November 1981): 51–53, 112.

Wilson, Robert, and Thierry Noyelle. "Interview: R. Buckminster Fuller." *Metropolis* (Paris) 2, no. 7 (September 1975): 59–63.

Wong, Yunn Chii. "Fuller's Corporate Soul." *ANY* 17 (1997): 45–47.

Youngblood, Gene. "Buckminster Fuller's World Game." *Whole Earth Catalog*, March 1970, 30–32.

Zimmer, William. "Fifty Years of Fuller." *Soho Weekly News*, January 12, 1978, 22.

Exhibition Checklist

As of March 4, 2008

Dymaxion House, Project Plan,
ca. 1927 **(plate 28)**
Graphite, watercolor, and metallic ink
on tracing paper
$10^3/_4$ x 10 in. (27.3 x 25.4 cm)
(irregular)
The Museum of Modern Art, New
York, Gift of The Howard Gilman
Foundation, 2000

4D Dymaxion House, project, 1927
(re-created 1987)
Aluminum, plastic, wire, and gravel
62 x 62 x 54 in.
(157.5 x 157.5 x 137.2 cm)
The Museum of Modern Art, New
York, Gift of the Smithsonian Institute
Traveling Exhibition Services and
Champion International Corporation,
1988

Goodrich-Non-Rigid-Baby Airship
Moored to House, 1927
Graphite and ink on paper
$8^1/_2$ x 11 in. (21.6 x 27.9 cm)
Department of Special Collections,
Stanford University Libraries

One Ocean World Town, ca. 1927
(plate 2)
Ink and graphite on paper
$10^7/_8$ x $8^7/_{16}$ in. (27.6 x 21.4 cm)
Department of Special Collections,
Stanford University Libraries

Attempt to synthesize the Brooklyn
Bridge and the Ferris Wheel, ca. 1928
(plate 13)
Ink and graphite on paper
11 x $8^1/_2$ in. (27.9 x 21.6 cm)
Department of Special Collections,
Stanford University Libraries

Comparison of Lightful Houses and
Traditional Homes, 1928
Ink and graphite on paper
11 x $8^1/_2$ in. (27.9 x 21.6 cm)
(irregular)
Department of Special Collections,
Stanford University Libraries

Cover design for *4D Time Lock*, 1928
(plate 3)
Ink and gouache on paper mounted
on paper
$11^1/_{16}$ x $8^9/_{16}$ in. (28.1 x 21.8 cm)
Department of Special Collections,
Stanford University Libraries

Early design for 4D Tower with
notes, 1928
Magazine cut-out mounted on paper
with graphite
$11^1/_8$ x $8^3/_{16}$ in. (28.3 x 20.8 cm)
Department of Special Collections,
Stanford University Libraries

4D Lightful Tower, Mobile Housing,
ca. 1928 **(plate 10)**
Graphite and ink on paper
$8^1/_2$ x $10^7/_8$ in. (21.6 x 27.6 cm)
Department of Special Collections,
Stanford University Libraries

4D Lightful Towers and 4D Transport,
ca. 1928 **(plate 5)**
Graphite and ink on paper
11 x $8^1/_2$ in. (27.9 x 21.6 cm)
Department of Special Collections,
Stanford University Libraries

4D logo, undated, ca. 1928
Ink and graphite on paper
11 x $8^3/_8$ in. (27.9 x 21.3 cm)
Department of Special Collections,
Stanford University Libraries

4D logo, combining compass needle,
teardrop, and crescent moon, 1928
(plate 20)
Ink, graphite, and white highlights
on paper
11 x $8^3/_8$ in. (27.9 x 21.3 cm)
Department of Special Collections,
Stanford University Libraries

4D logo stencil, ca. 1928 **(plate 17)**
Graphite on excised paper with gold
overpaint mounted on paper
11 x $8^1/_2$ in. (27.9 x 21.6 cm)
Department of Special Collections,
Stanford University Libraries

4D Tower, ca. 1928
Ink and graphite on paper
11 x $8^3/_8$ in. (27.9 x 21.3 cm)
Department of Special Collections,
Stanford University Libraries

4D Tower Garage (Proposal for the
1933 World's Fair in Chicago), 1928
(plate 55)
Colored pencil and graphite on paper
$10^{15}/_{16}$ x $8^3/_8$ in. (27.8 x 21.3 cm)
Department of Special Collections,
Stanford University Libraries

Anne Hewlett Fuller
4D Tower: perspective, ca. 1928
(plate 11)
Gouache on paper mounted on board
10 x 12 in. (25.4 x 30.5 cm)
Avery Architectural and Fine Arts
Library, Columbia University, New York

4D Tower Suspension Bridge,
ca. 1928 **(plate 8)**
Graphite on paper
11 x $8^1/_2$ in. (27.9 x 21.6 cm)
Department of Special Collections,
Stanford University Libraries

4D Tower: Time Interval 1 Meter,
1928 **(plate 16)**
Gouache and graphite over positive
Photostat on paper
14 x $10^7/_8$ in. (35.6 x 27.6 cm)
Avery Architectural and Fine Arts
Library, Columbia University,
New York

Sketches of 4D furniture, ca. 1928
(plate 21)
Graphite on paper
$8^5/_{16}$ x $10^{15}/_{16}$ in. (21.1 x 27.8 cm)
Department of Special Collections,
Stanford University Libraries

Sketch for 4D Transportation Unit,
ca. 1928 **(plate 45)**
Graphite and ink on tracing paper
$8^1/_2$ x 11 in. (21.6 x 27.9 cm)
Department of Special Collections,
Stanford University Libraries

Sketch of 4D Towers, ca. 1928
(plate 7)
Graphite on paper
11 x 8$\frac{1}{2}$ in. (27.9 x 21.6 cm)
Department of Special Collections,
Stanford University Libraries

Sketch of Lightful Houses "Time
Exquisite Light," ca. 1928 **(plate 4)**
Graphite on tracing paper
18$\frac{7}{8}$ x 29$\frac{7}{8}$ in. (47.9 x 75.9 cm)
Department of Special Collections,
Stanford University Libraries

Sketch of Zeppelins dropping bombs
and delivering 4D Towers to be
planted in craters, ca. 1928 **(plate 6)**
Graphite and ink on paper
8$\frac{1}{2}$ x 13 in. (21.6 x 33 cm) (irregular)
Department of Special Collections,
Stanford University Libraries

Study for 4D logo, ca. 1928 **(plate 18)**
Watercolor, ink, and graphite on paper
8$\frac{1}{2}$ x 11 in. (21.6 x 27.9 cm)
Department of Special Collections,
Stanford University Libraries

Typical 4D Interior Before Partitioning
or Utility Units are Hung, ca. 1928
(plate 26)
Graphite and ink on paper
8$\frac{1}{2}$ x 10$\frac{7}{8}$ in. (21.6 x 27.6 cm)
Department of Special Collections,
Stanford University Libraries

Typical 4D Interior Solution Sketch,
ca. 1928 **(plate 14)**
Graphite and ink on paper
10$\frac{7}{8}$ x 8$\frac{1}{2}$ in. (27.6 x 21.6 cm)
Department of Special Collections,
Stanford University Libraries

Unknown artist, likely Anne Hewlett
Fuller (1896–1983)
Dymaxion House, ca. 1929 **(plate 31)**
Ink and wash on paper
11$\frac{9}{16}$ x 8$\frac{11}{16}$ in. (29.4 x 22.1 cm)
Department of Special Collections,
Stanford University Libraries

Proposed Design for Interior of
Romany Marie Tavern, ca. 1929
(plate 22)
Graphite on paper
8$\frac{1}{2}$ x 10$\frac{7}{8}$ in. (21.6 x 27.6 cm)
Department of Special Collections,
Stanford University Libraries

Isamu Noguchi (1904–1988)
R. Buckminster Fuller, 1929 **(plate 41)**
Chrome-plated bronze
13 x 8 x 10 in. (33 x 20.3 x 25.4 cm)
Collection of Alexandra and
Samuel May

Sketch for 4D Transportation Unit,
ca. 1929 **(plate 48)**
Ink and graphite on paper
8$\frac{1}{2}$ x 11 in. (21.6 x 27.9 cm)
Department of Special Collections,
Stanford University Libraries

Buckminster Fuller's Dymaxion House
(plate 19)
The Harvard Society for Contemporary
Art, Inc., exhibition brochure cover,
1930
Ink on paper
11 x 8 in. (27.9 x 20.3 cm)
(folded folio)
Department of Special Collections,
Stanford University Libraries

A Dymaxion Home, Project
Elevation, axonometric, and plan,
ca. 1930 **(plate 23)**
Graphite and watercolor on Photostat
22$\frac{1}{2}$ x 12$\frac{1}{4}$ in. (57.2 x 31.1 cm)
The Museum of Modern Art, New
York, Gift of The Howard Gilman
Foundation, 2000

Isometric Drawing for "A Collector's
Room," 1931 **(plate 43)**
Graphite on tracing paper
15 x 14$\frac{1}{4}$ in. (38.1 x 36.2 cm)
Department of Special Collections,
Stanford University Libraries

A Minimum Dymaxion Home, Floor
Net DWG #1, 1931 **(plate 27)**
Graphite on tracing paper
19$\frac{3}{16}$ x 24$\frac{13}{16}$ in. (48.7 x 63 cm)
Department of Special Collections,
Stanford University Libraries

Plan of "A Collector's Room," 1931
(plate 42)
Graphite on tracing paper
14$\frac{3}{8}$ x 11$\frac{5}{8}$ in. (36.5 x 29.5 cm)
(irregular)
Department of Special Collections,
Stanford University Libraries

Mock-up of *Fortune* cover demonstrat-
ing three typical streamline equiva-
lents, 1932 **(plate 44)**
Colored pencil and graphite on paper
mounted on magazine page
14 x 11$\frac{1}{4}$ in. (35.6 x 28.6 cm)
Department of Special Collections,
Stanford University Libraries

Shelter 2, no. 5 (1932) **(plate 40)**
The Noguchi Museum, New York

Structural Studies Associates sketch
for Dymaxion 20-Worker-Shelter,
Russian Cooperative Mobile Farming,
ca. 1932 **(plate 32)**
Graphite on tracing paper mounted
on paper
8$\frac{7}{16}$ x 10$\frac{13}{16}$ in. (21.4 x 27.5 cm)
Department of Special Collections,
Stanford University Libraries

Structural Studies Associates sketch
for Dymaxion 20-Worker-Shelter,
Russian Cooperative Mobile Farming,
ca. 1932 **(plate 33)**
Graphite on tracing paper mounted
on paper
8$\frac{1}{2}$ x 10$\frac{7}{8}$ in. (21.6 x 27.6 cm)
Department of Special Collections,
Stanford University Libraries

Structural Studies Associates sketch
for Dymaxion 20-Worker-Shelter,
Russian Cooperative Mobile Farming,
ca. 1932 **(plate 34)**
Graphite on tracing paper mounted
on paper
8$\frac{1}{2}$ x 10$\frac{15}{16}$ in. (21.6 x 27.8 cm)
Department of Special Collections,
Stanford University Libraries

Structural Studies Associates sketch for Dymaxion 20-Worker-Shelter, Russian Cooperative Mobile Farming, ca. 1932 **(plate 35)**
Graphite on tracing paper mounted on paper
8$\frac{1}{2}$ x 10$\frac{7}{8}$ in. (21.6 x 27.6 cm)
Department of Special Collections, Stanford University Libraries

Structural Studies Associates sketch for Dymaxion 20-Worker-Shelter, Russian Cooperative Mobile Farming, ca. 1932 **(plate 36)**
Graphite on tracing paper mounted on paper
8$\frac{9}{16}$ x 10$\frac{7}{8}$ in. (21.8 x 27.6 cm)
Department of Special Collections, Stanford University Libraries

Structural Studies Associates sketch for Dymaxion 20-Worker-Shelter, Russian Cooperative Mobile Farming, ca. 1932 **(plate 37)**
Graphite on tracing paper mounted on paper
8$\frac{7}{16}$ x 11 in. (21.4 x 27.9 cm)
Department of Special Collections, Stanford University Libraries

Structural Studies Associates sketch for Dymaxion 20-Worker-Shelter, Russian Cooperative Mobile Farming, ca. 1932 **(plate 38)**
Graphite on tracing paper mounted on paper
8$\frac{9}{16}$ x 10$\frac{7}{8}$ in. (21.8 x 27.6 cm)
Department of Special Collections, Stanford University Libraries

Structural Studies Associates sketch for Dymaxion 20-Worker-Shelter, Russian Cooperative Mobile Farming, ca. 1932 **(plate 39)**
Graphite on tracing paper mounted on paper
8$\frac{1}{2}$ x 10$\frac{7}{8}$ in. (21.6 x 27.6 cm)
Department of Special Collections, Stanford University Libraries

Dymaxion Car, ca. 1933 **(plate 50)**
Ink on tracing paper
13$\frac{1}{2}$ x 35$\frac{13}{16}$ in. (34.2 x 91 cm)
The Art Institute of Chicago, through prior gift of the Three Oaks Wrecking Company, 1990.167.1

Dymaxion Car, Plan or Top View, ca. 1933 **(plate 51)**
Ink on tracing paper
11 x 35$\frac{1}{2}$ in. (27.7 x 90.2 cm)
The Art Institute of Chicago, through prior gift of the Three Oaks Wrecking Company, 1990.167.2

General Assembly, Car No. 1, Drawing No. 1, 1933
Ink on tracing paper
24 x 42 in. (61 x 106.7 cm)
Department of Special Collections, Stanford University Libraries

General Assembly, Model C-2, Drawing No. 22, 1933
Ink on linen
30$\frac{1}{2}$ x 49 in. (77.5 x 124.5 cm)
Department of Special Collections, Stanford University Libraries

Study for Dymaxion Trademark, ca. 1933 **(plate 47)**
Graphite on perforated ruled notebook paper
8$\frac{5}{16}$ x 10$\frac{7}{8}$ in. (21.1 x 27.6 cm)
Department of Special Collections, Stanford University Libraries

Anne Hewlett Fuller
Dymaxion House with Dymaxion Car, ca. 1934 **(plate 25)**
Watercolor, ink, and graphite on illustration board
13$\frac{1}{8}$ x 17$\frac{1}{8}$ in. (33.3 x 43.5 cm)
Department of Special Collections, Stanford University Libraries

Dymaxion "2" 4D Transport, 1934 **(plate 49)**
67 in. x 19 ft. x 70 in. (1.7 x 5.8 x 1.8 m)
National Automobile Museum (The Harrah Collection), Reno, Nevada

Sketch of Dymaxion Bathroom, 1936 **(plate 57)**
Graphite and ink on vellum
14$\frac{3}{4}$ x 18$\frac{1}{4}$ in. (37.5 x 46.4 cm) (irregular)
Department of Special Collections, Stanford University Libraries

Telegram from Fuller to Isamu Noguchi in Mexico City explaining E=MC2, 1936 **(plate 56)**
Type ink on paper
7 x 8$\frac{1}{2}$ in. (17.8 x 21.6 cm)
Department of Special Collections, Stanford University Libraries

Dymaxion Deployment Unit, 18 Foot Diameter, 1941 **(plate 63)**
Diazotype
22 x 34$\frac{1}{8}$ in. (55.9 x 86.7 cm)
Department of Special Collections, Stanford University Libraries

Sketch for Dymaxion Deployment Unit, 1941 **(plate 61)**
Ink, graphite, and colored pencil on paper
11$\frac{1}{16}$ x 8$\frac{5}{8}$ in. (28.1 x 21.9 cm)
Department of Special Collections, Stanford University Libraries

Sketch for Dymaxion Deployment Unit, 1941 **(plate 62)**
Colored pencil, graphite, and ink on paper
11 x 8$\frac{1}{2}$ in. (27.9 x 21.6 cm)
Department of Special Collections, Stanford University Libraries

Dymaxion Map, 1943 **(plate 74)**
Pull-out from *Life* (March 1, 1943)
14 x 20$\frac{11}{16}$ in. (35.6 x 52.6 cm)
Department of Special Collections, Stanford University Libraries

Dymaxion Map, 1943 **(plate 75)**
Pull-out from *Life* (March 1, 1943)
13$\frac{15}{16}$ x 20$\frac{11}{16}$ in. (35.4 x 52.6 cm)
Department of Special Collections, Stanford University Libraries

Wichita House, sketch, ca. 1944 (drawing likely by L. Don Royston)
Blueprint
26$\frac{1}{2}$ x 30$\frac{3}{4}$ in. (67.3 x 78.1 cm) (irregular)
Department of Special Collections, Stanford University Libraries

Dymaxion Airbarac, Rest Area
Dormitory/3 Nurse 60 Bed Hospital,
1945 (drawing by L. Don Royston)
(plate 67)
Diazotype
26 1/8 x 36 13/16 in. (66.4 x 93.5 cm)
Department of Special Collections,
Stanford University Libraries

Dymaxion Dwelling Machine, Wichita
House, project
Study for air circulation: floor plan,
1945 **(plate 69)**
Graphite on paper
22 x 34 1/8 in. (55.9 x 86.7 cm)
The Museum of Modern Art, New
York, Gift of The Gilman Foundation,
Inc., 1978

Wichita House: Airbarac, 1945
(drawing by L. Don Royston)
(plate 68)
Graphite on tracing paper
26 1/2 x 36 1/8 in. (67.3 x 91.8 cm)
The Art Institute of Chicago, through
prior gift of Carson Pirie Scott and
Company and the Three Oaks
Wrecking Company, 1991.151

Dymaxion Dwelling Machine, Wichita
House, Model, 1946 **(plate 70)**
Painted fiberglass
Diameter: 36 in. (91.4 cm), height:
23 in. (48.4 cm)
Department of Special Collections,
Stanford University Libraries

Model of Dymaxion Dwelling
Machines community, ca. 1946,
refabricated 2008 **(see plate 71)**

First kinetic model demonstrating
the Jitterbug Transformation, 1948
(plate 96)
Steel, brass, acrylic plastic, and twine
25 1/2 x 25 1/2 x 25 1/2 in.
(64.8 x 64.8 x 64.8 cm)
Department of Special Collections,
Stanford University Libraries

Geometrical Study, 1948 **(plate 89)**
Ink, colored pencil, and graphite
on paper
12 3/4 x 19 3/8 in. (32.4 x 49.2 cm)
Department of Special Collections,
Stanford University Libraries

Playbill for production of *The Ruse of
Medusa* by Erik Satie, performed at
Black Mountain College, August 14,
1948 **(plate 81)**
Letterpress print on coated paper
11 1/8 x 7 1/2 in. (28.3 x 19.1 cm)
(folded)
Department of Special Collections,
Stanford University Libraries

Study of Closest Packing of Spheres,
1948 **(plate 88)**
Ink, colored pencil, and graphite
on paper
12 7/8 x 19 3/4 in. (32.7 x 50.2 cm)
Department of Special Collections,
Stanford University Libraries

Kenneth Snelson (b. 1927)
Early X-Piece, 1948–49
(re-created 1959) **(plate 86)**
Wood and nylon
11 1/2 x 5 3/8 x 5 3/8 in.
(29.2 x 13.7 x 13.7 cm)
Collection of the artist

Kenneth Snelson
Wood Star, 1948 (re-created 1997)
Wood, thread, and iron wire
15 x 15 x 15 in.
(38.1 x 38.1 x 38.1 cm)
Collection of the artist

Letter from Buckminster Fuller to
Kenneth Snelson, December 22, 1949
Collection of Kenneth Snelson

Model of the Standard of Living
Package, ca. 1949, refabricated 2008
(see plate 119)

Letter from Buckminster Fuller to
Kenneth Snelson, 1950
Collection of Kenneth Snelson

One of 30 Diamonds on Edge of
Icosahedron's 30 Edges . . . , 1950
(plate 123)
Colored pencil and ink on paper
8 1/2 x 11 in. (21.6 x 27.9 cm)
Department of Special Collections,
Stanford University Libraries

Photograph of Dymaxion Projection
Map displaying the world distribution
of "energy slaves" **(plate 78)**
Photograph by Aaron Siskind (1903–
1991) for Fuller's article
"Comprehensive Designing" in
Trans/formation 1, no. 1 (1950)
Gelatin silver print
13 15/16 x 9 3/4 in. (35.4 x 24.8 cm)
Department of Special Collections,
Stanford University Libraries

3-Way-Geodesic-Grid-4-Module-
Stress-Flow . . . , 1950 **(plate 122)**
Ink and colored pencil on tracing
paper mounted on paper with tape
11 x 17 in. (27.9 x 43.2 cm) (overall)
Department of Special Collections,
Stanford University Libraries

Basic Diamond Turbining, 1951
(plate 125)
Graphite on tracing paper
20 1/2 x 23 5/16 in. (52.1 x 59.2 cm)
Department of Special Collections,
Stanford University Libraries

Proposal: A Geodesic Hangar, Plan
Projection, Geodesic Dome, Diamonds
of Fiberglass Laminate, 1951
(plate 127)
Graphite on tracing paper
39 3/8 x 23 7/8 in. (100 x 60.6 cm)
(irregular)
Department of Special Collections,
Stanford University Libraries

Proposal: A Geodesic Hangar, Plan
Projection, Geodesic Dome, Styrofoam
or Tubular Aluminum, 1951
(plate 126)
Graphite on tracing paper
40 1/4 x 24 1/8 in. (102.2 x 61.3 cm)
Department of Special Collections,
Stanford University Libraries

Autonomous dome home, designed by
Fuller and MIT students, ca. 1952
Ink, graphite, and colored marker on
vellum mounted on board
20 x 30 1/16 in. (50.8 x 76.4 cm)
Department of Special Collections,
Stanford University Libraries

Autonomous dome home, designed by Fuller and MIT students, ca. 1952
Ink, graphite, and colored marker on vellum mounted on board
20 x 30$\frac{1}{16}$ in. (50.8 x 76.4 cm)
Department of Special Collections, Stanford University Libraries

Autonomous dome home plan, designed by Fuller and MIT students, ca. 1952 **(plate 121)**
Ink and toned overlays on vellum mounted on board
20 x 30$\frac{1}{16}$ in. (50.8 x 76.4 cm)
Department of Special Collections, Stanford University Libraries

Geodesic Dome for the Ford Motor Company, Dearborn, Michigan, 1952–53 **(plate 129)**
India ink, graphite, and felt-tip pen on tracing paper
30$\frac{1}{3}$ x 30 in. (77.1 x 76.2 cm)
Musée National d'Art Moderne/Centre de Création Industrielle, Centre Georges Georges Pompidou, Paris

Geodesic Dome for the Ford Motor Company, Dearborn, Michigan, 1952–53 **(plate 130)**
Ink on paper
29$\frac{1}{2}$ x 29$\frac{1}{2}$ in. (75 x 75 cm)
Musée National d'Art Moderne/Centre de Création Industrielle, Centre Georges Pompidou, Paris

Dymaxion Projection Map displaying the world distribution of "energy slaves" (replacement of human labor by machines) from *World Geo-Graphic Atlas*, 1953, edited and designed by Herbert Bayer (1900–1985), printed privately for the Container Corporation of America **(plate 79)**
Commercial offset print
16 x 11$\frac{1}{4}$ in. (40.6 x 28.6 cm) (folded)
Department of Special Collections, Stanford University Libraries

Octahedron-Tetrahedron Truss, 1953 (drawing by G. Welsh) **(plate 136)**
Graphite on vellum
30 x 32$\frac{1}{2}$ in. (76.2 x 82.6 cm)
Department of Special Collections, Stanford University Libraries

Roof System: Octahedron-Tetrahedron Truss, Proposal for Service Garage for New England Tel. & Tel. Company, Hyannis, Massachusetts, 1953 (drawing by G. Welsh) **(plate 135)**
Graphite on vellum
30$\frac{1}{16}$ x 32$\frac{1}{2}$ in. (76.4 x 82.6 cm)
Department of Special Collections, Stanford University Libraries

Radomes (31 Foot Diameter and 50 Foot Diameter), 1954 **(plate 131)**
Graphite on tracing paper
27$\frac{1}{2}$ x 36 in. (70 x 91.5 cm)
Musée National d'Art Moderne/Centre de Création Industrielle, Centre Georges Georges Pompidou, Paris

Minni Earth Location at U.N. Building, New York, 1956 (drawing by Elston Nelson) **(plate 133)**
Ink and graphite with plastic overlay on paper mounted on board
15 x 20 in. (38.1 x 50.8 cm)
Department of Special Collections, Stanford University Libraries

Minni Earth Location at U.N. Building, New York, 1956 (drawing by Winslow Wedin) **(plate 134)**
Ink and graphite on tracing paper mounted on board
15 x 20 in. (38.1 x 50.8 cm)
Department of Special Collections, Stanford University Libraries

Octet Truss, project, ca. 1959 **(plate 140)**
Wood struts
12$\frac{1}{2}$ x 49$\frac{1}{2}$ x 17$\frac{1}{2}$ in. (31.8 x 125.7 x 44.5 cm)
The Museum of Modern Art, New York, Gift of the architect, 1960

Buckminster Fuller, designed and built by Shoji Sadao and Edison Price
Tensegrity Mast, 1959
Anodized aluminum
160 x 30 x 30 in. (406.4 x 76.2 x 76.2 cm)
Collection of Fuller and Sadao PC

Buckminster Fuller and Shoji Sadao (b. 1927)
Dome Over Manhattan, ca. 1960 **(plate 145)**
Black-and-white photograph mounted on board
13$\frac{3}{4}$ x 18$\frac{3}{8}$ in. (34.9 x 46.7 cm)
Department of Special Collections, Stanford University Libraries

Buckminster Fuller and Shoji Sadao
Project for Floating Cloud Structures (Cloud Nine), ca. 1960 **(plate 144)**
Black-and-white photograph mounted on board
15$\frac{7}{8}$ x 19$\frac{3}{4}$ in. (40.3 x 50.2 cm)
Department of Special Collections, Stanford University Libraries

Close Packing of Polyhedra, ca. 1960–63 **(plate 105)**
Paper
Diameter 6 in. (15.2 cm)
Special Collections Research Center, Morris Library, Southern Illinois University Carbondale

Compound Curvature, Sphere Packing Voids, ca. 1960–63 **(plate 115)**
Metal
Diameter 8$\frac{1}{4}$ in. (21 cm)
Special Collections Research Center, Morris Library, Southern Illinois University Carbondale

Compound Curvature, Sphere Packing Voids, ca. 1960–63 **(plate 116)**
Metal
Diameter 10 in. (25.4 cm)
Special Collections Research Center, Morris Library, Southern Illinois University Carbondale

Compound Curvature, Sphere Packing Voids, ca. 1960–63 **(plate 117)**
Metal
Diameter 13 in. (33 cm)
Special Collections Research Center, Morris Library, Southern Illinois University Carbondale

Compound Edge Tangent and
Concentric Arrangement of Multiple
Polyhedra, ca. 1960–63 **(plate 107)**
Wood toothpicks
Diameter 13 $\frac{1}{2}$ in. (34.3 cm)
Special Collections Research Center,
Morris Library, Southern Illinois
University Carbondale

Compound Tetrahedra, ca. 1960–63
(plate 99)
Paper
Diameter 3 in. (7.6 cm)
Special Collections Research Center,
Morris Library, Southern Illinois
University Carbondale

Concentric Arrangement of Multiple
Polyhedra, ca. 1960–63 **(plate 114)**
Wood toothpicks
Diameter 9 in. (22.9 cm)
Special Collections Research Center,
Morris Library, Southern Illinois
University Carbondale

Cube Space Filling Triangular
Tessellation, ca. 1960–63 **(plate 104)**
Paper and wood toothpicks
Diameter 16 in. (40.6 cm)
Special Collections Research Center,
Morris Library, Southern Illinois
University Carbondale

Edge Tangent Arrangement of
Multiple Polyhedra, ca. 1960–63
Wood toothpicks
Diameter 11 $\frac{1}{2}$ in. (29.2 cm)
Special Collections Research Center,
Morris Library, Southern Illinois
University Carbondale

Great Circle Vector Equilibrium,
ca. 1960–63
Paper
Diameter 12 in. (30.5 cm)
Special Collections Research Center,
Morris Library, Southern Illinois
University Carbondale

Icosadodecahedron with Compound
Octahedron Inscribed, ca. 1960–63
(plate 111)
Paper and wood toothpicks
Diameter 6 $\frac{1}{4}$ in. (15.9 cm)
Special Collections Research Center,
Morris Library, Southern Illinois
University Carbondale

Icosahedron Dodecahedron Duality,
ca. 1960–63 **(plate 100)**
Paper
Diameter 7 in. (17.8 cm)
Special Collections Research Center,
Morris Library, Southern Illinois
University Carbondale

Icosahedron Inscribed in a Spherical
Rhombitricontrahedron Nolid,
ca. 1960–63
Paper
Diameter 8 in. (20.3 cm)
Special Collections Research Center,
Morris Library, Southern Illinois
University Carbondale

Icosahedron with 6 Great Circle
Planes, ca. 1960–63 **(plate 102)**
Paper
Diameter 8 in. (20.3 cm)
Special Collections Research Center,
Morris Library, Southern Illinois
University Carbondale

IVM, Octet truss, ca. 1960–63
(plate 113)
Wood
Diameter 14 in. (35.6 cm)
Special Collections Research Center,
Morris Library, Southern Illinois
University Carbondale

9 Great Circles Spherical Nolid with
Cube Inscribed, ca. 1960–63
(plate 101)
Paper
Diameter 7 in. (17.8 cm)
Special Collections Research Center,
Morris Library, Southern Illinois
University Carbondale

$\frac{1}{2}$ 9, Great Circles Rhombic
Dodecahedron, ca. 1960–63
Paper
Diameter 6 in. (15.2 cm)
Special Collections Research Center,
Morris Library, Southern Illinois
University Carbondale

Tensegrity Icosadodecahedron,
ca. 1960–63
Wood and wire
Diameter 12 in. (30.5 cm)
Special Collections Research Center,
Morris Library, Southern Illinois
University Carbondale

Tetrahedra/Octahedra Close Pack,
ca. 1960–63 **(plate 97)**
Paper
Diameter 4 $\frac{1}{2}$ in. (11.4 cm)
Special Collections Research Center,
Morris Library, Southern Illinois
University Carbondale

Tetrahedron, ca. 1960–63
Wood
Diameter 10 in. (25.4 cm)
Special Collections Research Center,
Morris Library, Southern Illinois
University Carbondale

Tetrahedron, Axii, Vertex, Face, Mid-
edge, ca. 1960–63 **(plate 112)**
Wood
Diameter 13 in. (33 cm)
Special Collections Research Center,
Morris Library, Southern Illinois
University Carbondale

25 Great Circle Vector Equilibrium,
ca. 1960–63 **(plate 109)**
Paper
Diameter 12 in. (30.5 cm)
Special Collections Research Center,
Morris Library, Southern Illinois
University Carbondale

2,4,6,7 . . . Frequency, Probably
Alternate Method, Spherical Geodesic
Octahedron, ca. 1960–63 **(plate 108)**
Paper
Diameter 14 in. (35.6 cm)
Special Collections Research Center,
Morris Library, Southern Illinois
University Carbondale

2 Frequency Spherical Cube with
Cube Inscribed, ca. 1960–63
(plate 103)
Paper
Diameter 8 in. (20.3 cm)
Special Collections Research Center,
Morris Library, Southern Illinois
University Carbondale

Vector Equilibrium, ca. 1960–63
Paper
Diameter 5 $\frac{1}{4}$ in. (13.3 cm)
Special Collections Research Center,
Morris Library, Southern Illinois
University Carbondale

Vector Equilibrium Nolid, ca. 1960–63
(plate 98)
Paper
Diameter 4 in. (10.2 cm)
Special Collections Research Center,
Morris Library, Southern Illinois
University Carbondale

Geodesic Dome for the Yumiuri Golf
Club, Tokyo, Japan, 1961–63 **(plate
143)**
Graphite on tracing paper
28 x 41 3/8 in. (71.2 x 105 cm)
Musée National d'Art Moderne/Centre
de Création Industrielle, Centre
Georges Pompidou, Paris

Boris Artzybasheff (1899–1965)
R. Buckminster Fuller, 1963 **(plate 1)**
Tempera on board
21 1/2 x 17 in. (54.6 x 43.2 cm)
National Portrait Gallery, Smithsonian
Institution, gift of *Time* magazine

Buckminster Fuller and Shoji Sadao
U.S. Pavilion Design for Montreal
Expo 67 (Trabeated Truss), 1964
(plate 153)
Photostat
12 x 18 in. (30.5 x 45.7 cm)
Collection of Fuller and Sadao PC

Buckminster Fuller and Shoji Sadao
Floating Tetrahedral City planned for
San Francisco Bay, 1965 **(plate 147)**
Black-and-white photograph mounted
on board
15 5/16 x 19 in. (38.9 x 48.3 cm)
Department of Special Collections,
Stanford University Libraries

Buckminster Fuller and Shoji Sadao
Harlem Redesign, 1965 **(plate 148)**
Graphite on tracing paper
24 x 20 in. (61 x 50.8 cm)
Collection of Fuller and Sadao PC

Buckminster Fuller/Fuller and Sadao,
Inc./Geometrics, Inc., Associated
Architects
Developed Exterior Elevation of One-
fifth Segment of Dome for Montreal
Expo 67, 1966 **(plate 155)**
Ink on Mylar
44 x 34 in. (111.8 x 86.4 cm)
Collection of Fuller and Sadao PC

Model for the U.S. Pavilion for
Montreal Expo 67, ca. 1966 (refabri-
cated 2008)

Buckminster Fuller/Fuller and Sadao,
Inc./Geometrics, Inc., Associated
Architects
Rendering of U.S. Pavilion for
Montreal Expo 67, ca. 1966 **(plate
154)**
Graphite on tracing paper
8 x 10 in. (20.3 x 25.4 cm)
Collection of Fuller and Sadao PC

American Painting Now inside the U.S.
Pavilion for Montreal Expo 67, 1967
Photograph, reprint
8 x 10 in. (20.3 x 25.4 cm)
Courtesy of the Estate of R.
Buckminster Fuller

Model of Triton City, 1967 **(plate
149)**
Mixed media
20 1/2 x 49 1/2 x 44 5/8 in. (52.1 x 125.7
x 113.3 cm)
National Archives and Records
Administration, Lyndon Baines
Johnson Library and Museum, Austin,
Texas 1968.74.2

U.S. Pavilion for Montreal Expo 67,
1967 **(plate 156)**
Photograph, reprint
5 x 7 in. (12.7 x 17.8 cm)
Courtesy of the Estate of R.
Buckminster Fuller

Buckminster Fuller and Shoji Sadao
Tetrahedron City, project, Yomiuriland,
Japan, Aerial perspective, ca. 1968
(plate 146)
Cut-and-pasted gelatin silver photo-
graph on gelatin silver photograph
with airbrush
11 x 14 in. (27.9 x 35.6 cm)
The Museum of Modern Art, New
York, Gift of the architects, 1974

Grand Strategy of World Problem
Solving: Demonstrating Technical and
Economic Efficacy of Individual
Initiative in the 20th Century, 1975
Poster with felt-tip pen and ballpoint
ink
24 x 28 5/8 in. (61 x 72.7 cm)
Department of Special Collections,
Stanford University Libraries

Cosmic Hierarchy, ca. 1976
Steel, acrylic, and glue
68 x 69 x 68 in. (172.7 x 175.3 x
172.7 cm)
S.C. Johnson. A Family Company

Tetrascroll, 1976 **(see plates 164–71)**
21 lithographs, printed in black, and
reproductions of photographs of
Allegra and Alexandra Fuller
Each page equilateral triangle with 36
in. (91.4 cm) sides, overall dimen-
sions variable
Printed by Universal Limited Art
Editions, edition of 34
The Museum of Modern Art, New
York, Gift of Celeste Bartos, 1977

Cosmic Hierarchy, from the portfolio
Synergetics Folio, 1977
Screenprint
36 x 23 7/8 in. (91.4 x 60.6 cm)
Whitney Museum of American Art,
New York, Gift of Leandro R. Rizzuto
2007.170.9

John Cage (1912–1992)
"For Bucky at 85 with love," 1980
(plate 82)
Ballpoint pen on paper
Overall: 15 1/2 x 11 1/4 in.
(39.4 x 28.6 cm)
Department of Special Collections,
Stanford University Libraries

Inventions: Twelve Around One, 1981
**(plates 29, 30, 52–54, 59, 60, 64,
65, 72, 73, 138, 139, 141, 142, 151,
152, 157–63, 172–75)**
Portfolio of 39 individual sheets:
13 screenprints in white ink on poly-
ester film, 13 photographic screen-
prints, and 13 Curtis plain blue
backing sheets
30 x 40 in. (76.2 x 101.6 cm) (each)
Collection of Chuck and Elizabeth
Byrne

Buckminster Fuller's 25 Great Circles,
n.d. **(plate 87)**
Colored pencil and graphite on paper
11 x 8 9/16 in. (27.9 x 21.7 cm)
Department of Special Collections,
Stanford University Libraries

Dymaxion Deployment Unit, n.d.
Ink on paper
14 x 18 in. (35.6 x 45.7 cm)
Department of Special Collections,
Stanford University Libraries

Dymaxion Deployment Unit, n.d.
Ink on paper
14 x 18 in. (35.6 x 45.7 cm)
Department of Special Collections,
Stanford University Libraries

Dymaxion Map, equator, n.d.
Ink on vellum
14^3/$_{16}$ x 21^{15}/$_{16}$ in. (36 x 55.7 cm)
Department of Special Collections,
Stanford University Libraries

Dymaxion Map, gyroscope along
equator line, n.d.
Ink on vellum
16^7/$_8$ x 21^{15}/$_{16}$ in. (42.9 x 55.7 cm)
Department of Special Collections,
Stanford University Libraries

Fly's Eye Dome sketch, n.d.
Marker, felt-tip pen, and graphite on
tracing paper
23^1/$_2$ x 23^7/$_8$ in. (59.7 x 60.6 cm)
(irregular)
Department of Special Collections,
Stanford University Libraries

Great circle model, n.d. **(plate 91)**
Wire
Diameter 20^1/$_4$ in. (51.4 cm)
Department of Special Collections,
Stanford University Libraries

Great circle model, n.d. **(plate 92)**
Wire
Diameter 20^1/$_4$ in. (51.4 cm)
Department of Special Collections,
Stanford University Libraries

Great circle model, n.d. **(plate 93)**
Wire
Diameter 20^1/$_2$ in. (52.1 cm)
Department of Special Collections,
Stanford University Libraries

Great circle model, n.d. **(plate 94)**
Wire
20^1/$_4$ in. (51.4 cm)
Department of Special Collections,
Stanford University Libraries

The Mercator Projection, n.d.
Collage, ink, and acetate on
poster board
40^1/$_{16}$ x 23^3/$_4$ in. (101.8 x 60.3 cm)
Department of Special Collections,
Stanford University Libraries

Strip X, n.d. **(plate 124)**
Graphite and felt-tip pen on
tracing paper
11^1/$_4$ x 13 in. (28.6 x 33 cm)
(irregular)
Department of Special Collections,
Stanford University Libraries

Three Frequency Geodesic Sphere,
n.d. **(plate 90)**
Felt-tip pen and graphite on paper
8^1/$_2$ x 10^1/$_4$ in. (21.6 x 26 cm)
Department of Special Collections,
Stanford University Libraries

Vector Equilibrium, n.d.
Wood toothpick
15^1/$_4$ x 15^1/$_2$ x 15^1/$_4$ in.
(38.7 x 39.4 x 38.7 cm)
Department of Special Collections,
Stanford University Libraries

**Additional works illustrated in
plate section**

Comparison of Lightful Tower and
Traditional Home, 1927 **(plate 9)**
Ink on paper "mimeo-sketch"
8 x 10^5/$_8$ in. (20.3 x 27 cm)
Department of Special Collections,
Stanford University Libraries

10 Deck 4D Tower, 1928 **(plate 12)**
Graphite on paper
10^7/$_8$ x 8^1/$_2$ in. (27.6 x 21.6 cm)
Department of Special Collections,
Stanford University Libraries

A Minimum Dymaxion Home, 1931
(plate 24)
Graphite on tracing paper
24^1/$_8$ x 28^5/$_{16}$ in. (61.3 x 72 cm)
The Art Institute of Chicago, through
prior gift of the Three Oaks Wrecking
Company, 1990.172

Space Filling Polyhedra, Cube Corner
Truncation Triangular Tessellation,
ca. 1960–63 **(plate 106)**
Paper and wood toothpicks
Diameter 6 in. (15.2 cm)
Special Collections Research Center,
Morris Library, Southern Illinois
University Carbondale

13 Great Circles Rhombic
Dodecahedron, Tetrahedron, Spin
Axii, ca. 1960–63 **(plate 110)**
Paper
Diameter 7 in. (17.8 cm)
Special Collections Research Center,
Morris Library, Southern Illinois
University Carbondale

Model of Triton City, 1967 **(plate 150)**
Mixed media
5^3/$_4$ x 49^1/$_2$ x 37^1/$_2$ in.
(14.6 x 125.7 x 95.6 cm)
National Archives and Records
Administration, Lyndon Baines
Johnson Library and Museum, Austin,
Texas 1968.74.1

Geometric Model, n.d. **(plate 95)**
Wood and twine
Diameter 33 in. (83.8 cm)
Department of Special Collections,
Stanford University Libraries

List of Lenders

The Art Institute of Chicago
Avery Architectural and Fine Arts Library, Columbia University, New York
Chuck and Elizabeth Byrne
Fuller and Sadao PC
Lyndon Baines Johnson Library and Museum, Austin, Texas
Alexandra and Samuel May
Musée National d'Art Moderne, Centre Georges Pompidou, Paris
The Museum of Modern Art, New York
National Automobile Museum (The Harrah Collection), Reno, Nevada
National Portrait Gallery, Smithsonian Institution, Washington, D.C.
The Noguchi Museum, New York
S.C. Johnson. A Family Company
Kenneth Snelson
Special Collections Research Center, Morris Library, Southern Illinois
 University, Carbondale
Department of Special Collections of the Stanford University Libraries
Whitney Museum of American Art, New York

Whitney Museum of American Art
Staff List

Jay Abu-Hamda
Stephanie Adams
Leslie Adato
Noreen Ahmad
Alanna Albert
Adrienne Alston
Ronnie Altilo
Martha Alvarez-LaRose
Jeff Anderson
Callie Angell
Marilou Aquino
Rachel Arteaga
Bernadette Baker
John Balestrieri
Wendy Barbee-Lowell
Justine Benith
Harry Benjamin
Jeffrey Bergstrom
Caitlin Bermingham
Lana Bittman
Hillary Blass
Richard Bloes
Leigh Brawer
Amanda Brody
Barbara Brusic
Douglas Burnham
Ron Burrell
Garfield Burton
Elsworth Busano
Pablo Caines
Bridget Carmichael
Gary Carrion-Murayari
Howie Chen
Ivy Chokwe
Ramon Cintron
Ron Clark
Melissa Cohen
Kim Conaty
Curtis Confer
Arthur Conway
Jessica Copperman
Graham Coreil-Allen
Heather Cox
Claire Cuno
Sakura Cusie
Donna De Salvo
Hillary deMarchena
Anthony DeMercurio
Neeti Desai
Eduardo Diaz
Eva Diaz
Lauren DiLoreto
Gerald Dodson
Erin Dooley
Lisa Dowd

Delano Dunn
Anita Duquette
Bridget Elias
Alvin Eubanks
Altamont Fairclough
Jessa Farkas
Eileen Farrell
Jeanette Fischer
Rich Flood
Seth Fogelman
Carter Foster
Samuel Franks
Murlin Frederick
Annie French
Donald Garlington
Larissa Gentile
Stacey Goergen
Jennie Goldstein
Meghan Greene
Emily Grillo
Peter Guss
Kate Hahm
Kiowa Hammons
Barbara Haskell
K. Michael Hays
Matthew Heffernan
Dina Helal
Claire Henry
Tove Hermanson
Carlos Hernandez
Ann Holcomb
Nicholas S. Holmes
Tracy Hook
Abigail Hoover
Brooke Horne
Marisa Horowitz
Kat Howard
Henriette Huldisch
Wycliffe Husbands
Beth A. Huseman
Chrissie Iles
Carlos Jacobo
Kate Johnson
Diana Kamin
Amanda Kesner
Chris Ketchie
David Kiehl
Rebecca King
Anna Knoell
Tom Kraft
Emily Krell
Margaret Krug
Tina Kukielski
Diana Lada
Leonard Lauder

Diana Lee
Sang Soo Lee
Kristen Leipert
Monica Leon
Vickie Leung
Jeffrey Levine
David Little
Kelley Loftus
Sarah Lookofsky
Elizabeth Lovero
George Lowhar
Doug Madill
Carol Mancusi-Ungaro
Gemma Mangione
Joseph Mannino
Heather Maxson
Julia McKenzie
Julie McKim
Sandra Meadows
Graham Miles
Sarah Milestone
Dana Miller
David Miller
Ashley Mohr
Shamim M. Momin
Matt Moon
Victor Moscoso
Colin Newton
Sasha Nicholas
Carlos Noboa
Kisha Noel
Thomas Nunes
Brianna O'Brien
Nelson Ortiz
Christiane Paul
Angelo Pikoulas
Dana Pinckney
Berit Potter
Kathryn Potts
Linda Priest
Vincent Punch
Stina Puotinen
Christy Putnam
Jessica Ragusa
Jeremiah Reeves
Maggie Ress
Emanuel Riley
Felix Rivera
Jeffrey Robinson
Georgianna Rodriguez
Gina Rogak
Justin Romeo
Joshua Rosenblatt
Amy Roth
Carol Rusk

Doris Sabater
Angelina Salerno
Karla Salguero
Rafael Santiago
Galina Sapozhnikova
Lynn Schatz
Gretchen Scott
Julie Seigel
David Selimoski
Hadley Seward
Erin Silva
Matt Skopek
G.R. Smith
Joel Snyder
Michele Snyder
Stephen Soba
Jessica Sonders
Barbi Spieler
Carrie Springer
Chrystie Stade
Mark Steigelman
Minerva Stella
Nicole Stiffle
Hillary Strong
Emilie Sullivan
Elisabeth Sussman
Mary Anne Talotta
Kean Tan
Ellen Tepfer
Phyllis Thorpe
Kristin Todd
Robert Tofolo
James Tomasello
Limor Tomer
Alexis Tragos
Beth Turk
Lindsay Turley
Ray Vega
Snigdha Verma
Eric Vermilion
Jessica Vodofsky
Tiffany Webber
Cecil Weekes
Adam D. Weinberg
Margie Weinstein
Allison Weisberg
Adam Welch
Alexandra Wheeler
John Williams
Natalee Williams
Nicholas Wise
Rachel de W. Wixom
Sarah Zilinski
Alan Zipkin

Photo Credits

Courtesy the Estate of Hazel Larsen Archer and the Black Mountain College Museum + Arts Center (plate 83; Miller, fig. 3)

The Art Institute of Chicago (plates 24, 50, 51, 68)

© 2007 Artists Rights Society (ARS), New York/ADAGP, Paris, photograph by Sheldan C. Collins (Miller, fig. 4)

Images courtesy Avery Architectural and Fine Arts Library, Columbia University, New York (plates 11, 16)

© Irit Batsry (Smith, fig. 3)

Photographs by Ben Blackwell (plates 2, 8, 10, 12, 17–18, 22, 25–27, 31–39, 42, 44, 47, 55–57, 61–63, 67, 81, 90, 122, 123, 125–27, 133–36)

Photograph by Ben Blackwell/ © Aaron Siskind Foundation (plate 78)

Image courtesy Stewart Brand (Goldstein, fig. 8)

Images courtesy Carl Solway Gallery, Cincinnati (plates 29–30, 52–54, 59–60, 64–65, 72–73, 138–39, 141–42, 151–52, 157–63, 172–75)

© Centre Canadien d'Architecture/ Canadian Centre for Architecture, Montreal (Goldstein, fig. 6)

Courtesy Chermayeff and Geismar, photograph by George Cserna (Miller, fig. 13)

CNAC/MNAM/Dist. Réunion des Musées Nationaux/Art Resource, NY (plates 130, 131, 143); photograph by Jean-Claude Planchet (plate 129)

Photograph courtesy CNAC/MCAM/ Dist. Réunion des Musées Nationaux/ Art Resource, NY, © Gian Piero Frassinelli, photograph by Georges Meguerditchian; image © Superstudio (A. Natalini, C. Toraldo di Francia, R. Magris, G. P. Frassinelli, A. Magris, A. Poli [1970–72]) (Hays, fig. 12)

Photograph by Sheldan C. Collins (Miller, fig. 2)

© 1964 Peter Cook/© Archigram Archives (Hays, fig. 9)

Photographs © Bob Daemmrich (plates 149–50)

Courtesy the Delaware Art Museum, Wilmington, photograph by Geoffrey Clements (Goldstein, fig. 1)

Images courtesy The Estate of R. Buckminster Fuller (plates 3–7, 9, 13–14, 19–21, 43, 45, 48, 71, 74–75, 84, 87–89, 118–21, 124, 128, 132, 144–45, 147, 156, 164–71; Hays, figs. 2, 5, 6; Miller, figs. 7, 10; Picon, figs. 1–5, 7); photograph by F. S. Lincoln (plate 15)

Image courtesy The Estate of R. Buckminster Fuller/© 2007 Artists Rights Society (ARS), New York/VG Bild–Kunst, Bonn (plate 79)

Image courtesy The Estate of R. Buckminster Fuller/John Cage Trust (plate 82)

Image courtesy The Estate of R. Buckminster Fuller/Photographic Archive, The Museum of Modern Art Archives, New York (EX649.8) (plate 137)

Images courtesy The Estate of R. Buckminster Fuller/© 2007 The Isamu Noguchi Foundation and Garden Museum, New York/Artists Rights Society (ARS), New York, photograph by F. S. Lincoln (plates 40, 46)

Images courtesy of Estate of R. Buckminster Fuller/Time & Life Pictures/Getty Images, photograph by Bernard Hoffman (plate 58); photograph by Nina Leen (plate 77); photograph by John Phillips (plate 66)

Image courtesy The Estate of R. Buckminster Fuller/Time & Life Pictures/Getty Images/© 1943 Time, Inc., photograph by Fritz Goro (plate 76)

Images courtesy of Estate of R. Buckminster Fuller/© Time, Inc. (plates 74, 75)

Photograph © Pedro E. Guerrero (Goldstein, fig. 2)

Dymaxion House and photograph from the Collections of The Henry Ford, Dearborn, Michigan; Dymaxion "2" 4D Transport courtesy the National Automobile Museum (The Harrah Collection), Reno, Nevada (plate 49)

© Ron Herron (Hays, fig. 11)

Index

Numbers in italics refer to illustrations.